**Books are to be returned on or before
the last date below.**

Exhibition
Catalogue

LIBREX —

Gustav Metzger
History History

Gustav Metzger
History History

Edited by Sabine Breitwieser

Generali Foundation, Vienna

Hatje Cantz

Contents

Foreword

The Gustav Metzger retrospective pays tribute to one of contemporary art's key figures. For decades, Metzger has dedicated his work to an aesthetic whose main focus is not the beautiful, the good, and the true, but their opposite: destruction. Metzger coined the term *Auto-Destructive Art* for an artistic style that lays no claim to immortality and gives visual form to the twentieth century's destructive potential.

It may amaze some that an insurance company, whose aim is to guarantee the preservation of values, could take an interest in these works. However, exact knowledge about this social value is one of our fundamental requirements. No other branch of industry has to occupy itself so intensively with omnipresent destruction and its statistics.

Gustav Metzger is not concerned with natural catastrophes, but, among other things, with humanitarian catastrophes such as National Socialism, to which he lost a part of his family. History, as we encounter it in media images and newspaper cover stories, is a central theme of his artistic work.

In the year in which Austria celebrates the fiftieth anniversary of the Austrian State Treaty, we are delighted to be able to honor an artist whose work is characterized by an intensive engagement with history. This publication, the first of any large scope to contribute to the recognition of this highly unconventional body of works, is intended as an expression of this fact.

Dietrich Karner
President Generali Foundation

Acknowledgments

When I contacted Gustav Metzger and then met him for the first time a few weeks later in London, he immediately gave his full support to my plan. In view of his personal history, this is not something to be taken for granted, and I am therefore extremely grateful to him for the trust he has placed both in me, personally, and the Generali Foundation, and for his cooperation, in general.

Special thanks go to Justin Hoffmann, Kristine Stiles, and Andrew Wilson for their very insightful essays, and for the lively exchange on content, particularly with the last two people named, which was of great benefit to the project.

A number of people and institutions have supported this project and contributed greatly to its success. Our thanks go especially to Jan Debbaut, Director of Tate Collections, and Adrian Glew, Tate Archive, London; Richard Hamilton, London; Jon Hendricks, The Gilbert and Lila Silverman Fluxus Collection Foundation, Detroit; Luise Metzel/Verlag Silke Schreiber, Munich; Clive Phillpot, London; Museum of Modern Art, Oxford; Heike Munder, Migros Museum, Zurich; Norman Rosenthal, Royal Academy of Arts, London; Harry Ruhé, Amsterdam; Alan Sutcliffe, London; and Archiv Sohm, Staatsgalerie Stuttgart; Klaus Staeck, Heidelberg; Tony White, Arts Council, London.

The retrospective and the present publication on Gustav Metzger have been made possible by the assistance of a highly committed team, to which I am very obliged for the excellent cooperation. First, I collaborated with Hemma Schmutz, Assistant Curator and Exhibition Coordinator, and then with Cosima Rainer, who quickly and enthusiastically became familiar with her job and contributed strongly to the project. Thanks to our outstanding technical team, Thomas Ehringer and Dietmar Ebenhofer, it was possible to reconstruct a number of early works by Gustav Metzger. Anna Artaker compiled the bibliography and chronology; for the latter, we were kindly permitted to draw on the biography of Gustav Metzger written by Clive Phillpot and revised by Luise Metzel. Iris Ranzinger and Luise Reitstätter were responsible for the extensive and laborious image research and editing. Julia Heine successfully organized the production of this publication, for which there is a German and an English edition. And, as has been the case with other previous publications, Dorit Margreiter has again helped us create a beautiful book.

Sabine Breitwieser

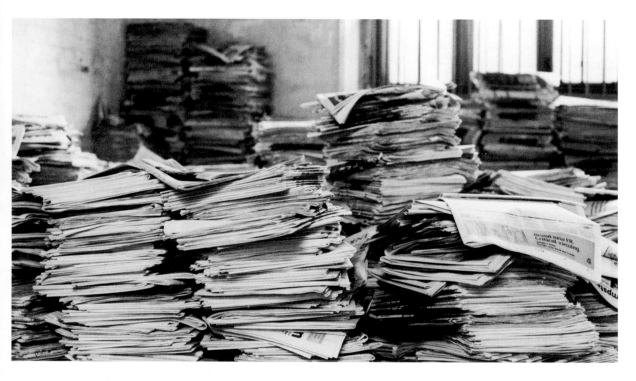

100,000 Newspapers, 2003

Sabine Breitwieser
Introduction

"The main thing I am interested in is complexity. Complexity in the sense that there is not just one answer to a question, but several different answers; that there is not only one path to beauty, but many possible paths. What I have tried to do is find an encounter with our reality, a compression, an answer, and a solution. ... I have never looked for just one thing, i.e., art or politics or revolution, but I wanted to bring together everything that was important to me and, I hope, to society, in one basic theory."[1]

A few remarkable meetings with Gustav Metzger that took place during the preparations for the exhibition and publication can help to illustrate this statement. Gustav Metzger is seldom to be seen without a newspaper, and, as a rule, he does not carry around a current edition, but instead one (or usually more) that interest him for various other reasons. Visits to galleries, bookstores, and vegetarian self-service restaurants also fit into the array of examples by means of which — whether deliberately or not — he revealed to me the range of his interests and activities.

Gustav Metzger arranged the first meeting with me — before we had even got to know each other — in the British Museum: in the African Galleries in front of the brass plaques made by the Edo people of Benin in Nigeria. These plaques were originally attached in identical pairs to pillars in the royal palace, and show scenes at the sixteenth-century court in the city of Benin, shortly after the first contact of Europe with West Africa. Like many other art treasures in museums, these, too, came into possession of the British Museum by military means, in this case during a British punitive expedition in 1897.

During a visit we made to the large El Greco exhibition in the National Gallery in London, it became apparent that Metzger was a regular visitor who was very familiar both to the staff and other exhibition visitors. We met Frank Auerbach there, who studied painting with Metzger under David Bomberg, and still works in the latter's former studio from the 1950s in Camden.

Another event was a trip we planned together from London to Oxford to visit the archive of the Museum of Modern Art, as well as a storage nearby where some of Metzger's works are kept. Metzger insisted on taking the bus instead of the train that departs from Paddington Station to Oxford. When I was getting on the train at the station on my own, I became aware for the first time of how bad the air was and how the glass roof of the station was blackened by soot. As Gustav Metzger later explained to me, the extreme air pollution caused by the diesel locomotives is the reason why he never goes to Paddington.

Gustav Metzger was born in Nuremberg in 1926. He is an artist, pioneer, and activist in various fields. As the son of orthodox Jews, he was sent to England with his brother in 1939 with the assistance of the Refugee Children's Movement, and thus survived the Holocaust. There is almost no other artist where a biographical detail is so centrally embedded in descriptions and documentations of their work.

Gustav Metzger's work sets out from his concept of *Auto-Destructive Art*, which he defined, in his first manifesto in 1959, as "a form of public art for industrial societies." He presented this concept in a number of *Lecture/Demonstrations*. Nuclear weapons, atomic energy, pollution, and, above all, the consequences of criminal and destructive acts like those committed by National Socialism are factors that fundamentally changed Metzger's understanding of aesthetics. His artistic conception is closely linked to the many political and ecological initiatives in which he has been involved since the 1950s (and which once resulted in a prison sentence).

Auto-Destructive Art is not centered on the artist subject, which largely recedes into the background to be replaced by an automatism—processes of destruction are induced using biological, chemical, or technological means. The life span of an auto-destructive work of art was, accordingly, conceived in the short term, varying "from a few moments to twenty years." In the *Auto-Creative Art* defined by Metzger a short time later, it is processes of growth that generate a work and keep it in constant flux. Metzger's early works are thus characterized by transformations: discarded cardboard boxes for television sets exhibited as art objects; canvases eaten away by acid; scraps of material in garbage bags; sculptures that lose or erode their components; liquid crystals that are heated to produce psychedelic displays of color; a drop of water held suspended between two states of matter. The materials used by Metzger all come from industrial production, mechanical processing, and, used in this procedural and self-destructive manner, can be seen as an attack on capitalist values and the art market.

Gustav Metzger is an enigmatic figure who has also left traces in pop culture. Pete Townshend, the "guitar destroyer" from the legendary rock band The Who, attended one of Metzger's lectures at the start of the 1960s and refers to his concept of auto-destruction. In the mid-1960s, Metzger presented his *Liquid Crystal Projections* at concerts by well-known bands in London, he later cited these projections as an example of *Auto-Creative Art*.

As the initiator and secretary[2] of the legendary *Destruction in Art Symposium* (DIAS) in 1966 in London, the most important meeting of artists at the time, Metzger drew worldwide attention to new trends in art. He gave Viennese Actionism, represented at DIAS—under the name "Institute for Direct Art"—by Günter Brus, Kurt Kren, Hermann Nitsch, Otto Mühl, and Peter Weibel, its first international—and internationally received—appearance.

In the 1970s, Gustav Metzger focused intensively on the problems related to environmental pollution, among other things, in his (unrealized) proposal for *Documenta 5* in Kassel in 1972. In a series of similarly conceived projects, he conducted car exhaust fumes into a transparent plastic cube, which changed color and became opaque. At the same time, he was interested in computer technology and was the editor of several issues of a bulletin on computer art. In 1974, having been invited to participate in the exhibition *Art into Society – Society into Art* in London, he forewent contributing an item to the exhibition. Instead, in his cataloguetext *Years without Art 1977–1980*, he called for a three-year "art strike" intended to protect the potential of politically committed art from being rendered harmless by the Establishment and the art market. Ten years after DIAS, in 1976, he organized, together with Cordula Frowein, an academic symposium entitled *Art in Germany under National Socialism*. A few years later, in 1981, in the exhibition *Vor dem Abbruch* in the Berne Kunstmuseum, he showed an installation featuring copies of the anti-semitic laws in effect from 1933 to 1943. In the same year, he put on *Passiv – Explosiv*, this time in a team with Klaus Staeck and Cordula Frowein. This was a counter-exhibition to the show *Westkunst* in Cologne, and was intended as a protest against the understanding of contemporary art propagated in the latter.

Gustav Metzger is just as committed to theoretical lectures, symposiums, and political forums as he is to his artistic work. For Metzger, the daily newspaper, as a sign of reality and the way it is shaped, as something which reflects and stores history plays a central role. In his most recent group of works, the *Historic Photographs*, which he developed in the 1990s, Metzger interrogates the way we come to terms with the images of humanitarian catastrophes documented in the media. By forcing the viewers to carry out particular activities if they want to see the historical photographs, Metzger highlights our ambivalence between voyeurism, trivialization, and compassion.

"Decides to become a sculptor instead of a professional revolutionary": this succinct entry is to be found in the summer of 1944 in an outline for a biography of Gustav Metzger.[3] What may look like a biographical anecdote about the then 18-year-old Metzger proves to be characteristic of his work, in which for 40 years he has uncompromisingly pursued a radical ambition. The rigor of his artistic approach and his refusal to make compromises with regard to the mechanisms of the art industry are also the reason for the outsider status that Gustav Metzger holds and defends to this day.

The present publication, which is being issued for a comprehensive retrospective of Gustav Metzger at the Generali Foundation in Vienna, provides a detailed overview of both his works and his person, and shows his importance from the 1960s to today. For the three specialist essays on the development of *Auto-Destructive Art*, DIAS, and the most recent works and activities of Gustav Metzger, we were able to win the services of the respective experts in these fields. The detailed and amply illustrated chronology situates Metzger's activities within the historical and political context in which they have taken place. This publication thus aims to honor Gustav Metzger not only as an artist, but also as an activist and pioneer in various areas.

1 Gustav Metzger in: Hoffmann, Justin. *Destruktionskunst*, Munich 1995: 51.

2 DIAS was organized by Gustav Metzger together with John Sharkey.

3 Metzger, Gustav. *damaged nature, auto-destructive Art*. Coracle Press, London 1996: 83.

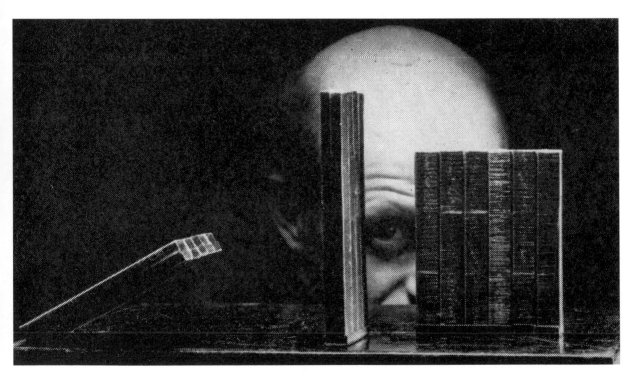

Model for an Auto-Destructive Monument, 1960

Justin Hoffmann
The Invention of Auto-Destructive Art

The emergence of *Auto-Destructive Art* (ADA) must be seen in the context of political circumstances and personal experiences. Gustav Metzger's artistic practice cannot be properly considered without taking into account the drastic conditions under which he was driven from Germany by Nazi racial policies and was forced to live as a Jewish emigrant in Great Britain. Another striking aspect of Metzger's artistic development is the clear turning point that can be registered in the years 1959/60. This caesura divides his œuvre into the early works, which are little known and marked by the influence of his teacher, David Bomberg, and those produced afterwards. In other words, the periods before and after 1959/60 are clearly distinct. The exhibition *Three Paintings by G. Metzger* (30 July to 19 August 1959) in Brian Robin's café in London was followed in the same year by the presentation of discarded cardboards (9 to 30 November 1959), accompanied by the presentation of his first ADA manifesto dated 4 November 1959. In September 1960, he presented a retrospective exhibition of paintings and drawings from the years 1945 to 1960 in London's Temple Gallery. This retrospective was intended as a summary of the way Gustav Metzger had worked up to this point, and cleared the way for new activities. For him, the exhibition marked the end of his use of traditional artistic means.

But what had happened during these months? What was the reason for this turning point in his artistic development? What was Gustav Metzger's "experience of truth," to use Alain Badiou's terminology,[1] that made him feel that his previous artistic work was obsolete? I will examine this question in the second part of this essay. Before that, I would like to describe in detail how Gustav Metzger founded the new artistic genre of ADA, which, despite his efforts, did not spread to become a movement.

I. *Auto-Destructive Art*: theory and practice

Looking at the development of ADA, what stands out is its unique manner of blending theory and practice. The way Metzger determined his own production with his conceptual ideas can be described as remarkable. Intellectual activity gave rise to new forms of artistic work. In his practice, the artist restricted himself to only some of the possibilities of ADA that he listed and described in texts. Each concrete realization represented a further corrective. Furthermore, the artist saw the works created during these years not as the production of autonomous works, but as a developmental phase comparable with the practice of carrying out experiments in the natural sciences. At the same time, however, he was greatly interested in publishing the demonstrations in order to promote the new artistic direction. For this reason, the works of the years 1959 to 1963 can be seen as the results of a test phase. Yet, owing to their work-critical, ephemeral character and their explicit orientation towards the general public, they can also be considered as pointing the way for later forms of a socially oriented artistic practice.

The first manifesto and the first model for an *Auto-Destructive Monument*

Gustav Metzger's first theoretical text, his manifesto *Auto-Destructive Art*, was written in November 1959 for a solo exhibition in an artists' café at 14 Monmouth Street in London. It established the guidelines for the form of art to which he had given this title. With the claim in the first sentence of the text—that ADA is public art—, Metzger dissociated himself from conventional art institutions such as museums and galleries. The new artistic style aspired to be accessible to all, free of charge, and was not meant for sale. According to the manifesto, ADA is a work that disintegrates or falls apart under the effect of physical-chemical processes. "I wanted to show that *Auto-Destructive Art* is something integral that has to do with society. *Auto-Destructive Art* comes from society, remains in society, and the closer it remains to society, the more effective it is as a whole."[2]

The acoustic level is used in a way that underlines the topical quality of ADA. In the era of rock 'n' roll, it is electrically amplified: "The perception of the processes can be enhanced if the viewer also hears something, as a sort of addition to the perception. ... I am talking about a technological development that is built in, can be built in, to reinforce the destructive process." In contrast with informal art, ADA does not show any traces of the individual artist. The lifetime of an auto-destructive art work should be restricted and not exceed twenty years.[3]

Gustav Metzger's presentation in Monmouth Street did not yet feature any auto-destructive art works. Metzger exhibited cartons, *Cardboards*, which had been used to package

technical equipment. On the one hand, these objects are mechanically produced ready-mades, and on the other, they appear as imprints or negative forms of the equipment. They seem like surrogates. The objects are originals, but they serve solely as a covering for another object, the "actual" object. Metzger was later to call works based on industrially produced objects *Machine Art*.

Shortly after the publication of the manifesto, Gustav Metzger produced the first *Model for an Auto-Destructive Monument*. In a photograph showing the approximately 15-centimeter-high model of the sculpture in front of the artist's head, it is possible to recognize that the sculptural arrangement consists of three elements: three slender rectangular bodies, each made up of several hollow, square components. Two of these are upright and placed at right angles to each other. One of them towers above the other. The third element rises out of the ground at a slight angle; the side touching the ground is parallel to the side of the taller rectangular body, towards which the angle opens. In its clarity and its reduction to a small number of elements, Metzger's formal language brings to mind the later minimal art. According to his concept, the monument is intended to gradually rust and disintegrate. The destructive process would be set in motion and kept going by air and weather. He had envisaged thin, polished steel as the material used. The steel was to be only a few millimeters thick so that it would rust away completely within a certain space of time. However, the thinness of the material also created structural problems, which Metzger wanted to solve by means of a skeleton construction inside the steel cuboids. "In the end, there would be the skeleton. At first, you would see only the steel ... but after a time you would see the frame. ... The frame cannot be destroyed; it is thrown away after ten years."[4]

A large public sculpture like the one represented in this model is central to Gustav Metzger's conception of ADA. Unlike other monuments, which are often meant to fulfill the desire to immortalize a person or even the artist, Metzger's monument vanishes after a maximum of twenty years. The public site is then available to society once again. For Metzger, the *Auto-Destructive Monument* was not only an aesthetic project, but was also a cybernetic model in an urban situation that included the possibility of interaction. However, Gustav Metzger did not succeed in finding an institution or private sponsor willing to finance the production and construction of one of these monuments: "These ideas were never realized. I am now speaking thirty years on. Not a single one. I never did anything except demonstrations."[5]

The second manifesto and the first *Lecture/Demonstrations*

Gustav Metzger was able to persuade the journalist John Rydon to write an article about his *Auto-Destructive Monument* project for the *Daily Express*. A photo of the model was published with the article. On 10 March 1960, in connection with this model, Metzger published his second manifesto. It differs from the first not only in content, but above all, stylistically. It begins with provocative, yet almost poetic words. ADA is not so much expounded in analytical fashion, as propagated at an emotional level. The second manifesto also seems more political, explicitly attacking the capitalist and communist systems. Here, Metzger says: "As far as the capacity for destruction is concerned, I am opposed to communism. … I was always much more anti-capitalist, anti-West, than anti-communist."[6] In the second manifesto, Metzger explains that he does not see destructive art as some sort of picturesque romanticism of ruins. He does not want to preserve something upon which the traces of the past can be seen. But Metzger is not opposed to the beautiful: "I am looking for a new beauty: A beauty that does not or cannot exist in any other guise. … People always think that someone who destroys, destroys art. What I say is: this art gives people the beauty appropriate to our times."[7] In his text, Metzger tries to distinguish between works that an artist strongly influences through his manipulation, and works that are largely independent of their author. The precondition for both is, however, something that sets the destructive process in motion. ADA is thus, in the broadest sense, always kinetic art.

The last part of the manifesto contains a list of techniques and materials that can be used to produce an auto-destructive art work. Years later, the German artist Werner Schreib would draw up a similar systematic list. Gustav Metzger's list can also be seen as an invitation to other artists to engage with ADA. Initially, he wanted to organize a movement. Among the people who regularly frequented the artists' café in Monmouth Street were two young artists who were also interested in destruction. According to Gustav Metzger, they worked with broken objects in a manner similar to that of junk art and Neo-Dada.[8] "The two were very young, 22, 23, and may have been involved in drugs. At any rate, they were very aloof. There was no conversation with them, even though my manifesto was lying there. I spoke to them at the time to try and get a movement going. But nothing came of it."[9] But Gustav Metzger continued to try to spread the idea of ADA by giving lectures and demonstrations. "At the time I thought: in one or two years there will be a movement. When Tinguely appeared in New York, it was already a movement. … Within six months there were two people in the world doing self-destructive art, and unfortunately from then on nothing more."[10]

The first lecture and the first demonstration of ADA took place on 22 June 1960 in the Temple Gallery in London. The twenty original photographs of the demonstration were lost. Gustav Metzger's action can best be seen in a picture in Udo Kultermann's book *Neue Formen des Bildes*

(*The New Painting*), 1967.[11] "This picture was taken at the end of the demonstration on the evening of the opening. The first lecture was in the afternoon for invited guests. Jasia Reichardt gave an introduction then I delivered a lecture."[12]

The artist spoke chiefly about the role of chance and chaos in art, science, and society. He then treated some white nylon stretched across a piece of glass with hydrochloric acid for twenty minutes. The acid was applied using a variety of different brushes. Whenever the artist painted the material with the fluid, it immediately disintegrated. Every further application created new holes. The work was placed between the audience and the artist. The nylon was lit up from the audience side. At first the viewer saw almost only the white piece of nylon. But with every new hole they could more clearly observe the artist working.

Gustav Metzger had only begun experimenting with acid as a painting material three weeks before the demonstration: "I thought, 'I'll put acid on paper,' and it didn't work. I thought, 'I'll put acid on material,' and it didn't work. I thought: 'My God. I'll go mad!' I had already agreed to give the lecture. And I thought it would be easy to destroy something. Then I found the nylon … by experimenting. I didn't do any research. I didn't know anything about acids. … After these first theoretical works, the first painting, I realized that it would take years to research it and disseminate it. … There was no need to paint, as [working with the nylon] was naturally also painting."[13]

Gustav Metzger called his appearance in the long room of the Temple Gallery a *Lecture/ Demonstration*, a term that he frequently used for similar events during the first half of the 1960s. In addition, new works by the artist were on display in the gallery. For the first time, Metzger exhibited newspapers: "I bought newspapers, the *Daily Express* and other papers, and I simply hung them in a corner of the gallery as a sign: this is reality, this is design."[14] Here, Metzger dispensed completely with any form of processing. The newspapers were hung as double pages without any frame. In his lecture, Metzger also spoke about the aesthetic and social meaning of newspapers. The *Cardboards* from his exhibition in 1959 had a kind of continuation in the presentation of *Bags*: bags containing scraps of material that textile companies near Oxford Circus put out in the street every evening as garbage. Gustav Metzger was fascinated by these bags. He picked up ten or twelve of them and took them home with him. He hung the best of them as a junk ready-made in the Temple Gallery. The audience consisted of about thirty people, including several art critics.[15] At this event, Gustav Metzger wanted to give a general overview of his practice. For this reason, he brought the *Cardboards* and the *Model for an Auto-Destructive Monument* with him to his *Lecture/Demonstration* in the Temple Gallery, even though the event only lasted one day.

In October 1960, the Heretics Society of Trinity College in Cambridge invited Gustav Metzger to give a lecture. The secretary of this society, Ian Sommerville, a friend of William

Burroughs, who studied mathematics at Cambridge, had heard of Metzger's first demonstration and was interested in the artist's ideas. Gustav Metzger accepted and gave his second *Lecture/Demonstration* to 250 people—including Brion Gysin and William Burroughs—in a hall in Cambridge. According to Metzger, he never again carried out a demonstration in front of such a large audience.[16] Because the event had been announced in a student magazine, a great number of those present were prepared for ADA. For the most part the audience reacted positively to Gustav Metzger's lecture and demonstration, and was attentive and interested.

The third manifesto, the South Bank demonstration, and further actions

In 1961, the International Union of Architects announced that it would hold a conference on the South Bank in London. Prominent artists were invited to show their works at this event. Gustav Metzger heard about the conference, went to the organizer with a folder of his works, and asked if he could carry out a demonstration there. He saw the conference as an opportunity to reach a larger audience with a presentation of ADA. The organizer agreed, promising the artist to finance the action with fifty to sixty pounds. One week before the action was to take place, Metzger rang up the person in charge of public relations for the congress. This person knew nothing of Metzger's project and was indignant that a demonstration of ADA was to be held in the context of this architectural event. Obviously, there had been no agreement between the public relations officer and the congress organizer. Two days later, Gustav Metzger received a call telling him that the action would not be allowed; even the organizer was now said to be against the idea. Metzger, however, wanted to present his demonstration on the South Bank, even if those in charge of the congress were to call the police. On the 1,000 leaflets that he had printed for the purpose a broad, black bar was printed over the original event in such a way that the bar looked like a graphic device. Along with a short description of the demonstration, the 1961 leaflet contains the two earlier manifestos and one new one. The latter reveals some new directions.

Gustav Metzger's assistants in the action handed out the leaflets to the bystanders. This shows how important the theoretical aspect of his work was to him and the great pains he took to get people to understand ADA. The term *Auto-Creative Art* occurs for the first time in the new manifesto. It is described there as an art of change and growth. In a similar manner to *Auto-Destructive Art*, the auto-creative process is set in motion by a particular physical, biological, or chemical reaction. As opposed to ADA, however, Gustav Metzger did not at first produce any works or demonstrations.

The expression *Machine Art* also occurs in this manifesto for the first time in addition to the terms *Auto-Destructive Art* and *Auto-Creative Art*. During his *Cardboards* exhibition, Metzger

had already realized that present-day technology produces forms of high aesthetic quality.[17] From then on, he preferred art that was produced by machine and not by hand. His engagement with ADA was always accompanied by reflection on the possibility of mechanical artistic production without any direct intervention by the artist. ADA was of great social relevance to Gustav Metzger, not least because it had almost the character of an industrial process: "If I want to make *Auto-Destructive Art*, I now do not have to create the form myself. I go to industry and select pieces that already exist. And because they already exist, they have the great advantage of already possessing a social content without my having to put it there as an artist. And owing to the fact that they are there and owing to my decision to use them, I enhance the expressive possibilities of *Auto-Destructive Art*."[18]

The South Bank demonstration consisted of two parts: an acid-painting action and an action using panes of glass that were to fall down and smash in a particular order. The latter action could not be carried out as planned, because the strong wind on the banks of the Thames made it impossible to coordinate the falling of the glass. The large panes were attached to metal tubes using only adhesive tape, and the gusts of wind detached them too early. For the painting action, three pieces of nylon material—black, red, and white—were stretched between metal rods. (The choice of colors reflected Metzger's interest in Suprematism.) The screens were placed one behind the other so that viewers were able to experience an impressive and colorful spectacle as the pieces of material were destroyed. Gustav Metzger relates: "I wanted the following effect: I make the holes and then people see through them, see the colors behind each other, through each other, and the extreme contrasts as well. I hadn't done any experiments. I hadn't ever tried it. I thought, I knew, it would work if I used this technique. But I didn't know what it would look like."[19] Some parts of the demonstration were recorded by a press photographer. The photographer whom Gustav Metzger had hired to photograph the various stages of the action had overslept and did not turn up to the event. The South Bank demonstration was the first artistic open air action in England. It was financed solely by the artist himself.

Gustav Metzger's next demonstration of ADA took place during the *Misfits* evening on 24 October 1962 at the Institute of Contemporary Arts (ICA) in London. The so-called *Festival of Misfits* was, however, less a festival than an exhibition. It was shown from 23 October through 8 November 1962 in the Gallery One, North Audley Street, London. In a manner comparable with *Neo-Dada in der Musik* in June 1962 in Düsseldorf and the first Fluxus concert in Wiesbaden in September 1962, *The Festival of Misfits* featured various performances at the ICA on Dover Street. The project came about on the initiative of Daniel Spoerri and Robert Filliou. They had written to Metzger asking him to participate. Besides Robin Page, he was the only artist in Great Britain to receive an invitation. Metzger had met Spoerri for the first time in 1959 during the installation of the latter's MAT-edition in Gallery One and for the second time when this exhibition was

ARTHUR KØPCKE- M
AHLEREI ZWISCHEN
MUSIK

DANIEL SPO
ERRI- COMP
ETITION FO
R CHAIRS A
ND TABLES.

DIC
K H
IGG
INS
- S
YMP
HON
Y N
O.
4-
SCO
RE:
SOM
ETH
ING
BIG
AND
SOM
ETH
ING
SMA
LL.

BENJAMIN P
ATTERSON -
PAPER PIECE

EMMETT WILLIAMS-A
LPHABET PIECE FOR
TWO ALPHABETS, 26
INSTRUMENTS, COND
UCTOR, AND PERFOR
MER. chance and
 exactitude

ROBERT FI
LLIOU- 53
KILO POEM

ROBIN PAGE- BLOCK GUITAR PIECE

G. METZGER - AUTO-D
ESTRUCTIVE CONSTRUC
TION WITH: AMPLIFI
ED SOUND. LUMINOUS
PAINT, PAPER. MAGN
ET, METAL, GLASS, P
LASTIC. ACID, NYLO
N. LIGHT, REFLECTO
RS. DURATION: TWE
NTY MINUTES.

A
L
I
S
O
N

K
N
O
W
L
E
S

P
R
O
P
O
S
I
T
I
O
N

Misfits evening, 1962, ICA, London, program, graphic design by Dick Higgins

dismantled in February 1960. At this second meeting, Spoerri told him that Tinguely was planning a big exhibition of a self-destructive art work. This stimulated Metzger to publish his model of the *Auto-Destructive Monument* in the newspaper *Daily Express* on 15 March 1960, before Tinguelys *Homage to New York* took place (17 March 1960). The *Misfits*-performances took place on the evening of 24 October 1962. The pieces performed included Robin Page's *Guitar Piece*, Emmett Williams' *Alphabet Symphony*, and the *Paper Piece* by Benjamin Patterson. Gustav Metzger gave a demonstration of ADA, applying acid on a nylon screen. The evening event at the ICA was well attended. Because of the confined space, Metzger gave the people near the screen something with which to protect themselves. He had not put up a special construction for displaying the screen. He retrospectively rated this demonstration as his most unsuccessful mainly because of this fact.[20]

In 1963, he again carried out an acid-painting action on the South Bank near what is now the film museum. It was filmed by Harold Liversidge. Liversidge had met Metzger at a theoretical course at Slade School of Art, London and showed a great deal of interest in his works. The film *Auto-Destructive Art – The Activities of G. Metzger* consists chiefly of a painting action in which Metzger works on a large screen with brushes and spray equipment. "I had a real gas mask and helmet on as protection. It wouldn't have worked otherwise because of the wind. I would have been burnt. ... I also had to wear gloves, rubber gloves."[21] At the beginning of the film, Metzger reads from off-camera his second manifesto. He saw this film, too, as a means for propagating his ideas.

Because the artist still did not succeed in realizing his *Auto-Destructive Monument* despite all these efforts, he intensified his theoretical work, writing various articles for journals. As he constantly emphasized in his texts, the artistic subject in ADA tends to take the back seat, something which distinguishes it from other forms of destruction art. It is replaced by an automatism—in his second manifesto, Gustav Metzger calls it an "agent"—that sets destructive processes in motion in each work. The artist does not appear during the creative-destructive process. However, he creates the framework for the self-activities of the material. The artist develops the concept and gives his work its initial form. The final form is shaped by a chemical or physical process that is not completely determinable. The auto-destruction is initiated by the artist, but the three-dimensional art work itself carries out the public action. The withdrawal of the author is meant to highlight the fact that there are certain objects or machines that can become independent and destroy themselves in an unplanned manner. *Auto-Destructive Art* aims to demonstrate the destructive possibilities of this technical potential. It aims to warn of a catastrophe. *Auto-Destructive Art* has a foretelling character; it demonstrates the suicide of the world of machines.

II. The turning point: the ecological experience

Let us return to the question of what induced Gustav Metzger to totally change his artistic production in 1959/60. Several years previously, he had a defining experience on the Shetland Islands in the far north of Great Britain. In an interview on 3 April 1989, he replied as follows to my question about the grounds for his deep mistrust of technology: "I had a very important experience in 1951. I went on a three-month trip that took me right up to Scotland. I had lived in London and wanted to get away from there. The Shetland Islands were a very peaceful place back then. There were no cars. They were not allowed. Except for a few that had to be brought over by ship. There was a kind of calm there that I had never experienced before. At the time, I kept a diary. And during this time I wrote down things that were important to me. One of these was that cars had to go. That was a kind of breakthrough for me in a new direction. It was quite extreme: they have to go! I thought a lot about the destruction caused by cars, the destruction of the human environment, of nature. It was an obsession. That was the start of my deliberate, politically consistent opposition to technology."

The Shetland Islands became a sort of Arcadia for him, a utopian ideal—but an ideal that existed in reality. A radical ecological attitude developed in connection with his efforts against nuclear weapons. After this profound experience of an almost pristine natural environment, the artist moved to the countryside. However, he did not move far from London, so that he could continue studying in David Bomberg's class. After this, starting in the summer of 1953, he lived in Norfolk for several years. Being opposed to atomic energy and nuclear weapons, he became a member of the King's Lynn Committee for Nuclear Disarmament in 1957 and the first secretary of the North End Society, a local enviromental organization. His ecological awareness was an important driving force behind his proclamation of ADA at the end of the 1950s. In the first manifesto of 1959, he anticipated land art and process art, proposing an artistic practice based on a synthesis of traditional artistic techniques, modern technologies and natural forces. When he writes in the second manifesto of 1960: "*Auto-Destructive Art* demonstrates man's power to accelerate disintegrative processes of nature and to order them," he emphasizes his interest in showing potential for destruction. ADA is to highlight processes that already exist but are too little noticed. In this manifesto, he also laconically mentions "natural forces" in a list of materials and techniques.

His project *Stockholm June* for the first UN environmental conference in Stockholm in 1972 can be more explicitly connected with his experiences on the car-free Shetland Islands. In this work he addressed the environmental pollution caused by the emissions from motorized vehicles. It is illustrated and described in the catalogue for *Documenta 5* in 1972 in draft form, but was never realized. The concept envisaged placing 120 cars around a two-and-a-half to four-meter-high construction. The exhaust fumes produced by the running motors were to be

conducted into the inside of the construction. In a second phase, the cars were to be taken into the construction, which would now be covered by an airtight plastic cover. The cars were then to be filled with petrol and started. Metzger assumed that the cars would burst into flames one day later.[22]

A precursor of this project bore the title KARBA (1970–72) and was meant to be realized at *Documenta 5* in Kassel. The project consisted of four cars whose exhaust fumes were to be led into a large plastic cube with three meter long sides during the entire exhibition. Metzger believed that the originally empty, transparent space would change into a dark-gray, opaque cube after several days. Although the planned site for KARBA is marked in the catalogue for *Documenta 5*, the project was not realized. Twenty years after *Stockholm June*, in 1992, Metzger designed another version of this project called *Earth minus Environment* for the UN environmental conference in Rio de Janeiro, to which NGOs were also invited. Even though he could not be certain of it being realized and paid for by an institution, it was important to him to present the concept publicly in the form of a model. He exhibited it in 1992 in Galerie A in Amsterdam, run by the Fluxus gallery owner, Harry Ruhé. He wanted to use this presentation to promote the realization of his project. As he wrote in a text on this project, dated 6 January 1992, he hoped that this installation would be shown in both Europe and Brazil: "Constructing the two works will also be in line with the central issue of the Earth Summit; the indivisibility of North and South when solving global problems."[23] In the same text, he draws attention to the fact that he had wanted to work with car exhaust fumes for the first time in 1964. In this first project (not realized until 1970 in an adapted form as part of the *Kinetics* exhibition at the Hayward Gallery), the poisonous emissions from a truck were conducted into a container on its loading platform. The vehicle was to drive through the city as a mobile public-art project, making visible the gradual discoloration and pollution caused by exhaust fumes. In accordance with the ideas of ADA, the artist here designed a set-up that produces physical-chemical processes; that is, to put it concretely: in which emissions take over the function of paint.

III. Art after the Holocaust: Metzger and Adorno

As has been emphasized several times, the experience of the Holocaust had a decisive influence on Gustav Metzger's artistic practice from 1959. The artist was born in Nuremberg in 1926. His parents were orthodox Jews who had moved to Germany from Galicia, Poland. During the Nazi regime, his parents and a large number of his relatives were killed in Poland. Gustav Metzger only survived owing to the activities of the Refugee Children's Movement. On 12 January 1939 he came to London with his brother, Mendel, in an evacuation operation and was put up in a hostel there.

After an apprenticeship as a cabinetmaker, Metzger studied art in England, but frequently earned his livelihood with skilled manual jobs or by working as a junk dealer and gardener. At the same time, he was politically active. He became involved in efforts to avert an imminent atomic catastrophe and took part in two marches supporting the occupation of a rocket base in 1958. In addition, together with Bertrand Russell, he belonged to the Committee of 100 and was imprisoned for a month because of the activities of this group.

Metzger's fears of a global catastrophe were based, above all, on three aspects: the political development of a social system that can produce the Holocaust; the global threat posed by the stockpiling of nuclear armaments and the Cold War; and a technological development, that causes the pollution of our environment.

If we compare statements and texts by Gustav Metzger with those of the German philosopher Theodor W. Adorno, some astounding parallels emerge. For both men, the Holocaust was the starting point for a process of realization: for a pessimistic view of global events. Both appeared after the war in public as critics warning against destructive developments, seeing the phenomenon of the Holocaust in a wider context and recognizing it as a symptom of other negative processes (the menace of consumerism, ecological catastrophe, etc.). Both saw the capitalistic and real-socialist systems as not being real alternatives to the Nazi regime. Both were concerned that the Holocaust would be too quickly forgotten. I would like to do more than simply make vague claims regarding the connections between Gustav Metzger's artistic work and Theodor W. Adorno's philosophical thought and will try instead to illustrate them in detail. To do this, I will compare quotes from Adorno's writings with some of Metzger's statements.

The destructive potential of humankind: errors of technology

The invention of ADA in 1959 was a decisive turning point in Gustav Metzger's work. To illustrate the central intentions of ADA, I would like to quote a passage from Metzger's *Manifesto Auto-Destructive Art* of 10 March 1960 and compare it with passages from Adorno's "Erziehung nach Auschwitz" (Education after Auschwitz) of 1967.

"*Auto-Destructive Art* re-enacts the obsession with destruction, the pummeling to which individuals and masses are subjected. *Auto-Destructive Art* demonstrates man's power to accelerate disintegrative processes of nature and to order them. *Auto-Destructive Art* mirrors the compulsive perfectionism of arms manufacture—polishing to destruction point. *Auto-Destructive Art* is the transformation of technology into public art. The immense productive capacity, the chaos of capitalism and of Soviet communism, the co-existence of surplus and starvation; the increasing

stockpiling of nuclear weapons—more than enough to destroy technological societies; the disintegrative effect of machinery and of life in vast built-up areas on the person ..."[24]

The factors mentioned in this manifesto—the stockpiling of nuclear armaments and the development of technology—also played an important role in Adorno's thought.

In his essay "Education after Auschwitz" he expounded several ideas on a type of education that would prevent the creation of people who cause genocides. In it, he says: "Furthermore, one cannot dismiss the thought that the invention of the atomic bomb, which can obliterate hundreds of thousands of people literally in one blow, belongs in the same historical context as genocide. The rapid population growth of today is called a population explosion; it seems as though historical destiny responded by readying counterexplosions, the killing of whole populations."[25] Adorno has the following to say about technological development: "A world where technology occupies such a key position as it does nowadays produces technological people, who are attuned to technology. This has its good reason: in their own narrow field they will be less likely to be fooled, and that can also affect the overall situation. On the other hand, there is something exaggerated, irrational, pathogenic in the present-day relationship to technology. ... People are inclined to take technology to be the thing itself, as an end in itself, a force of its own, and they forget that it is an extension of human dexterity. ... It is by no means clear precisely how the fetishization of technology establishes itself within the individual psychology of particular people, or where the threshold lies between a rational relationship to technology and the overvaluation that finally leads to the point where one who cleverly devises a train system that brings the victims to Auschwitz as quickly and smoothly as possible forgets about what happens to them there. With this type, who tends to fetishize technology, we are concerned—baldly put, with people who cannot love."[26]

Gustav Metzger introduced the term self-destruction (or auto-destruction) into art. In Adorno's works, this term also occurs in a philosophical context in the chapter "Meditationen zur Metaphysik" (Meditations on Metaphysics) in the book *Negative Dialektik* (*Negative Dialectics*): "After Auschwitz, our feelings resist any claim of the positivity of existence as sanctimonious, as wronging the victims; they balk at squeezing any kind of sense, however bleached, out of the victims' fate. And these feelings do have an objective side after events that make a mockery of the construction of immanence as endowed with a meaning radiated by an affirmatively posited transcendence. Such a construction would affirm absolute negativity and would assist its ideological survival—as in reality that negativity survives anyway, in the principle of society as it exists until its self-destruction."[27]

Culture and barbarity

The treatise *Dialektik der Aufklärung* (*Dialectic of Enlightenment*), which Adorno had previously written with Max Horkheimer in the 1940s while in Californian exile, is considered the key book of the epoch. In this work, the two authors look at the question of why human civilization cannot hope for a positive future, but will gradually sink into barbarity. This subject is also the intellectual basis for the development of ADA. Gustav Metzger's third manifesto of 23 June 1961 ends with: "*Auto-Destructive Art* is an attack on capitalist values and the drive to nuclear annihilation."[28]

Adorno's statement regarding cultural production after Auschwitz is famous and frequently quoted. In the essay "Kulturkritik und Gesellschaft" (Cultural Criticism and Society) in the book of the same name, he wrote: "The more total society becomes, the greater the reification of the mind and the more paradoxical its effort to escape reification on its own. Even the most extreme consciousness of doom threatens to degenerate into idle chatter. Cultural criticism finds itself faced with the final stage of the dialectic of culture and barbarism. To write poetry after Auschwitz is barbaric. And this corrodes even the knowledge of why it has become impossible to write poetry today."[29]

Lyrical, poetical, consummate art works in the traditional sense seem, after the Holocaust and in the face of an imminent World War III, to be no longer possible. In view of his skepticism regarding individualistic artistic production, Metzger sees the self-activity of the material as the basis for a contemporary artistic practice. His first *Lecture/Demonstration*, *Acid Painting on Nylon*, which was based on chemical reactions, took place in the Temple Gallery in London in 1960. In an action like this one, the artist only has to create a set-up that sets a process in motion. At first glance, however, even this artistic practice seems to contravene Adorno's verdict against artistic production. But what at first appears to be an absolute prohibition in the above-mentioned passage is directed at what Adorno sees as a failure of culture in general—something he makes clear in later texts in which he reflects on the guilt of philosophy, i.e., his own field of work. In "Meditationen zur Metaphysik" he revised his earlier statement: "Perennial suffering has as much right to expression as a tortured man has to scream; hence it may have been wrong to say that after Auschwitz you could no longer write poems. But it is not wrong to raise the less cultural question whether after Auschwitz you can go on living—especially whether one who escaped by accident, one who by rights should have been killed, may go on living."[30]

The question "Why am I the one to have survived?" and the accompanying sense of guilt with regard to those who died, and the idea that art has to be fundamentally different after the Holocaust also had a strong influence on the theory and practice of Gustav Metzger. Psychologists speak in such cases of a "survivor syndrome." This particular syndrome probably played a considerable role in the conception of ADA. In a DVD brought out by the Arts Council of England in 2004 Metzger says that the recollections of Nuremberg and of fascism haunt him to this day.

Critique of the system: admonishers are spoilsports

"The indignation at nihilism that has today been turned on again is hardly aimed at mysticism, which finds the negated something even in nothingness, in the *nihil privativum*, and which enters into the dialectics unleashed by the word nothingness itself. The more likely point, therefore, is simply moral defamation—by mobilizing a word generally loathed and incompatible with universal good cheer—of the man who refuses to accept the Western legacy of positivity and to subscribe to any meaning of things as they exist."[31]

The people who resist the obligatory positive view of the world are often, as Theodor W. Adorno writes, stigmatized by society. Because of his profoundly critical stance towards political establishment, Gustav Metzger was often maligned and excluded by the established art scene. The political and aesthetically radical character of his planned contribution to the *Festival of Misfits* in Gallery One in London, made him the "misfit" of the "misfits." He wanted to display every edition of the entire daily newspaper *Daily Express* in the staircase of the gallery for the duration of the exhibition. The front and backside of the double pages of the paper should be visible on the wall (for which two issues of the same edition were needed each day). In this way, every page of the newspaper would have been visible at one glance. The installation was to be updated each day, so that the current edition of the *Daily Express* would cover the wall. The work was rejected.

Gustav Metzger applied the critique of capitalism to his own area of work, criticizing the economic structure and mechanisms of the art system. In a similar vein to Adorno's criticism of reification, Metzger attacked commercialization in the field of art. There is a massive institutional critique to be found in Metzger's *Manifesto World* of 7 October 1962: "It is a question of a new artistic sensibility. The artist does not want his work to be in the possession of stinking people. He does not want to be indirectly polluted through his work being stared at by people he detests."[32] Gustav Metzger's critical attitude to the art system is also evidenced by his involvement in the Coalition for the Liquidation of Art, which in 1970 held a demonstration in front of the Tate Gallery. Metzger wanted to radically change the art system, and saw the artists' strike as a suitable method for achieving this. His pamphlet *Years without Art 1977–1980*, which called for a three-year strike, appeared as a contribution to the catalogue for Norman Rosenthal's and Christos Joachimides' exhibition *Art into Society – Society into Art. Seven German Artists* in 1974 at the ICA in London. It included a discourse against galleries. Another initiative against the art system was *Passiv – Explosiv* in Cologne in 1981, a project directed against the exhibition *Westkunst* by László Glózer and Kasper König. Among other things, it drew attention to the lack of feminist, interventionist, and conceptual works in this survey exhibition.

In Adorno's works, we also find this radical criticism of cultural production after World War II: "Years after that line was written [by Brecht], Auschwitz demonstrated irrefutably that culture has failed. That this could happen in the midst of the traditions of philosophy, of art, and of the enlightening sciences says more than that these traditions and their spirit lacked the power to take hold of men and work a change in them. There is untruth in those fields themselves, in the autarky that is emphatically claimed for them. All post-Auschwitz culture, including its urgent critique, is garbage."[33]

Adequate remembrance: the critique of monuments

In the text "Was bedeutet: Aufarbeitung der Vergangenheit?" (The Meaning of Working through the Past) from 1959, the same year in which Gustav Metzger proclaimed Auto-Destructive Art, Adorno explains what he finds suspicious about the phrase "working through the past" ("Aufarbeitung der Vergangenheit") in West Germany: "The murdered are to be cheated out of the single remaining thing that our powerlessness can offer them: remembrance. … That fascism lives on, that the oft-invoked working through of the past has to this day been unsuccessful and has degenerated into its own caricature, an empty and cold forgetting, is due to the fact that the objective conditions of society that engendered fascism continue to exist."[34] Giorgio Agamben also underlines the difficulty of any adequate appraisal of Auschwitz in his recently published book, Quel che resta di Auschwitz (Remnants of Auschwitz). In it, he writes: "The aporia of Auschwitz is, indeed, the very aporia of historical knowledge: a non-coincidence between facts and truth, between verification and comprehension."[35]

According to the artist himself, Gustav Metzger's ADA centers on the public monument.[36] This, however, means a fundamental interrogation of the monument as such. For his monument is based on the concept of transience, of decay — in other words, on a concept diametrically opposed to the one that usually motivates official monuments.

In 1976, together with Cordula Frowein, Gustav Metzger organized the symposium Art in Germany under National Socialism (17 to 19 September 1976). His aim was to promote research on the Nazi regime's art policies. For Metzger, an adequate critical engagement with fascism meant a thorough theoretical, historical reappraisal as well as his own artistic practice.
For some years, the subject of the series Historic Photographs has been the impossibility of presenting and documenting historical events. Some of the photos used by Metzger for this series come from the Nazi period or are connected with the Holocaust. What is special about these works is that these photographs are used, but are never completely visible. Looking at them requires effort. The viewer has to carry out an action to be able to see as much of the picture as possible.

IV. Metzger's relationship to technology

Although it might sound paradoxical, Gustav Metzger uses the latest scientific and technological knowledge to work against negative scientific and technological developments. He sums up this approach in his essay *The Chemical Revolution in Art* of 1965: "We shall use science to destroy science."[37]

In two essays, both titled "Automata in History" in the art journal *Studio International* in March and October 1969, Gustav Metzger gives a detailed account of his view of art and technology.[38] He provides a historical summary describing the development of a type of art using machines. In contrast with earlier periods, an artist at the present time can no longer afford works based on the latest technologies. For "technological art is kinetic art plus a lot of money."[39] It can only be produced by an interdisciplinary collective. Moreover, Metzger feels it is necessary to include political and social aspects in these artistic experiments. "Such organizations whose programmes do not include a concern with fundamental social change are already out-dated, and may ultimately be discredited."[40] For example, he calls on the group E.A.T. (Experiments in Art and Technology) associated with Robert Rauschenberg not to work with companies that produce napalm bombs for the Vietnam War.[41] In his opinion, technological art is only progressive when it is progressive in a political and ethical sense as well. In this essay, he also calls it "technology of paradise,"[42] which apparently outraged many readers of *Studio International* as being too Idealistic and anti-capitalistic.[43] Metzger relates this term to a tendency in the scientific discourse, which with its ideas of saving energy, reduced material consumption, and renewable energy sources, has a certain proximity to classical notions of paradise as a well-balanced and simple way of life. But Metzger's views also met with agreement. In the same year he was invited to take part in the working group Art & Science at King's College, London, and from 1969 to 1973 he was editor of PAGE, the bulletin of the Computer Arts Society.

Seen as a whole, Metzger's attitude to technology is ambivalent and has gone through several different phases. At the start of the 1960s, when he frequently used the expression *Machine Art*, he called for the appropriation of the latest technological possibilities in his text for the *Ark. Journal of the Royal College of Art*: "The next step in *Machine Art* is the entry of the artist into factories and the use of every available technique from computers downwards for the creation of works of art."[44] At a lecture for the Architectural Association in London in 1965, he presented his ambitious project *Five Screens with Computer*, which was published in 1968 in one of the first exhibition catalogues for computer art, entitled *Cybernetic Serendipity*. The concept envisaged five tall steel structures put up on a central square between two apartment blocks. These constructions were to contain 10,000 elements of the same shape that would be hurled out of the "screens" under computer control. The process was to come to a conclusion after ten years.

COMPUTER ARTS SOCIETY

PUBLIC MEETINGS

Nash House Cinema The Mall London SW 1

Sundays at 7.30 pm
4 May How to write a Computer Poem
 Robin Shirley explains
 With Spike Hawkins
1 June To be announced
29 June To be announced

Tickets 7/6 (Members 5/-)
Obtainable at door or in advance from
Dorothy Lansdown 50/51 Russell Square
London WC 1 01-580 2410

SOCIETY MEETINGS

British Computer Society
23 Dorset Square London NW 1

Wednesdays at 6.30 pm
23 April EVENT ONE Autopsy
 A discussion of the comments
 on EVENT ONE and the pattern
 of future events
28 May To be announced
18 June To be announced

Computer Arts Society members and guests
only No charge

PAGE will print a list of exhibitions conferences
events in the field of computer art graphics design.
Organisers in any part of the world are invited to
inform the Editor.

PAGE is available to libraries and institutions.
Annual subscription £1 ($.3). Order from Alan
Sutcliffe.

Books periodicals off-prints reviews and news
items relevant to the work of the Society are
welcomed for the library now being established.
Please send material to John Lansdown.

The Computer Arts Society can recommend speakers
on many aspects of the creative application of
computers in the pure and applied arts and for
introductions to computers and programming.
Write to the Secretary:
R.John Lansdown 50/51 Russell Square
London WC 1

The Committee of the Computer Arts Society wish
to thank the many individuals and organisations who
helped to make EVENT ONE a technical and
artistic success.

Copies of the 20 page programme for EVENT ONE
containing articles graphics etc. can be obtained
from Alan Sutcliffe. Price (post inclusive)
3/6 ($. 50).

PUBLICITY

If you have access to a notice board please pin up
this bulletin or circulate it to those who may be
interested.

A conference on the use of computers as an aid to
design will take place at the University of Southampton
15-18 April 1969. The conference is arranged by
the Institution of Electrical Engineers.

A one-day symposium on computer graphics arranged
by the Association for Computing Machinery takes
place at Brunel University 25 April 1969.

'Computers and Visual Research'. The Gallery of
Contemporary Art Zagreb has arranged an Inter-
national exhibition, competition, and symposium under
this title. The symposium will be held 5 - 7 May.
The exhibition opens 5 May 1969 and ends in August.
For details write to Dr.Boris Kelemen galerija
suvremene umjetnosti Katerinin trg 2 Zagreb
Yugoslavia.
The Gallery of Contemporary Art Zagreb launched
an important international movement 'New Tendencies'
with the exhibitions 'NT 1' (Zagreb 1961) 'NT 2'
(Zagreb Venice Leverkusen 1963) 'NT 3' (Zagreb 1965).
Concurrently with 'Computers and Visual Research'
the Gallery will hold the exhibition 'New Tendencies
4' which, as well as having recent work by artists
associated with NT, will be in the nature of a
retrospective.

Computer Graphics 70. Second International Sym-
posium 14 - 16 April 1970. Papers are being invited.
In combination with Symposium, CG 70 International
Exhibition is announced as 'the greatest ever
Computer Graphic event' Details from the
organiser; R.D.Parslow Computer Department
Brunel University Uxbridge Middlessex.

A section of the stage during EVENT ONE

Photo: Peter Hunot

In the 1990s, Metzger increasingly distanced himself from science and technology. In his text *Mad Cows Talk* he expressed his rejection of genetic and security technology. In an admonishing tone, he describes how the world is now in the process of destroying itself. "This growing insecurity, which affects everyone, expresses the implosion of the system. The more this system rapidly spreads out over the entire world, the more the implosion at its centre is revealed. Capitalism is dying on a truly global scale."[45] There is no more to be said.

1　　　"The universality of a truth is constituted in the repercussions of the event," in: Alain Badiou, *Saint Paul: La fondation de l'universalisme,* Presses Universitaires de France, Paris 1997.

2　　　Metzger, Gustav. Interview with the author, in German, Darmstadt. 3 and 4 April 1989.

3　　　Ibid.

4　　　Ibid.

5　　　Ibid.

6　　　Ibid.

7　　　Ibid.

8　　　Ibid.

9　　　Ibid.

10　　Ibid.

11　　Kultermann, Udo. *Neue Formen des Bildes*. Tübingen 1967: 6.

12　　Metzger, Gustav. Interview with the author, Darmstadt. 3 and 4 April 1989.

13　　Ibid.

14　　Ibid.

15　　Ibid.

16　　Ibid.

17　　Ibid.

18　　Ibid.

19　　Ibid.

20　　Ibid.

21　　Ibid.

22　　Metzger, Gustav. *Stockholm June*. 1972, in: *Documenta 5*, section 16: 56. In the present book: 258.

23　　Metzger, Gustav. *Earth minus Environment*. 1992. In the present book: 273.

24　　Metzger, Gustav. *Manifesto Auto-Destructive Art*. 10 March 1960. In the present book: 227.

25　　Adorno, Theodor W. *Education after Auschwitz*, in: Rolf Tiedemann (ed). *Can one live after Auschwitz? A Philosophical Reader. Theodor W. Adorno*. Stanford University Press, Stanford 2003: 20.

26　　Ibid.: 29.

27　　Adorno, Theodor W. "Meditations on Metaphysics: After Auschwitz," in: *Negative Dialectics*. Routledge & Kegan Paul, London 1973: 361.

28　　Metzger, Gustav. *Auto-Destructive Art, Machine Art, Auto-Creative Art*, 23 June 1961. In the present book: 228.

29　　Adorno, Theodor W. "Cultural Criticism and Society," in: Rolf Tiedemann (ed). *Can one live after Auschwitz? A Philosophical Reader. Theodor W. Adorno*. Stanford University Press, Stanford 2003: 162.

30 Adorno, Theodor W. "Meditations on Metaphysics: After Auschwitz," in: *Negative Dialectics*.
 Routledge & Kegan Paul, London 1973: 362–363.

31 Ibid.: 379–380.

32 Metzger, Gustav. *Manifesto World*. 7 October 1962. In the present book: 234.

33 Adorno, Theodor W. "Meditations on Metaphysics: Metaphysics and Culture," in: *Negative Dialectics*,
 Routledge & Kegan Paul, London 1973: 366–367.

34 Adorno, Theodor W. "The Meaning of Working Through the Past," in: *Critical Models. Interventions and
 Catchwords*. Translated and with a Preface by Henry W. Pickford, Columbia University Press,
 New York 1998: 91 and 98.

35 Agamben, Giorgio. *Remnants of Auschwitz. The Witness and the Archive*. Zone Books,
 New York 1999: 12.

36 Metzger, Gustav. Interview with the author, Darmstadt. 3 and 4 April, 1989.

37 Metzger, Gustav. *The Chemical Revolution in Art*, 1965. In the present book: 237.

38 Metzger, Gustav. "Automata in History," in: *Studio International*, March and October 1969.

39 Ibid.: March 1969: 107.

40 Ibid.: 108.

41 Ibid.: 108.

42 Ibid.: 108.

43 Benthall, Jonathan. "Technology and art," in: *Studio International*, May 1969: 212.

44 Metzger, Gustav. *Machine, Auto-Creative, & Auto-Destructive Art*, 1962. In the present book: 230.

45 Metzger, Gustav. "Mad Cows Talk," in: Justin Hoffmann (ed). *Gustav Metzger. Manifeste, Schriften,
 Konzepte*. Verlag Silke Schreiber, Munich 1997: 51.

Africa Centre, 1966, London, venue of DIAS

Kristine Stiles
The Story of the
Destruction in Art Symposium
and the "DIAS Affect"[1]

The *Destruction in Art Symposium* (DIAS) took place in London throughout September 1966. Gustav Metzger conceived and organized DIAS with the assistance of Irish poet, writer, and filmmaker John J. Sharkey, and an Honorary Committee of international artists, critics, and key figures of the British counterculture.[2] Around 100 artists and poets, representing some eighteen countries, contributed to DIAS. They sent photographs, original works of art, documentation, and theoretical texts to be exhibited, or they personally traveled to London to create destruction in art actions and exhibitions. Although they represented diverse nationalities, ethnicities, and genders, DIAS artists shared a commitment to the use of destruction as a mode of resistance to psychological, social, and political violence; they engaged destruction as a principle of organic life; and they addressed the processes and structures implicit in the interrelationship and interconnection between destruction and creation. While exploring destruction *in* art, they did not practice destruction *of* art, understanding destructivity as a causative principle consistent with, yet another dimension of, creativity and part of the cycle of making. They also utilized destruction as a seditious measure to critique conventional aesthetic forms, to expand the material practices and political languages of art and poetry, and to demonstrate the social necessity for artists' direct engagement in culture as a political force for change. It is noteworthy that many DIAS artists pioneered Happenings, Fluxus, Wiener Aktionismus, and Concrete Poetry, and that these media dominated at DIAS. DIAS represented the most concentrated influx of international experimental artists into London since the 1930s, laying global foundations for socially engaged art that had its first international expression there.

Affirming art and artists as a cultural force able to shape social and political life, DIAS artists stressed the centrality of art in producing new forms of knowledge, perception, and insight *in* life. This is *not* to say that they transformed art *into* life. Rather, destruction in art introduced

destructive processes into artistic vocabulary in order to collapse means, subject matter, and affect into a unified expression for the purpose of commenting directly on destruction in life. Their techniques included demolition and wreckage through such means as explosions, burning, tearing, axing, and cutting; the implementation of destruction by natural elements such as wind, fire, rain, water, and gravity; the destruction of diachronic narrative through sound, visual presentation, and performance; and the destruction of psychosexual conventions and social constraints through the creation of emotionally intense and conceptually challenging psychophysical situations. Embracing the seduction of destruction, DIAS artists understood the ancient interdependence of idolatry, iconoclasm, and sensuality, and they simultaneously perpetuated *and* shattered the triangulation of representation, desire, and dread.

DIAS reflected the mature theories and practices of men and women, many of whom were born in the 1920s and early 1930s and who had lived through World War II. They showed remarkable support for younger artists participating in DIAS, augmenting a dynamic cross-fertilization of generations. Thinking about the impact of DIAS as a cultural event, Jean-Jacques Lebel observed: "DIAS was only a symptom of this great subconscious upsurge of new effect and new desire. ... It was important for us to meet other people like ourselves, to realize that there was the beginning of a movement. ... It was a collective [that] affected our work as we went back to where we lived."[3]

A symptom it was. A movement it was not. DIAS was a unique convocation for which the term "symposium" is a misnomer. Rather, DIAS primarily offered a platform for diverse actions and exhibitions that occurred in dozens of London locations. The symposium itself, situated in the middle of the month (9 to 11 September), was a three-day forum for artists to present reasoned consideration of the theme of destruction, and moderate the impact of destruction art on a public unfamiliar with such practices. As symptom and sign, DIAS represented a multinational, artist-initiated, artist-controlled, and artist-defined event with a dedicated social aim. The enormous vitality and volatility of DIAS reflects its lack of academic, commercial, and/or institutional character. DIAS was not an historical "ism": although the international media and art journals widely covered it, and an effort was made to continue its momentum in future convocations, DIAS artists never exhibited again as a group.

DIAS did, however, present a resolute public face and share a turbulent camaraderie. *Life* magazine acknowledged this apparent unity when it featured a photograph of some participants in a special 17 February, 1967 issue on "HAPPENINGS: The worldwide underground of the arts creates The Other Culture." Such media and public recognition acknowledged DIAS as the representation of the counterculture analyzed by Theodore Roszak in *The Making of a Counterculture*, 1969. Decidedly non-conformist, engaged in but critical of mainstream society, the counterculture dispatched dissident social movements and lifestyles.[4] DIAS artists had already introduced new cultural formations in the watershed action art and poetry they practiced, and they moved in circles that included both the underground (associated with direct political activism) and various 1960s

subcultures (associated primarily with style).[5] Undeniably, the invitation that Metzger sent to the Dutch anarchist PROVO (from *provo*cateur) aligned DIAS with radical European groups and events. One week after they led violent riots for sweeping social change in Amsterdam, two PROVO members, Irene Donner van der Weetering and Bernhard de Vries, came to London for a pre-DIAS press conference in late June. De Vries, a 25-year-old poet and artist, had been elected in the spring of 1966 to a seat in the Amsterdam Municipal government, after leading an equally fierce protest against (and throwing the first smoke bomb at) the wedding of Dutch Princess Beatrix to Claus von Amsberg, a German who had served in both the Hitler Youth and the Wehrmacht during World War II. The PROVO were directly connected with such anarchist groups as the Situationist International and Sigma, the latter founded by the radical writer Alexander Trocchi. Trocchi occupied an office in the basement of Indica Bookstore, which also housed the British underground newspaper, *International Times* (IT), then preparing its first issue for October 1966. Jim Haynes, an editor for IT, and (Barry) Miles, who co-founded Indica also in 1966, both served on the DIAS Honorary Committee.[6] These are just a few of the individuals, events, and places associated with DIAS and the dense network interconnecting the counterculture and underground of the period.

Nevertheless, for all their evident public unanimity, privately the artists were egocentric, contentious, and competitive. They were also primarily imposing, assertive, powerful men, who sought attention for their work and believed that it would change art and society. This is one reason that the connections forged in London virtually disappeared when artists returned home. In fact, most DIAS participants failed to respond to Metzger's and Sharkey's call for assistance when they were brought up on charges of having "unlawfully caused to be shown a lewd and an indecent exhibition" at DIAS. This charge came after police showed up after a presentation of Hermann Nitsch's *Orgies Mysteries Theater* (OMT) when two journalists (suspected of being government informants) notified authorities.[7] Ten months later in July of 1967, Metzger and Sharkey stood trial by jury for three days at London's Old Bailey, awaiting a possible six-months prison sentence.[8] DIAS was full of such contradiction. For despite his sophisticated handling of the media, despite his refusal to sponsor the killing of animals, despite his strong efforts to moderate destruction actions for safety, Metzger also invited provocation, celebrated the association of DIAS with anarchists, fed the media with salacious accounts of blood, nudity, and destruction, all the while fully aware of the probability of government surveillance. Indeed, Metzger is the central figure here. For while he conscientiously formed an Honorary Committee and gained the tireless assistance of Sharkey, Metzger was the "Secretary" of DIAS, the modest title he chose for himself and behind which he orchestrated DIAS.

Nominally, then, DIAS might best be considered an organizing structure, fleetingly embodied. It faded into invisibility, disappearing as a principle of its production, sharing the ephemeral nature of the destruction objects, performances, and site-specific installations it spawned and invited. In addition, the international unrest that erupted two years later, in 1968,

eclipsed DIAS, even though DIAS was part of the foundation for that tumultuous year. In what follows, I discuss selected DIAS events in order to convey its flamboyant character and challenging, controversial, and committed purpose before turning to its recuperation in art history and the changed climate for its reception. First and foremost, DIAS was the particular art historical contribution of Gustav Metzger. As the architect of DIAS, Metzger's theories of *Auto-Destructive* and *Auto-Creative Art* informed DIAS at every level. His aesthetic praxis and his prescient focus on destruction required deliberation on the causes and circumstances of the most pressing issue facing humanity then (and still today). His attention to destruction and his success at drawing out an international body of artists concerned with the same issue—a rally that not only identified and reinforced these artistic practices but summoned new work on the subject of destruction in art and society—set DIAS dramatically apart from other international convocations of artists, such as the German ZERO (1958 to 1961), Lebel's Festivals of Free Expression (1964 to1967), and Fluxus Festivals (1962 to the present). But while I identify DIAS as Metzger's most decisive work of art, he himself did not exhibit at DIAS and only actively participated in the symposium, not wanting to risk a conflict between his roles as organizer and artist. The "DIAS affect" that I theorize in the conclusion of this essay extends beyond Metzger to the interconnected, interdisciplinary web of artists who participated in DIAS. As I shall show, the DIAS affect survives into the present, igniting aesthetic ideas, cultural practices, and social changes with some of the most strident, socially engaged, and politically astute art of this and the last century. Moreover, and following Hayden White's critique of history, it is through affect that the meanings of the events called "history" may best be understood in relation to the elasticity of time past, present, and future.

I. The *Destruction in Art Symposium*

Standing behind a massive desk, Metzger opened the official DIAS press conference at 11:00 a.m. on 31 August 1966 in a room at St. Bride Institute. It was crowded with the Press, which "seemed receptive and interested."[9] He read the roster of participating artists, making it absolutely clear that destruction was an international phenomenon, and then invited everyone to move upstairs. Once there, artist Raphael Montañez Ortiz (known at DIAS as Ralph), a 6'5" dark-skinned Puerto-Rican American, approached a man sitting in a chair reading a newspaper. Looming over the unsuspecting reader, Ortiz said: "You're in my chair." "How can this be your chair?" the man responded. "It's a club chair." "No, it's my chair; I own it," said Ortiz. Turning to the club manager, Ortiz asked, "Will you inform this man that this is my chair?" Once Ortiz's ownership had been confirmed (he had surreptitiously purchased the chair the day before the press conference), the bewildered patron left the chair and Ortiz flew at it: "I picked up the chair and threw it across the

room. Everybody in the place stopped what they were doing and ... I leapt on top of it, kicking it and ripping it. Photographers were taking photographs and people were taking notes. I am tearing it and jumping on it and wrestling with it all over the ground and doing everything by hand. I pulled the springs out. Then I stood a few seconds away from it and went back and ripped and pulled at it putting the final finishing touches to the piece."[10] Metzger considered Ortiz's event "a great success" and recalled, "It took quite some time, perhaps ten minutes; he was slow with a rather majestic sort of motion."[11]

The London press reacted quite differently. A reporter wrote: "Today I had the misfortune to be introduced to sick art ... high-falutin', organised vandalism."[12] Then he wondered, "Or am I a complete square?" The following day, newspaper headlines heightened the DIAS scandal, exclaiming: "Chicken-Killer Says Ban Won't Deter Him,"[13] and "YOU CAN'T KILL A CHICKEN IN THE NAME OF ART."[14] Such histrionics purposefully insinuated that Oritz planned to "splatter chicken blood on the people who watched."[15] Indeed, following a ceremonial custom that included his mixed Yaqui Indian ancestry, Oritz did ritualistically kill and dissect a chicken and read its entrails on 4 September, but without DIAS sponsorship. Granada Television, one of the largest independent television networks in Britain, covered the event. When asked about acting with such aggressive self-interest, Ortiz responded: "I sort of felt that I was going to an art Olympics. I was going to do my thing and win the gold ... I was paying a lot of attention to the ideas that I had been working with. I was not going to be careful."[16] In this serious and simultaneously humorous comment on his feelings and intentions, Ortiz spoke for most of the macho participants at DIAS.

Further newspaper commentaries show that one event built upon the next in intensity. A *Guardian* reporter, for example, announced that the American "master of the happening," Al Hansen, planned events on Carnaby Street (center of stylish mod and hippie culture), a visit to a slaughterhouse, and a search for a World War II bomb crater.[17] This same reporter went on to describe "the man who once stuck his head in a Xerox machine is making a film of destruction in everyday life," referring to English sound and visual poet Bob Cobbing; and she called English artist John Latham a "home grown" artist who wanted to burn a *SKOOB Tower* (BOOKS spelled backwards) in the "Inner Temple gardens [site of British legal institutions] ... to expose the way the scientific establishment controls our belief systems." Latham would, indeed, burn a *SKOOB Tower* ignited with Irish whiskey in front of the British museum on 23 September. This event, while associated with DIAS in the public mind, was not sponsored by DIAS and ended when the fire brigade arrived.

A day before the symposium began, Canadian artist Robin Page performed KROW I (WORK spelled backwards) in the basement of the international counterculture bookstore, Better Books, which also hosted a press conference on DIAS and a makeshift exhibition of DIAS artists' documents that caused so much dissention among the artists that Belgian artist Jean Toche

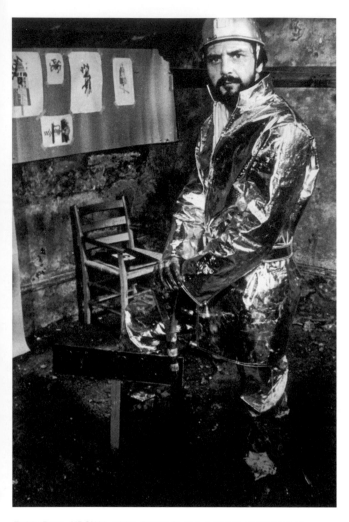

Robin Page, KROW I, 1966, Better Books, London, performance

refused to participate further in DIAS. Austrian artist Otto Mühl found the exhibition "disorganized and very bad," and wrote home: "Vostell wants to make another one with us ... We're going to see that we do our events fast and then scram. ... As far as I can tell from the photos I've seen, we in Vienna are not weaker 'destruction people,' but stronger."[18]

A *Daily Mirror* account of Page's event restores some of the raw authenticity of Better Books and DIAS events: "Mr. Robin Page, who has threatened to start an art form that involves stamping frogs to death, gave a demonstration of his ideas yesterday. Wearing a silver suit, silver-painted helmet and rubber knee-boots, he bored and pickaxed through the concrete floor of Better Books. ... Chips of concrete flew at the audience. After half an hour Page struck water. Mr. [Bob] Cobbing, the manager, then said: 'This must stop!' Page ... downed his shovel, sat in the hole, and drank a bottle of beer. He said: 'I feel very good. I have no more doubts about anything. It is a beautiful hole. If somebody wants to buy it, the price would be 125 pounds. It's a major work, but I'm open to offers.' Two girls in mini-skirts then paraded with placards protesting against the possible killing of chickens. Page was unrepentant."[19] Quoting Page's clearly facetious comments, the journalist claimed that the artist planned to "put frogs on a board on which questions were written about Destruction in Art; if the frogs gave the wrong answers, they would be stamped to death."

For his part, Metzger's view of the hole was luminous: "Absolutely magnificent. Everything was right, even the place, which was a bit of a shambles, a bit dank, too dark. Bits of our exhibition were kind of flaking off the walls. It was electric, a bit dangerous. Then he stood there and said, 'A Hole is a Hole.' There was a wholeness to it."[20] Rather than emphasize the object status of art, Page exhibited its processes. Accenting action as a mode of production, he worked to mine, delve, excavate, and provide insight *into* the cycle of making that may result in new understanding. His KROW I was clear, brief, and to the point, subtle yet simple, full of humor and the joy of play at work. The whole hole of Page's KROW I derived from the Zen thingness and nothingness of a hole, the nothingness of its wholeness. In this sense, KROW I might also be said to have described the meaning and function of Art and, therefore, offered something to crow about. A 17 year-old girl, Elsa MacKay, one of the mini-skirted protestors, disagreed: "Soppy sort of hole it looks to me."[21]

Thus far I have introduced the texture of DIAS events, the complexity of the artists' social status, their exquisite humor and the wisdom and intensity of their work. I have tried to convey the irony and spectacle caused by the media and the public fascination with, and furor over, DIAS. I would now like to turn to a brief recitation of the symposium program in order to consider the breadth of the topics it covered.

In his opening comments to the symposium, Metzger stated: "In the context of the possible wipe-out of civilization, the study of aggression in man, and the psychological, biological

and economic drives to war are possibly the most urgent work facing man." DIAS, he continued was intended "to isolate the element of destruction in new art forms, and to discover any links with destruction in society."[22] Among the topics Metzger listed for discussion included: "ART: Architecture, film, Happenings, language, music, plastic arts, theatre. SOCIETY: Atmospheric pollution, creative vandalism, destruction in protest, planned obsolescence, popular media, urban sprawl/overcrowding, war. SCIENCE: Biology, economics, medicine, physics, psychology, sociology, space research."[23]

Over the next three days of the symposium, many texts sent to DIAS were read. These began with the New York Museum of Modern Art's broadside for Jean Tinguely's *Homage to New York*, 1960, which included excerpts written by Alfred Barr, Peter Selz, Dore Ashton, Richard Huelsenbeck, and Marcel Duchamp.[24] A letter from the Situationist International was read that announced the death of *Auto-Destructive Art*. George Maciunas wrote to say that Fluxus was not about destruction, but opportunistically included his own tract *U.S. Surpasses All Genocide Records*, 1966, possibly written expressly for DIAS. Papers and manifestos by Marta Minujín (Argentina), Bernard Aubertin (France), and Milan Knížák (Czechoslovakia) were read, as well as works by French poets Jocelyn de Noblet, Pierre Garnier, Paul Armand Gette, and Julien Blaine. German artist Werner Schreib read excerpts from the German scholar Peter Gorsen's *Sexualität im Spiegel der Modernen Kunst* (1963), as well as a paper on his own *Pyrogravure* paintings, made with fire, smoke, and explosives. Perhaps most astonishing to Metzger was the material sent by the Argentinian artist Kenneth Kemble about the *Arte Destructivo* group he founded in Buenos Aires in 1961. Kemble sent texts, photographs, and a cassette tape of "Ideas for Destruction Applied to Music and Poetry" that included 28 compositions in which readings by Picasso, Goethe, Aldous Huxley, Aristotle, and others had been superimposed with poetry, sound-texts, and noise to "change linear meaning by semantic explosion and implosion, spelling, syllabic indifference, and disintegration of vocalized sound."[25]

One panel during the symposium was devoted entirely to the Viennese artists in attendance: Günter Brus, Otto Mühl, Hermann Nitsch, Kurt Kren, and the then 19 year-old Peter Weibel. Anticipating contemporary installation art, Weibel lectured on the Viennese concept of "room painting" and how its environmental effect united artist and public in art's "social function as communication." Weibel also spoke about Kren's films, suggesting their power to terrify and emancipate spectators. Nitsch read from his own writings and emphatically insisted that he was *not* a political artist. However, he "agreed with DIAS" because, "[i]ntensity protests automatically. In my heart any political thinking should die. ... We have enough to fight when we struggle for a deep life and persist in that in our work without ideology. The vivacity of life realizes itself there, like a plant that grows well."[26]

Brus later highlighted this larger purpose: "Neither destruction nor violence have ever been the theme of my actions. I considered them as an expansion of Art ... react[ing] consciously or unconsciously to these phenomena. Art always relies on hope, even if its expression is sometimes as negative as can be."[27] Then, explicitly breaking the rule against performing during the symposium, Mühl and Brus both did so. Brus's action particularly impressed DIAS artists with its dramatic concentrated violence. Brus silently stood at the lecture table and blew up a large brown paper bag. Holding the end tightly to prevent his breath from escaping, Brus laid the bag on the table and suddenly brought his head crashing down, exploding the bag and smashing his head. Commenting on the "hot air" of talk at the symposium, Brus also seemed to suggest that Nam June Paik had not risked his body as a medium in 1962 when he had performed *One for Violin (Solo)*, raising a violin over his head and smashing it on a table.

No longer isolated at Europe's periphery, the Viennese found themselves in a context of radicalism that emboldened them. They were able to attend DIAS under the officious moniker "Institut für direkte Kunst," a parody of bureaucratic institutions invented by Mühl and Weibel for the purpose of fooling the Austrian state into funding the artists' trip to London. Their ruse succeeded. Only Rudolf Schwarzkogler remained behind. Seen for the first time outside of Vienna, their unprecedented art catalyzed DIAS with its radical form and powerful social commentary. DIAS was crucial to the Viennese, as Weibel explained: "It sounds banal but London was like heaven. ... It was so open. Brus wrote a postcard to his wife: 'Soon we will become millionaires.' It was the first time we had a big audience. People were applauding. It was a great success."[28] "When back in Vienna," Brus added, "I had the feeling to have been thrown in a cesspool."[29]

DIAS enabled the Viennese to understand that their work belonged to a larger international context replete with other artists dedicated to using destruction as a means to critique society. Mühl's sardonic humor tempered the serious symposium discussions, making his grim dismemberment of traditional culture even more ferocious. While they created additional performances after the symposium,[30] the films Kren screened had an immediate impact at DIAS.[31] British film critic Raymond Durgnat explained: "Kurt Kren's interventionist film records of the [Viennese] happenings disrupt their chronological and dramatic continuity by quickfire intercutting, ... concentrate on detail, allow no image to linger or impact to fade, let no progression or gestalt distract the spectator from their succession of libidinal promptings and joltings, [and his] mathematical schemes for the cutting ensure that Kren, in altering the happenings' structures, does not substitute his own."[32]

On the last day of the symposium, German artist Wolf Vostell discussed the differences between Happenings and Fluxus. As the participant who was most critical of DIAS, Vostell later admitted that the strength of DIAS resided in its theme, the "highly developed strategies" of DIAS artists, and he confessed: "Fluxus is a form of provocation, but DIAS was content *and* provocation."[33]

Welsh artist Ivor Davies read a *Destructivism Manifesto* written expressly for DIAS. Ortiz commented that, "It is only as a result of our psychological evolution that we have been able to remove ourselves in any sense from the cycle of helplessness inherent in nature and the natural destructive cycle." To which Page responded (in a general discussion on the subject "To Kill or not to Kill" that followed) that the inevitability of the human condition suggests that, "man is no longer a harmless animal without choice." This situation prompted Page's ironic suggestion to smash frogs unable to answer questions about destruction in art. Finally, the last panel of the symposium included Yoko Ono, Anthony Cox (American filmmaker and Ono's partner at that time), Pro-Diaz (Brazilian working in Paris with explosives on paintings), Barbara Gladstone (21-year-old American dancer trained by Martha Graham), Graham Stevens (recent graduate of architectural school), and Dick Wilcocks (young British poet).

Very few women actively participated in DIAS: only Ono, Gladstone, composer Anna Lockwood, and singer and composer Susan Cahn. Metzger had attempted to bring Carolee Schneemann, but she was unable to find funding. Ono's participation was key for Metzger, as her work related destruction to interpersonal, often intimate, human relations. Her quiet, self-contained, meditative approach to the very concept of destruction had a counterbalancing force for the heady machismo of male participants. Ono explained at the symposium that she did not understand the concept of destruction *if* it meant that Japanese monks who burned their temples to prevent them from deteriorating were destructive. "People have to take off their pants before they fight," she continued, "such disrobing is a form of destruction." "Happenings," she believed, had become "establishment," and she considered her work to be only "a rehearsal and not an ultimate state of mind." Her personal presence radiated in many DIAS performances including the famous *Cut Piece* that followed the symposium. Indeed, DIAS reserved two entire evenings at the Africa Centre for Ono to perform on 28 and 29 September. "We charged a lot of money for this," Metzger remembered, "Because we thought there would be a lot of interest and we needed the money. I don't think we paid Yoko, but maybe we gave her 30 percent or something. She was desperate. She needed money. It was expensive [to put on her show]. Nitsch was, too."[34]

The hours of discussion at DIAS had been the fruit of years of preparatory research by artists who honed their various theoretical points of view in an attempt to make their aesthetic and philosophical positions consistent with their critique of historical conditions. However contradictory and convoluted their ideas, and crude and unfiltered their art appeared to some, and however uncommon and strange, repulsive and frightening their expression was to others, DIAS artists recognized the need for a fully developed praxis and they were earnest in their labor. Nevertheless, some found DIAS vulgar and overstated. Others perceived the artists' interest in theory too sober. Bruce Conner, for example, refused to participate: "I did not think of any good reason to participate in the creation of a new art game of chatter and self-importance and counting of angels on their

pinheads."[35] Other artists like Allan Kaprow, Joseph Beuys, Claes Oldenburg, and George Brecht, considered DIAS too extreme.[36]

When Metzger and Sharkey wrote to Dick Higgins asking for suggestions for artists to invite from New York, he responded that "many of the New York big names" could not be considered potential contributors, adding: "Warhol … may be destructive but I think he doesn't know it."[37] Higgins was wrong in at least one "big name," because Ad Reinhardt sent a beautiful hand-written text entitled *Program for Program-Painting*, which Metzger reprinted on the cover of the *DIAS Preliminary Report*, the program of DIAS events. Despite his reservations, Higgins supported DIAS: "Things certainly must be roaring for the DIAS. It's all the talk here [New York]. You did well to involve Al Hansen. He's calling a press conference, and he's already preaching up such a storm. Six or seven people have already telephoned me asking if I know any details. Al's even talking about coming to London himself. If he can. I hope someone can be found with a spare cot, because, compared to him, any church mouse is a billionaire."[38] Once in London, Hansen presented himself as a lunatic fireman, wearing a fire helmet, for example, to perform in Nitsch's OMT action. He also set off chaotic explosions on an abandoned motor scooter chassis on the London Free School Playground, a key site for DIAS activities and events.[39] The quintessential existential jester in the court of DIAS, Hansen's very presence warned of the folly of self-importance.

Many more historical performances took place during DIAS, not the least of which was the grand finale on 30 September, featuring many events at the Mercury Theatre. Among those who participated was English artist Barry Flanagan, then an art student. Flanagan was fresh from chewing up a copy of Clement Greenberg's famous formalist treatise *Art and Culture*, 1961, during a party he helped Latham organize one month before DIAS (but after several pre-DIAS press conferences had already set the stage for new forms of destruction). Latham permanently lost all teaching positions in England for his indigestible indiscretion, but the infamous *Still and Chew/ Art and Culture,* 1966–1967, eventually found its way into the collection of the Museum of Modern Art in New York. In any case, for the last night of DIAS events, Flanagan set up an ephemeral sand sculpture in the main aisle of the theater, situating his miniature earthwork so that the audience and DIAS participants would scuff through it, erasing and scattering its presence. English artist Mark Boyle also participated in the last evening with *Projections*, a slide-projection event in which the photographs of DIAS artists and their works that Boyle had taken throughout the month were permitted to remain in the projector long enough to scorch and disappear, leaving the theater with the stench of burned cellulose. Ortiz called *Projections* a "voodoo slaughter," presumably of DIAS itself.

The cataclysmic increase in world destructive potential since 1945, is inextricably linked with the most disturbing tendencies in modern art, and the proliferation of programmes of research into aggression and destruction

PROGRAM FOR PROGRAM-PAINTING

1. THE RE-DESTRUCTION OF THE VERTICAL STRIPE AND HORIZONTAL BAND IN ART.
2. THE RE-DISSOLUTION OF LINE AND EDGE, COLOR AND CONTRAST IN ART.
3. THE RE-OBLITERATION OF TEXTURE AND BRUSHWORK IN ART.
4. THE RE-ABROGATION OF ASYMMETRIC AND SYMMETRIC COMPOSITION IN ART.
5. THE RE-ANNIHILATION OF THE SCUMBLE AND SMEAR IN ART.
6. THE RE-DEMOLITION OF SHAPE, FORM AND SIGN IN ART.
7. THE RE-NEGATION OF STYLIZATION, SPONTANEITY IN ART.
8. THE RE-NULLIFICATION OF SUBJECT AND REACTION IN ART.
9. THE RE-EXTERMINATION OF NEO-EXISTIALISM AND NEO-POP IN ART.
10. THE RE-DEVASTATION OF MEANING, WITS AND RUSTICITY IN ART.

Ad REINHARDT, 1966, NEW YORK

THE GUARDIAN

London Friday September 9, 1966

Art that is ripe for destruction

The Destruction-in-Art boys are among us and we shall ignore them, as they put it, only at our peril. They are from 10 countries and have assembled in London for a three-day symposium starting today. They will exhibit photographs of men sitting in the dripping blood of eviscerated animals, which is said to be art; they have bashed a hole in the basement floor of a London bookshop and struck water, which is said to be art; they are bickering over whose works shall be exhibited, and with them this also is said to be an art. Some of them would like to stamp on frogs or crucify a lamb. They have smashed up a piano, though Laurel and Hardy used to do it better.

Now, why shouldn't an artist affront us to make us see what he wants us to see? If he shows us men sitting under a bleeding sheep it may only be to remind us that we usually eat the sheep without thinking that it died, which is fair enough. And the destroyers have at least a case when they argue, as they seem to argue, that men are violent and that this violence may be diverted: better that canvases should be ripped, or chickens decapitated, than that a single man should be hurt. But pictures of women bundled up in transparent sacks, or of men smeared with blood and muck, whatever the artistic purpose, are more likely to degrade than to exalt. Violence makes violence.

The destroyers-in-art include writers who obliterate words, burn books, and cut odd words out of dictionaries and paste them up haywire. They tear books apart and shuffle the pages so that the narrative now reads surprisingly (which is art). Words are displaced and lines transposed in a new and meaningful way. Some newspapers, it seems, especially in their hurried first editions, have long possessed a natural aptitude for the new and the meaningful. That's art. Or is it? More often it is error. Just as destruction-in-art is mainly perverse, ugly, and anti-social.

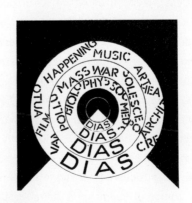

II. The Reception of DIAS

By 1979, the year that I began my research on DIAS, it had been forgotten. Moreover, many of its participants firmly believed that they, and by extension DIAS, had "failed" because they had not changed society.[40] Metzger remembered few details in 1982 and together we reconstructed his memory based on my previous three years of interviews and research. Ortiz had never discussed either DIAS or his notorious destruction-actions with his wife of seven years, even though he meticulously maintained his DIAS archive in their small New Jersey apartment.[41] These experiences reflect the general situation in the early 1980s for DIAS participants. Today, by contrast, an entirely different scholarly and intellectual climate exits. Many of the artists have been accorded their rightful place in art history, and even highly controversial Wiener Aktionismus is now accepted. Information on the counterculture that 25 years ago could only be obtained through artist interviews and artists' archives has become the celebrated *bête noire* of Cultural Studies, itself founded in the intervening years; and information about "the 1960s," once scattered in libraries with rare collections, limited edition journals, and underground newspapers, may be traced readily on the Internet.

Despite these developments, most scholars have entirely overlooked the fact that while academics aligned with Deconstruction deconstructed Enlightenment constructs and humanist epistemologies in the 1970s and 1980s, artists had already confronted the material, psychophysical, social, and political dimension of destructive experiences since the late 1950s. Summoning destruction to mitigate the commercialization and fetishization of form that accompanied the loss of connection to social meaning in contemporary art of the period, DIAS artists examined and exposed contradictions in social and political practices. In this sense, DIAS artists wielded destruction *against* destruction as a means to deconstruct cultural assumptions about artistic creation and contributed to the conceptual and social context that reinforced the emergence in the late 1960s of the philosophical movement of Deconstruction that followed the publication of Jacques Derrida's *De la grammatologie* in 1967. This decisive text appeared one year after DIAS and nearly a decade after many of its artists and poets, such as Henri Chopin, Latham, Lebel, Nitsch, Ortiz, Vostell, and Metzger, had begun to use destruction to analyze culture, religion, philosophy, society, politics, and the media in their art.

The last twenty years have also witnessed a significant development in the understanding and reception of the concept of destruction in art and society. For example, it may be hard to believe in 2005 that violence, as a category of investigation, still remained largely absent from philosophical dictionaries in 1982, as psychologist and Holocaust survivor Bruno Bettelheim remarked then.[42] The term destruction, let alone the arcane category "destruction in art," did not appear in the 1985 third edition of Raymond Williams' influential *Keywords*, a sociological study of

how key words shape and alter cultural and political understanding of new social practices.[43]
By the 1990s, however, destruction, violence, and their correlates (trauma and abjection) had
garnered newfound attention. Metzger's work on destruction began to receive renewed consideration,
followed by interviews and publications in the late 1990s, and capped by a BBC special in 2004.
This history of reception is meaningful because it belongs to what I theorize as the DIAS affect,
namely the generation of mental states that lead to social and cultural changes. To emphasize
affect here is to consciously shift focus from the traditional notion of factual historical data and
art historical "influence" (based on adaptation of visual style) in order to attend to the tangible
and intangible transference of ideas and feelings through society by emotions and actions that
may result in entirely different visual and behavioral forms of cultural address, but that carry the
genealogy of their prototype.

To make this point more strongly, it is important to reiterate that my research in the late
1970s on DIAS began in an art historical situation lacking "key words" to guide its interpretation
and in dialogue with artists who felt that they had failed. Add to this the fact that many influential
critics of the period (and into the present) privileged Minimalism as the "advanced" art of the mid-
1960s. This made access to underground radical art more difficult, and they wrote *as if* Happening,
Fluxus, and Wiener Aktionismus had not preceded Minimalism, *as if* DIAS had never existed, and
as if they could effectively expunge such experimental modes from the histories of art. A consider-
ation of the function of affect, to which I shall presently turn, I hope will assist in the reconsideration
of how different spheres of awareness contribute to the repercussion of ideas well beyond formalist
concepts of stylistic influence. In this way, the nuance of cultural transmission may be better
explored, deliberated on, and advanced as affinities occur in layered temporal, situational, and
parallel, but visually different, places and practices in a wide variety of cultural, social, and scientific
modes of production.

In this regard, little could contrast more starkly with Minimal Art's pristine appearance
and exhibition venues in the mid-1960s than the sites and objects of DIAS. Yet such divergent
environments reflect the values and aims of different avant-gardes of exactly the same period,
which some champions of Minimalism have failed to grasp. Neither have they understood the
paradox that DIAS artists identified: by the late 1950s, the need to change the very function of
objects in both capitalist and communist cultures required unraveling the vaunted value of individual
works of art by disembodying base matter as a means to reveal destruction in society. DIAS artists
found a material process by which to deconstruct the sensuality of objective forms and strip away
the seductive amnesia and traumatic forgetting embodied in formal aesthetics to confront the
psychological and social necessities of contemporary life. Minimal Art and some of its apologists
have neither answered to, nor accounted for, such necessities. Although Conceptual Art achieved
the most concrete and systematic disassembly of conventional art institutions, DIAS was its rude

herald. Blowing up and burning down conventional forms of representation, dismantling language, paring the lumpy body from the skeleton "to brew a body and soul extract"—as Brus insisted— DIAS echoed the historical denunciation of the humanist project already engaged by Lautréamont, Nietzsche, Jarry, Dada, Artaud, Surrealism, and Bataille.[44] The problem was, of course, that the very means of destruction distracted from its social aims even though the content of destruction in art directly connected to and commented on Adorno's belief that "writing poetry [and making art] after Auschwitz is barbaric."

III. Conclusion, the "DIAS affect"

Picture a cluttered stretch of open land in London about two city blocks long with only a few trees. The site had never been completely cleared of the rubble left from German bombs during World War II. The intervening years added the burden of urban junk: broken furniture and scraps of metal, glass, paper, and car parts. A section of brick wall at the perimeter of this *terrain vague* provided a makeshift surface for public announcements, including the following notice, painted like graffiti: "YES. LONDON FREE SCHOOL PLAY GROUND. PLEASE HELP US TO HELP YOUR CHILDREN BY GIVING AN HOUR ANY EVENING OR SUNDAY TO CLEAN." This chaotic place was the London Free School Playground where artists assembled to practice destruction in art.

Now visualize an elegant hall, dating from 1776, with high ceilings and a surrounding balcony supported by delicate iron columns with ornate brackets. Mounted on the walls are photographs of Brus's *Selbstbemalung*, Nitsch's *Orgien Mysterien Theater*, and Mühl's *Material-aktionen*. There are texts exhibited by Robert Filliou (France), Mathias Goeritz (Mexico), and Diter Rot (Germany), many of which had been brought to DIAS by the German Fluxus and Happening collector and archivist, Hanns Sohm.[45] In a corner of the room lie the remains of a wooden piano and upholstered armchair destroyed by Ortiz, with strings, keys, raffia, and springs spilling onto the floor. A panel of DIAS speakers sits at a table before the audience. This building, which still stands on King Street in London's Covent Garden, is the Africa Centre, founded in 1961 by President Kenneth Kaunda of Zambia and Laurean Cardinal Rugambwa, an Archbishop of Tanzania. The Africa Centre officially opened in 1964 as a platform for the discussion of African liberation movements and other gatherings of cultural and political merit.

These two places epitomized the local atmosphere in which DIAS unfolded. Metzger was quite content with the scale and presence of the Africa Centre but would have preferred a less forlorn site than the war-torn urban playground, the only place available where explosions and the use of fire could take place. Co-founded by Michael X, a Trinidadian emigrant and founder of the militant Black Power movement in Britain, the London Free School Playground also sat on

Notting Hill, which had witnessed massive race riots in late summer of 1958 when a virulent white backlash broke out against the thousands of West Indian immigrants who had come to England in the 1950s and settled in the district. Unprecedented at the time in England, this racial violence led to the passing of the first Race Relations Act in 1965 and to the establishment of an Afro-Caribbean multicultural festival on Notting Hill in 1964 that has become internationally famous. As Notting Hill symbolized Britain's Civil Rights movement, the Africa Centre represented the end of the British Empire and colonization.

Before Notting Hill became the site of massive gentrification and Hollywood films, along with the Free School Playground it inspired Pink Floyd's famous punk rock song, "Another Brick in the Wall," 1979. The band's anti-establishment lyrics stood in marked opposition to war, and for resistance to mindless institutional bureaucracy, avoidance of numbing educational inflexibility, and defiance of vapid, uninspired mainstream and academic cultures. In their aggressive dress, acid-colored Mohawk hair, and reckless, chaotic conduct, the punk subculture succeeded in circulating the issues raised by DIAS, whose affect haunted Punk in Britain and beyond.

Indeed, Metzger's use of destruction to launch a critique of totalitarianism and capitalism was taken up by many artists in the late 1970s and early 1980s, although they knew nothing of Metzger's work. I am thinking especially of the San Francisco group Survival Research Laboratories (SRL), founded in 1978, and Neue Slowenische Kunst (NSK), founded in the former Yugoslavia in 1980 (an umbrella organization that also incorporates such groups as Laibach and Irwin, them-selves associated with Slavoj Zizek's theories). Shades of Metzger's concepts assume a different shape in the voices of NSK. For example, in a 1965 lecture at the London Architectural Associa-tion, Metzger observed: "*Auto-destructive Art* is a comprehensive theory for action in the field of the plastic arts in the post-second world war period. The action is not limited to theory of art and the production of art works; it includes social action. *Auto-Destructive Art* is committed to a left-wing revolutionary position in politics, and struggles against future wars."[46] In a 2004 video, NSK remarked: "All art is subject to political manipulation except that which speaks the language of the same manipulations; every new order presupposes the existence of disorder and is already affected with an inherent virus of future disorder."[47] While NSK appears to leach from its public persona the ambitious commitment explicit in Metzger's words, the same driving social aims remain implicit in their concepts. At the same time, NSK's aesthetic strategy consists in what some members of the Slovene School of Psychoanalysis theorize as over-identification with the symptom such as fascist costumes and flirtation with the visual codes of totalitarianism. These would seem to undermine Metzger's experience and work, even though the group has clearly inherited the other-wise substantive imperative to critique the social and political structures of oppression unleashed by the DIAS affect.

SRL is closer to Metzger and DIAS in its robotic displays of explosive mayhem and destruction, parodying military practices and especially recalling Ivor Davies's outlandish destruction installation at an actual Army Drill Hall in Edinburgh where he held a DIAS press conference on 1 September 1966. During the event, Davies fired objects that were wired to a switch box and dressed an anatomic model in clothes packed with color-filled balloons that symbolized body fluids, its male "genitalia" a long metal pipe injected with a clear milky substance. In 1982, Mark Pauline and SRL would "manufacture maniac machines with personalities ... [and] dynamite detonations spurting blood, rockets on cables, dead animal-robot mutations, mechanical flipping men, huge blowers, giant paintings of public figures being mercilessly mocked and tormented, [creating] the general atmosphere of a rusty carnival in hell exuding sweat, fire, and poisonous fumes."[48] Despite these similarities, the difference in cultural reception between DIAS and SRL is stunning: in 1966, Davies was able to convince an unsuspecting military, having no concept that his "presentation" might be associated with art, to lend its facilities for such a display; by the early 1980s SRL would carry out its events late at night as surreptitious guerrillas in parking lots, under freeway overpasses, and other unauthorized public sites. By the 1990s, a group like the Spanish La Fura Dels Baus, which also belong to the DIAS affect, would attract hundreds to large-scale public festivals of destruction actions.

Affect accumulates value over time and cannot be measured in terms of labor or consumption. Art operates through affect to permeate cultural ideas, often imperceptibly. John Latham has long theorized such effects as the long-term "time base" of art.[49] Yet, while scholarship on the role of affect increasingly appears in the sciences and literature and while affect plays a central but uncharted role in art, it has been neglected by Art History. Charles Altieri's important study of the aesthetics of affect, *The Particulars of Rapture*, 2003, attempts to remedy this situation and provides an introduction to the meaning of affect that is useful for my discussion of DIAS. In particular, Altieri argues that the affect of the arts brings out "an aesthetic dimension ... in all areas of our lives, [and] takes many forms, some of which do not involve conceptual formulations of any kind, and [includes] many modes of expressive activity ... not available when we think in terms of beliefs."[50] Continuing, Altieri writes: "Affect refer[s] to the entire range of states that are bounded on one side by pure sensations and on the other by thoughts that have no visible or tangible impact on our bodies. ... Affects are immediate modes of sensual responsiveness to the world characterized by an accompanying imaginative dimension."[51] Affects are to be found in feelings or "elemental ... states characterized by an imaginative engagement in the immediate processes of sensation"; moods that variously alter one's sense of subjectivity making it "diffuse"; passions "within which we project significant stakes for the identity"; and emotions.[52] All of these states are pertinent to the transmission of affect, but I am particularly concerned with the translation of emotions, "which contribute to the construction of attitudes that typically establish a particular cause and so situate the agent within a narrative and generate some kind of action or identification."[53]

I became interested in the issue of affect when I first began to follow the movement of Metzger's ideas through and across culture. One example is remarkable. In the early 1960s, Metzger began to lecture on his theories of *Auto-Destructive/Auto-Creative Art*. In 1962, artist-educator Roy Ascott (who would later become a member of the DIAS Honorary Committee) invited Metzger to lecture at the Ealing School of Art in London, where Pete Townshend, soon to become lead guitarist of the rock group The Who, studied.[54] Townshend later credited Metzger's lecture with giving him the idea to destroy his guitar during musical performances. If one extrapolates from how the destruction of musical instruments became a metaphor for the destruction of hypocritical social and moral behaviors and values, as well as a symbolic model of protest against the Vietnam War, then Townshend's act of destroying his guitar could also be understood as a sign for war resistance, awakening protestors to action. Such an account of the affect of Metzger's ideas necessarily condenses complex successions of cultural concepts but demonstrates one of the ways in which artists' theories and works enter society and alter it. Indeed, the "value" of such transmission, as Altieri writes in another context, "lies in how selves inhabit the affects more than in how they interpret them."[55] How Townshend *emotionally inhabited* the idea of destruction contributed to new attitudes that enabled audiences to interpret and expand upon his actions, thereby influencing millions to adopt a different *and constructive* view of the use of destruction in art and society. I would argue that such a history establishes a chain of remembrance that began with Metzger's tragic Holocaust experience, the mourning that he creatively transformed in DIAS into a consideration of how destruction in art might be used as a parallel image for, and critique of, social destruction. This view, then, informed the technique of artists through whose work such concepts transmuted again into forms for and of cultural resistance.

Another influential DIAS affect occurred almost immediately after DIAS when the psychologist Arthur Janov drew upon Ortiz's action, *Self-Destruction*, (performed 22 September at the Mercury Theatre) as the impetus for the development of his Primal Scream Therapy.[56] In his performance, Ortiz entered the stage, previously set with milk bottles, a large rubber duck, a diaper, and a large talcum powder canister to enact a childlike Oedipal crisis. Continuously crying, "Mommy, mommy, mommy, ma, ma, ma, ma," in a gesture of psychological regression he ripped off his suit, put on a diaper, powdered himself with talcum powder, and banged the rubber duck violently, and then guzzled the milk, vomited onto the stage, slapped the puddle angrily, and crawled off stage still crying, "Mommy! Mommy!" Janov recalled that his theory emerged after one of his patients told the story and requested him to follow in his therapeutic practice the actions "of a man named Ortiz who was currently doing an act on the London stage."[57] Significantly, Janov's bibliography for his 1970 book *The Primal Scream* includes the very authors Ortiz studied to arrive at his performance: Viktor Frankl, Sigmund Freud, R. D. Laing, Rollo May, Abraham Maslow, among others. In addition, in 1970 Mühl underwent Janov's therapy, which contributed to the *Self-Realization*

actions that he instituted at the Actions-Analytic Commune. The same year, Ono and John Lennon also worked with Janov, who identified their most emotionally vulnerable album, "John Lennon/ Plastic Ono Band," as their "Primal album." In these multifaceted ways, Ortiz's work rapidly translated into intellectual, artistic, and popular culture, reaching millions of people who had never heard of him or his art and returning to inform the lives of other DIAS artists.

In an entirely different context, DIAS participants Mark Boyle and Joan Hills, who developed *Son et Lumière* exhibitions, credited both Ortiz and Metzger in their work. They dedicated a section on "vomit" of *Son et Lumière for Bodily Fluids and Functions*, 1967, to Ortiz that visualized such bodily fluids as saliva, earwax, tears, urine, sweat, blood, sperm, and gastric juices; and they dedicated a section on "earth" in *Son et Lumière for Earth, Air, Fire and Water* to Metzger. The latter acknowledged Metzger's first projections of liquid crystals to produce moving images in the 1960s. These projections inspired the light shows that Boyle and Hill later developed for the rock band The Soft Machine, for Jimi Hendrix, and for other rock musicians with whom they worked. Such light shows anticipated the whole tourist industry of *Son et Lumière*, to say nothing of the eventual development of MTV that successfully fused the Surrealist visual complexity of the juxtaposition of incongruous elements with artists' film and video work (such as that of Kren and Conner) and the aura of the live sound and light performances of Rock 'n' Roll bands. To suggest such a scope for the DIAS affect is not to claim the originality of these various modes of production for DIAS, but to underscore how affect represents the ways in which "emotions play in our psychological lives ... generat[ing] behavior and ... other mental states" that can lead to new and original forms of art and culture.[58]

Perhaps the deepest and most sustained example of DIAS affect in the arts has been the international impact of Wiener Aktionismus on the development of a certain genre of violent self-expressivity in performance art. The ways in which the Viennese artists courageously exposed and confronted the traumatic effect on the psyche of the profoundly destructive history of western culture and religion provided *the* aesthetic model for artists to represent pain and suffering in ever more violent terms. The violent history they represent has been equally augmented by the increase in wars, genocide, environmental destruction, and natural disasters that have led to what I have theorized as "cultures of trauma."[59] Indeed, an entire corpus of feminist, gay, lesbian, and transsexual performance, as well as other aspects of identity politics (including post-colonial subjectivities) may be found in the simultaneously liberating and potentially harmful ways that Wiener Aktionismus has been interpreted. DIAS is also responsible in this nexus. DIAS strengthened the resolve of the Viennese who became more strident upon their return to Vienna. At that time, Brus and Mühl in particular began to make "political actions," or *Zock* Festivals, characterized by strong ideological and inflammatory performances culminating in the infamous *Art and Revolution* at Vienna University in the summer of 1968.[60] Among the many incendiary acts performed at the

Art and Revolution action, Brus undressed, cut himself on the chest and thigh with a razor-blade, urinated and then drank it, defecated on stage and smeared the feces on his body, and then masturbated while singing the Austrian national anthem. Although Brus retired from performing actions in 1970, unwilling to harm his body further, his intrepid readiness to submit his body to intense, expressive purpose authorized other artists to do the same. The principle legacy of Wiener Aktionismus, and by extension DIAS, has been the pervasive increase in danger to performers over the past thirty years, such as the bloodletting actions of Franko B in the late 1990s and 2000s. Couple such artist's actions with theories that unreflectively celebrate "transgression," "narcissism," and "masochism" and the situation appears increasingly sobering.[61]

Returning to the immediate question of the DIAS affect, DIAS was also the catalyst for the Dialectics of Liberation Congress, organized only ten months after DIAS by psychiatrists David Cooper and R.D. Laing, along with the assistance of Joseph Berke (an American psychiatrist who worked with Laing in London at Kingsley Hall, famous for its application of anti-psychiatry to heal severe schizophrenia; Berke delivered a paper at the DIAS symposium entitled "Man as a Self-Destroying Art"). While DIAS attempted but failed to attract a wide body of scholars from various fields, the authority of their academic and professional status enabled the Dialectics organizers to bring social scientists, political figures, scientists, intellectuals, and activists to London, ironically at precisely the same moment that Metzger and Sharkey stood trial in July of 1967. Whilst DIAS organizers faced prison sentences, the Dialectics presented discussion rather than images and actions, thereby demonstrating the difference between the passive cultural reception of officially sanctioned modes of academic address and the unpredictable and uncontrollable power of artists' interventions that society continually suppresses, censors, and prosecutes.

Still other instances of the DIAS affect include the founding of the Guerrilla Art Action Group (GAAG) in 1969 by Jon Hendricks and Jean Toche, closely associated with Ortiz's various destruction actions and exhibitions in New York. John Latham and Barbara Steveni also founded Artist Placement Group (APG) in 1966 in the heady context of DIAS. The aims of APG to place artists in business, educational, and other forms of institutional practices (as a means to integrate artistic approaches to problem solving) equally reiterated concepts considered at DIAS. In an entirely different vein, the architect Graham Stevens credits DIAS with being the first art venue that supported his fledgling creation of pneumatic environments. These led directly to Stevens's many scientific patents, environmental consultations around the globe, and art.[62] Indeed, this is just a beginning of the list of affects spreading out rhizomatically from DIAS, a form of expansion that Gilles Deleuze and Félix Guattari would theorize in part under the cultural instruction by DIAS participant Jean-Jacques Lebel.[63]

DIAS artists understood the significance of their undertaking, even if they could not anticipate or recognize the force of their historical extension. "We [were] the first generation to live

beyond that [Second World] War, and to *have* to create an ethos for ourselves, to recognize our-selves, and to create some kind of sense for another generation, to create some sense of bonding," Barbara Gladstone remembered after reflecting on her participation in the DIAS symposium.[64] While DIAS may have reflected the "ethos" of one generation, it left its affect on many subsequent generations. The DIAS affect reflects the aims and purposes of Metzger's art, the most important object of which was DIAS itself. DIAS must enter the histories of art as a model for post-studio, socially engaged international art practices of the late twentieth and early twenty-first centuries, and form part of the texture and fabric of how art and artists contribute to social reform, for better or worse. In conclusion, the words of psychiatrist Robert Jay Lifton, a specialist in trauma, provide a compelling parallel to the DIAS affect: "The more significant an event, the less likely it is to be studied."[65]

1 This essay represents the first publication of many aspects of my unpublished dissertation *The Destruction in Art Symposium (DIAS): The Radical Project of Event-Structured Art*, University of California at Berkeley, 1987. My dissertation also includes the first biographical sketch of Metzger's life up to and through the period of DIAS. I would like to thank Gustav Metzger and Sabine Breitwieser for the invitation to contribute to this catalogue, which brought me back to this 900-page opus and will bring me forward to its revision in a book, *The Story of DIAS and the DIAS Affect*. Laurel Fredrickson, Susan Jarosi, and Jay Bloom thoughtfully read versions of the text. Anna Artaker patiently supported a difficult writing period and superbly edited this essay; Cosima Rainer graciously assisted me with many details of my interaction with the Generali Foundation. Most of all, my gratitude extends to Metzger and all DIAS artists, whose affect shaped my life.

2 The Honorary Committee included Wolf Vostell, Enrico Baj, Mario Amaya, Frank Popper, Bob Cobbing, Dom Sylvester Houédard, Ivor Davies, Roy Ascott, Jim Haynes, and (Barry) Miles.

3 Lebel, Jean-Jacques. Unpublished interview with the author, Paris. 27 to 29 October 1980.

4 Roszak, Theodore. *The Making of a Counterculture: Reflections on the Technocratic Society and its Youthful Opposition*, Doubleday, Garden City 1969.

5 On subcultures and the underground, see Nuttall, Jeff. *Bomb Culture*. Dell, New York 1968; Melly, George. *Revolt into Style: The Pop Arts in Britain*. Allen Lane, London 1970; Hebdige, Dick. *Subculture: The Meaning of Style*. Methuen, London 1983; Nelson, Elizabeth. *The British Counter-Culture, 1966–73: A Study of the Underground Press*. St. Martin's Press, New York 1989.

6 Yoko Ono, fresh from participation in DIAS, met John Lennon at Indica in November 1966. Through DIAS, she became associated with the underground.

7 This suspicion was more than counterculture paranoia. Harvey Matusow participated in DIAS. He had been a member of the Communist Party, before becoming an informant for Senator Joseph McCarthy in the American "red scare" of the 1950s. After recanting and serving over three years in jail for perjury, Matusow remade himself as an artist.

8 My dissertation reconstructs this trial, which concluded in a relatively light fine.

9 Ortiz, Raphael Montañez. Unpublished interview with the author, Piscataway, New Jersey. 4 to 6 May 1982.

10 Ibid.

11 Metzger, Gustav. Unpublished interview with the author, Frankfurt, Germany. 13 to 17 May 1982.

12 London, John. "The Artist – 1966," in: *The Evening News*, London. Wednesday, 31 August 1966.

13 N.N. "Chicken-Killer Says Ban Won't Deter Him," in: *New York Times International Edition*, Friday, 2 September 1966.

14 Fielding, Henry. "Thursday Diary," in: *Sun*, London. Thursday, 1 September 1966.

15 Ibid.

16 Ortiz/Stiles.

17 Shearer, Ann. "Art limb from limb," in: *The Guardian*, London. Thursday, 1 September 1966.

18 Mühl, Otto. Letter to "Friedel," 8 September 1966, in Otto Mühl Archive, Friedrichshof, Austria. Conversation with Vostell confirmed this comment. Vostell, Wolf. Unpublished interview with the author, Berlin. 15 June 1979.

19 James, Paula. "Destroyers Stage Their First Event: In the Name of Art He Creates ... A Hole," in: *Daily Mirror*, London. Friday, 9 September 1966.

20 Metzger/Stiles.

21 James, Paula. "Destroyers Stage Their First Event ... ," in: *Daily Mirror*, London. Friday, 9 September 1966.

22 Metzger, Gustav. Abstract of his opening remarks at DIAS symposium, excerpted, in: *Excerpts from Selected Papers Presented at the 1966 DIAS* In the present book: 241.

23 Ibid.

24 Unless otherwise cited, the record of the symposium comes from archived unpublished notes taken by Ivor Davies.

25 Kemble, Kenneth. Unpublished interview with the author, New York. 24 February 1986.

26 Nitsch, Hermann. Unpublished interview with the author, Prinzendorf, Austria. 8 September 1982.

27 Brus, Günter. Letter to the author, 17 May 1986.

28 Weibel, Peter. Unpublished interview with the author, Vienna, Austria. 9 September 1982.

29 Brus/Stiles.

30 Nitsch presented the 21st performance of the OMT, and Mühl, Brus, and Susan Cahn performed *Ten Rounds for Cassius Clay*, a tribute to the African-American boxer, who having changed his name to Muhammed Ali refused to fight in Vietnam, dispatching the US government with the famous rejection, "I ain't got nothing against them Vietcongs."

31 Some of the films Kren presented on 15 September include: *48 Köpfe aus dem Szondi-Test*, 1960, *Bäume im Herbst*, 1960, and *Mauern-Positiv-Negativ und Weg*, 1961, and Mühl's *Papa und Mama*, 1964, *Leda and the Swan*, 1964, *O Tannenbaum*, 1964, and *Cosinus Alpha*, 1965, as well as Brus's *Ana*, 1964, and *Selbstverstümmelung*,1965.

32 Durgnat, Raymond. *Sexual Alienation in the Cinema*. Studio Vista, London 1972: 135.

33 Vostell/Stiles.

34 Metzger/Stiles.

35 Conner, Bruce. Letter to the author, 15 December 1985.

36 My assertion is based on communication with all these artists.

37 Metzger/Stiles.

38 Higgins, Dick. Letter to John Sharkey, 27 July 1966.

39 Hansen, Al. Unpublished letters to the author from 1980 to 1987.

40 Lebel/Stiles.

41 See Stiles, Kristine. *Rafael Montañez Ortiz. Years of the Warrior, Years of the Psyche, 1968-1988*,
 El Museo del Barrio, New York 1988.

42 Obvious exceptions include: Walter Benjamin's *Critique of Violence* and *The Destructive Character* from
 the 1930s, reprinted in *Reflections: Essays, Aphorisms, Autobiographical Writings*, Harcourt Brace
 Jovanovich, New York 1975: 277–304; Hannah Arendt, *On Violence*, Harcourt, Brace, and World,
 New York 1970; and John Fraser's *Violence in the Arts*, Cambridge University Press, Cambridge 1974.

43 See Williams's revised *Keywords: A Vocabulary of Culture and Society*, Oxford University Press,
 New York 1985.

44 Brus, Günter. "Zerreißprobe," 1970, in: Hubert Klocker (ed). *The Shattered Mirror: Wiener Aktionismus,
 Wien 1960-1971*. Ritter Verlag, Klagenfurt/Austria 1989: 142.

45 Between 1979 and 1982, I worked in Sohm's Archive then located in his home before it moved to the
 Staatsgalerie, Stuttgart. Although Sharkey was my first tutor on DIAS, Sohm was my first tutor of
 Happenings, Fluxus, Wiener Aktionismus, Concrete Poetry, the counterculture, and the underground.
 My scholarship is in Sohm's debt.

46 Metzger, Gustav. *Auto-Destructive Art: Metzger at AA*. Creation/Destruction, London 1965: 1.

47 Neue Slowenische Kunst quoted in Michael Benson's video *NSK: Predictions of Fire*, 2004. This statement
 is an obvious reiteration of Walter Benjamin famous comment on barbarism in his "Theses on the
 Philosophy of History," in: *Illuminations*. Schocken Books, New York 1969: 256.

48 "Mark Pauline," in: *RE/Search* 6/7 (1983): 23.

49 Latham, John. *Event Structure: Approach to a Basic Contradiction*. Syntax, Calgary, Canada 1981.

50 Altieri, Charles. *The Particulars of Rapture: An Aesthetics of the Affect*. Cornell University Press, Ithaca
 and London 2003: 3.

51 Ibid: 2.

52 Ibid.

53 Ibid.

54 New types of art education can be traced through British art schools in the 1950s, especially Roy
 Ascott's Ground Course at Ealing Art School in 1961. This history is also part of the DIAS affect.

55 Altieri, Charles. *The Particulars of Rapture: An Aesthetics of the Affect*. Cornell University Press,
 Ithaca and London 2003: 256.

56 Janov, Arthur. *The Primal Scream: Primal Therapy: The cure for Neurosis*. Putnam, New York 1970.

57 Ibid: 9–10.

58 Elster, Jon. *Alchemies of the Mind: Rationality and the Emotions*. Cambridge University Press,
 New York 1999: 137.

59 See Stiles, Kristine. "Shaved Heads and Marked Bodies: Representations from Cultures of Trauma,"
 in: Jean O'Barr, Nancy Hewitt, Nancy Rosebaugh (ed). *Talking Gender: Public Images, Personal Journeys,
 and Political Critiques*. University of North Carolina Press, Chapel Hill 1996: 36–64; originally published in

Strategie II: Peuples Mediterranéens, Paris. No. 64–65, July–December 1993: 95–117.

http://www.duke.edu/~awe/publications/shaved_heads.html

60 Brus quoted in: Klocker, Hubert (ed). *The Shattered Mirror*. op. cit.: 209.

61 See, for example, Amelia Jones's attempt to re-theorize narcissism as redemptive in her *Body Art: Performing the Subject*, University of Minneapolis Press, Minneapolis 1998. For further consideration of such issues, see my "Never Enough is Something Else: Feminist Performance Art, Probity, and the Avant-Garde," in: Harding, James M. (ed). *Avant-Garde Performance, Textuality and the Limits of Literary History*. University of Madison, Wisconsin, Madison 2000: 239–289.

62 Stevens, Graham. Unpublished interview with the author, Heathrow, England. 20 October 1985. Among many other things, Stevens invented the waterbed and the "Hovertube" (a pneumatic tube used to walk on water).

63 See Stiles, Kristine. "'Beautiful Jean-Jacques': Jean-Jacques Lebel's Affect and The Theories of Gilles Deleuze and Fèlix Guattari," in: *Jean-Jacques Lebel*. Edizioni Gabriele Mazzotta, Milano 1999: 7–30. Also on affect in art see, Kristine Stiles, "Remembrance, Resistance, Reconstruction, The Social Value of Lia and Dan Perjovschi's Art," in: *Idea*. Cluj, Romania 2005.

64 Gladstone, Karyn (Barbara). Unpublished telephone interview with the author, 4 May 1984.

65 Lifton, Robert Jay. *The Future of Immortality and Other Essays for a Nuclear Age*. Basic Books, Inc., Publishers, New York 1987: 32.

Historic Photographs No 1: Hitler adressing the Reichstag after the fall of France, July 1940, 1995,
Gustav Metzger installing the work

Andrew Wilson
Each Visible Fact
Absolutely Expresses Its Reality[1]

The work of Gustav Metzger hinges on a direct address to reality that is absolutely linked to disappearance and extinction. By the time of his involvement in the founding in 1960 of the Committee of 100, organizing mass demonstrations of direct action against nuclear war, Metzger had for more than a year been working on his theories of *Auto-Destructive Art* and its realization through, at first, the painting of acid on nylon. For Metzger, art and his political outlook have been and remain today inextricably linked together. Despite the direct and terrible effects of the Holocaust, Metzger has always seen his art not as a personal expression of what he has himself experienced, but as a fully socialized and public form of art in which he appears—if at all—as a witness or facilitator. By the early 1970s, his art had entered what he explicitly termed its "political" phase, which culminated with his call in 1974 for artists to undergo three years without art—a "strike" he followed between 1977 and 1980. Despite his continuing involvement with the anti-nuclear movement through the 1980s—both with unrealized projects such as *The Button*, 1982 (addressing the insanity of Mutually Assured Destruction) and the formation of the Artists Support Peace movement—on the face of it, his activities as an artist appeared to have markedly tailed off.

This is, however, a mis-reading. Through the 1980s, Metzger's activities were largely directed at attending a peripatetic round of lectures, symposia, and conferences, and engaging in many discussions and conversations over a wide variety of topics throughout Europe. (During this period, and until his return to London in 1994, he had lived or traveled through Germany, Switzerland, Italy, France, and Holland, as well as occasional stays in England.) He had entered a period of thinking that he embraced, in a performative sense, as an essential aspect of his work, entailing both the action of formulating ideas that are essential to the wellbeing of society today as he understands it, whilst also communicating these ideas in as direct a form as possible: the live

spoken word. This had always been an essential part of his practice—whether it had been giving *Lecture/Demonstrations* and distributing manifestos in the 1960s, or enacting events in the 1970s that relied on joining a durational element with an exploratory and interactive activity, such as in his *Controlling Information from Below* of 1972—and through the 1980s and 1990s it was an aspect of his work that came to assume greater importance.

When he returned to Britain at the end of 1994, after what had effectively been almost twenty years of traveling through Europe, Metzger was to most people an obscure and largely forgotten artist, and if he was known at all it was for his work of the 1960s—his theory of *Auto-Destructive Art*, first publicly formulated in 1959, and for his organization of the *Destruction in Art Symposium* of 1966. In broad terms, the fact that he had moved over forty years from making paintings as a student of David Bomberg, to making paintings that destroyed themselves, to carrying out an art strike, to having discussions about death and extermination, did little to help his public profile as an artist. Furthermore, if the construction of art history can largely be said to concern itself with the objects that artists leave behind and their status within an art market, not only had Metzger not left many objects behind but also this absence had anyway always been conceived as a key aspect of his assault on the capitalist system and the art market in particular. It was hardly surprising that in the 1980s and early 1990s, Metzger's achievement was hidden from sight.

Arriving back in London, however, Metzger had already started to formulate plans for a new body of work that would occupy him for the next four years. The series of *Historic Photographs* were themselves conceived as public works of art that dealt not just with history but also with how we deal with those images that are thrown up on a regular basis and are caught by history. The series adopted strategies that engaged with the spectator as much as with the artwork; the work threw the spotlight on the mechanics and meaning of photographic image-making and its particular status within the production and delivery of news. Above all, the series involved the spectator in immediate, visceral, and uncompromising ways that were as much an affront to looking as an invitation to investigate.

The most immediately apparent aspect of the *Historic Photographs* is that they did not present themselves so much as photographs but as objects in space. The first two works in the series—*Historic Photographs No 1: Hitler addressing the Reichstag after the fall of France, July 1940*, 1995 and *Historic Photographs No 1: Liquidation of the Warsaw Ghetto, April 19 – 28 days, 1943*, 1995—both presented the photograph as hidden.[2] The former was enclosed behind a structure of MDF and galvanized zinc, the latter behind a screen of wood shuttering boards that had been cut down from planks of scaffolding and held in galvanized zinc mounts. Where the former gave off an aura of studied anonymity that chimed well with the totalitarian ordering of the Nazi war machine and the terror it unleashed, all of which was celebrated by the event pictured (but covered over), the choice of used wood shuttering as the means of hiding the photograph from view in the

other work was deeply affecting. The smell of the wood, its rough natural surfaces bearing traces of past use was almost too much to bear given the photograph we knew to be shrouded behind it—even though we couldn't quite see it.

Metzger's purpose in covering these photographs was twofold: he was both giving to "photography a new significance, another lease of life," whilst at the same time his aim was "to put photography down."[3] These two photographs that Metzger chose, and the other photographs he went on to incorporate into the series, are all well-known images. They are images that are so well-known that now, when presented with them, they are no longer properly seen and their true significance no longer recognized. They exist—if they exist at all—as a form of shorthand aide memoire, as a quick route into certain moments. Metzger's strategy is to present us with the idea of a given image that can then be reconstructed anew in our mind from its effacement in front of us. The title suggests the particular photograph while the form of covering-over gives a feeling for what the image might be and mean: "Here a new start is available. We cannot be sure what we are looking at. Memory and recall are in action, but what certainties are there?"[4]

The certainties that Metzger manipulates revolve around the assertion he made in 1961 that "[e]ach visible fact absolutely expresses its reality"—which, in this instance, is the space we find ourselves inhabiting alongside these works or "blanks," as Metzger has termed them; as well as the physical nature and material chosen by Metzger to form these "blanks."[5] In Maurice Blanchot's discussion of the imaginary, he describes how the viewer sees the object first, only to see it effaced by the image: "After the object comes the image … The thing was there; we grasped it in the vital movement of a comprehensive action—and so, having become image, instantly it has become that which no one can grasp, the unreal, the impossible. It is not the same thing at a distance but the thing as distance, present in its absence, graspable because ungraspable, appearing as disappeared. It is the return of what does not come back."[6] Blanchot's observation goes some way towards accounting for Metzger's strategy—the recovery and re-presentation of a photographic image through a "making strange"—in which the object and "revealed" image confront the viewer as something that becomes potently real again through an act of resistance, of meaning, of reality, of sight; in which the once easy assimilation of images now becomes fraught with difficulties.

The viewer's confrontation with the image and the object that shrouds it is further complicated by Metzger's use of space in the presentation of these works. Most of the photographs are covered-over, others are all too clearly present; however, in all these works, and through their very different presentations within the gallery space, he rubs our faces in our different memories of and feelings for the images he has chosen. With *Historic Photographs: The Ramp at Auschwitz, Summer 1944*, 1998, the viewer is herded up a wooden ramp, alternative exit is denied by iron bars, and an enlarged (and so degraded and partially abstracted) photocopy collage of a

photograph documenting the selection process on arrival at Auschwitz of those that will die imme-
diately and those that will live a little longer, is made unbearably close in the narrow corridor the
viewer has to pass through, and over which the overpowering smell of the wood hangs heavy;
there is no retreat possible from Metzger's particular presentation of this image. In contrast,
a fabric screen hangs in front of *Historic Photographs: To Walk Into, Massacre on the Mount,
Jerusalem, 8 November, 1990*, 1996. However, although this image is apparently curtained-off, the
viewer is encouraged to move through the narrow gap between the screen and photograph to see
the horrific photograph up close. Again, Metzger manipulates the impact that is derived both from
the viewer's bodily proximity to the work and the manner in which the image is revealed over the
time spent by the viewer moving along it, and which becomes a mental form of moving through it.
This work is paired with *Historic Photographs: To Crawl Into—Anschluss, Vienna, March 1938*,
1996/98, the photograph having been fixed to the floor with a loose fabric covering over it. However,
in this instance the viewer is invited to crawl under the cover to see anew the photograph of
Viennese residents together with the Nazi Hitler Youth forcing Austrian Jews to scrub the street on
their hands and knees. In a most affecting way the viewer adopts the position, if not the terror, of
the persecuted Jews. We are made to see these photographs not as images and representations
of something else that is removed from us, but as a bodily experience—an event, a something that
happens—a seeing through touching and a seeing through having something covered-over.[7]

By forcing the viewer into an often unbearable proximity with these works, Metzger sets
in motion a bodying of perception and history alongside his overt and manipulative bodying of
space. His thinking about these works has been directed as much at their physical material
appearance as at how the works are experienced and what that experience may be. Characteristically,
his first talk on the subject of these works was titled *The Exclusion of the Spectator in Art*. Here
he talked, on the one hand about the physical object whereby "the material must speak. If that is
the starting point then one is on the right way. The material needs to exude the presence of the
subject. ... The subject needs as it were to power through the cover. The cover in this sense is
porous permitting the depicted image a transmission towards the public. ... A sculptural form is
created whose meaning is inextricably interwoven with the presented image. ... The sculptural
form itself is the equivalent of the image."[8] The hidden meaning of these works, then, is teased
out through a potentiality of experience, which is personal to each viewer and is felt both bodily in
a visceral manner as well as mentally while coming to terms with the particular physical presence
of each work. He describes these photographs as "an arena where the extreme is placed on view
but the activity takes place in the mind of the viewer. The suffocating horror is felt, not seen. It is
strictly internalized—there is no blood on the floor. But there is a psychic arena set up when people
move through an exhibition. Signals sent and received, often against the will of the participants."[9]
By punctuating the exhibition space with his "blanks," Metzger is also arranging the creation of

a "psychic space, where uncertainty and the unknown are given freedom to range. The bafflement in confronting the works has its correspondence in so many experiences faced in daily life. Bafflement, uncertainty, a sense of loss."[10]

And yet there is a particular historical resonance to the choice of photographs by Metzger that would make up the *Historic Photographs* series. The source photographs encompass the Nazi Holocaust, the Israeli conflict in the Middle East between 1948 and 1990, the Vietnam War in 1972, the Oklahoma City bomb in 1995, the desecration of Twyford Down in 1998, the conflict in Serbia and the former Yugoslavia in 1999. These are all images of despair and unlearned lessons from the past which show humanity to be in peril whether through war, terror, destruction of nature, bigotry, dogma, or the arrogance of belief. What Metzger has constructed with these works is indeed a reinvigoration of photography, but also a narrative—through using his particular installation of the works to construct a performative space—the aim of which is close to his ideal of the creation of an auto-destructive public art: "We want monuments—to the power of man to destroy all life. ... We are concerned with a Pharaonic vision."[11]

For instance, to these ends, the two works from the *Historic Photographs* series, *To Walk Into* and *To Crawl Into*, were conceived by Metzger to be installed in close proximity to each other. As he explained: "There has been an intense public debate for decades in Israel about the mistreatment of the Arabs. The discussion goes along the lines that because the Jews had been persecuted by the Nazis this forces them to retaliate, forces them to relive the Holocaust by inflicting the Holocaust on somebody else under their domination. When I experienced the horror of this catastrophe of the Jews killing unarmed Arabs and wounding hundreds on that day in 1990, the revulsion in me became so strong that it opened up the door to the whole project of the *Historic Photographs*. I decided to show works where Jews dominate and mistreat Arabs. There are the Nazis, and there you, the Israelis, are, and I accuse you: 'You shouldn't do this. They, the Nazis, shouldn't have done it, but you shouldn't do it.' It is my duty as a Jew to say this to Jews: 'Don't do it. I warn you, don't repeat the Nazis.' That is why these works are placed in direct confrontation with each other. And that is also about the aesthetic of revulsion. I am revolted by each image, by each historical reality and I want to warn people and how can I warn them as an artist?—by bringing them as close as possible to that pictorial reality by saying: 'Go in, crawl on your knees, pray that this may never happen again. Walk in so that you touch both the Jewish police and the poor Arabs and feel your way through this reality—don't just look at it.' By making it as difficult as I do, I expose people more to the deepest parts of this reality than if I had just said: 'Look at this picture.'"[12]

The key to this goal of Metzger's—that people be exposed to the "deepest parts of this reality"—can be found in his much earlier elaboration of the aesthetic of revulsion in his writings on *Auto-Destructive Art* in the 1960s that might reveal "by elimination of matter the amount of time

Historic Photographs: Trang Bang, Children fleeing South Vietnam, April 1972, 1998,
Spacex Gallery, Exeter, 1999, installation view

left to us,"[13] and stimulate a collective awareness of the force of society. Since 1959, Metzger had, through his works, encouraged a state of cathartic change in the viewer, as opposed to reinforcing an acquiescence with the position of society spiraling towards annihilation. In the *Historic Photographs*, the aesthetic of revulsion is located primarily at the oppression, tension, and manipulation that the viewer might feel when confronting—bodily and mentally—these works and the tight and constricting spaces in which they are sited, so that, "when you are in you can't move away without being close to feeling trapped. The *Historic Photographs* show an aggression towards nature and an aggression towards humanity."[14]

One other aspect of the *Historic Photographs* and Metzger's use, almost entirely, of press or newspaper photographs as his source, is the degree to which the series enacts the creation of an archive—indeed, as does much of his work. Metzger is himself rarely without newspapers. For him, they embody a particular reality of "information" in that through newspapers "you pick up and unravel reality and lies together."[15] For the *Festival of Misfits* in London in 1962, Metzger had proposed that on each day of the exhibition two copies of that day's *Daily Express* would have been presented on one wall from the ground floor to the basement of Gallery One that housed this Fluxus[16] exhibition. Repeated visits to the exhibition would have laid open for viewing and analysis the ways in which news stories unfolded—in this case, the exhibition coincided with the Cuban missile crisis. This work was not in the event,[17] but in the early 1970s he made a series of newspaper works, one of which, *Controlling Information from Below*, 1972, was partially reconstructed in 2003 as *100,000 Newspapers, A Public-Active Installation*.[18] In such works as these, Metzger offers a situation in which the viewer and artist can together follow the impulse to classify by creating order from an apparent heterogeneity of material, and by so doing question establishment orthodoxies. The installation of *100,000 Newspapers* was divided into two. One brightly-lit room contained newspapers that were piled and strewn across its concrete floor. Viewers of the work were requested to look through the newspapers and cut out anything they found interesting. Later, Metzger sorted through these cuttings and mounted them on canvas stretched panels under headings such as "Work," "Biotechnology," or "Extinction." In a second room, batches of newspapers were ordered on a structure of metal shelves and walkways, but in the center of the room some shelves had given way and a pile of newspapers and loose pages had formed what the critic Peter Suchin described as a disruption of "the righteous archival rigidity of the stack surrounding them. The ostensibly calm eye of the storm was itself, so to speak, enraged and out of control. The deathly coldness of this subterranean double space seemed more than appropriate after hearing Metzger remark at the Tate that reality is, today, something most people find impossible to bear. ... Nightmare narratives are brought to our attention on a daily basis, only for us to turn away in cowardly acts of distraction and self-deceit. ... Layers and layers of printed text, yesterday's news sinking under its own weight, may well be regarded as paralleling Walter Benjamin's influential account

of historical change as an allegorical ruin. Metzger also echoes Benjamin in believing that we live, today, in a constant state of emergency and despair."[19]

What an installation like *100,000 Newspapers* emphasizes is the extent to which Metzger's strategies have remained entirely consistent since 1959 when he first started to elaborate his practice in terms of his theories of *Auto-Destructive Art*. It is a public art, an art of the event rather than the object, an art that through his presentation of an aesthetic of revulsion and the action of catharsis involves the viewer closer than is often comfortable; it is an art that is both a witness to states of being and a challenge to action. Equally revealing is the degree to which this work differs from its original source, *Controlling Information from Below*. Indeed, having made work that has inscribed within it the need not to exist materially other than as memory or occasionally as document, one aspect of Metzger's work over the last decade has been the necessary remaking of work from the past that no longer exists, and in almost every respect these works have been altered to engage with new issues and meanings pertinent to the new context of their recreation.[20] In 1996, his re-presentation of the 1959 *Cardboards* environment was accompanied by a statement that acknowledged this unavoidable fact. To the 1959 statement about the work, which emphasized the productivist, functional, ready-made, and temporary nature of the work, is added in 1996 the observation that "the distinction between the highly finished forms then and now, reflects a deep change in my response to science, technology, and the technological environment. … Cardboards, cardboard boxes, are for us now inextricably linked to fraught figures seeking shelter in cities; the present showing re-emphasizes the social content of—cardboards."[21]

The differences between the two newspaper works of 1972 and 2003 are perhaps more subtle than this, but no less telling. In 1972, Metzger proposed the creation of a newspaper archive for activists of all sorts, and visitors were given the tools to create this—the day's newspapers, index cards, paste, etc. At the same time, Metzger provided physical and mental sustenance for these embryo archivists in the form of rice and lentils, inviting visitors to rinse and boil the food and "watch the activity"; he also cleaned a bathroom so that the visitors could take a bath or shower. Similarly, for the exhibition *British Thing* later in the year in Norway, Metzger presented a room where visitors could receive a calming massage after having experienced the exhibition. In 2003, the visitors chose items for the archive but the ordering of the cuttings was carried out by Metzger. Similarly, although there was no food, bath, or massage facilities, the exhibition was complemented not only by two film works by Stewart Home and Wolfe Lenkiewicz, but also by an extensive program of talks and events. In this situation, Metzger assumes the role of guide much more than he had in the past; guiding towards a resolution in which viewers can clearly identify their role in creating the framework for a more aggressively politicized engagement and a fundamental questioning of the structures of contemporary society. The aim, however, remains the same—that the viewer should enter a situation in which they can find and then use their own voice.

On the face of it, Metzger's work can be equated with what critic/curator Nicolas Bourriaud has recently termed Relational Aesthetics, in which a strand of current art practice is characterized as "taking as its theoretical horizon the realm of human interactions and its social context, rather than the assertion of an independent and *private* symbolic space."[22] And yet where Rirkrit Tiravanija provides a Thai meal to visitors as his exhibition, or Gabriel Orozco strings up a hammock in the garden of MoMA New York, or Liam Gillick creates a structured environment at the Whitechapel Art Gallery that provides the potential for conversation, discussion, and interaction between visitors and through the work, interaction as such is treated as representation rather than actual, so that in taking part in Tiravanija's meals, for instance, the viewers see themselves as representative parts of the work, which entails the creation of a micro-community defined by the walls of the gallery and who is there. In this respect, social context becomes an abstraction. For Metzger, the presentation of cooking lentils to provide a bio-kinetic model for social activity (eating the lentils was not its aim) alongside the actual analysis and discussion attendant in his newspaper works of 1972 and 2003, is neither representation or abstracted but actual, and is also meaningfully directed as a means of taking part in the world, so as to question the structures and signs of everyday life—understanding and so using the reality of visible facts.[23]

By the 1990s, the sorts of analysis and discussions that had been taking place in his work in the early 1970s were being carried out in public by Metzger both in conferences that he was attending or taking part in, or in carefully conceived lectures. These lectures serve to provoke a response, act as witness, and provide a spur to action. They cover a wide ground—death, extinction, ecology, time, and the body—which provide both a counterpart and commentary to his gallery-based works. Although it was not until 2002 that Metzger gave a talk explicitly on the subject of extinction,[24] it is a subject that had been touched on in many of his staged talks since he wrote *Nature demised resurrects as environment* in the summer of 1992 as an angry response to what he saw as the "betrayal of hope" following the Rio Earth Summit, and which poignantly ends with Metzger proposing what might be his reaction were he to return to the forests around Nuremberg that he had known as a child, since which time "nature has been turned into a hybrid: environment. ... It is not just that Nature is wiped out: it is our memory that is overturned. It is our apprehension of a future, where people will not have that contact with forests where an englobing experience was given—shelter, verdancy. Not knowing is a form of erasure. It is quite different from not having."[25]

Metzger extended this capacity for society and science to create hybrid states, where "nature" becomes "environment," with his 1996 talk *Mad Cows Talk*, which in the form of a silent slide installation was part of his contribution to *Life/Live* at the Musée d'Art moderne de la Ville de Paris later in the year. Ostensibly taking CJD—Mad Cow's Disease—as its subject, and the reaction of the rest of Europe to the disease and the accompanying worldwide bans on British

beef, Metzger takes this as another opportunity to discuss humanity's capacity for self-annihilation, in this respect through the increasing industrialization of farming and the accompanying reliance on biotechnology, whereby "The human body is under attack as never before."[26] In all this, and the creation of what he comes to term the "technoid double," he uncovers correspondences between the nuclear bomb and the Holocaust, as both entail "the forced violation of the most profound taboos sanctioned in humanity [that] led to a conduit towards the forbidden. ... Humanity is anchored in nature, and has persistently forced a radical change on nature. But with atomic power and biotechnology inventing a means of destroying all life, and finding ways to create all life, place humanity on planes with God-like capacities. ... This shattered being turns into a golem, who will march inexorably to its own destruction, taking the entire world with him."[27]

In this talk, as in *Nature demised*, Metzger stresses the need for a "breathing space" and calls on nature to "cultivate its garden." It is not unsurprising that in his next major talks, early the following year, he engages with the idea of breath and purification, but in ways that are shockingly direct. In *breath in$_g$ culture*, the first of these two talks that were both presented in London at Autogena Projects in Covent Garden, Metzger investigates the notion of breath and breathlessness, the loss of breath and the taking of breath, as a physical metaphor for the destruction of nature, which he suggests is inscribed in us all as the death-wish. Throughout the talk he graphically describes the bodily functions of breathing and the many different, often violent, ways that breath can be lost, all the time illustrated by slides of works of art that, together with his commentary, go some way towards creating a performative aesthetic of revulsion. Significantly, he invokes the concept of "Ruach"[28] from Judaism as the breath of God on the world and on all living things and states that the "disparition of 'ruach' is a guiding feature of our present. The insects, the butterflies, the hedges in which they and birds lived, have gone and are going fast. ... This breathing landscape was the 'lung' for human beings. Breath supports life." Metzger's belief is that with the destruction of such "lungs," allied to the loss of large areas of the ozone layer, earth and heaven are now "locked in a life and death struggle."[29]

With the second talk, *A Little Talk on Architecture*, Metzger extends his graphic descriptions of the loss of breath by confronting, head-on, notions of disappearance and erasure by engaging with the example of the Nazi extermination camps. Metzger had always alluded to Judaism and to recent history, which is also the history of his own life and the murder of his family by the Nazis, but never in such a way as he did in these two talks. While making the *Historic Photographs*, he had suggested that the covering of the photograph could be compared to the covering of the Torah. The central concept of this second talk is the "Mikwa," the Jewish bath house, in which immersion leads to ritual purification. In the previous talk he had shown a slide of a bath house from Pompeii and explained that "when you enter this confined space, it will be warm. There are pipes in the floor and in the walls to heat up. Your breath will change, but you

also respond differently to the situation and breath will get reflected."[30] In the second talk he describes how the Mikwa encapsulates hiding, just as in Judaism "hiding becomes the path to survival. Hide and disguise."[31] In stating that "The death camps are about invisibility, they are not meant to be seen. … The railway tracks starting from all parts of Europe towards Auschwitz and other death camps end in invisibility," he uses his own history graphically to explain how "Architecture is the manifestation of programmes whose origin may be hidden. … Architecture is the uprising of hidden power." Metzger's matter of fact delivery of his lecture belies its subject and so enhances the cathartic power of the aesthetic of revulsion he unleashes on the listener. However, more claustrophobically affecting is his description of the passage of purification in a Mikwa compared to the action of the Nazi gas chambers that destroyed his family, and in which the visibility lent to these actions by photographic documentation is allied to the disappearance that this so cruelly documents:

"Mikwa: echoing chamber. Der Körper entblößt. The body is uncovered. There are no photographs of people in a Mikwa. The Nazis took photographs of naked Jewish women on the point of being put in shallow graves. A subdued sound. Echoes of the water's movement, echoes as the figure enters the water. One's feelings veer from acceptance of the situation to questions on escape. Entrapment is a recurring sensation. The Mikwa as a premonition of the death camps, a training ground, it could be said. These people had to strip—the body uncovered. Under the pressure of the gas, the onset of death, the death throes, bodily fluids and matter involuntarily make their exit mingling with the absorbing gas. The death camps implode the meaning of the Mikwa which is not to do with physical cleansing as rather with spiritual purification. The Mikwa is a path towards unifying and reinforcing Jewish experience."

Within the talk, hiding, invisibility, and disappearance are shown to be crucial concepts within Judaism. However, by applying such metaphors to architecture the essence of his talk is that architecture provides a model for our own willing enslavement; a slavery that is inescapably inscribed within our culture and being. Similarly, the previous talk had used the metaphor for the loss of breath to show how far we are implicated in our own potential extinction unless action is taken. This strategy of Metzger's can be extended to the *Historic Photographs*. There, the gesture of hiding is in the foreground, but the aim is for the viewer to find the image and in doing so ask questions of the reality of the image and their own reception of it; for the viewer to find and then use their own voice.

If invisibility and disappearance are, like destruction, leitmotifs of Metzger's work, so also is their opposite. Just as his theories of *Auto-Destructive Art* are concerned as much with notions of creation as they are about destruction, so does his work embody the action of revealing truths. The *Historic Photographs* in this sense are about something hidden and then revealed— the significant issue being the action of revealing is one carried through by the viewer. This

dichotomy is also at the heart of what, on the face of it, seems an uncharacteristic work, his 2003 video work *Power to the People*. This documents the demonstration in London on the first day of the Iraq War on 20 March, 2003, when school children sat down in protest in the streets around Parliament Square, blocking the traffic, and chanted "power to the people" with police virtually powerless to act against them. The video incorporates footage from several different sources— including 17-year-old Neela Dolezalova's video diary of the Hands Up For Peace action when thousands of hands made by children were planted in Parliament Square—inter-cut by Metzger with newspaper headlines and front pages documenting the start of the war, the suffering inflicted on Iraqi civilians, and the demonstrations in London. For Metzger, this demonstration, harking back as it did to those forty years earlier organized by the Committee of 100 that he had helped initiate, revealed the power we can all find by following an engaged and creative questioning of our own state and that of the world we move through and exist in.[32]

Since 2001/2002, Metzger has embarked on a series of pencil and wash drawings made both in his studio and outside in a London park. Given the nature of his work over the last forty or so years, the appearance of these ostensibly traditional works is unsettling. These drawings appear to reiterate directly his reaction to the teaching he received from David Bomberg, certain tenets of which have remained constant throughout much of his life, and especially the defining characteristics of the Bombergian "spirit in the mass."[33] With these drawings he is not concerned so much with the final image, with observation or depiction, but with the process and activity of drawing itself—with attitudes to drawing and so, by extension, with attitudes to nature and also art—describing them as a "statement of attitude in different ways to different aspects of life."[34] Understood in this way, the drawings take the form of visual manifesto—as declarations of intent. These exploratory and intuitive drawings emphasize the qualities of different marks and physical impressions in ways that are similar to his painting on mild steel from 1958 in which the surface is both attacked and carved into but also dusted with pigment and chalk.[35] Metzger has identified how the new drawings—spare and open in expression—present "an openness of feeling and a response to nature"; for him "emptiness is just as important as fulfilment of the line." In realizing these drawings—just as with his recent video, the *Historic Photographs*, and his talks—Metzger continues to enlarge his practice of *Auto-Destructive Art*, prioritizing both the power of destructive forces that we all confront as well as the animating and transformational principle manipulated in the act of creation rather than the finite physicality of the object or its reduction into product. Metzger's work over the last decade is utterly consistent with his earlier elaboration of *Auto-Destructive Art* and his realization that if "[e]ach visible fact absolutely expresses its reality," the true nature of that reality is hidden, yet has to be uncovered if we are to find and use our own voices.

1 Metzger, Gustav. *Auto-Destructive Art, Machine Art, Auto-Creative Art*, self-published manifesto, 23 June 1961. In the present book: 228.

2 The material realization of these works was the result of prolonged discussions over many months between Metzger, myself, Simon Cutts, Erica Van Horn, and Clive Phillpot. Following Metzger's return to London, Simon Cutts who had a proposal to make a book project with Metzger at his East London space, workfortheeyetodo, introduced him to me. This led to the production and presentation of these two works, and *Earth minus Environment*, 1992/95, as well as the publication of the book *Metzger. Gustav damaged nature, auto-destructive art*. coracle@workfortheeyetodo, London 1996.

3 Metzger, Gustav. *Killing Fields. Sketch for an Exhibition*. In the present book: 281.

4 In the present book: 282.

5 One work, *Travertin/Judenpech*, 1999, was a site-specific installation Metzger constructed for the exhibition *Dream City* at the Haus der Kunst in Munich. Seen in the context of the *Historic Photographs* series, the work presents itself as a blank but with no photographic image at all, and Metzger's particular manipulation of the viewer's encounter with the work is also comparable with the *Historic Photographs*. *Travertin/Judenpech* opposes the building material beloved by the Nazis, and used for much of the Haus der Kunst, with asphalt that was spread, following Metzger's instructions, on a portion of the walkway along the entrance to the building and also on the right half of all the steps leading up to the entrance door, in such a way that it is difficult to avoid walking on it. The word "Judenpech" is a medieval term for asphalt but also means "bad luck for the Jews."

6 Blanchot, Maurice. *The Space of Literature*. The University of Nebraska Press, Lincoln 1989: 255–256.

7 *Historic Photographs: To Crawl Into – Anschluss, Vienna, March 1938*, 1996/98, was re-presented as part of Metzger's contribution to *Dream City* in Munich in 1999 in such a way as to emphasize these points even more. The work was installed in a gallery in the Munich Kunstverein that had been the site of the *Entartete Kunst* (Degenerate Art) exhibition in 1937, at the opening of which Adolf Hitler had declared "From now on we are going to wage a merciless war of destruction against the last remaining elements of cultural disintegration." For this location, Metzger remade the work for the third time, re-titling it *To Crawl Into/To Walk Onto – Anschluss, Vienna, March 1938*, 1999, because in the morning, the cloth covered the photograph and the viewer was invited "to crawl into," and during the afternoon the cloth was pulled back and the viewer was invited "to walk onto." Furthermore, the photograph was covered by a metal mesh, imprisoning the image, making it physically as well as psychologically painful to crawl over. When walking on it the mesh created an additional sound element.

8 Metzger, Gustav. "Notes re. workfortheeyetodo, before talk," holograph notes, Tate Gallery Archive (uncatalogued) 8229, folder 5. Elements of this talk were re-worked for his text published in 1999 by *Camera Austria*.

9 Ibid.

10 Metzger, Gustav. *Killing Fields. Sketch for an Exhibition*. In the present book: 283.

11 Metzger, Gustav. Untitled statement, in: *Art and Artists*, London. Vol. 1, No. 5, August 1966: 22.

12 Metzger, Gustav. Interviewed by Andrew Wilson. "A Terrible Beauty," in: *Art Monthly*, London. No. 222, December 1998/January 1999: 9.

13 Metzger, Gustav. Untitled statement, in: *Art and Artists*, London. Vol. 1, No. 5, August 1966: 22.

14 Metzger, Gustav. Interviewed by Andrew Wilson. "A Terrible Beauty," in: *Art Monthly*, London. No. 222, December 1998/January 1999: 9.

15 Metzger, Gustav. *From the City Pages*, In the present book: 259–261. Metzger wrote in relation to his newspaper works that "We are actively preparing to kill all life on earth. Newspapers are aligned with this society: they help to maintain it and must share the blame for the increasing ugliness of people and cities. The advertisements of the polluters and destroyers keep the presses rolling. Picasso said that art is a weapon to fight the enemy. I have something to say; and I am saying it—and that is politics." In the present book: 261.

16 At the time the term "Fluxus" was not associated with this exhibition. It is only in retrospect that it has been assimilated within the canon of Fluxus exhibitions, by virtue of the fact that it had been sanctioned by George Maciunas and that the exhibiting artists were associated with Fluxus: Daniel Spoerri, Robert Filliou, Addi Köpcke, Robin Page, Benjamin Patterson, Per Olof Ultvedt, Ben Vautier and Emmett Williams.

17 A version of this work was constructed for Metzger's 1997 retrospective at the kunstraum muenchen, Munich, and another, with the title *Daily Express*, 1962/98, was constructed for Metzger's 1998 exhibition at the Museum of Modern Art, Oxford. The latter reconstruction consisted of the front pages of two different editions of the *Daily Express* for 24 October 1962 concerning the unfolding of the Cuban missile crisis. As part of Metzger's contribution to *Out of Actions* at the Museum of Contemporary Art, Los Angeles, in 1998, the curator Paul Schimmel arranged for the purchase of two copies of the newspaper for each day of the London exhibition. This was done and the papers piled within a plastic box. Metzger donated the resulting work to the museum's collection.

18 The other newspaper-derived works are *Mass Media Today*, installed for *Art Spectrum: London*, Alexandra Palace, London, August 1971; *Executive Profile*, installed for *The Body as a Medium of Expression*, Institute of Contemporary Arts, London, November to December 1972. *Controlling Information from Below* was part of *3 Life Situations* at Gallery House, London, March to April 1972.

19 Suchin, Peter. "Gustav Metzger," in: *Frieze*, May 2003: 100.

20 This has been a constant feature of his output over the last decade. A number of his exhibitions have consisted mainly of reconstructions of works from the 1950s, 1960s, and 1970s. For *Out of Actions* (1998, Museum of Contemporary Art, Los Angeles and tour) he reconstructed the 1961 *Demonstration of Auto-Destructive Art* in front of an audience for a video that accompanied the tour. The only other lecture demonstration to have been reconstructed is the lecture demonstration that had been given at the Temple Gallery in 1960. This was represented as *Recreation of first public demonstration of Auto-Destructive Art*, 1960/2004 for *Art and the Sixties, This Was Tomorrow* at Tate Britain, London. It was

produced purely to achieve the work for exhibition and was not created in front of an audience. During the exhibition one element from the work was removed by gallery cleaners thinking it to be rubbish and necessitating that it be replaced by another *bag*.

21 Metzger, Gustav. Untitled statement on *Cardboards* for *Made New*, City Racing, London 1996. In the present book: 274. This work was again remade by Metzger in 2000 with a new title making direct reference to Kurt Schwitters, *been there, done that, K.S.*, for the exhibition *City Racing 1988-1998: A Partial Account*, Institute of Contemporary Arts, London, 2001.

22 Bourriaud, Nicolas. *Relational Aesthetics*. Les presses du réel, Dijon 2002: 14.

23 The extreme and often visceral subject matter of Metzger's work is sometimes compared with that produced by a younger generation of artists in Britain in the 1990s—the so-called young British artists. For instance, in the catalogue to his 1998 retrospective in Oxford, Norman Rosenthal suggested that though these artists, such as Damien Hirst, "know little if anything of Metzger" and yet "if they but knew, would quickly acknowledge Metzger as seminal a figure as any that has emerged in Britain in the last 50 years. It is the 'Sensation' generation … that has most completely absorbed the ideas of destruction and damaged nature as being the essence of art" (Rosenthal, Norman. "Gustav Metzger—The Artist as Wanderer," in: *Gustav Metzger*, Museum of Modern Art, Oxford 1998: 84) and he suggests that works by Rachel Whiteread, Hirst, Marc Quinn, Sarah Lucas, and Marcus Harvey bear some comparison with Metzger's. The difference, however, is that the intentions behind Metzger's work and its concern with the reality of visible facts are completely at variance with the media complicity and market acquiescence of Hirst and his peers. Michael Landy is the only artist from this generation who has consistently and correctly expressed an identification with, and understanding of Metzger's work.

24 *On Extinction—a presentation* took place at London's Ecology Centre in Mile End at the beginning of October. Because the windows could not be blacked out, instead of showing slides Metzger laid out on the ground along a curved glass wall the material—mostly newspapers and magazines—that he would have had photographed for slides. The talk accompanied an exhibition at the centre and was programmed following the success of a talk he had given a week earlier at the end of September, *Water and Culture*, as part of a larger two-day symposium held at the Whitechapel Art Gallery under the title "Crossovers."

25 Metzger, Gustav. *damaged nature, auto-destructive art*. coracle@workfortheeyetodo, London 1996: 21–23.

26 Metzger, Gustav. *Mad Cows Talk*. Holograph notes, Tate Gallery Archive (uncatalogued) 8229, folder 10.

27 Ibid.

28 This repeats his use of the term the previous year in his talk *Earth to Galaxies* in Glasgow, published as Gustav Metzger, *Earth to Galaxies. On Destruction and Destructivity*, Tramway, Glasgow 1996 (Tramlines No. 5). In the present book: 276–279.

29 Metzger, Gustav. *breath in$_g$ culture*: Holograph notes, Tate Gallery Archive (uncatalogued) 8229, folder 9. A partial transcript of this talk can also be accessed on www.autogena.org.

30 Ibid.

31 Metzger, Gustav. *A Little Talk on Architecture.* Holograph notes, Tate Gallery Archive (uncatalogued) 8229, folder 6. Subsequent unreferenced citations from this talk are from this source.

32 Metzger was especially moved by the protest because the school children chose to sit down on the corner of Parliament Square directly opposite from the site that the Ministry of Defense had occupied in the 1960s (on Parliament Bridge Street and Great George Street), where on 18 February 1961, over 4,000 people—Metzger included—sat down for four hours in a mass-demonstration organized by the Committee of 100, while Bertrand Russell, in an act heavy in Lutheran symbolism, pinned a notice to the door of the Ministry declaring that "Hitler tried to wipe out a whole people. Today the nuclear tyrants of East and West threaten the entire human race with extinction. … We hereby serve notice on our Government that we can no longer stand aside while they prepare to destroy mankind." The full text is printed in *Peace News*, 24 February 1961. Metzger was extremely moved by the courage of the children in sitting down where they did, at a far greater risk than when he had sat down there forty years earlier. To Metzger these were his grandchildren.

33 Dennis Creffield, a fellow student of Bomberg's, has explained the two central tenets of Bomberg's teaching in ways which are reflected in Metzger's work: "'The spirit in the mass' is that animating principle found in all nature—its vibrant being—not simply the sheer brute physicality of the object. 'Structure' did not mean anatomical structure or geometrical reduction—it was the unique image—or metaphor—in which the experience of 'the spirit in the mass' found embodiment." Letter from Dennis Creffield to Richard Cork, 11 April 1985, quoted in Cork, Richard. *David Bomberg*. Yale University Press: New Haven 1987: 263. Metzger has also continued to reflect the social-utopian aspects of Bomberg's thought as well as his intransigence and uncompromising nature.

34 This and subsequent unreferenced citations are taken from the DVD work by Ken McMullen, *Pioneers in Art and Science: Metzger*, Arts Council England, London 2004.

35 One of these works is illustrated in Stephen Bann. *Experimental Painting*. Studio Vista, London 1970, plate 41.

Chronology

compiled by Anna Artaker

The biographical information about Gustav Metzger is based on Clive Phillpot's biographical chronology (in: Metzger, Gustav. *damaged nature, auto-destructive art*. Coracle, London 1996) as well as on the revised version by Luise Metzel translated into German (in: Hoffmann, Justin (ed). Gustav Metzger. *Manifeste, Schriften, Konzepte*. Verlag Silke Schreiber, Munich 1997). The present chronology was extended and up-dated in consultation with Gustav Metzger.

1926

1926

On April 10, 1926, Gustav Metzger is born in Nuremberg. His parents, Juda and Fanny Metzger, orthodox Jews from Galicia, Poland, came to Nuremberg in 1918.

1938–1942

His father and both sisters are deported from Nuremberg to Poland even before the so-called Reichskristallnacht. Later, his sisters are able to flee to England. In 1939, his mother follows her husband who is interned in a camp on the Polish-German border. In 1942, Metzger's oldest brother Chaim (Heinrich) and the maternal grandparents are deported from Strasbourg. During the war, almost all members of the family (including his parents) are killed in Poland.

1939

On January 12, Gustav Metzger and his older brother Max (Mendel) arrive in England with the help of the Refugee Children's Movement. They live in a boy's home in London.

Gustav Metzger celebrates his Bar Mitzvah at the Kilburn Synagogue in London. At the outbreak of war, he and his brother Mendel are evacuated to Hemel Hempstead, Hertfordshire along with the rest of their school.

1941

Gustav Metzger begins a three-year training course as a cabinetmaker at the ORT-OSE Technical College, Leeds.

1925–1934

Gustav Metzger's early childhood in Nuremberg is marked by the rise of National Socialism in Germany. In 1925, Adolf Hitler reestablishes the Nationalsozialistische Deutsche Arbeiterpartei (NSDAP, National Socialist German Workers' Party) after it had been prohibited following the unsuccessful putsch in Munich two years earlier. In 1927, as many as 15,000 supporters gather for the NSDAP's Nuremberg Rally. The party is able to take advantage of the outbreak of the global economic crisis in October 1929 and the crisis of the Weimar Republic. It develops into a mass party and at the Reichstag elections of 1932 becomes the strongest political fraction in Germany. In 1933, the seizure of power takes place: after being appointed Reich Chancellor in January, almost all political powers are vested in Adolf Hitler in March. In July, the NSDAP is declared the single unity party. In 1934, the "standardization of the provinces with the Reich" takes place. The fascist regime triumphs.

1933–1945

Immediately after seizing power in April 1933, the National Socialists (Nazis) call for a boycott of Jewish businesses and Jews are refused entry to public cafés and restaurants. The Nuremberg Laws of 1935 aggravate the Jews' situation even more by, amongst other things, excluding them from government service and forbidding marriage with Germans. In 1938, during the night of November 9, the Jewish pogrom, known as "Reichskristallnacht" (The Night of Broken Glass) takes place throughout the Reich. At least 91 Jews in Germany and Austria (part of the Reich since the Anschluss in March 1938) are murdered, tens of thousands taken away to camps.

NSDAP Nuremberg Rally, 1927, Nuremberg

1942

Exhibition Henry Moore, John Piper, Graham Sutherland,
1941, Temple Newsam House, Leeds

1942
The college closes because of the war.
Metzger works in a furniture factory in Leeds.

He becomes interested in revolutionary politics
and reads communist literature as well as the
writings of the English sculptor, graphic artist,
and typographer Eric Gill and the Hungarian
natural healer Edmund Szekely, who is working
in Mexico.

Until 1944 he frequents exhibitions of contem-
porary British art in Temple Newsam House
near Leeds where, among others, works from
Henry Moore, Graham Sutherland, Matthew
Smith, Jacob Epstein, Paul Nash, Barbara
Hepworth, John Piper, and Henry Gaudier-
Brzeska are shown.

1943
Gustav Metzger moves from the furniture
factory to a furniture workshop.

In autumn he moves to Harewood near Leeds.
He works for six months in the carpenter's
workshop on the Harewood Estate, a large
eighteenth-century country estate, which is
also home to Lord Harewood's valuable art
collection. At Harewood he takes part in
compulsory monthly hunts, and subsequently
becomes a vegetarian.

In Gustav Metzger's native city, Nuremberg, 19 Jews commit suicide out of fear, six are murdered, and 81 are taken away. In January 1942, at a conference held at Wannsee lake in Berlin, the so-called "final solution to the European Jewish question" is decided. Anti-Semitic persecution reaches its climax. Throughout the entire area where the Third Reich exercises power, people of Jewish origin are deported to extermination camps. A total of six million Jews from all over Europe are murdered between 1942 and the end of the war in 1945.

1937

[July 19] The traveling exhibition *Entartete Kunst* (Degenerate Art) opens in Munich. In the exhibition, works by avant-garde modernists are shown together with drawings from mentally handicapped persons and photos of deformed people. On the previous day, the *Große Deutsche Kunstausstellung* (Great German Art Exhibition) was opened in the newly-built Haus der Deutschen Kunst in Munich, presenting the Nazi idea of "German" art.

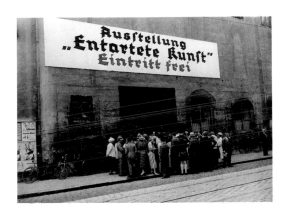

Exhibition *Degenerate Art*, July 1937, Kunstverein München, Munich

1940–1945

In June 1940, U.S. president Franklin D. Roosevelt inaugurates an Office for Scientific Research and Development to push ahead with atomic research. Decisive in this is the fear that Hitler's belligerent Germany is working on the development of a weapon that uses the unbelievable amounts of energy released by the chain reaction set off by splitting uranium atoms. It is a fact that the first nuclear fission was successfully carried out in Berlin in December 1938.

1944

[April] Gustav Metzger moves to Bristol, where he lives in a political commune with Trotskyites and anarchists. There he becomes acquainted with the writings of the psychoanalyst Wilhelm Reich, one of Freud's followers.

Gustav Metzger works on farms outside the town. During the summer he decides to become a sculptor rather than a professional revolutionary.

After a further move to Tring, Hertfordshire, Gustav Metzger works as a gardener in the organic garden of Champneys Nature Cure Clinic, one of the oldest and largest natural healing centers in England. At the same time, he begins making his first small, stone objects.

In late summer, Gustav Metzger applies to become Henry Moore's assistant. At a meeting in the National Gallery in London, Moore recommends that he take life drawing classes at an art school.

In the Ashmolean Museum in Oxford, Gustav Metzger happens to meet Eduardo Paolozzi. In London, Paolozzi introduces Metzger to William Turnbull and Nigel Henderson who are studying with Paolozzi at the Slade School of Fine Art in London.

[December] Gustav Metzger moves to Cambridge. A reunion takes place with his brother Max who has meanwhile begun to study art in Leeds.

1945

[January till June] Gustav and Max Metzger attend life drawing classes taught by John Hookham at the Cambridge School of Art, they work as gardeners and occupy themselves with sculpture in their free time.

[September] Together they move to London; the brothers enroll in Bainbridge Copnalls class for sculpture at the Sir John Cass Institute in Aldgate, London, and they attend evening classes at Borough Polytechnic, where painter David Bomberg teaches.

1946–1948

The brothers are awarded a Haendler Trust Scholarship for fulltime art studies and attend classes for sculpture, painting techniques and art history at the Sir John Cass Institute and also at the newly founded Anglo-French Art Centre in St. Johns Wood, London.

In the beginning of 1946, Gustav Metzger enrolls in David Bomberg's class for painting and composition at Borough Polytechnic.

1944

In June 1942, the Manhattan Project to develop and supervise the U.S. atomic bomb program starts and is placed under military leadership. Three years later, in July 1945, the first atom bomb tests are carried out in New Mexico. A few weeks later, on August 6 and 9, the two first atom bombs are dropped on Hiroshima and Nagasaki. The devastating effect of the bombs shocks the public and at the same time leads to acceleration in the Soviet atomic weapons program.

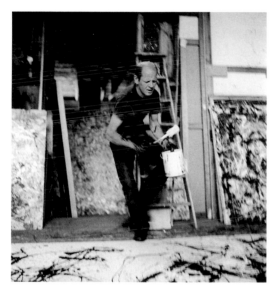

Jackson Pollock, 1950

1946
From 1946 on, U.S. painter Jackson Pollock realizes his *Drip-Paintings* in which he drops or hurls liquid paint, later also synthetic resin, onto a canvas, which is usually lying on the floor. He takes over the technique from painter Max Ernst—whose origins are in Germany—but Pollock develops it significantly. At the beginning of 1948, he shows the *Drippings* in public for the first time.
In a lecture in February 1965—which is published in June of the same year as *Auto-Destructive Art*—Gustav Metzger says that Pollock's *Drip-Paintings* come closest to the idea of painting he followed as a student under David Bomberg in 1946. According to his view, painting should be "extremely fast and intensive." However, Metzger only becomes familiar with Pollock's work ten years later, around the year 1956.

1948

At his first exhibition, a group show in the Ben Uri Gallery in London, and following that, the group show *London Group* at Academy Hall, London [May 21 through June 6], Gustav Metzger shows his largest painting, a triptych painted in tempera.

He receives a stateless person passport and during the summer takes a three-month study trip through the Netherlands, Belgium, and France. In Colmar, France, he views the Isenheimer Altar by Grünewald.

[Autumn] He begins a three-semester art grant from the Jewish Community in Antwerp and studies drawing and painting under the painter Gustaaf de Bruyne at the Koninklijke Academie voor Schoone Kunsten, Antwerp, Belgium.

Max Metzger enrolls at the academy in Brussels but in summer 1949 he moves to Paris where he studies art history at the Sorbonne. After graduating, he remains in France and lives and works there as an art historian and Judaica specialist.

1948

1949

[Summer] Gustav Metzger leaves Antwerp and travels the Mediterranean coast of France from Nice to Collioure for two months. Afterwards, he pays a visit to an aunt—one of his mother's sisters—and her family in Paris.

After his return to England the Haendler Trust Scholarship is extended for a further year on the recommendation of the sculptor Jacob Epstein. In the winter term (until spring 1950) Metzger studies at the Oxford School of Art.

1950

[Autumn] He continues his course of study at the Central School of Art and the Hamstead Arts Council's Hamstead Artists' House. He attends David Bomberg's evening classes at Borough Polytechnic until the summer of 1953.

[September 3 through October 14] Metzger participates, showing three pictures, at the exhibition *East End Academy* in the Whitechapel Art Gallery, London.

East End Academy, 1950, Whitechapel Art Gallery, London

1951

Repeated visits to the exhibition *Festival of Britain*, South Bank, London.

Six years after the end of World War II, the *Festival of Britain* [May through September 1951] intends to demonstrate the progress of reconstruction in Britain and Britain's pioneering modernity both to a home audience and also to war-devastated Europe. The newly built South Bank Promenade in London is the main location for the event in the capital. Along with concerts in the newly constructed Royal Festival Hall and an exhibition of the accomplishments of British science and industry in the so called Dome of Discovery, there are also open-air sculpture presentations. Exhibitions of contemporary painting, sculpture, and design also take place in various venues throughout London and the whole of Great Britain for the festival.

[Summer] Three-month trip to Scotland including the Isles of Skye, Lewis, and Shetland.

Earns his livelihood as a casual laborer; lives in the countryside near London.

1952

Gustav Metzger paints in his studio near Mornington Crescent, London. Later, the studio is taken over by Leon Kossoff and then by Frank Auerbach, both students of David Bomberg.

Festival of Britain, 1951, South Bank, London

1950s

In June 1948, with the Soviet army's blockade of Berlin (June 24, 1948 through May 12, 1949) the Cold War begins. The power struggle between the Western powers under the leadership of the U.S. and the so-called Eastern Bloc, the Soviet Union's sphere of influence, also finds its expression in rising budgets for development and deployment of atomic weapons. From 1949 on, also the Soviet Union has an atomic bomb. The arms race for the hydrogen bomb begins. In 1951, the first H-bomb tests take place at the Nevada Test Site in the Nevada desert in the U.S. By the middle of the 1960s, Great Britain, France, China and Israel also have atomic weapons; from 1998, India and Pakistan, too.

1953
[Spring] Research on David Bomberg.

Gustav Metzger becomes co-founder of the artist group Borough Bottega and helps with the organization of its first exhibition, *Drawings and Paintings by the Borough Bottega*, Berkeley Galleries, London [November 16 through December 4], where he also shows his work.

[December] Gustav Metzger leaves the Borough Bottega group and as a result, David Bomberg writes him a letter breaking off relations.

1953 He moves to the small town of King's Lynn, Norfolk, (about 150 kilometers north of London on the English east coast) where he lives until 1959.

1954
He works as a second-hand dealer on the Tuesday Market in King's Lynn.

1956
Sets up a painting studio in King's Lynn and begins to paint again.

At the same time as the regional cultural festival, King's Lynn Festival of Music and Arts, that takes place annually in summer, Metzger organizes a small exhibition in a shop in the old center of King's Lynn with works by the sculptors Anthony Hatwell, Eduardo Paolozzi, and William Turnbull.

1953
Discovery of the gene's double helix molecular structure by James Watson, Francis Crick, and Maurice Wilkins.

1955–1957
On July 9, 1955, a call to renounce the development and use of weapons of mass destruction is published and becomes known as the Russell-Einstein Manifesto. Renowned scientists from all over the world sign it. Two years later, in 1957, after the signing of the manifesto, the first Pugwash Conference on Science and World Affairs follows in the town of the same name in Nova Scotia, Canada.

1956
[October 4], The first earth-orbiting satellite in the world, Sputnik I, is launched by the Soviet Union. The spherical satellite with a diameter of approximately 58 centimeters needs approximately 96 minutes for one orbit. Just 96 days after its launch, the satellite burns up on re-entering the lower layers of the earth's atmosphere.

Mathematician and artist Ben Laposky from the U.S. and the Austrian pioneer of computer art Herbert W. Franke are the first to use computer technology for artistic experiments.

Repeated visits to the exhibition *This is Tomorrow* at the Whitechapel Art Gallery, London [August 9 through September 9].

This is Tomorrow was initiated by the Independent Group, a regular discussion group formed at the beginning of the 1950s, among whose members were artists such as Richard Hamilton and Eduardo Paolozzi, and also architects and art historians interested in post-war consumer and popular culture. The exhibition is considered a forerunner of Pop Art, which will conquer the art world beginning in London. Hamilton's now famous collage *Just what is it that makes today's homes so different, so appealing?* is one of the exhibition poster subjects. The collage unites several elements characteristic for Pop Art. It shows a room made of cut-out bits of advertisements with status symbols such as a television, a tape recorder, and a vacuum cleaner, a bodybuilder, and a pin-up girl. Here, the utopia of the post-war 1950s, the improvement of living conditions for everyone by means of consumer goods, is met ironically rather than enthusiastically.

1956

This is Tomorrow, 1956, Whitechapel Art Gallery, London
poster, exhibition view

1957

[July] For the King's Lynn Festival, Metzger organizes an exhibition in a crypt of ancient sacred art from Norfolk churches.

He becomes a founding member of the King's Lynn Committee for Nuclear Disarmament and is active there until moving to London. This local action committee works against the British atomic armament policies, which are aligned with the U.S. doctrine of atomic retaliation from 1957 onward.

1957

[Autumn] Metzger organizes the North End Protest to oppose plans to demolish the old fisherman's quarter to build a new throughway. The protests lead to the formation of the North End Society. He becomes its first secretary. The activities of the North End Society against the demolition of a historic area of the town gain local and regional attention but are, in the end, unsuccessful. The inhabitants are relocated and the historic district is sacrificed for the highway.

Lynn News and Advertiser, November 26, 1957

CONFLICTING INTERESTS

Two men with conflicting views about the future of Pilot Street take a look at it on the ground—Mr. F. Le Grice (left) and Mr. G. Metzger.

FOR & AGAINST ROAD THROUGH NORTH END

MR. G. METZGER is the champion of the cause for preserving Lynn's North End fishermen's quarter against the threat of slum clearance.

MR. F. LE GRICE, president of Lynn Chamber of Trade wants to see the speeding up of the town's development plan. In particular he wants to see a proposed new road opening up the way through North End from Railway Road to the docks and adjoining, industrial areas and freeing the town centre of heavy transports.

On Friday Mr. Metzger and Mr. LeGrice met. Together they went on a tour of the area earmarked for slum clearance.

They walked along Pilot Street, into St. Nicholas' Chapel churchyard, through Austin Street and then into St. Ann's Street and North Street.

Mr. Metzger, a Pole by birth who has made his home in Lynn, knew that the Chamber of Trade has taken an interest in the future planning of the town and on Friday afternoon he repeated to the "Lynn News and Advertiser" some of the points he had made to Mr. Le Grice.

He said that above all North End had great emotional and spiritual qualities, people having lived there for a thousand years. St. Nicholas' Chapel gave the area an atmosphere of sanctity that should not be spoiled by a large and constantly used road.

"I told Mr. Le Grice that the fishermen must not be pushed out of North Lynn," he said, "They bring another element right into the town. They have lived their lives there for hundreds of years and should not be moved."

Mr. Metzger also pointed out that the area would look far less like a slum if the houses were painted and the walls repointed.

KEEP CHARACTER

"The area must be preserved as residential," said Mr. Metzger, "If the area is re-developed it must keep its character. I do not mean that any new buildings must be imitations of the old, but they must be small dwelling houses. An outstanding architect must design the area."

At the churchyard, Mr. Metzger pointed out a wall that would hide the proposed road from view.

He commented however, that a person standing on the other side of the proposed road would hardly be able to reconcile the road with the chapel.

GOOD ROUTE

Mr. Le Grice said that as the president of the Chamber of Trade he could not do better than refer Mr. Metzger to a book entitled "Buildings of Architectural and Historic Interest in King's Lynn", a report of the Society for the Protection of Ancient Buildings, published in 1945.

The report agrees with the

CONTD. ON PAGE 2.

1958

[October through November] Metzger visits the
Kurt Schwitters exhibition in Lord's Gallery,
London and the second Schwitters exhibition
there, eight months later.

He supports the Direct Action Committee
Against Nuclear War (DAC) and, in December,
takes part in two supporting marches for the
North Pickenham missile base occupations.

The Direct Action Committee Against Nuclear
War is one of the precursors of the Committee
of 100. One of the committee's first initiatives
is the protest march, which takes place over
Easter 1958, going from Trafalgar Square in
London to Aldermaston, where construction
has begun on the Atomic Weapons Establish-
ment—the British center for the development
and production of atomic weapons. The four-day
Aldermaston March (also known as the Easter
March) grows into a huge annual peace
demonstration, soon to be copied in other
countries. For example, from 1960 onwards,
Easter marches for peace and disarmament
take place in various cities of West Germany.
Even today, Easter marches for peace are
organized by local peace action groups
throughout Europe. The annual march to the
Atomic Weapons Establishment in Aldermaston
also still takes place.
The artist Gerald Holtom designed a peace
symbol for the first Easter march, which
subsequently became the worldwide symbol
for the peace movement.

Art dealer Philip Granville at the exhibition
Kurt Schwitters, 1958, Lord's Gallery, London

1958

On February 17, the founding meeting of the
Campaign for Nuclear Disarmament (CND)
takes place in an overflowing Central Hall in
Westminster, London. Thousands of people
take part. The CND unites scientists, pacifists,
Christians, environmentalists, representatives
of the political left, and ordinary citizens in
protest against atomic weapons. It quickly
develops into the biggest nationally-organized,
peace and protest movement in Great Britain,
and is still active today.

TWO DEMONSTRATORS, covered in mud from head to foot, recover after a melee in ankle-deep mud and concrete near the concrete mixer. (DC 4519).

CLASH OF INTERESTS

TWO POLICE officers (below left) lead away Mr. Will Warren, one of the leaders of the march, from the huddle of demonstrators beside the concrete mixer on Saturday. He was the first to be escorted to the gate. Below right: The demonstrators squat in front of a lorry in an attempt to prevent its leaving the concrete mixer. (DC 4518 and 4523).

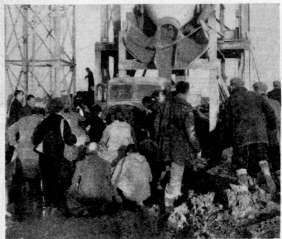

VIOLENT SCENES AT MISSILE BASE

Protest marchers forcibly ejected

SCENES OF violence unparalleled in West Norfolk occurred at the Thor missile base at present being built in the North Pickenham area on Saturday and Sunday when about 50 supporters of the Direct Action Committee against Nuclear War twice gained entry to the site to obstruct work there—a "non-violent" protest demonstration which turned into a riot.

The demonstrators left the area shortly after 3 o'clock on Sunday afternoon, quite satisfied with their achievements. Said Miss Pat Arrowsmith, 28-year-old field organiser of the Committee: "We set out to hinder work as long as we could by passive resistance, and I think that is what we achieved."

Yesterday three Labour M.P.s—including South-West Norfolk's Mr. Sidney Dye, in whose constituency the site is situated — were due to raise the matter in the House of Commons. And the Air Ministry stated that an investigation was being held into the whole affair.

The demonstrators were led by Miss Arrowsmith and Mr. Will Warren, a 52-year-old Quaker. Dr. J. W. Wells, the Heacham radiologist helped in the organisation and, in a loudspeaker-fitted car, gave instructions to the marchers en route.

POLICE IN

On Saturday, the demonstrators were drenched but undeterred by a strong jet of water from an R.A.F. fire engine. They then squatted down in front of lorries being loaded with concrete at a giant concrete mixer, despite efforts by drivers to move forward, and being squirted by another hose and pelted with mud by workmen.

Many of the demonstrators, including a number of women were manhandled by men working on the site and thrown down in an inches-deep mixture of mud and concrete.

Eventually civil and R.A.F. police removed them from the site. Some had to be forcibly dragged. They then congregated outside the locked gate of the site soaked through, shivering and covered in mud, but still determined.

CAMPED

Early on Sunday morning after having camped out all night outside the gate, about 20 of the demonstrators again entered the site and again reached the concrete mixer.

They were rounded up by R.A.F. men and detained for some time in the guardroom before being ejected. This time workmen took no part in their removal.

Outside they sat in the mud to form a human chain, preventing vehicles passing in and out of the gate until they were moved by R.A.F. police. This happened eleven times during the day.

PROTEST

This fantastic week-end began at noon on Saturday with a protest rally on Swaffham Market Place, where about 100 people gathered to listen to the speakers. Soon after one o'clock the marchers set off in two contingents of about 50 for their hour-long march to the site. The rear contingent, which was carrying a number of banners, returned to Swaffham and dispersed after the Direct Action contingent had entered the site.

The marchers were preceded by a rather embarrassed-looking bunch of youths and young boys on bicycles, carrying crudely-painted placards saying: "This demonstration is futile", "What good are you doing?" and "Go home".

When the marchers arrived at the entrance to the site soon after 2 p.m. they were met by plain-clothes police officers who warned them: "Once you are inside the gates you are on Air Ministry property."

OVER WIRE

But the Direct Action contingent pressed on up a driveway leading to the locked and heavily-guarded gate. This was obviously impenetrable, so they struck right, over the outer fence of barbed wire, using a wooden sign they had been carrying as a "bridge."

They followed the perimeter of the inner post-and-wire fence until they came to a section where there was a gap filled in with more barbed wire. Ignoring the warnings of R.A.F. personnel, they again used the wooden sign to get through—and they were inside the Top Secret site itself, followed by a bevy of reporters and cameramen.

Immediately an R.A.F. fire engine hose was turned on them. Completely drenched they scattered to dodge the water, but regrouped and resolutely made their way to their target, the cement mixer, the focal point of the site while it is under construction.

As lorries were loaded with concrete, the demonstrators

CONTD. ON PAGE 2.

Lynn News and Advertiser, December 9, 1958

PROTEST MARCHERS ARRESTED AT THOR SITE

It's Christmas in jail for 22

A TOTAL OF 45 members and supporters of the Direct Action Committee against Nuclear War were arrested on Saturday and Sunday when the Committee staged their second protest demonstration at the Thor missile base being built in the North Pickenham area. Of these, 22, including an Anglican priest, will spend their Christmas in prison — of their own choice.

On Saturday 36 demonstrators, including seven women, were taken to Swaffham Police Station in waiting police vans and R.A.F. lorries and appeared before two hastily-convened special courts, where they were remanded until the next normal sitting of the Swaffham magistrates next Monday.

Those who undertook not to re-enter the restricted area were released on bail.

But the 22 who refused to give such an undertaking—they included the three leaders of the demonstration, the Rev. Michael Scott, who had flown from Ghana specially for the demonstration, Mr. Michael Randle and 21-year-old Miss April Carter—were remanded in custody.

Early on Sunday morning another nine, five men and four women, were arrested. They appeared before yet another special court at Swaffham yesterday and were remanded on bail until next Monday.

At Saturday's courts Supt. A. C. Canham, who applied for the remand, was opposed to bail unless the necessary undertakings were given. Each of the accused was given the opportunity of thus choosing between bail and custody.

However, at yesterday's court, Supt. Canham said he was perfectly satisfied that the defendants would make no attempt to enter Air Ministry property, and thus he did not oppose bail.

'CONSPIRACY'

The charges against the 45 accused are of wilfully obstructing the police in the execution of their duty. But further charges of conspiracy may be laid against any of them. The matter has been put before the Director of Public Prosecutions. The men remanded in custody are in Norwich Prison, and the women in Holloway.

The demonstrators' protest on Saturday took the form of marching up the roadway—on Air Ministry property, and within the restricted area—leading into the site, and then lying down in the roadway to prevent vehicles passing in and out.

The police gave them two chances. The first time they entered the restricted area they were ejected on to the public road outside; those who entered a second time were arrested. They were given prior warning of this, and completely understood the consequences of their actions.

Sunday's demonstration came as something of an anti-climax. After the nine demonstrators had entered the restricted area, been ejected, re-entered and subsequently arrested, a much-depleted body of supporters merely picketed with banners at the entrance until the workers left the site at 4.30 p.m. They then dispersed, and the week-end's activities were finished.

EJECTED

Applying for the remands on Saturday, Supt. Canham said that when the procession stopped at the entrance at about 2.40 p.m. on Saturday he told the leaders that he understood it was their intention to enter Air Ministry property.

"I pointed out the boundary of Air Ministry property and asked if they were quite clear," said Supt. Canham. "Randle then said it was their intention to go on with their objective, which was the Air Ministry property."

After the procession had moved forward on to the Air Ministry property, he

CONTD. ON PAGE 2.

They did not enter

MR. G. METZGER, of Lynn (right), better-known for his attempts to save North End from demolition, talks with another marcher. At the rear is Dr. J. W. Wells, of Heacham. Neither of these West Norfolk marchers went into the restricted area. (DC 4808).

SMILING Det.-Sgt. H. J. Hempstead, of Downham, carries away a girl demonstrator under his arm with the help of a policewoman. (DC 4805).

Lynn News and Advertiser, December 23, 1958

1958

First Aldermaston March, Easter 1958

1958–1963
Influenced by the worldwide protest against atomic weapons, negotiations begin to stop atomic weapons tests in Geneva in October 1958. Along with the U.S. and the Soviet Union, Great Britain also takes part as the third state in the world to have atomic bombs at its disposal (beginning that year).
However, it takes another five years, till August 1963, until the atomic powers sign a partial test ban treaty.

[October] Founding of the National Aeronautics and Space Administration (NASA) in the U.S.

1959

[Spring] Metzger takes part in the second Aldermaston March.

[Summer] He begins to settle down in London.

In a café, which is run by sculptor Brian Robins at 14 Monmouth Street in London, Gustav Metzger has his first solo exhibition: *Three Paintings by G. Metzger* [July 30 through August 19].

In November of the same year [9–30 November], he presents *Cardboards*–found cardboard boxes arranged on the wall–at the same café. The first manifesto, *Auto-Destructive Art*, dated November 4, 1959, is also presented. It also contains a statement about *Cardboards*. Brian Robins makes a number of comments on it. He proposes the term *Auto-Destructive Art* rather than *Self-Destructive Art*.

Untitled, 1958, oil and chalk on mild steel

1959

1959
U.S. artist Allan Kaprow invents the Happening in New York.

The Wiener Gruppe, an association of poets and artists, formed around core members H.C. Artmann, Friedrich Achleitner, Konrad Bayer, Gerhard Rühm, and Oswald Wiener, puts on *literarisches cabaret* (literary cabaret) in December 1958 and April of 1959 in which various actions—similar to Happenings—take place on stage. At the second of these, the *2. literarisches cabaret* on April 15, 1959 in the Porrhaus in Vienna, Friedrich Achleitner and Gerhard Rühm drive a motor scooter through the room in which the event is being held. They put on fencing masks and use axes to demolish a piano that has been pushed on stage.

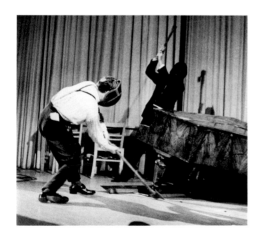

Friedrich Achleitner and Gerhard Rühm, 1959

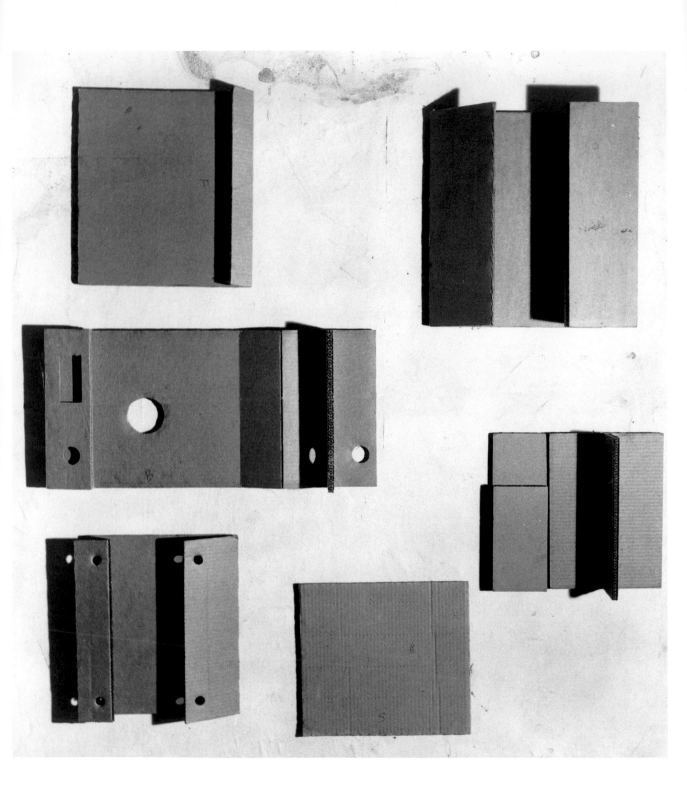

100 *Cardboards*, 1959

METZGER

The discarded cardboard which is on view was probably part of a
television package.

These cardboards are nature unadulterated by commercial considerations
or the demands of the contemporary drawing room.

They have reference to the greatest qualities in modern painting,
sculpture and architecture.

These cardboards were made automatically for a strict purpose and
for a temporary usage.

AUTO DESTRUCTIVE ART

Auto-destructive art is primarily a form of public art for industrial
societies.

Auto-destructive painting, sculpture and construction is a total unity
of idea, site, form, colour, method and timing of the disintegrative
process.

Auto-destructive art can be created with natural forces, traditional
art techniques and technological techniques.

The artist may collaborate with scientists, engineers.

Auto-destructive art can be machine produced and factory assembled.

Auto-destructive paintings, sculptures and constructions have a life-
time varying from a few moments to twenty years. When the disinte-
grative process is complete the work is to be removed from the site
and scrapped.

London, 4th November, 1959 G. METZGER.

The amplified sound of the auto-destructive process can be an integral part of the total conception –

The cardboards are on view from Monday 9th–30th November.

Open daily from 6 p.m. to midnight.

The exhibition will open quietly at 6 p.m. Monday 9th November.

Cardboards, Auto-Destructive Art, 1959, first manifesto

Bearded man trips over a box and finds a new form of art

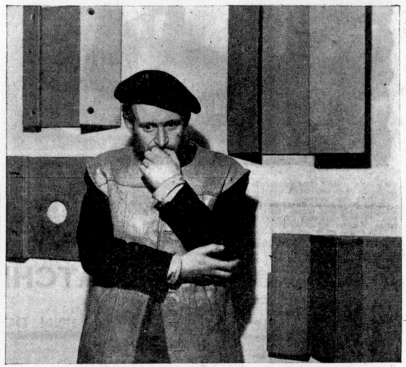

"Cardboarder" Gustav Metzger yesterday—and some of his works

IT'S PICTURES FROM PACKING CASES

By JOHN RYDON

A LONDON artist, who considers old cardboard boxes have qualities equal to the greatest in modern painting, is showing his first exhibition of "machine-made art."

He is bearded, 33-year-old Gustav Metzger, German-born abstract artist, who discovered his new "art" when he fell over a packing-case for a TV set in a shop doorway three months ago.

Mr. Metzger told me last night: "I took the packing case to pieces and thought of using them as decorations for my room.

"These carboards are nature unadulterated by commercial considerations or the demands of the contemporary drawing-room."

I stumbled down a precipitous staircase into basement premises in Monmouth-street, Holborn, where a whole wall was taken up with the Metzger "work." Geometrical slabs of cardboard packaging, some with holes in them, hung from nails.

Went 'on Mr. Metzger: "I don't want to sell any of these : (a) because I like them so much I want to keep them ; and (b) since there must be a large supply of similar material lying around I don't want to prevent other people getting it free too.

"I'm thinking of making a big collection of these cardboards with the aim of having a really BIG show. I've never seen anything quite like it."

I said I hadn't either.

Mr. Metzger continued : "I should like to have the chance of turning these into architectural decorations. You move them in any way you like.

"There is an inherent harmony and artistic quality in all of them."

Then the ex-joiner who has studied at art schools in Britain and the Continent asked whether I was interested in hearing his theory of "auto-destructive art."

I said I had heard enough.

Daily Express, 12 November 1959

1959

[November 12] Metzger visits Jean Tinguely's *Cyclomatic Event* and his lecture "Art, machines et mouvement, une conference de Jean Tinguely" at the Institute of Contemporary Arts (ICA), London.

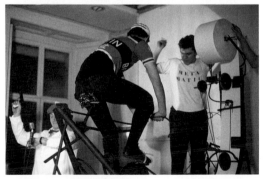

Jean Tinguely, *Cyclomatic Event*, 1959, ICA, London

AUTO DESTRUCTIVE ART

Auto-destructive art is primarily a form of public art for industrial societies.

Self-destructive painting, sculpture and construction is a total unity of idea, site, form, colour, method and timing of the disintegrative process.

Auto-destructive art can be created with natural forces, traditional art techniques and technological techniques.

The amplified sound of the auto-destructive process can be an element of the total conception.

The artist may collaborate with scientists, engineers.

Self-destructive art can be machine produced and factory assembled.

Auto-destructive paintings, sculptures and constructions have a life time varying from a few moments to twenty years. When the disintegrative process is complete the work is to be removed from the site and scrapped.

London, 4th November, 1959 G. METZGER

1960

MANIFESTO AUTO-DESTRUCTIVE ART

Man in Regent Street is auto-destructive.
Rockets, nuclear weapons, are auto-destructive.
Auto-destructive art.
The drop drop dropping of HII bombs.
Not interested in ruins, (the picturesque)
Auto-destructive art re-enacts the obsession with destruction,
the pummelling to which individuals and masses are subjected.
Auto-destructive art demonstrates man's power to accelerate disintegrative processes of nature and to order them.
Auto-destructive art mirrors the compulsive perfectionism of arms manufacture - polishing to destruction point.
Auto-destructive art is the transformation of technology into public art.
The immense productive capacity, the chaos of capitalism and of Soviet communism, the co-existence of surplus and starvation; the increasing stock-piling of nuclear weapons - more than enough to destroy technological societies; the disintegrative effect of machinery and of life in vast built-up areas on the person,...

Auto-destructive art is art which contains within itself an agent which automatically leads to its destruction within a period of time not to exceed twenty years.
Other forms of auto-destructive art involve manual manipulation. There are forms of auto-destructive art where the artist has a tight control over the nature and timing of the disintegrative process, and there are other forms where the artists control is slight.
Materials and techniques used in creating auto-destructive art include:
Acid, Adhesives, Ballistics, Canvas, Casting, Clay, Combustion, Compression, Concrete, Corrosion, Cybernetics, Drop, Elasticity, Electricity, Electrolysis, Electronics, Explosives, Feed-back, Glass, Heat, Human Energy, Ice, Jet, Light, Load, Mass-production, Metal, Motion, Motion Picture, Natural Forces, Nuclear energy, Paint, Paper, Photography, Plaster, Plastics, Pressure, Radiation, Sand, Solar energy, Sound, Steam, Stress, Terra-cotta, Vibration, Water, Welding, Wire, Wood.

London, 10th March, 1960 G. METZGER

Manifesto Auto-Destructive Art, 1960, second manifesto

1960

Metzger produces a second manifesto, *Manifesto Auto-Destructive Art*, dated March 10, 1960. The machine-written original also includes the first manifesto.

[March 15] He publishes the first *Model for an Auto-Destructive Monument* in the *Daily Express* two days before Jean Tinguely's *Homage to New York – machine – happening – autodestructive* at the Museum of Modern Art (MoMA), New York.

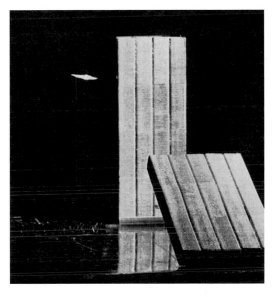

Model for an Auto-Destructive Monument, 1960

1960

[March 17] Jean Tinguely shows *Homage to New York – machine – happening – autodestructive* at the Museum of Modern Art (MoMA) in New York. This comprises a complex machine that Jean Tinguely constructed with artists and engineers, including the Swedish engineer Billy Klüver and U.S. artist Robert Rauschenberg. At a public presentation for invited guests, which lasts 27 minutes, the machine, once set in motion, destroys itself in a spectacular fashion.

[April 18] There is a mass demonstration of the CND (100,000 people) at Trafalgar Square in London.

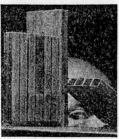

Modern art will fall to bits

By JOHN RYDON

GUSTAV METZGER has devised something most people will applaud—a form of modern art which will disintegrate within a certain period of time.

He calls it Auto-destructive Art. He has perfected the model for a 15ft.-high construction which he hopes will support his theory by falling to pieces within 10 years.

The 34-year-old German-born artist, who now works in London, says: " Auto-destructive Art demonstrates man's power

That's Metzger's eye peeping through his fall-down model.

to accelerate disintegrative processes of nature.

"It re-enacts the obsession with destruction, the pummelling to which individuals and masses are subjected."

Showing me three objects attached to the base of an old radio set, he said: " I made this model out of 4,900 ordinary office paper staples I found lying around and stuck together —so.

"It is the model for my first Auto-destructive sculpture, which will be constructed of mild steel one-eighteenth of an inch thick exactly like the model."

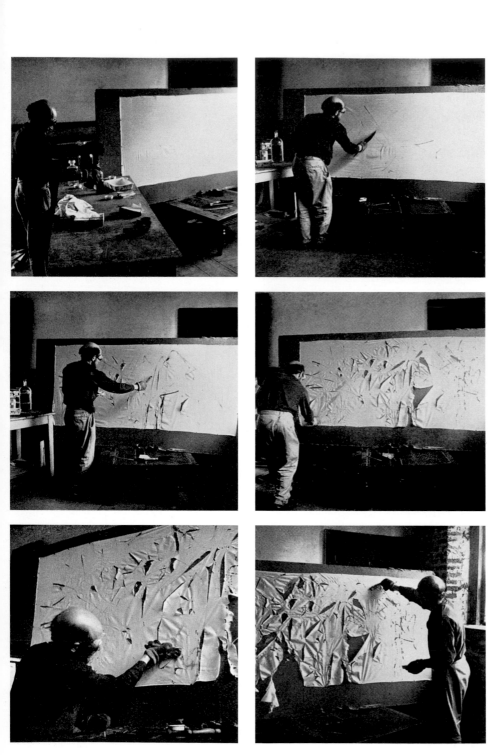

Acid Nylon Painting, 1960, King's Lynn

[June] In the studio in King's Lynn, Gustav Metzger develops a technique for painting with acid on nylon. John Cox photographs the process.

[June 22] *Auto-Destructive Art*; first *Lecture/Demonstration*, Temple Gallery, London, with an introduction by art critic Jasia Reichardt. Gustav Metzger paints an *Auto-destructive acid >action< painting* on nylon, shows "chaotic metal rods" and the *Model for an Auto-Destructive Monument* and objets trouvés (packing material and a fabric-filled *Bag* that Metzger had found on the street); some of the walls are covered with daily newspapers.

[September] *Paintings & Drawings 1945–1960*, "retrospective" solo, Temple Gallery, London.

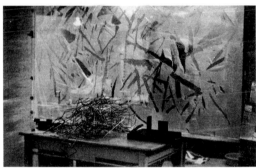

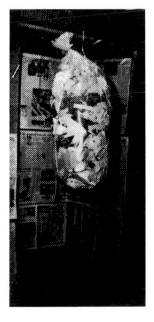

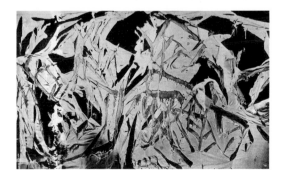

Bag, 1960

"chaotic metal-rods", *Model for an Auto-Destructive Monument* (on the table), *Auto-Destructive acid >action< painting*, 1960 *Lecture/Demonstration*, 1960, Temple Gallery, London

1960

[October] *Lecture/Demonstration* at the
Heretics Society, Trinity College, University of
Cambridge, organized by Ian Sommerville who
is studying mathematics at Cambridge. Also
among the numerous visitors are the American
writer William S. Borroughs and a colleague,
writer and painter Brion Gysin.

[Autumn] Founding member of the Committee
of 100.

The Committee of 100 is founded in October
1960 by Nobel prizewinner Bertrand Russell
(philosopher, mathematician, and essayist)
and the Reverend Michael Scott. It defines
itself as a movement of peaceful resistance
opposed to atomic war and the production of
weapons of mass destruction.
The forms of protest organized by the Committee
include civil disobedience such as sit-ins
where the participants risk arrest and prison
sentences. For Bertrand Russell, the Committee
of 100 represents a necessary radicalization
in the struggle against the atomic threat.
He resigns as president of the Campaign
for Nuclear Disarmament founded two years
previously because it rejects civil disobedience
as an expression of protest.

[October] Gustav Metzger meets the Italo-
Argentine artist Lucio Fontana who is exhibiting
in London. He shows him his *Auto-destructive
acid >action< painting* in the Temple Gallery,
which he had produced during his first *Lecture/
Demonstration*.

Lucio Fontana, 1963

ACT OR PERISH

A call to non-violent action by Earl Russell and Rev. Michael Scott

We are appealing for support for a movement of non-violent resistance to nuclear war and weapons of mass extermination. Our appeal is made from a common consciousness of the appalling peril to which Governments of East and West are exposing the human race.

DISASTER ALMOST CERTAIN

Every day, and at every moment of every day, a trivial accident, a failure to distinguish a meteor from a bomber, a fit of temporary insanity in one single man, may cause a nuclear world war, which, in all likelihood, will put an end to man and to all higher forms of animal life. The populations of the Eastern and Western blocs are, in the great majority, unaware of the magnitude of the peril. Almost all experts who have studied the situation without being in the employment of some Government have come to the conclusion that, if present policies continue, disaster is almost certain within a fairly short time.

PUBLIC MISLED

It is difficult to make the facts known to ordinary men and women, because Governments do not wish them known and powerful forces are opposed to dissemination of knowledge which might cause dissatisfaction with Government policies. Although it is possible to ascertain the probabilities by patient and careful study, statements entirely destitute of scientific validity are put out authoritatively with a view to misleading those who have not time for careful study. What is officially said about civil defence, both here and in America, is grossly misleading. The danger from fall-out is much greater than the Authorities wish the population to believe. Above all, the imminence of all-out nuclear war is ignorantly, or mendaciously, under-estimated both in the statements of politicians and in the vast majority of newspapers. It is difficult to resist the conclusion that most of the makers of opinion consider it more important to secure defeat of the " enemy " than to safeguard the continued existence of our species. The fact that the defeat of the " enemy " must involve our own defeat, is carefully kept from the consciousness of those who give only a fleeting and occasional attention to political matters.

ACTION IMPERATIVE

Much has already been accomplished towards creating a public opinion opposed to nuclear weapons, but not enough, so far, to influence Governments. The threatening disaster is so enormous that we feel compelled to take every action that is possible with a view to awakening our compatriots, and ultimately all mankind, to the need of urgent and drastic changes of policy. We should wish every parent of young children, and every person capable of

P.T.O.

Committee of 100, first pamphlet, 1960, graphic design by Gustav Metzger

feelings of mercy, to feel it the most important part of their duty to secure for those who are still young a normal span of life, and to understand that Governments, at present, are making this very unlikely. To us, the vast scheme of mass murder which is being hatched—nominally for our protection, but in fact for universal extermination—is a horror and an abomination. What we can do to prevent this horror, we feel to be a profound and imperative duty which must remain paramount while the danger persists.

CONSTITUTIONAL ACTION NOT ENOUGH

We are told to wait for the beneficent activities of Congresses, Committees, and Summit meetings. Bitter experience has persuaded us that to follow such advice would be utterly futile while the Great Powers remain stubbornly determined to prevent agreement. Against the major forces that normally determine opinion, it is difficult to achieve more than a limited success by ordinary constitutional methods. We are told that in a democracy only lawful methods of persuasion should be used. Unfortunately, the opposition to sanity and mercy on the part of those who have power is such as to make persuasion by ordinary methods difficult and slow, with the result that, if such methods alone are employed, we shall probably all be dead before our purpose can be achieved. Respect for law is important and only a very profound conviction can justify actions which flout the law. It is generally admitted that, in the past, many such actions have been justified. Christian Martyrs broke the law, and there can be no doubt that majority opinion at the time condemned them for doing so. We, in our day, are asked to acquiesce, passively if not actively, in policies clearly leading to tyrannical brutalities compared with which all former horrors sink into insignificance. We cannot do this any more than Christian Martyrs could acquiesce in worship of the Emperor. Their stead-fastness in the end achieved victory. It is for us to show equal steadfastness and willingness to suffer hardship and thereby to persuade the world that our cause is worthy of such devotion.

TOWARDS WORLD PEACE

We hope, and we believe, that those who feel as we do and those who may come to share our belief can form a body of such irresistible persuasive force that the present madness of East and West may give way to a new hope, a new realisation of the common destinies of the human family and a deter-mination that men shall no longer seek elaborate and devilish ways of injuring each other but shall, instead, unite in permitting happiness and co-operation. Our immediate purpose, in so far as it is political, is only to persuade Britain to abandon reliance upon the illusory protection of nuclear weapons. But, if this can be achieved, a wider horizon will open before our eyes. We shall become aware of the immense possibilities of nature when harnessed by the creative intelligence of man to the purposes and arts of peace. We shall continue, while life permits, to pursue the goal of world peace and universal human fellowship. We appeal, as human beings to human beings: remember your humanity, and forget the rest. If you can do so, the way lies open to a new Paradise; if you cannot, nothing lies before you but universal death.

Published by the Committee of 100, 13 Goodwin Street, London, N.4. Telephone : ARChway 1239. Printed by Goodwin Press Ltd. (T.U.), 135 Fonthill Road, Finsbury Park, N.4.

Committee of 100, first pamphlet, 1960, back, graphic design by Gustav Metzger

110

1961

The art theorist Lawrence Alloway introduces Gustav Metzger to William C. Seitz who is preparing the exhibition *The Art of Assemblage* for the MoMA, New York [October 2 through November 12, 1961].

[March 10 through April 17] Metzger is invited to take part in the exhibition *Bewogen Beweging*, Stedelijk Museum, Amsterdam, curated by Pontus Hultén. He does not exhibit in the exhibition, but the first manifesto is printed in Dutch translation in the catalogue. The manifesto is translated into Swedish and Danish for the exhibition's subsequent venues in the Moderna Museet, Stockholm, Sweden, and the Museum Louisiana, Humlebæk, Denmark.

[July 3] Metzger's first presentation of *Auto-destructive Art* in a public space (South Bank demonstration), South Bank, London, together with assistants. The occasion is the opening of the International Union of Architects (IUA) Congress.
Gustav Metzger demonstrates an *Acid Nylon Painting*; the three nylon "canvases" placed behind each other dissolve within 20 minutes of contact with the acid. He also shows an *Auto-Destructive Mobile* made of sheets of glass that successively fall to the ground and break. A flyer, the so-called South Bank Manifesto, which is distributed among the viewers, contains the third manifesto: *Auto-Destructive Art, Machine Art, Auto-Creative Art*, dated June 23, 1961, plus a short description with technical details of the two actions and a reprint of the two first manifestos.

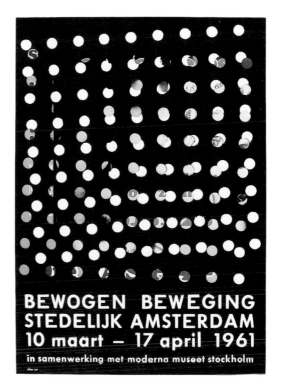

Bewogen Beweging, 1961, poster, graphic design by Dieter Roth

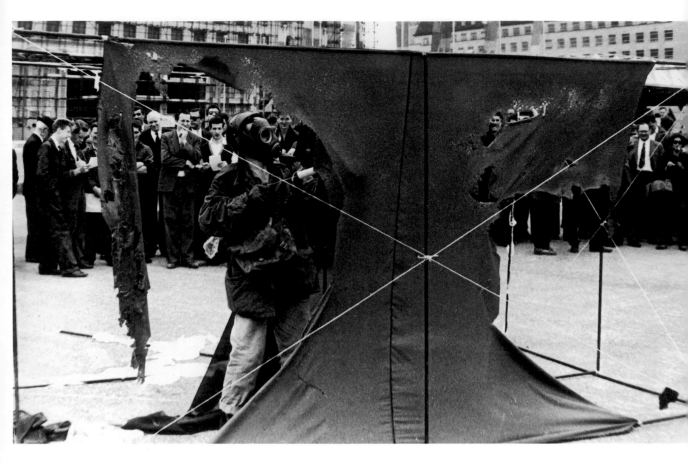

South Bank demonstration, 1961, London

AUTO-DESTRUCTIVE ART

Demonstration by G. Metzger

SOUTH BANK LONDON 3 JULY 1961 11.45 a.m.—12.15 p.m.

Acid action painting. Height 7 ft. Length 12½ ft. Depth 6 ft. Materials: nylon, hydrochloric acid, metal. Technique. 3 nylon canvases coloured white black red are arranged behind each other, in this order. Acid is painted, flung and sprayed on to the nylon which corrodes at point of contact within 15 seconds.

Construction with glass. Height 13 ft. Width 9½ ft. Materials. Glass, metal, adhesive tape. Technique. The glass sheets suspended by adhesive tape fall on to the concrete ground in a pre-arranged sequence.

AUTO-DESTRUCTIVE ART

Auto-destructive art is primarily a form of public art for industrial societies.

Self-destructive painting, sculpture and construction is a total unity of idea, site, form, colour, method and timing of the disintegrative process.

Auto-destructive art can be created with natural forces, traditional art techniques and technological techniques.

The amplified sound of the auto-destructive process can be an element of the total conception.

The artist may collaborate with scientists, engineers.

Self-destructive art can be machine produced and factory assembled.

Auto-destructive paintings, sculptures and constructions have a life time varying from a few moments to twenty years. When the disintegrative process is complete the work is to be removed from the site and scrapped.

London, 4th November, 1959 *G. METZGER*

MANIFESTO AUTO-DESTRUCTIVE ART

Man in Regent Street is auto-destructive.
Rockets, nuclear weapons, are auto-destructive.
Auto-destructive art.
The drop drop dropping of HH bombs.
Not interested in ruins, (the picturesque)
Auto-destructive art re-enacts the obsession with destruction, the pummelling to which individuals and masses are subjected.
Auto-destructive art demonstrates man's power to accelerate disintegrative processes of nature and to order them.
Auto-destructive art mirrors the compulsive perfectionism of arms manufacture—polishing to destruction point.
Auto-destructive art is the transformation of technology into public art. The immense productive capacity, the chaos of capitalism and of Soviet communism, the co-existence of surplus and starvation; the increasing stock-piling of nuclear weapons—more than enough to destroy technological societies; the disintegrative effect of machinery and of life in vast built-up areas on the person,...

Auto-destructive art is art which contains within itself an agent which automatically leads to its destruction within a period of time not to exceed twenty years. Other forms of auto-destructive art involve manual manipulation. There are forms of auto-destructive art where the artist has a tight control over the nature and timing of the disintegrative process, and there are other forms where the artist's control is slight.
Materials and techniques used in creating auto-destructive art include: Acid, Adhesives, Ballistics, Canvas, Clay, Combustion, Compression, Concrete, Corrosion, Cybernetics, Drop, Elasticity, Electricity, Electrolysis, Electronics, Explosives, Feed-back, Glass, Heat, Human Energy, Ice, Jet, Light, Load, Mass-production, Metal, Motion Picture, Natural Forces, Nuclear energy, Paint, Paper, Photography, Plaster, Plastics, Pressure, Radiation, Sand, Solar energy, Sound, Steam, Stress, Terra-cotta, Vibration, Water, Welding, Wire, Wood.

London, 10 March, 1960 *G. METZGER*

AUTO-DESTRUCTIVE ART MACHINE ART
AUTO CREATIVE ART

Each visible fact absolutely expresses its reality.

Certain machine produced forms are the most perfect forms of our period.

In the evenings some of the finest works of art produced now are dumped on the streets of Soho.

Auto creative art is art of change, growth movement.

Auto-destructive art and auto creative art aim at the integration of art with the advances of science and technology. The immediate objective is the creation, with the aid of computers, of works of art whose movements are programmed and include "self-regulation". The spectator, by means of electronic devices can have a direct bearing on the action of these works.

Auto-destructive art is an attack on capitalist values and the drive to nuclear annihilation.

23 *June* 1961 *G. METZGER*

B.C.M. ZZZO London W.C.1.

Printed by St. Martins' Printers (TU) 86d, Lillie Road, London, S.W.6.

1961

Metzger participates in Committee of 100 demonstrations. On September 12, 50 members of the Committee of 100 who lent their names to a call for a demonstration against the English atomic weapons policy are summoned before the Bow Street Magistrates Court. Thirty-seven members put in an appearance and 32 of them, including Bertrand Russell and his wife, refuse to withdraw the call for the demonstration and are sentenced to up to two months imprisonment. Gustav Metzger serves a one-month prison sentence in Drake Hall Open Prison, Staffordshire. Undeterred by the organizers' prison sentences, the demonstration takes place on September 17 in Trafalgar Square, London, where 1,324 demonstrators are arrested.

1961
[February] Sixthousand Committee of 100 demonstrators demonstrate in front of the Ministry of Defence in London.

[April 12] The Soviet Union succeeds in sending off the first manned space flight. Yuri Gagarin is the first man in space. He circles the earth in 108 minutés on board the space capsule Vostok I.

[June 30] In the Parisian Galerie J, run by Jeannine Goldschmidt, who at the time was the wife of art critic Pierre Restany, French artist Niki de Saint Phalle presents her so-called *tirs* for the first time. Paint bombs, spray cans, or objects filled with color are mounted on a board and covered in white plaster for these "shooting pictures." The artist then shoots at the thus prepared white relief or—as in Galerie J—gives the gun to visitors who are invited to shoot at the picture. When the projectile strikes, the color containers burst and color runs down the white picture.

[July 31] Bertrand Russell publishes *Has Man a Future?*. The book is characteristic of the era's apocalyptic mood. In the book, Russell goes as far as to doubt mankind's survival in the face of the threat of atomic weapons. In order to prevent an atomic catastrophe, he pleads for the establishment of an international government.

[September 22] For the exhibition *Bewogen Beweging* in the Danish Louisiana Museum in Humlebæk, Jean Tinguely demonstrates *Étude pour une fin du monde n°1, monstre-sculpture-autodestructive-dynamique et agressive* for approximately 1,500 people. It is his second auto-destructive machine, which is equipped with, amongst other things, fireworks. These are lit during the seven-minute action.

[November] In the Galería Lirolay, Buenos Aires, Argentina, a group exhibition takes place: *Arte destructivo*, conceived by Argentinean artist Kenneth Kemble. The exhibition includes a soundtrack that alludes to violence, sex, and death. In addition, various everyday objects are on display (an armchair, umbrellas, a flag, photos by the artists, wax dolls, etc.). These have been changed or destroyed by tears, teeth, burning, or cutting. In his text published in the exhibition catalogue, Kenneth Kemble links *Arte destructivo* with the destructive potential of the atomic bomb—as Gustav Metzger had already done in his South Bank Manifesto in July of the same year.

Arte destructivo, 1961, Galería Lirolay, Buenos Aires
invitation card
Kenneth Kemble

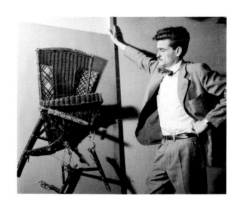

1962

[October 23 through November 8] Metzger is invited to take part in the exhibition *Festival of Misfits*, Gallery One, London, organized by Daniel Spoerri and Robert Filliou.

In addition to Gustav Metzger and the organizers Daniel Spoerri and Robert Filliou, participants include Addi Köpcke, Robin Page, Ben Vautier, and Emmett Williams. Per Olov Ultvedt and Benjamin Patterson, both of whom are announced on the invitation, were unable to take part. The *Festival of Misfits* is accompanied by the first Fluxus Event in England that takes place on October 24 at the Institute of Contemporary Arts (ICA), London. The *Misfits* evening at the ICA includes not only exhibition participants but also two further protagonists of the Fluxus Movement; Dick Higgins and Alison Knowles.

1962

Festival of Misfits, 1962

GALLERY ONE 16 NORTH AUDLEY STREET GROSVENOR SQUARE LONDON W1 HYDe Park 5880

If you are too successful, and have nostalgia for the days when you were not,

if you are unsuccessful, and hope some day success will knock at your door,

if you are too beautiful, and find men in the street are bothersome,

if you are ugly, madame, and wish you were beautiful,

if you sleep profoundly at night, and feel that it is a waste of time,

if you suffer from insomnia, and have time on your hands,

if you have teeth, and no meat,

if you have meat, and no teeth,

if you belong to the weaker sex, and wish you were of the stronger,

if you're in love and it makes you suffer,

if you're loved and it bores you,

if you're rich, and envy the simple happiness of the poor,

if you're poor, and long for la Dolce Vita,

if you're afraid to die, or find no point in living,

if you're a drunkard or a teetotaler,

if you believe in heaven or believe in hell,

if you're satisfied with the colour of your skin, or would rather change it,

if you believe in yourself and are pleased with what you do,

or don't believe in yourself, and wonder what you are doing, and why

then come to see the
FESTIVAL OF MISFITS

built by people who sometimes sleep soundly, sometimes don't; sometimes are hungry, sometimes overfed; sometimes feel young, rich and handsome, sometimes old, ugly and poor; sometimes

believe in themselves, sometimes don't; sometimes are artists, sometimes not.

We make music which is not Music, poems that are not Poetry, paintings that are not Painting, but

 music that may fit poetry

 poetry that may fit paintings

 paintings that may fit . . . something,

something which gives us the chance to enjoy a happy, non-specialized fantasy.

Try it
THE FESTIVAL OF MISFITS

Robert Filliou, one-eyed good-for-nothing Huguenot

Addi Kocpke, German professional revolutionist

Gustav Metzger, escaped Jew

Robin Page, Yukon lumberjack

Benjamin Patterson, captured alive Negro

Daniel Spoerri, Rumanian adventurer

Per Olof Ultvedt, the red-faced strongman from Sweden

Ben Vauthier, God's broker

Emmett Williams, the Pole with the elephant memory

You are invited to the opening between 10 a.m. and 6 p.m. on 23rd October. The Festival will continue until Thursday 8th November. Admission 2s. 6d.

In conjunction with the Festival there will be a special evening at the Institute of Contemporary Arts in Dover Street at 8.15 on Wednesday, 24th October, which will include a 53 kilo poem by Robert Filliou, an Alphabet Symphony by Emmett Williams, a Paper Piece and The Triumph of Egg by Benjamin Patterson and a Do-it-yourself Chorale by Daniel Spoerri.

Gallery One, invitation card, 1962

Gustav Metzger's proposal for the exhibition is to paste the pages of the London *Daily Express* on the stairwell of the gallery everyday. Both sides of the double pages are to be fixed on the wall, forming a block so that all of the pages are visible at a glance. The installation should be renewed on a daily basis using the current edition of the *Daily Express*. The previous day's edition should be removed and discarded. At the time of the exhibition, the world news was dominated by the Cuba crisis and fear of atomic warfare. The proposal was rejected and this installation was never realized. (It was only in the 1990s, over 30 years later, that variations of this proposal were realized in Munich, Los Angeles, and Oxford.)

Gustav Metzger takes part in the *Misfits* evening at the ICA. He sprays a nylon canvas with acid in front of a large audience and distributes his fourth manifesto, *Manifesto World*, dated October 7, 1962.

1962
[March 21] In cooperation with the U.S. television station NBC, Jean Tinguely films *Fin du monde n°2*, in the Nevada desert. It is his third auto-destructive sculpture and it is not conceived for viewers but is meant to be recorded cinematically and photographically. Colored clouds of smoke that escape during the action are reminiscent of the radioactive atomic "mushrooms" above the U.S. Army's Nevada test site, also located in the desert. The climax of the approximately 30-minute action is the blowing up of a feather-filled refrigerator.

On October 15, 1962, Soviet atomic guided missiles, which are within range of the U.S., are discovered on photographs taken by American pilots over Cuba. Five days later, the U.S. president, John F. Kennedy, reacts by installing a sea blockade to prevent further atomic weapon deliveries to Cuba. He insists on immediate withdrawal of the missiles already deployed. All American troops are placed on full alert. Two days later, this decision is announced to the world. A six day crisis follows in which the world teeters on the brink of an atomic war. It is only on October 28 that the acute phase of the crisis ends with a public statement by the Soviet head of state, Nikita Khrushchev, announcing withdrawal of the missiles.

[November] A presenter of the "Sunday Night at the London Palladium" program on ITV, the British television station, popularizes the slogan "Swinging London."

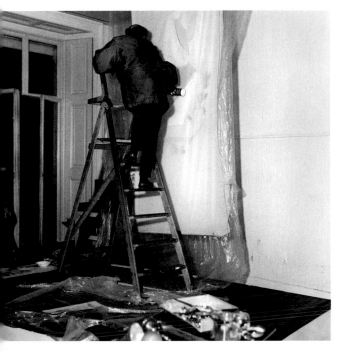
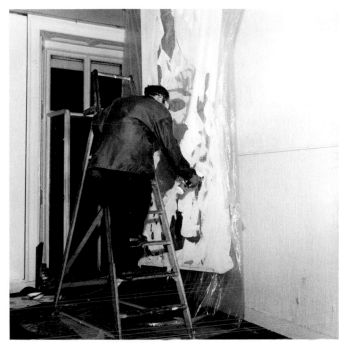
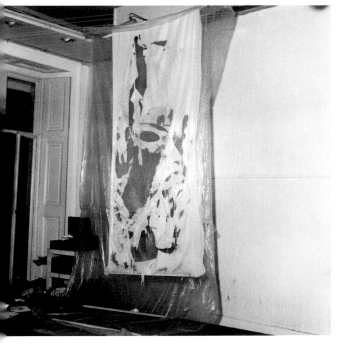
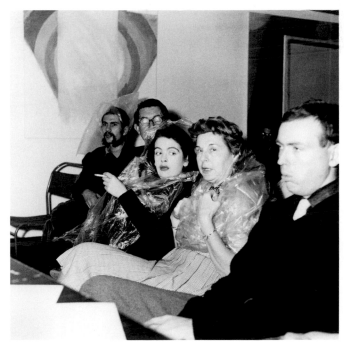

Misfits evening, 1962, ICA, London

1962

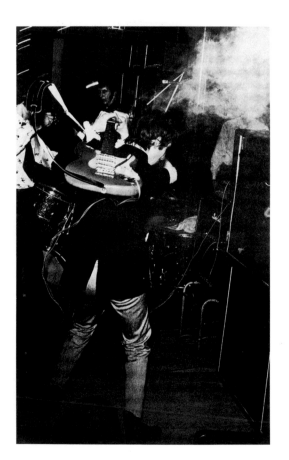

[December] *Auto-Destructive Art, Auto-Creative Art: The Struggle for the Machine Arts of the Future*, *Lecture/Demonstration*, Ealing School of Art, London, at the invitation of Roy Ascott, pioneer of telematic art. It is Gustav Metzger's first lecture at an art school. He includes slides and film screenings on the themes of art, society, space travel, and war. Among the listeners is the (then) art student Pete Townshend, who would later become the guitarist of the rock band The Who.

Pete Townshend repeatedly and explicitly referred to this lecture and Gustav Metzger's concept of *Auto-Destructive Art*, which had a decisive influence on The Who's appearances. Townshend says: "I was doing my first gig with The Who and took it as an excuse to smash my new Rickenbaker, that I had just hocked myself to the eyebrows to buy. I really believed it was my responsibility to start a rock band that would last only three months, an auto-destructive group. The Who would have been the first punk band except that we had a hit." (Jonathan Jones, "Schools of Thought," in: *The Guardian*, March 19, 2000).

Pete Townshend, 1967

1963

[February] *Lecture/Demonstration* at the Bartlett Society, School of Architecture, University College of London. He does his first light projection with nylon-covered slides. As with a normal slide projection, light is shone through a slide frame. The slide, however, does not have a photo but instead is covered with nylon. The nylon is painted with hydrochloric acid and dissolves on contact with the acid within a few seconds so that the light, at first dimmed by the white nylon, shines through the holes. The nylon's dissolution process is magnified by the projection and can be observed in great detail.

Metzger attends a film course at the Slade School of Fine Art, London, where he meets film student Liversidge and future documentary filmmaker and novelist Petor Whitehead. Over the summer, Harold Liversidge shoots the film *Auto-Destructive Art – The Activities of G. Metzger*. For the film, Metzger re-enacts the acid-painting action at the South Bank, London. In addition, he reads from his second manifesto and one can see shots of his first light projections.

Metzger works together with the artist Marcello Salvadori on the latter's project of founding a center for art, science and technology in London (Centre for Advanced Creative Studies).

[Autumn] Metzger participates in a conference of artists and writers in Rimini, Italy, at Salvadori's instigation; meets art theorist Frank Popper and art critic Pierre Restany.

1963

[June] In a spectacular action at Impasse Ronsin in Paris, the Argentinean artist Marta Minujín destroys the work she produced during a three-year stay in Paris. The woks are on exhibition until being destroyed at the closing event.

U.S. engineer Ivan E. Sutherland presents Sketchpad, the first program for interactive computer graphics, at the Fall Joint Computer Conference. Sutherland began his work in 1961 at the Massachusetts Institute of Technology (MIT). The program is the result of his dissertation on computer graphics, the first scientific work on the subject.

1963

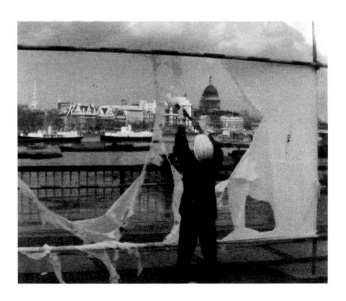

Harold Liversidge, *Auto-Destructive Art – The Activities of G. Metzger*, 1963, film still

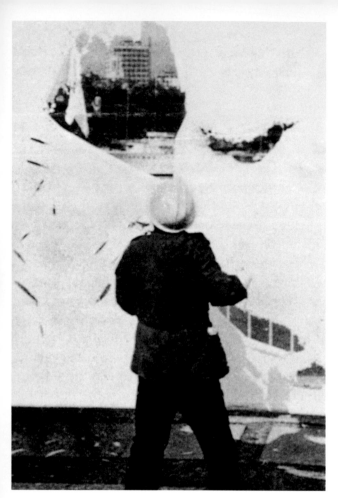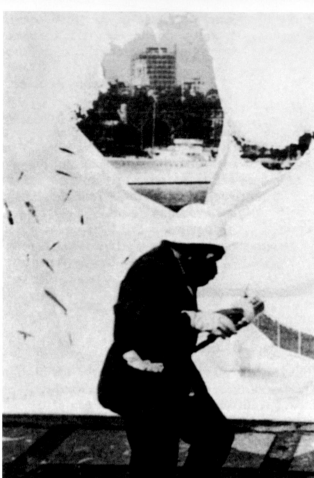

During the shooting of the film by Harold Liversidge, 1963

1964

[February and March] He travels in the Netherlands, Germany, and France.

Metzger's fifth manifesto, *On Random Activity in Material/Transforming Works of Art*, dated July 30, 1964 is published in the September edition of the magazine *Signals* along with a reprint of the first three manifestos.

1965

[February 24] *Auto-Destructive Art*, lecture, Architectural Association (AA), London, at the invitation of Royston Landau, architect and architecture theorist. The announced demonstration, in which, among other things, neon tubes will be made to fall and shatter, is cancelled by Gustav Metzger due to lack of preparation time. However, AA students carry out the action and it turns into an extreme and controversial Happening. The lecture is published in June as *Auto-Destructive Art* and appears for a second time, as a reprint, in October of the same year.

Auto-Destructive Art. Metzger at AA, London 1965

[February] Exhibition *Study for an Exhibition of Violence in Contemporary Art* at the Institute of Contemporary Arts (ICA), London. Gustav Metzger is not represented in the exhibition.

[April 25 through May 29] In the American Student and Artists' Center in Paris, the French artist Jean-Jacques Lebel organizes the first *Festival de la Libre Expression,* which is open to countless international artists, poets, cineastes, and musicians. Along with many other actions from various artists created especially for the festival, the U.S. performance artist Carolee Schneemann does *Meat Joy*. The festival is held in Paris two more times, in May 1965 and April 1966, before taking place for one last time in the South of France in summer 1967. The third festival in 1966 ends with police breaking up the happening *120 Minutes dédiées au Divin Marquis*, in homage to the Marquis de Sade. They arrest Lebel, the Happening's organizer.

1965

[February] The exhibition *Generative Computer-grafik von Georg Nees* opens at Stuttgart's Technical College. It is the first public exhibition of computer art and is followed by *Computer-generated pictures* at the Howard Wise Gallery in New York in April of the same year.

[June 11] Gustav Metzger assists documentary filmmaker Peter Whitehead in shooting the film *Wholly Communion*, documenting the International Poetry Incarnation at the Royal Albert Hall, London.

The beat poet Allen Ginsberg from the U.S. and Ernst Jandl, Austrian representative of experimental and concrete poetry, are among the participants in the four-hour event, which brings 7,000 visitors. The International Poetry Incarnation is the expression of a lively underground scene—especially of English-speaking literature—in the late 1950s and 1960s. The living and performative character of the spoken language is preferable to the printed word. A total of nineteen poets or, more accurately, "performers" (from England, the U.S., Austria, the Netherlands, Finland, and New Zeeland) take part in the event.

[September 7] *Notes on the Chemical Revolution in Art*, rear projections with three theater projectors and assistants at a fund-raising gala for the Institute of Contemporary Arts (ICA) organized by artist Mark Boyle in the Theatre Royal, Stratford, London. It is the first large-scale light show in London.

1965

[October 11] *The Chemical Revolution in Art, Lecture/Demonstration*, Society of Arts, Cambridge University, Cambridge, organized by architecture student Robin Nicholson. For the first time, Gustav Metzger uses color and movement effects of liquid crystals in changing temperatures for his projections. However, this first public presentation of projected liquid crystal phenomena is not successful. Alongside the experiments with liquid crystals, Gustav Metzger projects a drop of ink in clear water and in glycerin. To do this, he uses long, transparent, plastic containers made for holding toothbrushes. The container, which is to be placed in the projector, is filled with glycerin. Ink drips into the glycerin and disperses. The process is highly magnified by the projector and can be observed in great detail. For other projections, Gustav Metzger takes circuit boards used for fine electrical wiring, small synthetic boards that are regularly perforated. The boards are dipped into water and pushed into the projector. The water in the holes blocks some of the light from shining through. The heat of the projector, however, quickly causes the water to evaporate, and the light can then shine through the holes unhindered. The grid-like perforations result in equally spaced points of light but because of the unequal distribution of water in the perforations, the strength of the light varies in each image. In his lecture, Gustav Metzger demonstrates ten different projection techniques. In addition, two students carry out an *Acid Nylon Painting*. In order to do this they receive instructions by radio from Gustav Metzger who is outside the lecture theatre.

The Chemical Revolution in Art, 1965,
Cambridge University, *Lecture/Demonstration*,
assistant and Gustav Metzger during the preparation

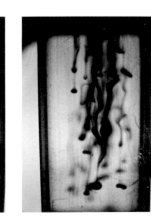
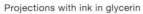

Projections with ink in glycerin

The Chemical Revolution in Art, 1965,
Cambridge University, *Lecture/Demonstration*,
projections with circuit boards

Acid Nylon Painting, 1965

1965

[November] Metzger exhibits an installation with found objects, books, film, *Bags*, etc., in the display window of Better Books, Charing Cross Road, London, on the occasion of the publication of the second edition of his February lecture to the Architectural Association.

Better Books is not only a bookshop for London's counter-culture, but also an important event and exhibition center. The Better Books premises, opposite St. Martin's School of Art, are a venue for readings, performances, exhibitions, and film screenings. A number of events for the *Destruction In Art Symposium* (DIAS) take place at Better Books. The organizer is the writer Bob Cobbing, known for his spoken-word poetry and activity as the publisher of *Writers' Forum* which publishes the works of experimental writers.

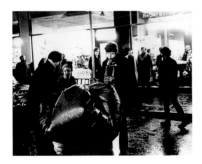

Concert in front of Better Books, London, 1966

1966

[January] *Art of Liquid Crystals*, solo exhibition in the window of Better Books, Charing Cross Road, London. Liquid crystals are placed between pairs of the thin, elongated, glass plates used in microscopes. Four of these pairs of long microscope specimen plates are assembled at right angles to each other into a cross. A small motor turns this horizontal cross so that each one of these pairs of plates moves with its enclosed liquid crystals over a glowing wire and is heated up. With increased temperature, the liquid crystals melt and become transparent. If the cross turns further, the melted crystals cool and become grey before taking on very strong, intense coloration. After a minute, the climax of the color change is achieved, just as the glass plates reach the heated wire once again. After the crystals are remelted, the color-changing process repeats.

[January 8] *An Evening of Auto-Destructive and Auto-Creative Art*, light projection, Better Books, Charing Cross Road, London. During this second public presentation of liquid crystal projections, Metzger realizes his first successful projections. Frank Popper is among those involved in the event.

ART OF LIQUID CRYSTALS

A new art technique is on view in a window of Better Books
(corner of Charing Cross Road and New Compton Street)
Two aspects of the technique are displayed:
1. as the spectator passes pieces of glass mounted in the
window, a series of colour changes may be observed
2 a chemical is mounted between microscope cover slips. In the
course of a one-minute cycle, the chemical is melted and then
cooled. As the chemical cools, colour changes are observed
which vary according to the position of the spectator and
the light source. This work is called EARTH FROM SPACE
The technique is based on the use of liquid crystals. It can
be used on a large scale, inside buildings or out. The exhibit
is the work of Gustav Metzger. He is the author of AUTO-DESTRUCTIVE
ART – the first illustrated monograph on the subject, published
in October 1965
An evening on auto-destructive and auto-creative art will be
held at Better Books on 8th January, Saturday at 9 p m. Speakers
include Frank Popper of Paris, a leading authority on kinetic
art.
The PRESS is invited to view the exhibit in the window of
Better Books on Thursday 6th January between 11 and 12 or
between 2 and 3, when Mr Metzger will be present
For further information please phone TEM 6944

[April] In a press release, Metzger makes the first announcement of the *Destruction in Art Symposium* (DIAS), he conceives and plans it, and invites artists, writers, psychologists, sociologists, and other interested parties to participate in the symposium and the planned exhibition and program of events. Monthly press releases about DIAS follow. John Sharkey, an Irish poet and playwright who manages the exhibition space of the Institute of Contemporary Arts in London at the time, becomes his first supporter and plays an important role in the organization of DIAS. Together they form the Honorary Committee to support DIAS. In September 1966, the members include: Mario Amaya, editor of the (at the time new) British art magazine *Art and Artists*; Roy Ascott, pioneer of telematic art; Italian artist Enrico Baj; Bob Cobbing, writer and manager of Better Books; art theorist Ivor Davies; journalist and playwright Jim Haynes; artist and writer Dom Sylvester Houédard; (Barry) Miles, manager of the Indica Bookshop; French theoretician Frank Popper; German artist Wolf Vostell; John Sharkey and Gustav Metzger who, as initiator and driving force behind DIAS gives himself the unassuming title Honorary Secretary. In the search for interesting artists, Metzger refers to the book *Happenings. Fluxus. Pop Art. Nouveau Réalisme.* edited in 1965 by Wolf Vostell and Jürgen Becker.

1966
[September] John Latham and Barbara Steveni found the Artist Placement Group (APG) in London. Based on the idea that artists represent a neglected resource for society, the APG attempts to employ the potential of artistic creativity in business, industry, and politics. The status of the artist as an outsider is regarded as an advantage in so far as those who are "placed" inside companies, political organizations, or industry have the competence to develop completely new and innovative ways of looking at these structures. Among the other members of the APG are the artists Jeffrey Shaw, Barry Flanagan, Stuart Brisley, David Hall, and Anna Ridley.

There is intense public cooperation between Günter Brus and Otto Mühl, both protagonists of Viennese Actionism. In Vienna, the *1. Totalaktion* (First total action) takes place in the Adolf-Loos-Villa along with the simultaneous action, the *2. Totalaktion* (Second total action), *Ornament ist ein Verbrechen* (Ornament is a crime) in the Galerie Dvorak. It has the subtitle *Für Vernünftige und Geisteskranke nicht ohne Bedeutung* (Not without meaning for the reasonable and the mentally ill). On July 4, the *Vietnam Party* is held in the Perinetkeller. In the same year, Günter Brus and Otto Mühl, together with Josef Dvorak, Kurt Kren, Hermann Nitsch, and Peter Weibel, found the Institut für direkte Kunst (Institute for Direct Art), Vienna. Joining later, among others, are Otmar Bauer, VALIE EXPORT, and Rudolf Schwarzkogler. In September, the Institut für direkte Kunst takes part in DIAS in London.

[October] The first edition of the *The International Times* (IT), the newspaper of the active counterculture, appears in London. In the second edition, Pete Townshend acknowledges that Gustav Metzger's *Auto-Destructive Art* has had a decisive influence on The Who's sensational stage show.

[March 29 through April 16] *Liquid Crystals in Art*, solo exhibition, Lamda Theatre Club, Swiss Cottage, London. Shown is a smaller version of his exhibition from January of the same year in the shop window of Better Books.

Invitation to Kingsley Hall in the East End of London. Gustav Metzger shows projections with liquid crystals and meets the well-known psychoanalyst, author, and influential founder of "anti-psychiatry," Ronald D. Laing and his colleagues Joseph Berke and Leon Redler, as well as the anthropologist Gregory Bateson.

[May] Metzger shows projections at the "Symposium on Destruction/Creation," Ravensbourne College of Art, Kent. Peter Holliday who teaches art at Ravensbourne College organizes the symposium. Metzger and others involved in the planning of DIAS participate, among them, Ivor Davies, Mark Boyle and the Benedictine monk and poet Dom Sylvester Houédard, who writes about the one-day symposium "The Aesthetics of the Death Wish." An abridged version of the article appears in August 1966 in *Art and Artists*.

[July 10 and 11] Metzger participates in "IDEA: International Dialogue in Experimental Architecture," organized by the New Metropole Gallery, Archigram Magazine and BASA, in Folkstone, Great Britain as reporter for *Peace News*, the magazine founded in 1936 by the British peace movement. He becomes deeply involved in the discussions.

[July] *Lecture/Demonstration* with projections at the Hornsey College of Art, London, during Clive Latimer's Sound/Light-Workshop.

Gustav Metzger meets Clive Latimer in 1946. Latimer had early success as a furniture designer. He is later involved, in the interaction of sound and light in the context of the Sound/Light-Workshop, which he runs at Hornsey College of Art. Students of the Sound/Light-Workshop develop a light show for a concert at the college of the then almost unknown rock band Pink Floyd in November 1966—this occured three months after Gustav Metzger had shown his projections there. This light show, in which the light changed according to the rhythm of the music offered the climax of Pink Floyd's Mixed Media Show at the time. Joe Gannon, a 17-year-old art student crucial to the development of this sensational show, goes on to become Pink Floyd's new light show designer. The light show, which later also used liquid crystals, subsequently becomes a significant component of Pink Floyd concerts.

[July] Metzger lectures to the class of sculptor Philip King at the Sculpture Department of St. Martin's School of Art, London.

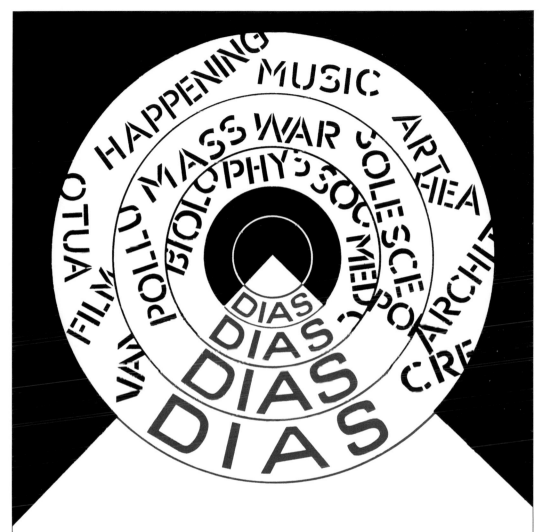

DESTRUCTION IN ART SYMPOSIUM SEPT 9TH & 10TH AFRICA CENTRE

SUNDAY 11TH 10 AM – 10 PM (PUBLIC DAY) ADMISSION FEE 10s
DETAILS & INFORMATION FROM:
THE SECRETARY, BM/DIAS, LONDON W C 1
(DOCUMENTATION EXHIBITION. BETTER BOOKS. SEPT – OCT
11 AM – 8 PM)

131 DIAS, 1966, poster, graphic design by John Sharkey

[September 9 through 11] *Destruction in Art Symposium* (DIAS), Africa Centre, London.

There are events in connection with the symposium throughout September. The symposium is the central item on the DIAS agenda. On August 31, the New York artist Ralph Ortiz—who, since the 1970s calls himself Rafael Montañez Ortiz—organizes an action in the St. Bride Institute, one of the DIAS venues. During the action, Ralph Ortiz maltreats and destroys an armchair after having rudely chased away an unsuspecting newspaper reader. As expected, the *Chair Destruction* attracts the attention of the press. The reaction in the newspapers is, however, almost entirely scandalous and negative. Likewise, before the symposium, artist Mark Boyle presents a slide show in the Jeannetta Cochrane Theatre in London in which live insects are placed into a slide projector. The heat of the projector causes the death of some insects. Their death struggles are projected greatly magnified. Following that, after the final press conference before the symposium, Canadian artist Robin Page digs a hole in the floor of the basement of Better Books using a pick and shovel. The action is broken off when water unexpectedly comes out of the hole.

Approximately 150 people attend the symposium, which took place from September 9 through 11 in the Africa Centre in King Street, London. For three days, participants present papers and discuss various aspects of destruction. On the second day of the symposium, Gustav Metzger gives a lecture "The Scientific Destruction of Science and Technology." Otto Mühl and Günter Brus are the only ones to break an agreement to do no more than present papers, and instead carry out various phonetic actions. In one action, Günter Brus bursts an air-filled paper bag lying on the table in front of him with his head. Kurt Kren's films about the Viennese artists—screened on two evenings—cause a great stir.

Further actions take place after the symposium and until the final DIAS event on September 30. Diverse open-air actions are presented at the London Free School Playground, a piece of vacant land in Notting Hill, West London. John Latham and Werner Schreib, for example, carry out actions with explosives. Günter Brus and Otto Mühl show *Ten Rounds for Cassius Clay*, (an action reminiscent of Mühl's material actions) in the St. Bride Institute; Yoko Ono repeats her *Cut Piece* along with other actions at the Africa Centre.

DIAS, symposium program

SYMPOSIUM

Africa Centre, 38 King Street, W C 2

	Chairman's Introduction

September 9th
3-5 pm

Ivor Davies: 'A Pattern of the Development of Destruction as Creation' .
Jean Tinguely: 'Hommage to New York' – text of Museum of Modern Art,
New York, statement – read by Fred Bazler.
Reading of letters to the Symposium from Association Internationale pour
L'Etude de Dada et du Surrealism; Internationale Situationniste, Paris;
George Maciunas of Fluxus, New York.
Text by George Maciunas: 'US Surpasses all Nazi Genocide Records.'
– read by Beverley Rowe.
Dr Erling Eng: 'The Phenomology and Structure of the Obscenic'.
Chair: Gustav Metzger

6-9 pm

Dom Sylvester Houedard: 'Apophatic Art'.
Jean J Lebel: Speaks on Happenings .
Aspects of Destruction in Art. A discussion with Francis Galton
Chair: Ivor Davies

September 10th
11 am – 1.30 pm

Gustav Metzger: 'The Scientific Destruction of Science and Technology'.
Bob Cobbing: 'The Destruction of the DIAS Exhibition'.
John Latham: 'Event Structure and the English Dream'.
Garry A Jones: 'Total Aesthetic'
Anthony Scott: 'On Chopped Writing'
Letters to the Symposium from: Felice Canonico and Simon Vinkenoog.
Chair: Ivor Davies

2.30 – 5 pm

Henri Chopin: 'Tape Presentation'
Werner Schreib: 'Pyrogravure'
Peter Gorsen: 'Sexualitat im Spiegel der Modernen Kunst'– extracts read
by Werner Schreib.
Bernard Aubertin: Texts – read by Julien Blaine.
Chair: Ivor Davies

5.30 – 7 pm

Peter Weibel: 'Film, Division of Labour and Direct Art'.
Otto Muhl: 'Translation – Action for Two Voices'.
Gunter Brus: 'Head-Destruction'.
Hermann Nitsch: 'Lecture on the O M Theatre'.
Chair: Jean J Lebel

September 11th
10.30 am – 1 pm

Reading of Statements by Milan Knizak and other artists.
Ralph Ortiz: Statements and Discussion
Dr Joseph Berke: 'Man as Self-Destroying Art'.
'To Kill or not to Kill' – Discussion – Juan Hidalgo, Ralph Ortiz, Robin Page
Chair: Ivor Davies

3-5 pm

Reading of Texts from their Publications
Al Hansen: 'A Primer of Happenings & Time/Space Art'
Juan Hidalgo: Group ZAJ
Wolf Vostell: 'De/Collage Happenings'.
Chair: Gustav Metzger

5.30-7.30 pm

Ivor Davies: 'The Realism of Self Contradiction'
Pro-Diaz: On Art.
Yoko Ono: Talk .
Barbara Gladstone: 'Reflections of a Dancer'
Biff Stevens: 'On Pneumatic Environments'
Anthony Cox: 'Extracts from 'Lecture in the Dark'
Dick Wilcocks: 'Destructive Poem'
Chairman's concluding remarks.
Chair: John Sharkey

Films and slides by Davies, Hansen, Kren, Latham, Nitsch, Ortiz, Page and Vostell were shown on
the nights of September 10th and 11th.

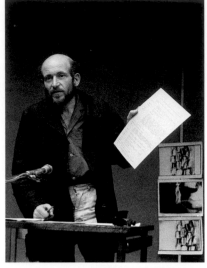

Africa Centre, London
Gustav Metzger, opening speech
Inside Africa Centre
Lecturers (left to right):
Jean-Jacques Lebel, Peter Weibel
Otto Mühl, Juan Hidalgo

Günter Brus
Hermann Nitsch
Robin Page, Ivor Davies
Gustav Metzger, Wolf Vostell

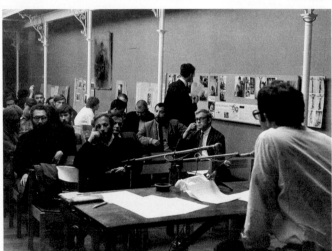

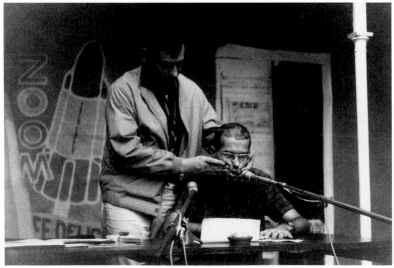

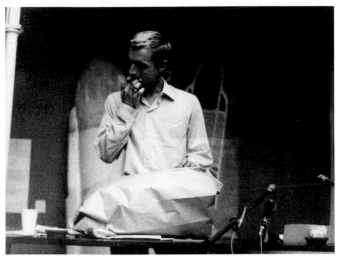

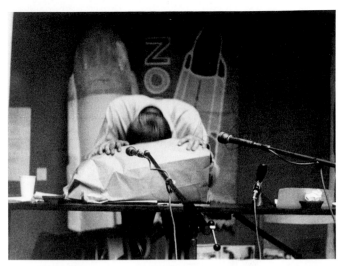

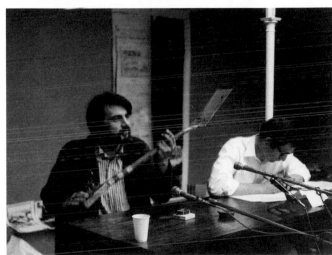

Lecturers (left to right):
Gustav Metzger, Wolf Vostell, Al Hansen,
Yoko Ono
Barbara Gladstone

London Free School Playground

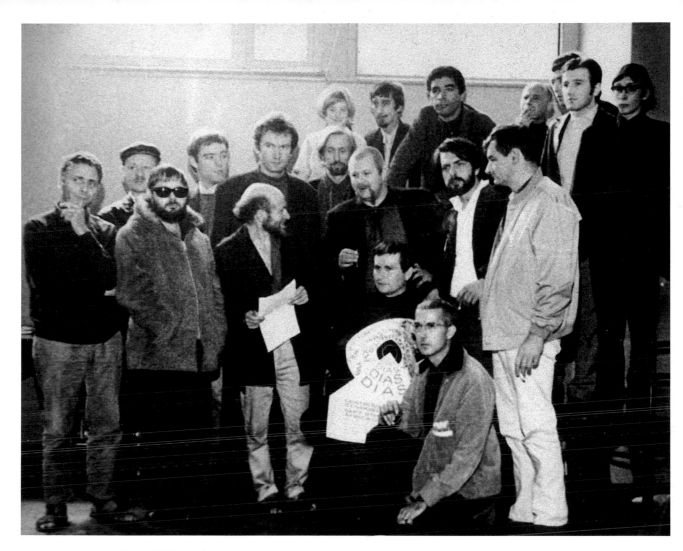

Some DIAS participants:
(left to right)
First row: Jean Toche (with sunglasses), Gustav Metzger, Wolf Vostell, Hermann Nitsch
(with poster), Juan Hidalgo (kneeling), Robin Page, Otto Mühl
Second row: Henri Chopin, Werner Schreib, unknown, Ivor Davies, John Latham
Back row: Susan Cahn, John Sexton, Ralph Ortiz, Kurt Kren,
Ener Donagh, Peter Weibel, Bryant Patterson

August 31 Morning Press Conference, St Bride Institute – followed by 'Chair Destruction' by Ralph Ortiz

September 1 Afternoon Press Conference at Richard Demarco Gallery, Edinburgh by John J Sharkey and Ivor Davies – followed by Explosive Art Demonstration by Ivor Davies at Drill Hall, Edinburgh

September 1 Mark Boyle: 'Presentation' – Jeannetta Cochrane Theatre

September 2 'Meditation on Violence' – films presented by Bob Cobbing – Better Books

September 3 'DIAS at Speakers' Corner', Hyde Park. Ernst Fleischmann, Gustav Metzger, Ralph Ortiz

September 4 'DIAS visits 'The Liquidators'. Warner Cinema, Leicester Square

September 5 'An Evening with Ralph Ortiz – Better Books

September 6 'Filmed Destruction'. Presented by Harvey Matusow. Better Books

September 6 Jean Toche 'Typewriter Destruction'. Better Books

September 8 Morning Press Conference – St Bride Institute
Robin Page –'KROW I'. Better Books
Afternoon Press View at Battersea Park 'Pneumatic Environment' by Biff Stevens and team from Sheffield University. This structure was on view for the remainder of the month.

September 9 Symposium – Africa Centre
September 10 " " "
September 11 " " "

September 12 Afternoon events at London Free School Playground
Al Hansen 'Event with Motor-Cycle'
Werner Schreib 'Pyrogravure'
Robin Page 'Event'
Jean J Lebel 'Distorted Postcards-French-Op'
John Latham 'Skoob with Powder'
Pro-Diaz: Painting with Explosives

September 12 Concert at Conway Hall
AMM Group 'Sounds in the Dark'
Henri Chopin : Tape Presentation
Action Music by Gunter Brus and Otto Muhl 'Breath Excercises'
Yoko Ono 'Whisper Piece'
Ralph Ortiz 'Paper Bag Event'
Al Hansen 'Paper Happening'
After the concert Werner Schreib performed his 'Rouge et Noir' outside the hall.

September 13 Afternoon events at London Free School Playground
Ivor Davies: Explosions in House
Robin Page: Event
John Latham: 'Flying Skoob'
Yoko Ono: 'Shadow Piece'
Pro-Diaz: Painting with Explosives

September 13 Gunter Brus and Otto Muhl present Direct Art 'Ten Rounds for Cassius Clay'. St Bride Institute.

September 14 Wolf Vostell: 'Rebellion Plus Minus Decomposition'– Action-Lecture Institute of Contemporary Arts.

September 15 Afternoon Concert at Africa Centre
ZAJ Group – Presented and performed by Juan Hidalgo. Works included 'William Tell' by Tomas Marco, 'Mandala' by Walter Marchetti, 'Money' and 'Music for Five Dogs and 6 Male Performers' by Juan Hidalgo Followed by 'Shadow Piece' by Yoko Ono

September 15	Africa Centre Kurt Kren: 13 Films Simultaneous Happening of the Vienna Group with the participation of Al Hansen Gunter Brus: 'Self-Destruction' Al Hansen 'Event' Hermann Nitsch: Film Projections Peter Weibel: Action-Lecture 'Proposals on Non-Affirmative Art' Otto Muhl: 'Lecture Destruction'
September 16	Afternoon Event at London Free School Playground Lollypop Group – Rose and Ener Donagh, Harry Franklin, John Sexton: Destruction of Giant Lollypop Pete Davey: Destruction of 'Live Body'.
September 16	Hermann Nitsch: Action : OM Theatre (5th Abreaktionsspiel) St Bride Institute
September 16	John Calder 'On Censorship' Better Books
September 17	Al Hansen: 'Coin Piece' performed in Biff Stevens' 'Pneumatic Environment'
September 20	Discussion on DIAS at Institute of Contemporary Arts: Jasia Reichardt, Ivor Davies, Al Hansen, Gustav Metzger, Ralph Ortiz. Chair: John J Sharkey
September 21	Jeff Nuttall and young people: Discuss Violence – Better Books
September 22	Ralph Ortiz: 'Self-Destruction'. Mercury Theatre
September 23	Evening Events at London Free School Playground John Gilson and team: 'Destruction in Space' Al Hansen: Happening with children
September 23	John Latham: 'Film'. Mercury Theatre
September 28	'Evening with Yoko Ono'. Assisted by Anthony Cox. Africa Centre
September 29	'Evening with Yoko Ono'. Assisted by Anthony Cox. Africa Centre. Works included: Line Piece, Bag Piece, Cut Piece, Strip-Tease for Three, Wall Piece, Dawn Piece.
September 30	DIAS – Final Event. Mercury Theatre Destructive Art Group of Buenos Aires, 1966. Tape ' Ideas for Destruction Applied to Music and Poetry'. Artists: Kenneth Kemble, Antonio Segui, Graciela Martinez, Ruben Santantonin, Maggie Bottazzi, Jorge Lopez Anaya, Silvia Torras, Jorge Bottazzi, Veronica Williams, Irene Sabbiane. Ray Stackman: Self-Destructive Object Gianni Emilio Simonetti: 'Ready-Game-Bum' Ralph Ortiz: Event-Film Mark Boyle: Projections Ivor Davies: 'Silent Explosion' Yoko Ono: Disappearing Piece Barry Flanagan: Sand Sculpture John Latham: 'Film' Anthony Cox: 'Sword Piece' Carl Fernbach-Flarsheim: Tape. 'Pages from an Instruction Manual' Garry A. Jones: 'A Reflection on Destruction', 'Expansion/Contraction', 'Escalation, A Portrait of Mass Hysteria'

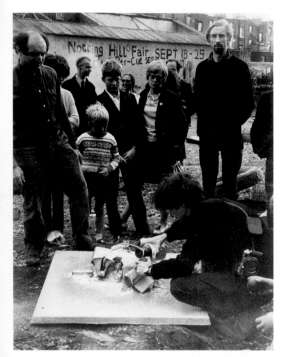

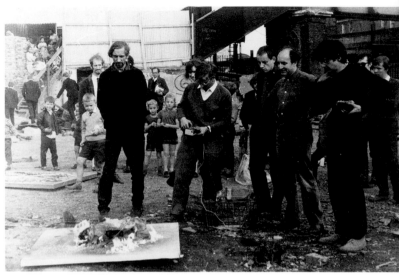

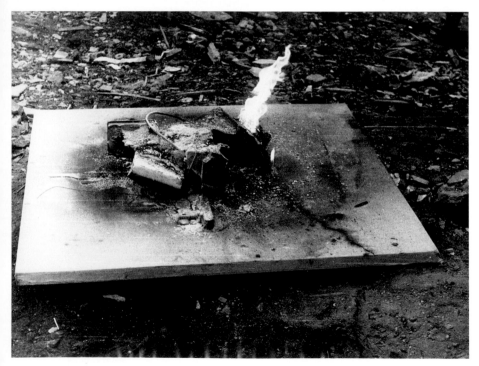

DIAS event, September 12, 1966, London
Free School Playground, London
Pro-Diaz (left), Tony Cox (right, kneeling),
John Latham

140

Psychedelicamania at roundhouse

THE Roundhouse at Chalk Farm was once called "a derelict barn". On Saturday it saw in the New Year with little elevation of its stature. The scene was the Giant Freak-Out All Night Rave, where the participants, "emancipated from our national social slavery" as the ads shrieked, are supposed to "realise as a group whatever potential they possess for free expression." Either there was no potential among these liberated souls, or somewhere the organisation went wrong.

If to get high, expand the conscience, freak-out, have the senses bombarded with kinetics and sound, you first have to suffer frostbite, malnutrition and nausea, give me the "At Home With the Fugs and the Brain Police" album, anytime.

However, despite the lack of facilities "the participants" — i.e. the paying guests — adjusted as they always do. They blasphemed at the groups, got it together in the corners, and looned about to keep the circulation on the move.

On stage the Pink Floyd, the Who, and the Move each attempted to excite the audience into some positive action. The Pink Floyd have a promising sound, and some very groovy picture slides which attract far more attention than the group, as they merge, blossom, burst, grow, divide and die.

The Who got on to the stage after an hour wait during which participants were treated to "See-Saw", by Don Covay. The Who almost succeeded in winning over the show with an immediate flurry of smoke bombs and sound barrier smashing. But somebody pulled out the plug and the Who fell as quiet as a graveyard. The trouble recurred to cut short two more numbers. After playing most of their new album tracks rather half-heartedly, Pete Townshend wheeled upon a fine pair of speakers and ground them with his shattered guitar into the stage. It was fair comment. The group had thrice been switched off as well as being constantly plunged into darkness by a team of lighting men — none of whom seemed to know where, in fact, the stage or the Who were positioned.

The Move were more successful. Technically they had no hitches and their act came smoothly to a stage-shaking climax as TV sets with Hitler and Ian Smith pictures were swiped with iron bars, and a car was chopped up.

Two girls were incensed enough to strip to the waist and the remaining, shivering crowds surged menacingly towards the stage, the demolished car, and the birds.

The proceeds of the happenings are going to Centre 42 which, ultimately, hopes to raise a brand new amphitheatre at the Roundhouse. Whether they will continue to put on pop shows when the theatre is built remains to be seen. They owe it to the pop scene to do so. — NICK JONES.

THIS IS MUSIC ?

". . . a car was chopped up . . ."

Melody Maker, January 7 1967, page 2

1966

[December 30 and 31] Metzger does light projections with liquid crystals, twelve projectors and assistants as visuals for the Giant Freak-Out All Night Rave, a series of concerts by the bands Cream (December 30), The Move, and The Who (December 31) in the Roundhouse, London. Concertgoers are enthusiastic about the psychedelic effect of the continuous merging and diverging of the colors, although on December 31 the projections for The Who cannot be carried out as planned due to power cuts.

1967

[April] Metzger speaks at the symposium "The Future of the Visual Arts" at the Brighton Festival. The festival, held every spring since 1966 in the popular holiday resort of Brighton, includes exhibitions and discussion events as well as dance perfomances, theater, and concerts.

[May] *Destruction in Art*, lecture, Festival of Art, Exeter, Great Britain.

[June] *The Aesthetic of Revulsion*, lecture, Bristol Arts Centre, Bristol, part of the accompanying program for the exhibition *Shock*, organized by artist Ian Breakwell.

1967

The Swedish engineer Billy Klüver, who works in the U.S. for Bell Telephone Laboratories in New Jersey, and U.S. artist Robert Rauschenberg are founding members of the group Experiments in Art and Technology (E.A.T.). E.A.T. encourages collaboration between engineers and artists in researching the artistic possibilities of new technologies. Prior to the founding of E.A.T., a number of interdisciplinary projects were created by artists, technicians, and industry—most notably at the festival *9 Evenings: Theater and Engineering* in 1966 in New York. The 1968 exhibition *Some More Beginnings* presents, for the first time, a great number of technical, electronic, and media projects. The parallel exhibition *The Machine as Seen at the End of the Mechanical Age*, curated by Pontus Hultén of the Museum of Modern Art (MoMA) in New York, shows prize-winning installations. A further milestone for E.A.T. is the Pepsi Pavilion at the Expo in Osaka, Japan in 1970.

[February] The English artists Mark Boyle and Joan Hills provide a light show to accompany a performance of the art rock band The Soft Machine at the UFO Love Festival, Tottenham Court Road, London.

Mark Boyle, Joan Hills,
Liquid Light Environment
for The Soft Machine, 1967

Milan Knizak, the practitioner of Happenings in Prague, has launched an ambitious project - the Keeping Together Manifestation. It takes place from 1 - 31 March, 1967. He asks people in all countries to join the manifestation, - particularly by sending letters to governments, embassies, and military dignitaries. You are invited to send descriptions, photos, and other documentation of your activity in the Keeping Together Manifestation to Knizak, who plans to produce a publication recording this world-wide action. The address is: AKTUAL, Novy Svet, 19, Prague, 1. Czechoslovakia. Below is the text of the Keeping Together Manifestation.

"Embassies are delivered letters on keeping together/magazines and newspapers are asked to take part in Keeping Together Manifestation/bills are hung in houses asking for Keeping Together Manifestation/military dignitaries are delivered letters asking to give up their functions in the Keeping Together Manifestation Movement/clergymen are asked to preach on keeping together/trade unions are asked to hold meetings on keeping together/department houses are asked to make up their shop-windows with slogans on keeping together/just belligerent states are delivered petitions asking to stop the wars in the Keeping Together Manifestation Movement/leaves of magazines are distributed/ Zoo is visited/tenants of houses are delivered letters of the same contents/hands are given/trees in parks are hung with flags/ornated christmas trees are standing in the middle of streets/foreign words are written on walls and sidewalks/people - taking part in love DO Keeping Together Manifestation/people - working DO Keeping Together Manifestation/ - mankind is living DOING Keeping Together Manifestation."

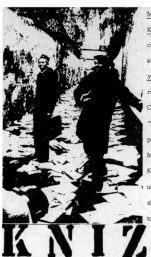

KNIZAK

The PRELIMINARY REPORT - Destruction in Art Symposium, London, September 1966, is now available. It lists the titles of papers read at the Symposium, has a list of events, and the names of participants. 5 pages. Also available: "Destruction in Art" by Jasia Reichardt. This is a reprint of an article in Architectural Review, December, 1966. 4 pages with 9 illustrations. The price of each publication (including postage) is 2s. = 30c. Please send cheque etc. with your order. These publications can be obtained from: BM/DIAS, 296, Gray's Inn Road, London, W.C.1. Photo credits. Knizak, Studio International, October, 1966, P.211. Kren, Life, (U.S. edition) February, 17, 1967, P.86. Kren on bike, and from left - Jean J. Lebel, Robin Page, Gunter Brus. in London, September, 1966.

DIALECTICS OF LIBERATION

Some of the most brilliant but unclassifiable thinkers in the world today will be meeting in London later this year to take part in a congress called "The Dialectics Of Liberation." The Institute of Phenomenological Studies (65A Belsize Park Gardens, London NW3) is sponsoring and convening the congress, which will run from July 15 to July 30, beginning on the Saturday with an introduction by Dr David Cooper, followed by an opening address from Dr Ronald Laing. Both Dr Laing and Dr Cooper are founding members of the Institute of Phenomenological Studies, along with Dr Leon Redler and Dr Joseph Berke, who is organising secretary for the congress.

Those who have agreed to take part at the time of writing include Gregory Bateson, Mircea Eliade, John Gerassi, Allen Ginsberg, Paul Goodman, David Cooper, Ronald Laing, Jules Henry, Herbert Marcuse, Jakov Lind and Paul Sweezy. During the two weeks a series of lectures will be held each morning, followed by discussion and seminars in the afternoon. In the evenings and at weekends there will be various productions and events, including poetry readings and workshops. There will be a registration fee of 15 guineas ($45) to cover the expenses of the congress, which at the moment are being met by the Institute alone. Fee reductions may be considered for those who really wish but cannot afford to attend the congress, and payment can be made in instalments.

DIAS INFORMATION 1. March 1967.

KREN

Kurt Kren is at work on a new film. Tentative title: "14/ anno ? - prayer-wheel". It will be a 16 mm loop-film, repeated at least forty times. Kren invites anyone to contribute to the film. There are two ways of participating. 1. You can send film. 2. Kren will make film according to your specifications. The film, or the specification, that you send must include the word money, and your name. Embellishments, photos, etc. in addition to the words are optional. Note: the term money is to be in your language, - geld, etc. There are the following charges for taking part in the film. 1. A charge of 1 dollar for 10 frames sent in. 2. A charge of 1 dollar for 1 frame made up by Kren. You can send or order unlimited amount of film. Please send your material and money as soon as possible. The film will probably have its premiere in Paris. Kren has produced 13 films. He is a master of the technique of very quick cutting. His films were screened twice during DIAS, and were enthusiastically reviewed by Raymond Durgnat, author of "Eros in the Cinema". (International Times, London, Vol.1, No.1, 1966.) The address of Kren is: Kurt Kren, A 1210, Vienna, Freytagg. 1 - 14/21/13. Austria.

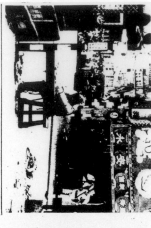

Martyr's shadow over Nazi trial

by ERIC CLARK

THE MEMORY of a man who, of his own free will, walked to his death in a gas chamber 25 years ago today, will overshadow the trial of a Nazi war criminal. Franz Stangl. Stangl is now in Germany after his extradition from Brazil in June.

The man was Janusz Korczak, writer, doctor, educationist, lover of children—a Polish Jew who became a martyr when he refused to let 200 Polish orphans die without him.

He is the main reason why the Polish Government is pressing to be allowed to try Stangl. Korczak was murdered in Treblinka II extermination camp, commanded by SS Hauptsturmführer Franz Paul Stangl. The trial of Stangl in Germany later this year may well be the last major Nazi war crimes case.

The Poles had been seeking Stangl since 1945. Earlier this year they failed to have him extradited from São Paulo in Brazil. They blame Stangl, now 59, for the deaths of 1,500,000 Jews, Poles, Belgians, Austrians, Yugoslavs and Russians. To the Poles Korczak has become a personification of Jewish and Polish tragedy.

Polish attempts to re-extradite Stangl will be unsuccessful; it was a Brazilian condition of returning Stangl to Germany that, after a prison sentence, he should be sent to his native Austria.

Korczak, who was 64 when he died, was born Henryk Goldszmit. He gave up a lucrative practice as a doctor at the age of 30 to teach in an orphanage. He wrote more than 20 books for adults and children, described in Poland today as 'a valuable and completely new page in Polish literature'.

'You can stay'

In the 1930s, Polish anti-Semites could not forgive his Jewish ancestry: when the Germans came they placed him in the ghetto. Even then he need not have died. The Polish underground—Arnia Krajowa—made every effort to save him. There were also Germans who admired his talent and would have seen that he was spared.

By 6 August 1942 Treblinka II had been open a month. Each day 5,000 to 6,000 people were to leave Warsaw for its gas chambers in time, 400,000 from the Warsaw ghetto were to die there. On 6 August Korczak, having refused all offers of safety for himself, was taken to Gdansk station in Warsaw. Quietly, with 200 orphans beside him, he marched to the train. The green flag of the orphanage fluttered over the group.

Even then Korczak could have saved himself. The commandant in charge of the loading had heard of him and had read one of his children's books. He gave him the option of staying : 'The children must go, but you can stay behind.'

Korczak refused. With the others, he was loaded into cattle vans disinfected with chloride of lime. At Treblinka, he died with the orphans. Six months before, in his last will and testament on 9 February, he had written that as a hospital he had 'learned that a child dies with dignity, maturity and wisdom.'

Stangl is still being questioned about other Nazi criminals still at large. His revelation that Martin Bormann, Hitler's deputy, is still alive and in Brazil—reported exclusively in The Observer on 16 July—has been reproduced throughout the Communist world.

Bleak outlook for car men

By MICHAEL EVANS

What the motor firms fear: the build-up of stocks at a Standard-Triumph compound near Coventry Airport one bad winter.

Japan's £530m Vietnam war profits

BY CHRISTOPHER LUCAS, Tokyo, Saturday

The Lisbon torture shocks Spurs

Celtic 3 Tottenham Hotspur 3

Hongkong A bomb-disposal officer wearing protective clothing can be opens a parcel found stuffed between the red and amber lights of a street crossing. It contained nothing but old newspapers.

Six burn food surpluses

By Antony Terry
Bonn, Saturday

HUGE SURPLUSES of fruit and vegetables caused by the long hot summer...

UNDERSEA PARKS TO SAVE FISH

BY OUR NATURE CORRESPONDENT

POLLUTION of Britain's coastal waters by oil and industrial wastes, and the ravages of some spear-fishing skin divers, so grave so great that underwater...

CND claim a victory

ALEXANDER BRANDER

FRANZ STANGL: camp commandant—the first picture since his arrest.

A SUNDAY IN AUGUST

The print reproduced here is extracted from newspapers published in London on Sunday, August 7, 1967. From : Sunday Telegraph, News of the World, Observer, Sunday Times.

DEATH IN ICTERIC. Icteric is one of the best new magazines. It is a quarterly magazine, concerned with social architecture and creative/ intermedia activities. Part of the next issue, - No. 3, to be published in October, will be devoted to death. It will include articles by anthropologists, persons in various professions which they see as obsolete, etc. Included will be a questionnaire on death. From : Icteric, 13, Eslington Terrace, Newcastle on Tyne, 2, England. Price, 2s. 6d. Postage, 6d.

KINETIC ART 1. Frank Popper's book, 'Naissance de l'Art Cinétique. L'Image Du Mouvement Dans Les Arts Plastiques Depuis 1860', was published in June. This is the first comprehensive work on the subject. The book has 9 chapters, bibliography, illustrations, etc. Published by Gauthier-Villars, Paris. 300 pages, price, 68 F.

KINETIC ART 2. Willoughby Sharp, publisher of Kineticism Press, will make a European lecture tour in September, 1967. 3 topics are offered : Kineticism : Physical movement in 20th c. sculpture/Luminism: Actual light in 20th c. sculpture/Feedback : Science and the art of light and movement. Enquiries to Willoughby Sharp, 204, East 20th Street, New York, N.Y. 10003. Telephone, 674-5430.

DIAS TRIAL. At the four day trial at the Old Bailey from July 19th, DIAS was found guilty of arranging and presenting an indecent exhibition, and fined the sum of £100. Details in a future issue of DIAS INFORMATION.

DIAS INFORMATION 3. August 1967. Distributed by : BM/DIAS, London, W.C.1., England.

PAPA WHAT DID YOU DO WHEN THE NAZIS BUILT THE CONCENTRATION CAMPS MY DEAR THEY NEVER TOLD US ANYTHING

De Gaulle lays wreath at the monument to four million people killed by the Nazis at the Auschwitz concentration camp. Polish president Edward Ochab is second from right

US planning 'death ray' weapon

FROM OUR OWN CORRESPONDENT

New York, Sept. 5

The United States Atomic Energy Commission is pressing research towards a neutron bomb — an enhanced radiation weapon crudely described as a sort of death ray. In a joint statement the A.E.C. and the Defence Department said.

"Such a device would be very 'clean'." The term 'very clean' would mean a device in which only a small amount of the energy released would come from fission. The blast effect would be very small, but the radiation effect from neutrons would be predominant.

The A.E.C. is also conducting research on pure fusion weapons.

The statement said:—

The United States has a stockpile of tens of thousands of individual nuclear weapons, ranging in power from less than a kiloton (the equivalent of 1,000 tons of T.N.T.) to several megatons (millions of tons of T.N.T.).

They include artillery-fired projectiles, atomic demolition munitions, anti-submarine rockets and torpedoes, depth charges, strategic and tactical missiles, and bombs.

Chinese tests

Overall, the departments believe the United States maintains a nuclear weapons superiority over the Soviet Union.

"The Chinese nuclear tests to date", the statement observes, "indicate a rational, well organized nuclear weapons development programme.

"A launch of an intercontinental ballistic missile test vehicle by China this year would be necessary if they are to meet the most rapid deployment schedules considered possible. . . . There will be a period of testing and missile improvement.

"If the Chinese then achieve a first operational I.C.B.M. capability in the 1970-1972 period, it is possible they will have a significant deployment in the mid-1970s."

292 SCIENCE FOR ALL.

indeterminate veracity for vegetable substances, we will be able to form some idea of how locusts vegetation. Till after the first moult (that is, that enveloped them when first hatched) they, however, do not commence to migrate. After that, having eaten up all the food in their vicinity, they are forced to set out on their travels in search of more food. They march, often in a swarm a mile or two wide, during the warmer hours of the day, clearing out everything eatable in their path. When they come to wood they first of all clear out the brushwood, and eat the dead leaves and bark.

Fig. 7.—Migratorious or the Locust Locust (Acridium peregrinum).

LOCUSTS AND GRASSHOPPERS. 293

by their great numbers soon clear the ground of vegetation. . . .

Text. "Science for All". Edited by Robert Brown, London, 1893.

Photo. Sunday Times, 10.9.1967. Above. The Times, 6.9.1967.

DIAS INFORMATION 4. September 1967.
From: BM/DIAS, London, W.C.1.

SHOCK

THE SUNDAY TIMES, 16 APRIL 1967

Under the title "SHOCK" - Ian Breakwell and the Bristol Arts Centre, 4-5 King Square, Bristol, 2, arranged; "Shock or an Evening at the Theatre" on June 3rd., and an exhibition of photographs and documentation from June 3-30. The exhibition is mounted with the co-operation of DIAS, and the 90 photographs on show are lent through DIAS. The exhibition includes, Brus, Canonico, Davies, Destructive Art Group of Buenos Aires, Ferro, Knizak, Latham, Muhl, Noblet, Nuttall, Ono, Ortiz, Vostell. "Given the situation on any news page of any newspaper, there would seem to be two creative alternatives. 1. to make images of "beauty", i.e. the answer to hate is a love poem - the exhibitions at the Arts Centre so far this year have been examples of this. OR. 2. to make images which show "what is on the end of every fork." (Burroughs). The current exhibition is an example of the second alternative". Ian Breakwell. 3rd. June, 1967

Programme of the evening on June 3rd. Overture, by Ron Geesin/Readings by Alan Burns, Carol Burns, Ken Smith. With music by the Ed Williams Trio/Performance - "Restaurant Operations" by Ian Breakwell/Performance - "A Nice Quiet Night" by The People Show. Written by Jeff Nuttall, with music by the Mel Davis Trio/Sound Poetry by the Osmaston Phonic. (John Hall: voice and alto, Geoff Casbolt: drums. Mick Casbolt: guitar)/Extracts from - "You'll Come to Love Your Sperm Test", with John Antrobus, Sal Lane, Mike Harvey/Films - Untitled by Ivor Davies/"Fireworks" by Kenneth Anger/"The Illustrated Chest" by Yoji Kuri/A lecture, "The Aesthetic of Revulsion" by Gustav Metzger, formed part of the "SHOCK" programme. The Bristol Arts Centre, a non-profit organization, has its own theatre, gallery, restaurant. It is part of the British Film Institute's structure in the provinces.

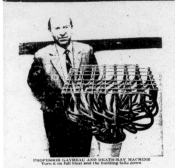

PROFESSOR GAVREAU AND DEATH-RAY MACHINE
Turn it on full blast and the building falls down

FUTURE

The future of DIAS is the subject of a policy statement issued in London in April. It is proposed to hold Destruction In Art Symposia in America, 1968: Japan, 1969: Sweden, 1970. The Symposia will be based on the principles of DIAS, London, 1966. Committees will be formed in the countries mentioned. Also- a world-wide communication network.

SOHM

"... preserving the ephemera of destructive art." archiv sohm, 7145, markgröningen, bahnhofstr. 38, germany.

ZAJ

Pronounced Zach (as Bach), this is a group of advanced musicians, writers and artists in Spain. It was formed in Madrid in July, 1964, by Juan Hidalgo, Walter Marchetti and Ramón Barce. Participants in ZAJ include Tomás Marco, Manuel Cortés, José Cortés, Ramiro Cortés, José Luis Castillejo. Apart from arranging concerts, exhibitions and festivals, ZAJ has published notices, calendars, scores and books. For details write to: Juan Hidalgo, Batalla del Salado, 1, Madrid-7, Spain.

1967

LIBERATION

international
CONGRESS
DIALECTICS
OF LIBERATION

a unique gathering
to demystify human violence in all its forms
the social systems from which it emanates,
and to explore new forms of action

R.D.Laing	**Gregory Bateson**	**S. Carmichael**
Sat July 15th. 3pm.	Mon July 17th. 10.30am.	Tues July 18th. 10.30.am.
Jules Henry	**Erving Goffman**	**Paul Sweezy**
Wed July 19th. 10.30. am.	Thur July 20th. 10.30.am.	Fri July 21st. 10.30.am.
Ernest Mandel		**Paul Goodman**
Mon July 24th. 10.30.am.		Tues July 25th.10.30.am.
Lucien Goldmann		**John Gerassi**
Wed July 26th. 10.30.am.		Thur July 27th. 10.30.am.
Herbert Marcuse		**David Cooper**
Fri July 28th.10.30.am.		Sat July 29th. 3pm.

at the Roundhouse, Chalk Farm Rd. London N.W.I. 10/-per lecture (£4.15.0. entire series)

(Buses —68, 31, 24. Tube Chalk Farm.) 7/6 lecture students (£3.10.0. entire series)

Advance Tickets, Institute of Phenomenological Studies, the Roundhouse London

8 p.m. Saturday, July 22nd, 1967 **London**

Allen Ginsberg, Stokely Carmichael, R. D. Laing and others

DIAS INFORMATION 2. June 1967. Distributed by: BM/DIAS. London. W.C.1. England.

[July 19] A three-day trial of the organizers of DIAS begins in the Old Bailey, London. They are charged with initiating and running an indecent exhibition: Hermann Nitsch's *21. Aktion* (21st action) on September 16, 1966 for DIAS.

The center of the action in the St. Bride Institute in London is the same as previous actions—the laceration of a slaughtered and skinned lamb. During the action, visitors are asked to pour blood that they have been given in test tubes onto a wound an actor has made in the lamb's side. For the first time, the action is accompanied by a ten-man scream choir and a sixteen-strong noise orchestra. Peter Weibel directs the orchestra, which also includes a jerry can and a pot lid in addition to a piano. The action is interrupted every three minutes, the lights in the room are turned off and for one minute an 8-millimeter film is projected onto a sheet on which the lamb had been nailed—as if crucified—at the beginning of the action. The content of the film triggers police intervention and charges are brought against Gustav Metzger and John Sharkey.
The film shows a "Penisbespülung" (penis rinsing) in which the bloody brain of a cow is laid on a naked penis and blood, water, and egg yolk are poured over it while it is moved backwards and forwards with a string. Two journalists present consider the film shots to be obscene. They inform the police who, when they arrive, demand the offending film but are instead given an unexposed roll of 16-millimeter film.

Although neither Gustav Metzger nor John Sharkey have anything directly to do with the film screening since, as visitors, they are seeing it for the first time, they are still found guilty. Gustav Metzger is fined 100 pounds and Sharkey is put on probation.

At the same time as the trial, the congress "Dialectics of Liberation: Towards a Demystification of Violence" takes place in the Roundhouse, London, organized by two of the central, founding figures of "anti-psychiatry," Ronald D. Laing and David Cooper. Among the speakers are Herbert Marcuse and Gregory Bateson. Gustav Metzger's participation in the congress is restricted because of the DIAS trial. He attends the event after the trial, however, and meets Carolee Schneemann and John Plant.

1968

[January 22 through February 4] *Extremes Touch: Material/Transforming Art*, solo exhibition, Filtration Laboratory, Department of Chemical Engineering, University College of Swansea, Arts Festival, Swansea, Wales, organized by John Plant, a student at the time. Gustav Metzger uses the technical possibilities of the laboratory where the exhibition takes place to create kinetic works.

Three large sheets of Styrofoam are held aloft by air pressure; a hose, moving like a snake because of the escape of compressed air, controlled by means of a valve and an installation with a jet of water, makes an interior rainbow at around noon.

1968

Also exhibited are: *Mica and Air Cube*, a plexiglass cube in which colored, light-reflecting minerals (more precisely, mica flakes, a product used in silo technology) are kept in continuous motion by compressed air and *Drop on Hot Plate*, a water drop on a hot plate, which remains constant because the supply of water from the hose balances out the amount of evaporation. Also shown are the first mechanized *Liquid Crystal Projections*, which no longer have to be hand-regulated.

The planned open-air works are rejected for security reasons. The exhibition is documented on film.

Extremes Touch, 1968, Swansea, exhibition view

ARTS FESTIVAL '68

UNIVERSITY COLLEGE OF SWANSEA

EXTREMES TOUCH

MATERIAL/TRANSFORMING ART

CO-ORDINATED BY GUSTAV METZGER

In Filtration Laboratory, 294. Department of Chemical Engineering.

22nd January - 4th February, 1968.

Open Sunday to Friday 12 - 2, 4 - 6, Saturday 12 - 6.

Open to the public. Approached from main entrance of Applied Science block, signs guide to exhibition on the second floor.

The exhibition is arranged by the Arts Festival '68 Committee (Chairman: John Plant), with the assistance of the departments of Metallurgy, Chemical Engineering, Physics, Chemistry, and Electrical Engineering.

It is not possible to show all techniques in one period.
Exhibits marked in red are either hot or cold. Approach with care.

NO SMOKING

Materials and techniques employed. Water - jet, fall, atomized.

Main line compressed air. Floating structures. Liquid crystal phenomena

with electronically controlled continuous melting and cooling phases, - in

reflected light, and with projected polarized light. Expanded metal. Vacuum.

Nylon, copper, rubber and plastic tubes. Mica. Hot plates. Fibre optics.

Carbon dioxide. Liquid nitrogen. Dewar. Silicones. Polyethylene oxide.

Stroboscope. Graphite. Plastics. Hot air blower. Sound.

"Driven along in an incessant but variable movement some (atoms) bounce
far apart after a collision while others recoil only a short distance from
the impact those that do not recoil far being driven into a closer
union and held there by the entanglement of their own interlocking shapes . . ."
Lucretius.
Quoted on page 116 - L. S. Penrose, "Automatic Mechanical Self-Reproduction".
In New Biology, No. 28 Benguin Books, London, 1959.

BAPTIST & CONGREGATIONAL
JUDSON MEMORIAL CHURCH
55 WASHINGTON SQUARE SOUTH, N.Y.C. 12, N.Y. GRAMERCY 7-0351

JUDSON GALLERY 239 THOMPSON ST.

FRIDAY MARCH 22 1968 7-9 PM

DESTRUCTION ART SYMPOSIUM
D.I.A.S.—U.S.A. 1968 PREVIEW

DESTRUCTION EVENTS

COUNTRY	ARTIST	EVENT
AUSTRIA	HERMANN NITSCH	CARCUS MUTILATION
KOREA	NAM JUNE PAIK	SELF MUTILATION
USA	AL HANSEN	SADOMASO
USA	BICI HENDRICKS	ICE BREAKING
USA	CHARLOTTE MOORMAN	DESTRUCTION
USA	RALPH ORTIZ	THE DEATH OF WHITE HENNY AND BLACK PENNY
USA	LIL PICARD	SOFT BURNINGS AND COAL FEATHERS

NO ADDMITION CHARGE

SENIOR MINISTER: HOWARD MOODY

1968

[March 22 through April 4] Following the exam-
ple of the *Destruction in Art Symposium* (DIAS)
in 1966 in London, the artists Jon Hendricks
and Ralph Ortiz organize the *Destruction in
Art Symposium USA* (DIAS–U.S.A. 1968) in the
Judson Gallery in New York. Participating
artists are Al Hansen, Bici Hendricks, Charlotte
Moorman, Hermann Nitsch, Nam June Paik,
Ralph Ortiz, and the ethnic German art critic Lil
Picard. In the courtyard of the Judson Memorial
Church and in the exhibition spaces, a number
of actions take place, including Hermann
Nitsch's 27th action with a skinned lamb carcass
and Nam June Paik's piece, *One For Violin
(Solo)*, performed by Charlotte Moorman.
During the performance of the piece, which
consists of the performer smashing a violin on
a table, an incident occurs: a visitor attempts
to prevent the violin being destroyed by lying
on the table on which Charlotte Moorman is
supposed to smash the instrument. As a result,
Moorman smashes the violin on the head and
arms of the visitor who suffers slight injury.
As a reaction to the assassination on April 4
of Martin Luther King Jr., the black civil rights
champion and Nobel Peace Prize winner, the
symposium is cut short.

plundring
mbat Hué

• *I medicinska fakulteten vid Hués universitet fann marinsoldaterna det här skelettet när de slog sig fram till universitetsområdet efter tio dagars strider. Det fick följa med ut till granatkastarställningen.*

Leaflets that have reached London recently announce that "DIAS-U.S.A.-68" will take place in the last week of April and the first week of May in the Judson Gallery, which is part of the Judson Memorial Church, 55 Washington Square South, New York, N.Y. 10012. The activities include a symposium, events and an exhibition. A four page statement released in New York last September states that "DIAS-U.S.A.-68" is modelled on DIAS - Destruction In Art Symposium, London, September, 1966.

Johnson sitt stöd. da till

• *En bild av East 3rd Street, Manhattan, som gatan såg ut innan renhållningsarbetet återupptogs.*

NEW YORK: DIAS INFORMATION 5. March 1968. Published by BM/DIAS, London, W.C.1.

DIAS-Information, No. 5, March 1968

Gustav Metzger does six months of research for an article about automata commissioned by Peter Townsend, editor of the art magazine *Studio International*. The article, "Automata in history" appears in two parts in *Studio International* (March and October 1969). During his research, Gustav Metzger meets author Jonathan Benthall who is interested in the connection between art and science and who repeatedly publishes on this subject.

[May] *Theory of Auto-Destructive Art*, lecture at the Anti-University in London, an institution which exists for a short time only.

[May] *Theory and Practice*, lecture, Blackheath Art Society, London.

[May 10 through June 20] The Finch College Museum of Art, New York, shows the highly acclaimed exhibition *Destruction Art. Destroy to Create*, curated by Elayne H. Varian, in which important representatives of Destruction Art are shown including Arman (real name Armand Pierre Fernandez), John Latham, Ralph Ortiz, Niki de Saint Phalle, Jean Tinguely, and Jean Toche.
The exhibition is the last major event where Destruction Art is depicted as an international movement.

1968

Destruction Art, Finch College Museum of Art, New York, 1968, catalogue

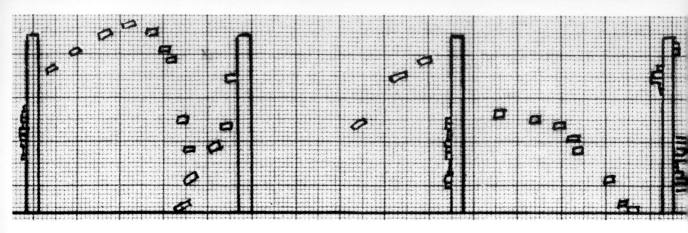

Five Screens with Computer, 1969,
Computer-controlled *Auto-Destructive Monument*, drawing, model, two computer graphics

1968

[June 7] At the University of Vienna, the *Kunst und Revolution* event takes place with Günter Brus, Otto Mühl, Franz Kaltenbäck, Peter Weibel, and Oswald Wiener. At the event, proceedings being run simultaneously lead to heavy criticism from the public. Günter Brus, Otto Mühl, and Oswald Wiener are arrested. In 1969, Günter Brus and Oswald Wiener leave for exile in Berlin.

Mark Boyle accompanies rock musician Jimi Hendrix's U.S. tour with a light show.

[August through October] The exhibition *Cybernetic Serendipity: The Computer and the Arts,* curated by Jasia Reichardt, opens at the Institute of Contemporary Arts (ICA) in London. It is the first exhibition attempting to present all aspects of computer-assisted creative work in different areas: art, music, poetry, dance, sculpture, and animation. The aim of the exhibition is to examine the role of cybernetics on modern art. The exhibits are robots, poetry, music, and drawing machines as well as various kinds of artworks in which coincidence plays a decisive role. Further venues for the exhibition in the U.S. are the Corcoran Gallery, Washington D.C. and the Palace of Arts and Science, San Francisco.

The Computer Arts Society is founded—as a branch of the British Computer Society—by architect John Lansdown and computer music pioneer Alan Sutcliffe.

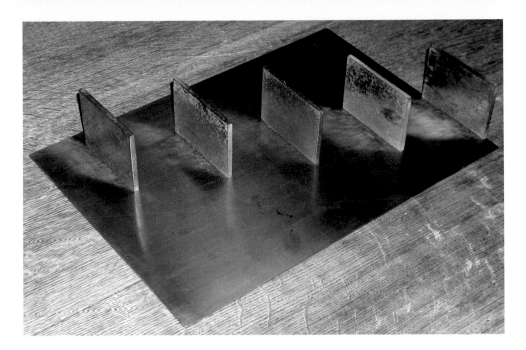

1969

[March 29 and 30] Metzger participates in the exhibition *Event One*, Computer Arts Society, Royal College of Art, London, with the project *Five Screens with Computer*, his biggest project for a computer-controlled *Auto-Destructive Monument*, to which he devotes himself until 1972. He produces models and computer graphics for it. The technically demanding project has not yet been realized.

Metzger begins his job as the publisher of PAGE, the *Bulletin of the Computer Arts Society* (1969–1973).

1969

[July 16 through 24] The U.S. astronauts Neil Armstrong and Edwin Aldrin take off for the moon, land there on July 21, and return safely to earth on July 24. The lunar rocket Apollo 11 was developed under the leadership of Wernher von Braun who constructed the German V2 rocket and the first U.S. intercontinental ballistic missiles.

11 September OUTFACE – THE ARTIST WITHIN THE TECHNOSTRUCTURE
Stroud Cornock

9 October THE HUMAN END OR PAINTING PROGRAMMED
Colin Sheffield and Mike Thompson

13 November ART AND BEHAVIOURAL SCIENCE
George Mallen

11 December COMPUTERS FOR MUSIC
Alan Sutcliffe

These meetings are open to members and guests. There is no charge for admission.

PUBLIC MEETINGS

Because of the excess of expense over income it has been decided not to continue the series of public meetings that were held in the Nash House Cinema.

AIMS AND MEMBERSHIP

The aims of the Society are to encourage the creative use of computers in the arts and allow the exchange of information in this area.

Membership is open to all at £1 or $3 per year; students half price. Members receive PAGE and reduced prices for Computer Arts Society public meetings and events. The Society has the status of a specialist group of the British Computer Society, but membership of the two societies is independent.

Libraries and institutions can subscribe to PAGE for £1 or $3 per year. Extra copies will be sent to the same address at half price. No other membership rights are conferred and there is no form of membership for organisation or groups. Re membership, subscription, circulation and information, write to Alan Sutcliffe.

BULLETIN OF THE COMPUTER ARTS SOCIETY
AUGUST 1969 SIXPENCE

PAGE

PAGE welcomes information regards events relevant to the Society taking place in any part of the world. Views expressed are those of individual contributors. This number designed by Malcolm Le Grice.

COMPUTER ARTS SOCIETY ADDRESSES

Chairman Alan Sutcliffe ICL Brandon House Bracknell Berkshire
Secretary John Lansdown 50/51 Russell Square London WC1
Editor of PAGE Gustav Metzger BM/Box 151 London WC1

Elektronische Computergrafik. Beckmann/Gähl 70.

[April] Gustav Metzger takes part in the inaugural meeting of the British Society for Social Responsibility in Science (BSSRS). President of the BSSRS is biophysicist Maurice Wilkins who, together with James Watson and Francis Crick, was honored with the award of the Nobel Prize for Medicine for the discovery of the molecular structure of DNA. Maurice Wilkins is also the founder of the BSSRS team for Art & Science to which Gustav Metzger belongs. The meetings of the Art & Science group take place every two weeks in Wilkins's laboratory in King's College, London.

1969

[May 5 through August 30] Metzger participates in the exhibition *Computers and Visual Research*, Zagreb, Yugoslavia (today's Croatia) with models and computer graphics for the project *Five Screens with Computer*.

[July] *On the Possible*, lecture, Portsmouth College of Education, Portsmouth, Great Britain.

[Autumn] *The Social Relevance of Art*, lecture, Slade School of Fine Art, University College of London, organized by Stuart Brisley.

1970
[February 4] *Do You Eat?*, lecture, Slade School of Fine Art, University College of London, organized by Stuart Brisley.

[April 14 through 16] Metzger delivers two papers at the congress "Computer Graphics '70," Brunel University, Uxbridge, Great Britain.

Metzger translates a book by computer graphics pioneer Herbert W. Franke, *Computer Graphics, Computer Art,* which is published by Phaidon Press, London.

H.W. Franke, *Computergraphik Computerkunst*, Munich 1971

Do you Eat?

Where does the money come from?

 (a) Private funds
 (b) State funds
 (c) Sale of work
 (d) Through being employed

Does it matter where your money comes from?

Do you feel responsible towards society?

 (a) Are you doing anything about it now?
 If so, what is it that you are doing?

 (b) Do you plan to affect society at some
 time in your future? If so, will it
 be in the field of the arts?

1970

The Artist in Technological Art and Social Responsibility?
A talk by Gustav Metzger in the Reading Room, Slade School,
University College London. 4 February 1970. 6 p.m.

[September 5 through November 22] Although he is not invited, Gustav Metzger shows his *Mobbile* at the opening of the exhibition *Kinetics*, Arts Council of Great Britain, Hayward Gallery, London. It is an automobile with an (initially transparent) plastic box mounted on its roof into which its own exhaust gasses pass. On September 4, the car is driven to the area around Waterloo Bridge and is parked there. On the following day it is parked in the upper class area around Bond Street.

[October 2] *Metzger Retrospective*, National Film Theatre 2, London, lecture and presentation with discussion, film, slides, and projections. The cinema seats are packed in newspaper to provoke a Happening right from the start.

1970

[October] Gustav Metzger organizes the London demonstration of the International Coalition for the Liquidation of Art. Approximately 60 persons respond to the Coalition's call and carry out a sit-down strike inside and outside the Tate Gallery.

[November 6 through January 6, 1971] Metzger is invited to participate in the exhibition *Happening & Fluxus*, Kölnischer Kunstverein, Cologne. He does not exhibit in the show but is represented in the publication.

1970
[January] The rock opera *Tommy* by The Who premieres in the London Coliseum.

The book *Wien. Bildkompendium Wiener Aktionismus und Film*, a historical compendium on Viennese Actionism, is published in Vienna by Peter Weibel with VALIE EXPORT as his collaborator.

[November] Exhibition *Software. Information Technology. It's New Meaning for Art*, organized by Jack Burnham, opens at the Jewish Museum, New York. Participating artists include: Vito Acconci, Eleanor Antin, John Baldessari, Hans Haacke, Joseph Kosuth, Allan Kaprow, and Lawrence Wiener.

Mobbile, 1970

1971

[1970 through 1971] He creates designs for projects in public spaces in London (for the South Bank, the Royal Festival Hall, and the Thames under Waterloo Bridge). For the South Bank, Gustav Metzger develops a plan to fill one of the arches of Waterloo Bridge in the form of a cube using stacked newspapers. He wants to use one wall of the Royal Festival Hall in the evenings for liquid crystal projections. The most extravagant project is a steel plate over the Thames. A large steel plate is held in place in the Thames under Waterloo Bridge by compressed air. When the Thames has reached its high-water mark (its level varies according to the rhythm of the tides), the air pressure increases causing the steel plate to rise a few centimeters above the surface of the water. It remains "afloat" until the water level of the Thames sinks again. The compressed air is to be produced by six precisely placed motors mounted on a raft-like float, smaller than the steel plate and lying below it, in the water. The office of Alistair McAlpine, heir to one of the biggest construction companies in England and patron of the arts, examines and confirms the technical feasibility of the project. City councilor Ellis Hillman presents the projects to the Greater London Council but they are rejected, except for the Thames project.

[August 11 through 30] Metzger shows *Mass Media Today* at the exhibition *Art Spectrum: London*, Alexandra Palace, London.
Metzger has four large walls available for the installation *Mass Media Today*. Every day he presents cuttings and complete pages from the English press, partly with machine-written critical commentary and partly without. For example, he presents the same day's *Sun* and *Daily Mirror* on top of each other, page for page. The process shows that the two papers are not only almost identical in format, but also in content, right down to the photo of the nude woman on page three.

1971

Dennis Meadows Donella Meadows
Erich Zahn Peter Milling
Die Grenzen des Wachs-tums
Bericht des
Club of Rome
zur Lage
der Menschheit

rororo sachbuch

1972
The study *Limits to Growth* by Dennis Meadows, commissioned by the Club of Rome, is published. The problems of the damage and destruction to the environment (pollution and poisoning of seas and rivers, air pollution, pollution-related death of forests and the salinization and desertification of the soil, and species extinction) and their long-term consequences gain their first wider public audience.

On January 30, 1972, thirteen civilians taking part in a peaceful civil rights demonstration in the Catholic district of Bogside, Derry (Londonderry) in Northern Ireland are shot by British army soldiers. The cause of the shootings has never been fully explained.

1972
[February] Gustav Metzger attends Joseph Beuys's action *Information/Action* in the Tate Gallery, London, and takes part in the discussion with the German actionist artist. It is Beuys's first visit to London.

1972

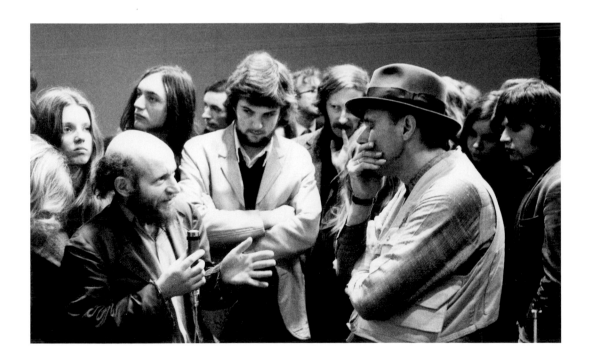

Gustav Metzger, Joseph Beuys, 1972, Tate Gallery, London

Gallery House London

Gallery Director **Sigi Krauss** Assistant Director **Rosetta Brooks**

Inaugural Show
3 LIFE SITUATIONS
29.3.–15.4 1972

**Gustav Metzger
Second Floor**

**Marc Chaimowicz
First Floor**

GALLERY HOUSE

**Stuart Brisley
Ground Floor**

German Institute 50, 51 Princes Gate, Exhibition Road London SW7 2PG Tel 01-589-7207 / 3648.

3 Life Situations, 1972, Gallery House, London, folder

[March 29 through April 15] Participates in the exhibition *3 Life Situations*, Gallery House, London. The exhibiting artists, Stuart Brisley, Marc Chaimowicz, and Gustav Metzger, are assigned one floor each. This is the first exhibition in Gallery House, which at that time is affiliated with the Goethe Institute. Gustav Metzger has all rooms on the second floor at his disposal. The rooms are laid out in a row, one after another, but are not connected with each other and can only be entered individually from the hallway.

In the first room, he presents the model for *Stockholm June*, a project he drafted in connection with the first UN Environmental Conference in Stockholm in 1972.

In the second room, designs for realized and unrealized projects in public space are presented.
Projects Realised I (Monument to Bloody Sunday) shows a large building opposite the Institute of Contemporary Arts in London, which Gustav Metzger declares to be a monument for Bloody Sunday in Northern Ireland.
Projects Unrealised concerns the projects Gustav Metzger presented unsuccessfully to the Greater London Council in 1971. However, the *Projects Unrealised* are "realized" and shown as large-format photo montages made by artist Birgit Burkhardt (a student at the Slade School of Art at the time) following suggestions by Metzger.

164

The next two rooms are dedicated to the work
Controlling Information from Below. In the first
room, stacks of newspapers and magazines
are made available for visitors along with
tables, seating, scissors, paper, and glue.
Written on the wall is: "SMASH IT" and under-
neath is a picture of Lenin from one of the
magazines. In the second room is a filing
cabinet and a cassette recorder. Visitors are
requested to pin cuttings or collages from the
newspapers on the wall and to make an
archive with the various newspaper reports.
Visitors do, indeed, produce collages for the
walls but neglect the offer to make an archive
and, in the end, want to set fire to the stack
of newspapers.

The last room is not accessible for visitors.
It is used for the preparation for *Controlling
Information from Below* and for small group
discussions.

The bathroom—including bathtub, shower,
and fresh towels—is left free for use; Metzger
wants to emphasize the aesthetic experience
of the bathroom with its steam, scents, and the
physical enjoyment of bathing.

Visitors are also welcome to use the kitchen.
Foods, such as rice and lentils, are available.
Metzger is not necessarily interested in cooking,
but in the activity of the rice and lentils during
the cooking process, which he links with
kinetic art.

1972

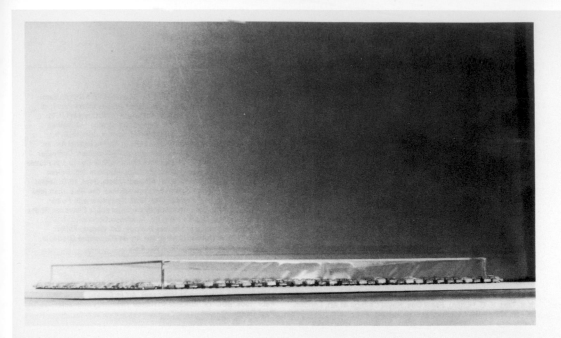

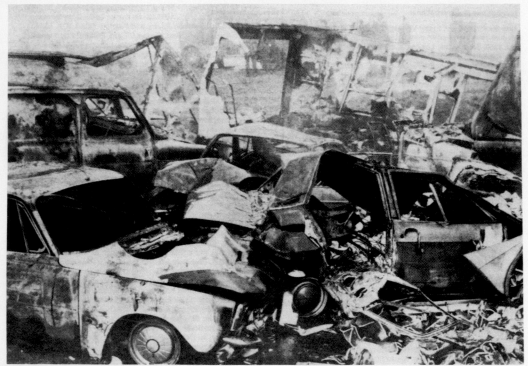

Stockholm June; ein Projekt für Stockholm 1.–15. Juni 1972.

Phase 1. 120 Autos werden Wagen an Wagen um einen rechteckigen, 2,5 bis 4 m hohen Bau, dessen Seiten aus durchsichtigem Plastik bestehen, aufgestellt. Das Plastik ist in regelmäßigen Abständen perforiert, um die Abgase herauszulassen. Die Abgase aller Wagen werden ins Innere der Struktur geleitet. Die Motoren laufen von frühmorgens bis spät abends.

Phase 2. In der Nacht zum 14. werden sämtliche Autos in den Bau hineingebracht, säuberlich hintereinander an den Seiten aufgereiht, die Maschinen mit Benzin gefüllt und gestartet. Die Struktur wird nun mit einer undurchlöcherten Plastikhülle überdeckt und verdichtet. Falls bis zum Mittag des 15. die Wagen nicht in Flammen aufgegangen sind, werden kleine Bomben in die Skulptur hineingeworfen.

16 · 56

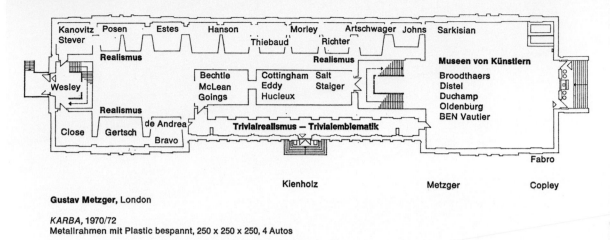

Gustav Metzger, London

KARBA, 1970/72
Metallrahmen mit Plastic bespannt, 250 x 250 x 250, 4 Autos

Documenta 5, 1972, accompanying catalogue

1972

[April] *Unrealizable Disintegrative Architecture and Other Projects*, solo exhibition, Architectural Association (AA), London. Musician Brian Eno and architect Bernard Tschumi visit the exhibition lecture.

[June 30 through October 8] He is invited to take part in *Documenta 5*, Kassel, by curator Harald Szeemann.
Metzger conceives the project KARBA, a reduced version of *Stockholm June*. For the duration of the exhibition, the exhaust from four autos is to be fed into a transparent plastic cube with a side length of approx. three meters. It then becomes discolored and opaque because of the accretion of exhaust fumes. Although the location for KARBA appears on a diagram in the catalogue accompanying *Documenta 5*, the project is not realized. Also documented in the exhibition catalogue for *Documenta 5*, is the likewise unrealized project *Stockholm June*.

[September 23 through October 15] Metzger participates in the exhibition *British Thing*, Henie Onstad Kunstsenter, Hovikødden, Norway. Gustav Metzger's contribution to the exhibition consists of an offer of a free massage for exhibition visitors. The massages take place in the museum in a separate, private room, which is closed during the massage treatment.

THE INSTITUTE OF CONTEMPORARY ARTS.

Executive Profile presented by GUSTAV METZGER

The growing concern over environmental issues is undermining
faith in Capitalism; even Heads of State at the E.E.C.
Paris Summit had to adopt a posture condemning GROWTH as
the ultimate good.

Consequent on this shift in public opinion, the City and
Business pages of newspapers, and the magazines devoted to
finance and business, are turning into ghettos where the
old maladjusted, dangerous, and intellectually and morally
retarded attitudes, are being maintained and encouraged.

The Executive Profile exhibition will assemble a large collection
of images of executives with typed comments by the exhibitor
demonstrating this point. The material, dating from
1968, comes from The Times, Observer, Sunday Times, Financial
Times, Campaign, The Director and other sources.
The exhibition forms part of the ICA's programme THE BODY
AS A MEDIUM OF EXPRESSION, and special emphasis will be
placed on physical and psychological states. An automatic
photographic studio will form part of the show, so that
visitors can affix their own image next to their comments
on the exhibition. Pre-prints of an article on the exhibition
by Metzger to appear in the December number of Studio
International will be available.
Gustav Metzger pioneered the theory of auto-destructive
art and auto-creative art in 1959, and has since made a number
of theoretical and technical contributions. The Documenta
5 catalogue surveys his work and writings.

For further information on the exhibition please contact
Giana Luke or the Press Office on 930 0493.

168 *Executive Profile*, 1972, ICA, London, exhibition text

[November 24 through December 22] *Executive Profile*, solo exhibition for *The Body as a Medium of Expression*, Institute of Contemporary Arts (ICA), London. He exhibits cuttings showing photos of people in leading positions in industry and commerce (executives) taken from the business section of various newspapers with added commentary. These articles and photos are ordered according to categories, e.g., directors posing with the origins of their wealth—whether models, real estate or munitions —or photos of captains of industry used for advertising etc. Visitors receive a pre-printed form and are requested to fill in their personal information. They are also asked to hand in the completed form along with a photo, which they can have made in a machine installed in the exhibition.

Ethics of the Art/Science/Technology Link, lecture, Leicester Polytechnic and Kingston Polytechnic, Leicester, Great Britain. After the lecture, a *Mobbile* is driven through the city center.

Election to deputy chairman of the Artists' Union in London. The Artists' Union is an attempt to unionize artists, as an initiative to represent the political interests of visual artists. Other members of the Artists' Union include Mary Kelly (chairperson from 1972–1974), Stuart Brisley, Marc Chaimowicz, and Peter Sedgley.

1972

Mary Kelly, Artists' Union poster, 1972

169

Art into Society – Society into Art, 1974, ICA, London
Gustav Metzger and Joseph Beuys

1974

[October 30 through November 24] Metzger is invited to take part in the exhibition *Art into Society – Society into Art. Seven German Artists*, ICA, London, curated by Christos Joachimides and Norman Rosenthal.

Along with Metzger, others invited to take part are: Albrecht D., Joseph Beuys, KP Brehmer, Hans Haacke, Dieter Hacker, and Klaus Staeck. Because of his critical position vis-à-vis the art industry and its mechanisms, Gustav Metzger demonstratively does not exhibit. Instead, in the catalogue he calls for *Years without Art 1977–1980*—a call which will be taken up again and propagated by artist and author Stewart Home in 1985 under the name *Art Strike*—and he announces a change from art production to theory. Gustav Metzger follows the Beuys actions in the exhibition and on November 1 takes part in a panel discussion with the artists. The crowds are immense.

During the German Month in Great Britain, which included the exhibition in the ICA, he meets the German artist and art historian Cordula Frowein. Metzger and Frowein begin a long collaboration involving a series of books and other projects.

Art into Society – Society into Art, 1974, ICA, London, Gustav Metzger

1974
[October 15 through December 8] The exhibition
*Kunst im Dritten Reich: Dokumente der Unter-
werfung* (Art in the Third Reich: Documents
of Submission) opens in the Frankfurter
Kunstverein. It is a collaborative work between
the Institute of Art History of the University
of Frankfurt and the political scientist Iring
Fetscher. A catalogue for the exhibition is
published by Georg Bussmann, art historian,
curator, and head of the Frankfurter Kunstverein.
(Two years later, Bussmann takes part in the
symposium *Art in Germany under National
Socialism*, organized by Gustav Metzger
together with Cordula Frowein in London.) It is
the first post-war exhibition to deal scientifically
with National Socialist art production. Further
German venues for the exhibition are Ham-
burg, Stuttgart, Ludwigshafen, and Wuppertal.

1975
At the Asimolar Conference in California,
government safety regulations for dealing with
genetic engineering in the U.S. are worked out.
These serve as a model for the European
genetic engineering laws which follow.

[November] The Sex Pistols make their first
public appearance at St. Martin's School of
Art in London. Punk rock is born.

1976

[April 10] *The Role of the Art Magazine*, panel discussion with Gustav Metzger, the artist Dan Graham, Dave Rushton, and the art historian Paul Wood, as a part of "Art Libraries Society International Conference on Art Periodicals," University of Sussex, Great Britain, organized by librarian and art historian Clive Phillpot.

[September 17 through 19] Together with Cordula Frowein, Gustav Metzger organizes the symposium *Art in Germany under National Socialism* (AGUN). It takes place at the School of Oriental and African Studies, University of London and in the Drill Hall, London. For this first, three-day, scientific symposium on National Socialist art, architecture and design, eighteen scholars from West Germany, England, and the U.S. meet in closed sessions on the subject. Accompanying the symposium, a collection of SS Allach porcelain is shown at the University of London. Allach porcelain is high-quality china produced during the Third Reich exclusively as gifts for high-ranking SS members and other leading National Socialists. The porcelain factory in Allach, near Munich, was founded in 1936 on Heinrich Himmler's orders especially for this purpose and was not profit oriented— contrary to other enterprises owned by the SS. The best porcelain designers, artists, and craftsmen in Germany were put under contract for the design and production of objets d'art and porcelain figures. The English private collection of SS Allach china shown for AGUN comprises 75 items of the finest quality.

1976

1976

In San Francisco, the first gentech company is founded: Genentech Inc.

[September] The first British punk festival takes place at the 100 Club in London with punk bands the Sex Pistols, the Clash, the Damned, etc. In November, the Sex Pistols' first single, *Anarchy in the UK*, appears on the EMI label.

Sex Pistols poster, 1976

AGUN International Symposium
Art in Germany
Under National Socialism
London 17–19 September 1976

1. The first international symposium on art in the Third Reich
 will be conducted in English and German. Attendance will
 be by invitation, and restricted to fifty contributors and
 participants.

2. Contributors will present a paper embodying recent research.
 Papers or recordings can be in English or German.
 Contributors will not pay the symposium fee.

3. Participants will share in the work of the symposium and
 can join the discussions. Participants will pay the
 symposium fee of £9 before the opening of the proceedings.

4. The AGUN Symposium is being organized by Gustav Metzger,
 assisted by Cordula Frowein, who are fluent in German.
 Correspondence will be conducted in English, but letters
 addressed to the organizer in German are welcome.

5. The AGUN Symposium has no funds to assist with travel or
 other expenses of contributors or participants.

6. The organizers will not be responsible for the publication
 of the symposium proceedings. They would be glad to hear
 from anyone who would like to publish the proceedings, or
 assist with the editing of the material.

7. Participants and contributors are requested to send a
 biographical note listing studies, appointments, publications,
 lectures, etc. to reach organizers by 30 June 1976.

8. Contributors need to send title of paper and outline
 (200 - 500 words) to reach organizers by 30 June 1976.

9. Contributors unable to attend the symposium should send
 paper or tape recording to reach organizers by 15 August 1976.
 A tape recording must be accompanied by a typed version of
 the full text. Recordings to be played on a cassette recorder.

10. The presentation of a paper at the symposium should not
 exceed 40 minutes.

11. Contributors wishing to project slides or film need to send
 technical information on their material, and the projection
 equipment the AGUN Symposium is to supply by 30 June 1976.

Communications to:
Gustav Metzger, British Monomark, Box 151, London, W.C.1.,
England.

**Art in Germany
Under National Socialism
London 17–19 September 1976**

AGUN International Symposium
British Monomark, Box 151, London WC1, England.
Gustav Metzger

Wolfgang Schäche
1 Berlin 31
Ringbahnstrasse 5

23 May 1976

Dear Mr. Schäche,

Please find enclosed some documents on our plans for the AGUN Symposium.

I would be grateful if you can send us some information on your work on the art of the Third Reich.

With thanks

Yours sincerely

Gustav Metzger

1977

Metzger participates in the exhibition *Towards another Picture*, Midland Group Gallery, Nottingham, organized by Andrew Brighton and Lynda Morris. In compliance with *Years without Art 1977-1980* Gustav Metzger shows anonymously. His project envisages that page three of the daily newspaper *The Sun* will be hung on the wall every day. As is common with tabloids, page three of *The Sun* shows a photo of a nude woman. Towards the end of the exhibition, it will be possible to see the pages of each edition side by side. However, the project is not properly executed and, instead of being presented alongside each other, the pages are presented piled on top of each other so that only the current page three can be seen each day.

[October 8 through 10] Metzger takes part in a conference on "Faschismus – Kunst und Visuelle Medien," Historical Museum, Frankfurt, organized by the Ulmer Verein. The organizers had all participated in AGUN 1976 and, inspired by it, initiated the event in West Germany. In the intensive discussions, Gustav Metzger maintains that Third Reich art should not be condemned wholesale as kitsch—a position he and Cordula Frowein had already taken at AGUN in London the year before. Contrary to the art historians present, who viewed National Socialist art production solely from a political standpoint and took almost no notice of its aesthetic qualities or, if they did, viewed them in an exclusively negative way, Metzger champions a serious confrontation with the aesthetic qualities of Nazi art and pleads for recognition of quality where it exists.

As a result of the conference in Frankfurt, a book is published in 1979 in Gießen, Germany: *Die Dekoration der Gewalt – Kunst und Medien im Faschismus*, edited by Berthold Hinz, Hans E. Mittig, Wolfgang Schäche, and Angela Schönberger.

1978

[April] Peter Weibel compiles the documentation exhibition *Wiener Aktionismus* as part of the *Internationales Performance Festival* at the Galerie nächst St. Stephan, Vienna.

1979

[September] The first *Ars Electronica* takes place in Linz, Austria. It is the first regular event that deals with the artistic possibilities and social consequences of digital technology.

1978

1980

Metzger explores the Frankfurter Schule and attends lectures and seminars given by the philosopher Jürgen Habermas. Conversations and correspondence with Kristine Stiles about her dissertation on DIAS at the University of California, Berkeley, U.S.

1981

[April 6 through May 2] Metzger participates in the exhibition *Vor dem Abbruch*, Kunstmuseum Bern. He shows an installation comprising copies of National Socialist publications listing all the anti-semitic laws from 1933 until 1943. Immediately after the exhibition, part of the work is shown again at the request of student representatives of the University of Bern under the title *Faschismus Deutschland: Darstellung Analyse Bekämpfen* [May 14 through 21].

[May 20] Metzger takes part in a discussion about the exhibition at the University of Bern. He is unsuccessful in talks with UN representatives in Geneva about further international venues for a more extensive traveling exhibition.

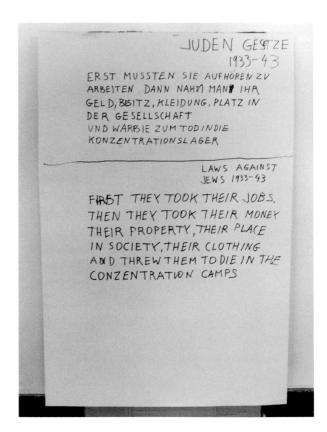

Vor dem Abbruch, 1981, Kunstmuseum Bern, board from the installat

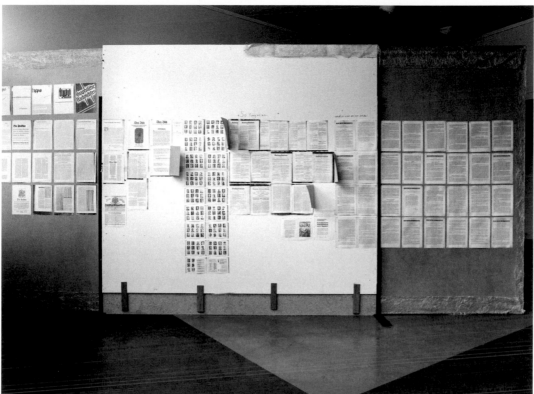

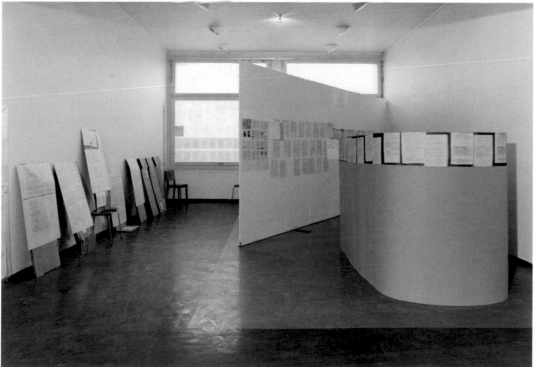

Vor dem Abbruch, 1981, Kunstmuseum Bern, exhibition views

erscheint wöchentlich
redaktionsschluss: freitag, 18 uhr
auflage: 3000

nr. 5/14.5.81

woka

wochenkalender
studentenschaft uni bern
erlachstr. 9, 3012 bern, tel: 23 00 03
druck: kopierservice, kramgasse 76
verantwortlich für die redaktion:
franziska teuscher

Die SUB organisiert zusammen mit dem Künstler Gustav Metzger
eine Ausstellung und eine Diskussion über den Faschismus.
Gustav Metzger verbrachte die Zeit von 1926-1938 in Nürnberg
und erlebte so als Kind das Aufkommen des Nationalsozialis-
mus in Deutschland. Da er Jude ist, musste er Deutschland
verlassen und erlebte den Krieg in England. Bis 1959 malte
Metzger und machte Skulpturen. Aus Unzufriedenheit mit seiner
Beschäftigung wandte er sich der Kunstgeschichte und dem
Thema "Kunst und Gesellschaft" zu. Er begann Zeitungsausschnitte
auszustellen. Für Gustav Metzger, einen deutschen Juden, war
und ist der Faschismus und dessen Beziehung zur Kunst und
Gesellschaft ein zentrales Thema. Zuerst stand die Kunst im
Faschismus für Metzger im Vordergrund, heute sind es mehr die
aktuellen Fragen zum Faschismus.
Da auf der ganzen Welt die Ideen des Faschismus neuen Auf-
schwung erhalten (militante Rechte in Spanien, die Regierung
Reagans), scheint es dem Künstler und uns wichtig, dass sich
alle mit dem Faschismus auseinandersetzen. Denn der Kampf
gegen den Faschismus ist nur möglich, wenn mensch ihn gut
kennt.

faschismus
- darstellung
- analyse
- bekämpfen

Veranstaltungen

14.-21.5. Ausstellung im Uni-Hauptgebäude, Eingangshalle
95% der ausgestellten Dokumente stammen von Na-
tionalsozialisten.
DO 14. und 21.5., 13.oo und 17.oo Führung von Gustav Metzger
durch seine Ausstellung
MI 20.5., 19.oo, HS 57: Diskussion mit Gustav Metzger (und
evt. noch einem weiteren Referenten) über Faschismus
heute, Kunst im Faschismus, Kunst zur Darstellung
des Faschismus.

Woka (Weekly calendar of the Student union, University of Bern), No. 5, May 14, 1981

178

Gustav Metzger, Klaus Staeck, and Cordula Frowein

[July 31 through September 13] Together with Cordula Frowein and Klaus Staeck, Metzger organizes the exhibition *Passiv – Explosiv*, Hahnentorburg, Cologne, a protest exhibition directed against the *Westkunst. Zeitgenossische Kunst seit 1939* exhibition, Messehallen, Cologne, curated by Kasper König and László Glózer [May 30 through August 16].

Passiv – Explosiv is held in the rooms of the professional association of visual artists in the Hahnentorburg. Shown for the most part are copies of texts and pictures along with books, documents, and posters. There are no art works or photographs. The exhibition is divided into various sections. One room is dedicated to documentation of the protest against *Westkunst*, others show documents relating to art trends not represented in *Westkunst* (Happening, Fluxus, concept art, political art, feminist art, etc.) or political events; in one room visitors can deposit additions while the so-called Museum Room deals with the question of how transient works of art can be adequately presented in museum spaces.

1981

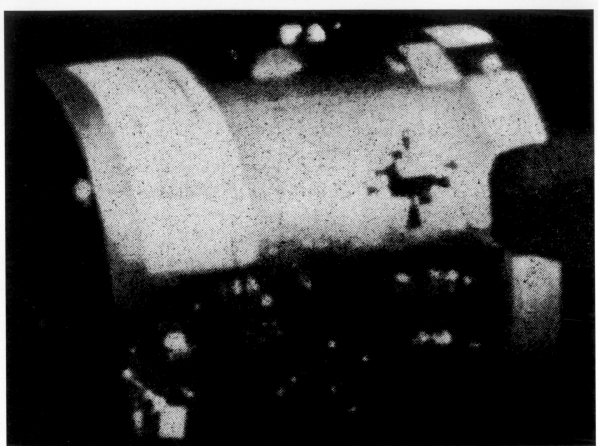

Fotos: NASA

PASSIV — EXPLOSIV

Entwurf einer Ausstellung

Kollektiv: Cordula Frowein, Gustav Metzger, Klaus Staeck
Architekt: Hanns Fritz Hoffmanns

Ort: BBK Köln Hahnentorburg Rudolfplatz Tel. 24 48 30

31.7.—13.9.81 täglich geöffnet von 11—19 Uhr
(außer montags)

Eröffnung Freitag 31. Juli 20 Uhr mit Gespräch

Abendveranstaltungen mit: Georg Bussmann, Jochen Gerz,
Christos Joachimides, Mauricio Kagel, Ulrike Rosenbach, Manfred Schneckenburger…

Direkte Verbindung zwischen Westkunst und Rudolfplatz: Straßenbahn-Linie 1 + 2

Verantw. i.S.d.P. Staeck 6900 Heidelberg Postfach 102063 Telefon 0 62 21/2 47 53

181 *Passiv – Explosiv*, 1981, Hahnentorburg, Cologne,
room 2, textile room; room 1, structure room

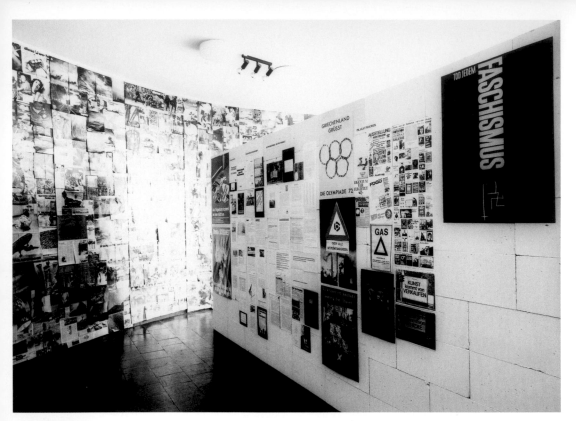

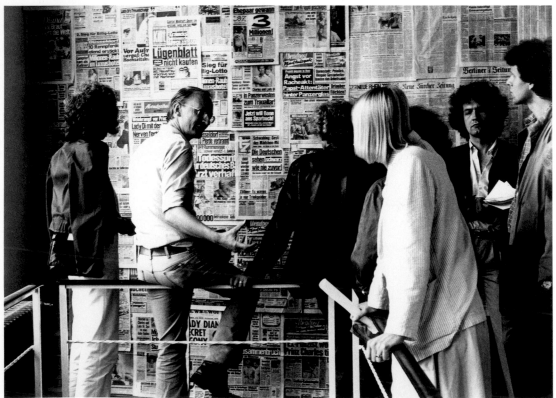

182 *Passiv – Explosiv*, 1981, Hahnentorburg, Cologne, room 6, political art

Within the context of his criticism, Gustav Metzger enters into a public debate in Cologne with the cultural scientist Bazon Brock who defends the *Westkunst* exhibition. At the conference of the International Council of Museums (ICOM) in Düsseldorf, Metzger criticizes a film about architecture, which is one of the films in a nine-part series, produced jointly with WDR in connection with *Westkunst*. At the final *Westkunst* public panel discussion where Joseph Beuys is the central figure, Gustav Metzger asks the question that has since become an anecdote: "Joseph Beuys, everybody is an artist: Himmler too?" After a short pause, Beuys answers affirmatively finally adding that Himmler would not have become Himmler if he had enjoyed a different education.

Auto-Destructive Art, lecture, Philosophy Department of the University of Frankfurt, Frankfurt, at the invitation of the Polish cultural scientist Stefan Morawski.

1982
[October] Metzger meets with the publicist Robert Jungk—who is active against atomic power—about planning *Convergence 84*, a project for 1984 that foresees bringing together as many revolutionary and radical leftist groups from around the world as possible (including those active against prevailing conditions) for a series of meetings. The idea to do this in 1984 comes from reflection on George Orwell's novel *Nineteen Eighty Four*. The project is not realized.

[Autumn] During a visit to Paris, Frank Popper asks Gustav Metzger to contribute liquid crystal projections for the planned exhibition *Electra*. Gustav Metzger proposes *The Button* instead, a complex multi-media project with viewer participation. The project thematizes the Mutually Assured Destruction Strategy (MAD) of the superpowers USA and USSR, which is based on both sides having a large enough atomic weapons arsenal to wipe out the enemy. The mutual deterrence thus achieved is regarded as a strategy to avoid atomic war. The concept behind *The Button* is initially greeted enthusiastically by the exhibition organizers but its realization is blocked in the end.

1983

[May 16 through 21] Metzger's work is documented in the Gardner Art Centre, University of Sussex, Great Britain.

[May 19] *Gustav Metzger on his Work*, *Lecture/Demonstration*, Visual Arts Society, University of Sussex, Great Britain. Both events are organized by Andrew Wilson.

[December] Gustav Metzger initiates Artists Support Peace.

1984

[February 15] Artists Support Peace organizes a celebration for peace in the Sandham Memorial Chapel in Burghclere, Great Britain. (The Sandham Memorial Chapel contains murals by Stanley Spencer created between 1927 and 1932. In the pictures, the artist deals with his World War I experiences.) Afterwards, there is a visit to the nearby Women's Peace Camp and a march to the missile base at Greenham Common. Both of Stanley Spencer's daughters take part in the march, as do Richard Hamilton, his wife Rita Donagh, and Norman Rosenthal.

From 1983 until 1990, U.S. atomic missiles are stationed at the former airfield at Greenham Common. The Women's Peace Camp is a provisional village of tents set up by women expressing their protest through a continuous siege of the missile base. The women's siege begins in 1981 when the planned stationing of Cruise missiles becomes known and continues even after withdrawal of U.S. armed forces in 1992 as a warning against atomic weapons. The camp is not closed until 2000.

The linking of women's movements and disarmament groups attracts worldwide attention.

In March, Artists Support Peace organizes a one-day action in Covent Garden Square.

1986

[November 22] Gustav Metzger and Cordula Frowein attend the celebrations to mark the opening of the Sohm Archive in the Staatsgalerie Stuttgart. There, Metzger meets the artist and Fluxus theorist Jon Hendricks as well as Gilbert and Lila Silverman, the couple who collect Fluxus art.

Gustav Metzger and Cordula Frowein attend various Fluxus events in Wiesbaden.

1983

In the U.S., the first transgenetic plants—
with foreign genes spliced in—are awarded
a patent.

1983–1987

After the superpowers U.S. and USSR sign
two agreements to limit strategic weaponry—
Strategic Arms Limitation Treaty, SALT I, 1972
and SALT II, 1979—the Cold War worsens in
1983. The cause of this is the U.S.'s stationing
of atomic missiles in Western Europe. The
move is accompanied by huge peace protests
in Europe.

It is only in 1985, after Michail Gorbachev
comes to power in the Soviet Union, that there
are renewed disarmament talks. In 1987, an
agreement to reduce the numbers of interme-
diate range nuclear missiles is signed (Interme-
diate Range Nuclear Forces, INF Treaty). This
envisages the removal of all intermediate range
missiles in Europe within three years.

1985

Artist and author Stewart Home publishes the
first flyer announcing the *Art Strike 1990–1993,*
which takes up and propagates the ideas in
Gustav Metzger's polemic *Years without Art
1977–1980.*

There are already 400 gentech companies in
the U.S.

1986

1986

[February 19] Launch of the first Soviet space
station MIR.

[April 26] The reactor explodes in the atomic
power station in Chernobyl, USSR; the maximum
credible accident happens.

A description of the cattle disease bovine
spongiform encephalopathy (BSE), which has
broken out in Great Britain, is published and
shows that the disease is transmitted by
infected meat and bone meal in animal feed.
The disease, also known as mad cow disease,
was first diagnosed in 1985.

1988
Metzger completes an extensive study of
German book design from 1927 to 1950. The
study has not yet been published.

1989
[April 3 and 4] Metzger talks with Justin
Hoffmann in Darmstadt about Hoffmann's
dissertation on Destruction Art. Further
meetings follow in London.

[Autumn] Metzger participates in the conference
"Wort und Bild" in Zurich.

1990
He begins research in Zurich art libraries for
a monograph on Johannes Vermeer and meets
artist Jean Tinguely for the first time, in Basel.

[Autumn] Trip to Italy.
Metzger meets with the archivist and collector
Francesco Conz and the Fluxus artist Ben
Patterson in Verona.
Attends the opening of Yoko Ono's exhibition
in Milan.

[November] Gustav Metzger begins planning
the work series *Historic Photographs*.

1988
The British government prohibits the use of
animal meal in animal feed, however, not the
export of animal meal. Infected animals have
to be slaughtered and destroyed.

1990
The Human Genome Project has its official
start in the U.S.; a government-financed
project to decode human genetic make-up.

The EU imposes an export prohibition for
British cattle older than six months. Cases
of BSE surface in Switzerland and Portugal.

The *Art Strike 1990–1993,* initiated by Stewart
Home, gets support and publicity in Great
Britain and the U.S.; Gustav Metzger is not
involved.

1990–1993

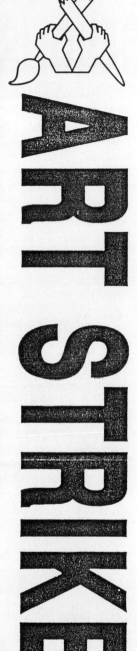

WE CALL ON ALL CULTURAL WORKERS TO PUT DOWN THEIR TOOLS and cease to make, distribute, sell, exhibit, or discuss their work from 1 January 1990 to 1 January 1993. We call for all galleries, museums, agencies, 'alternative' spaces, periodicals, theatres, art schools &c., to cease all operations for the same period.

Art is conceptually defined by a self-perpetuating elite and marketed as an international commodity. Those cultural workers who struggle against the reigning society find their work either marginalised or else co-opted by the bourgeois art establishment.

To call one person an 'artist' is to deny another the equal gift of vision; thus the myth of 'genius' becomes an ideological justification for inequality, repression and famine. What an artist considers to be his or her identity is a schooled set of attitudes; preconceptions which imprison humanity in history. It is the roles derived from these identities, as much as the art products mined from reification, which we must reject.

Unlike Gustav Metzger's Art Strike of 1977–1980, our intention is not to destroy those institutions which might be perceived as having a negative effect on artistic production. Instead, we intend to question the role of the artist itself and its relation to the dynamics of power within capitalist society.

Donations, letters of support, testimonials, enquiries &c., may be sent to either of the following addresses:

Art Strike Aktion Committee
(California)
PO Box 170715
CA 94117–170715
USA

Art Strike Action Committee (UK)
BM Senior
London
WC1N 3XX
UK

If you require a reply, please enclose an SAE (SASE) or IRCs.

1991

[Autumn] Metzger takes part in the "International Design Seminar" (INDESEM), which is organized every two years by students of the Technical University, Delft, Netherlands. Along with an installation with chairs and sofas made of balled Delft newspapers, a documentation of his earlier works is exhibited in the Department of Architecture, Technical University, Delft, Netherlands. During INDESEM Gustav Metzger meets Hermann Hertzberger, director of the Berlage Institute, Amsterdam (a research institute for architecture, urban studies, and landscape planning), and the architect Daniel Libeskind.

1991

Department of Architecture, Technical University Delft, 1991, installation and documentation

1992

Metzger makes sporadic visits to lectures and seminars at the Berlage Institute, Amsterdam, since 1992, where he talks with Kenneth Frampton, a U.S. architecture theorist.

[June] Metzger participates in an exhibition in Harry Ruhé's Galerie A, Amsterdam, with a model for *Earth minus Environment* and a two-page statement about the project. The unrealized project was created for the UN Environmental conference in Rio de Janeiro in 1992 and is a variation of *Stockholm June*.

[September 12 and 13] *Auto-Destructive Art*, event with lecture, Happening, light projections, and *Earth minus Environment*, V2 organisation, 's-Hertogenbosch, Netherlands, directed by Gustav Metzger, organized by Alex Adriaansen, Joke Brouwer, Rik Delhaas, and Eugenie den Uyl. V2 is a network of artists and theorists in the areas of electronic art, media, science, and technology.

Gustav Metzger writes *nature demised resurrects as environment*, which is planned as a contribution for a book by the V2 organisation, 's-Hertogenbosch (with Gustav Metzger, Roy Ascott, and composer Dick Raaijmakers). The essay appears in Gustav Metzger's first book, *damaged nature, auto-destructive art,* published by Coracle in London.

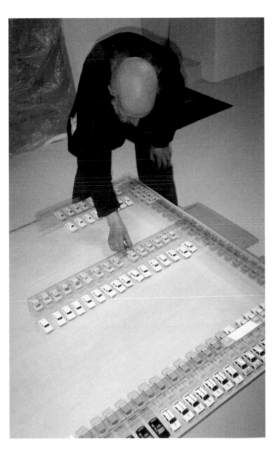

Earth minus Environment, 1992, model

1993

1993

[January] "Schoenberg-Kandinsky-Symposium," Royal Conservatory of Music and Gemeente- museum Den Haag, organized in The Hague by Hans Evers and J. L. Locher. On one of the evenings, Metzger shows his projections from the 1960s. He is awarded the Academy of Light Award together with Lev Termen (also Leon Theremin), inventor of the Thereminvox and other electronic instruments, and Oskar Fischinger, known in the 1930s for his abstract animated films. Fischinger's widow accepts the award on her husband's behalf.

[March 11 through June 13] Metzger participates in the exhibition *The Sixties: Art Scene in London*, Barbican Art Gallery, London, curated by art historian David Mellor. Metzger is repre- sented by documentation on *Auto-Destructive Art* and also DIAS.

Gustav Metzger makes the first plans for an Elements Centre in Amsterdam, which is to be dedicated to researching earth, water, and air in relation to art, architecture, design, and production, and which is to be housed in a nineteenth-century grain silo, which is under threat of redevelopment.

1991–2002

In July 1991, U.S. president George H.W. Bush and Soviet president Michail Gorbachev sign the START I agreement (Strategic Arms Reduc- tion Treaty). The agreement envisages a two- thirds reduction of both countries' atomic weapons from their highest levels at the height of the Cold War. The implementation of the treaty is delayed by the collapse of the Soviet Union on December 26. Nevertheless, START II is signed by Russian president Boris Jelzin and U.S. president George H.W. Bush in 1993. It envisages even deeper cuts in both countries' atomic weapons arsenals.

Eight years later, in 2001, the government of George W. Bush, the son of George H.W. Bush, revises this policy by unilaterally withdrawing from the 1972 agreement on limiting strategic arms and deciding to build an anti-missile defense system. With that, the strategy of using mutually assured destruction as a way of avoiding atomic war is weakened. The 2002 Nuclear Posture Review passed by the Senate envisages that the U.S.'s atomic weapons arsenal will be considerably extended in the following ten years. Atomic weapons research facilities throughout the country are to be re-activated.

1993

Approximately 800 British cows are infected with BSE every week.

1994

[August] *Johannes Vermeer and Cesare Ripa*, paper delivered at the Cesare Ripa Conference, University of Utrecht, Netherlands, organized by art historian Jochen Becker.

[December] *Vermeer and Freud's Fetish Theory*, paper delivered at the "Dutch Past" event, University College of London.

1995

[March 16] *Auto-Destructive Art and the Twentieth Century*, lecture at the invitation of the art historian John A. Walker, Art History Society, Middlesex University, London, organized by Marianne Turner and David Lowe.

[June 19 and 20] Metzger makes a statement at the conference "Embodied Knowledge and Virtual Space," Goldsmiths College, London, organized by artist and art theorist John Wood, who teaches at Goldsmiths College.

Metzger attends the events "Primo Levi and The Jews in Italy," University of London; "Technophobia," ICA; "Virtual Reality and the Gallery," Tate Gallery; "Beyond Fear and Envy: Demystifying Japanese Design," Design Museum; all in London.

1994

Genetically modified tomatoes come onto the market in the U.S.
Sainsbury's supermarkets carry the genetically modified tomatoes in Great Britain.

A prohibition comes into effect in the EU preventing the feeding of cattle with animal protein. More and more diseased animals born after the animal meal prohibition are found. The cause remains unclear.

1995

[September 29] *Damaged Nature. Two New Works and Documents*, solo exhibition workfortheeyetodo, Hanbury Street, London, organized by Simon Cutts, Erica Van Horn, and Maggie Smith. The first two works from the work series *Historic Photographs* are shown for the first time: *Historic Photographs No 1: Hitler addressing the Reichstag after the fall of France, July 1940*, 1995, and *Historic Photographs No 1: Liquidation of the Warsaw Ghetto, April 19 – 28 days, 1943*, 1995. Also shown is a model of *Earth minus Environment* newly produced for this exhibition.

The work series *Historic Photographs* uses large-format reproductions of important historical events. The photographs are presented in such a way that they are no longer, or almost no longer, visible or the viewer has to engage in some activity in order to see the photo.

Concretely, the first work group concerns two large photos of events during the Third Reich—Hitler's speech in the Reichstag in Berlin following the occupation of France on the one hand and on the other, the violent cleansing of the Warsaw Ghetto and the murder or deportation of the Jewish inhabitants living there under the most precarious of circumstances. However, both photos are covered so that they remain invisible for the viewer. Only the title and the specific presentation refer to the invisible photo and the historical event that it documents.

1995

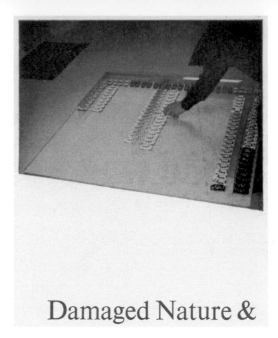

Damaged Nature &

workfortheeyetodo, invitation card

The *Historic Photographs* are the result of Gustav Metzger's decade-long involvement with photography. Although he does not make photographs himself as an art student he was interested in the problematic nature of the medium and its standing in art. Also, his involvement in auctioning historical photographs since the early 1970s in London increases his interest in photography, and not for economic reasons alone. At auctions he meets Sam Wagstaff an American collector of photographs and close friend of the photographer Robert Mapplethorpe. In the 1980s Gustav Metzger becomes increasingly fascinated by issues of photography. During a visit to Verona in fall 1990, the reports of the massacre on Temple Mount in Jerusalem in which Israeli police shoot around twenty Palestinians, lead to the planning of *Historic Photographs*.

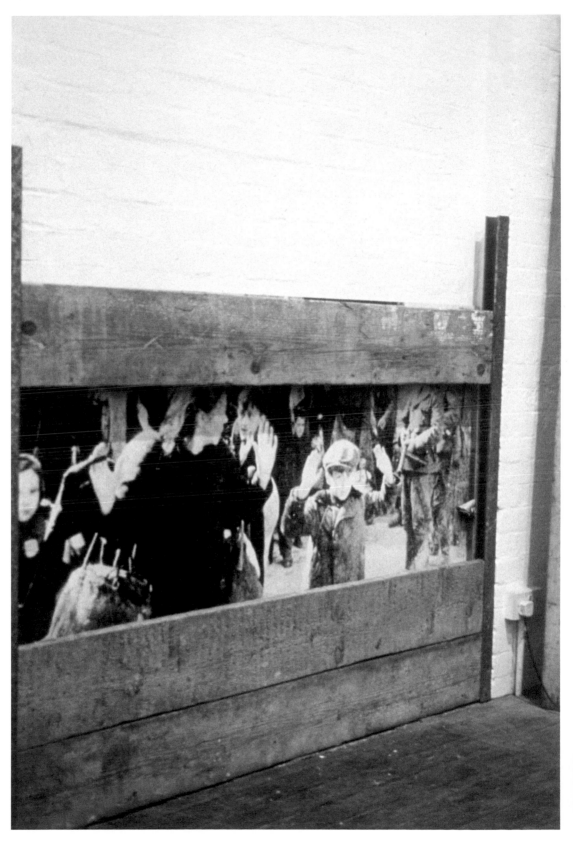

193 *Historic Photographs No. 1: Liquidation of the Warsaw Ghetto, April 19 – 28 days, 1943,* 1995,
Spacex Gallery, Exeter, 1999

1996

Mad Cows Talk, 1996, slide to the lecture

1996

[January 31] *The Exclusion of the Spectator in Art*, lecture, Hanbury Street Hall, and presentation of Gustav Metzger's book *damaged nature, auto-destructive art*, workfortheeyetodo, both in London.

[March 10] *A Little Talk on Architecture*, lecture, Neals Yard, Covent Garden, London, organized by Danish artist Lise Autogena/Autogena Projects.

[June 10] *Mad Cows Talk*, lecture, East West Gallery, Notting Hill, London, organized by Poets/Writers. The lecture is accompanied by 50 slides.

[October 5 through January 5, 1997] Metzger participates in the exhibition *Life/Live. La scène artistique au Royaume-Uni en 1996*, Musée d'Art Moderne de la Ville de Paris, curated by Laurence Bossé and Hans Ulrich Obrist. Gustav Metzger shows the two *Historic Photographs*, *To Crawl Into – Anschluss, Vienna, March 1938* and *To Walk Into – Massacre on the Mount, Jerusalem, 8 November 1990*, the model for *Earth minus Environment,* and the manuscript and slide series for his lecture *Mad Cows Talk*. The Fonds National d'Art Contemporain (FNAC) acquires the *Earth minus Environment* model. A further venue for the exhibition is the Centre Culturel de Belém, Lisbon, Portugal [January 23 through April 21, 1997].

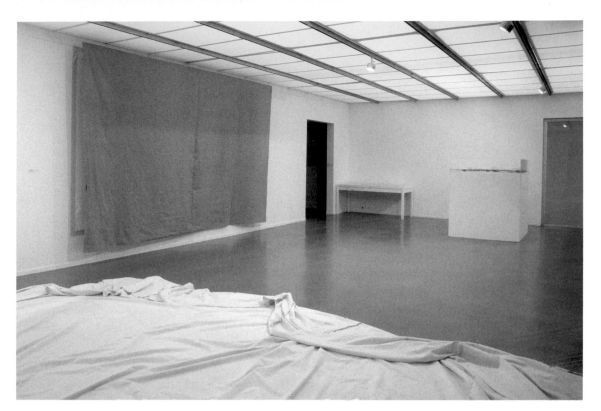

1996

Historic Photographs:
To Crawl Into - Anschluss, Vienna, March 1938, 1996
To Walk Into – Massacre on the Mount, Jerusalem, 8 November 1990, 1996
Musée d'Art Moderne de la Ville de Paris, exhibition view

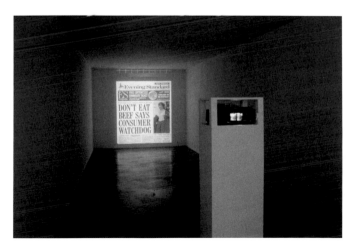

Mad Cows Talk, 1996, Musée d'Art Moderne de la Ville de Paris, exhibition view

195

[October 25 through November 17] Metzger participates in the exhibition *Made New. Barry Flanagan, Tim Mapston, Gustav Metzger, Alfred Jarry*, City Racing, London, curated by Andrew Wilson. For the show, Gustav Metzger reconstructs the *Cardboards* from 1959 with a short text that thematizes the problem of reconstructing a work in changed conditions. Appropriately, he does not show an exact replica of the work from 1959, but eight cardboard boxes which are, in turn, filled with compressed boxes. As with the previous *Bags* and *Cardboards* from 1959, they are found pieces from the street that Metzger shows as ready-mades. In addition, various documents about his work can be seen in a vitrine.

1996

[October 31] *From DIAS to Dunblane*, lecture for the event "In Memory of DIAS," with the Scottish artist Ross Birrell and Stewart Home, Centre for Contemporary Art (CCA), Glasgow, Great Britain, organized by Ross Birrell for "The National Review of Live Art 1996."

[November 8] *Earth to Galaxies. On Destruction and Destructivity*, lecture, Friday Event, Glasgow School of Art, in Glasgow Film Theatre, Glasgow, organized by Alice Angus and Ross Birrell. At this lecture more than 40 slides of shots from space, sent to earth by the Hubble space telescope are shown using two projectors. In 1990, the eleven-ton, thirteen-meter-long Hubble telescope is sent to make observations of space from earth orbit so that the pictures sent back to earth are unclouded by the atmosphere. In 1993, the defective telescope is repaired by seven astronauts in the weightlessness of outer space. Their assembly work is broadcast worldwide on television.

[November 11] *On Sustainability*, seminar at "John Wood's Design Futures Programme," Goldsmiths College, London.

1997
[January 12] *breath in$_g$ culture*, lecture, Neals Yard, Covent Garden, London, organized by Lise Autogena/Autogena Projects.

[March 24] Metzger delivers a lecture about his work at "Seminar 3: Band Widths," part of "Frequencies: Investigations into Culture, History and Technology," School of Oriental and African Studies (SOAS), University of London, organized by Alistair Raphael, Institute of International Visual Arts.

[June 20 and 21] *Historic Photographs: Representing Extremes?*, lecture at the conference "Speaking the Unspeakable: Representing the Holocaust in the Verbal, Visual and Plastic Arts," University College of London.

Series of interviews with the librarian and art historian Clive Phillpot, National Sound Archive, British Library, London, organized by the Arts Council.

[September 11 through November 15] *Gustav Metzger*, first solo exhibition in Germany, kunstraum muenchen, Munich, curated by Justin Hoffmann. Gustav Metzger produces a new work for the show: *Historic Photographs: Hitler-Youth, Eingeschweisst*. Using documentary material, the exhibition also gives an overview of Gustav Metzger's activities. He realizes a reduced version of his 1962 project for the *Festival of Misfits*. Two editions of the *Daily Express* from October 23, 1962, the first day of the *Festival of Misfits*, are purchased second-hand and placed on the walls so that all of the pages of the antique newspapers, lined up next to each other, are visible. A collection of Gustav Metzger's manifestos, writings, and concepts appears in German translation for the first time in conjunction with the exhibition (Verlag Silke Schreiber, Munich).

1996
British Health Minister Stephen Darrell announces that a link between the BSE cattle epidemic and a new variant of the Creutzfeldt-Jakob syndrome (CJS) can no longer be ruled out.
[April] Great Britain and the EU agree that the British will destroy all cattle more than 30 months old. This is meant to destroy all the animals still alive that had consumed animal meal. A total of approximately four million animals are slaughtered and destroyed.

1997
[February 23] The successful cloning of a sheep, Dolly, in a laboratory in Scotland is announced at a press conference.

[October 2] An article showing a causal connection between BSE and the new variant of Creutzfeldt-Jakob Syndrome appears in the journal *Nature*. The EU considers this article as further evidence of the connection.

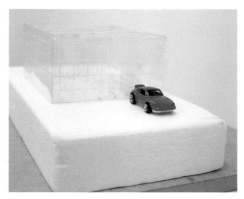

Après Paolozzi PN 004886402, 1997
Stockholm June, 1972, model 1997
kunstraum muenchen, Munich, 1997

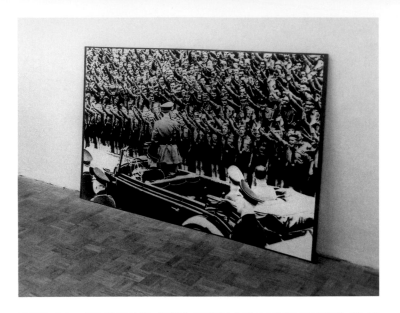

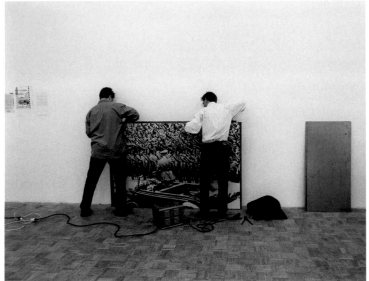

Historic Photographs: Hitler-Youth,
Eingeschweisst, 1997
kunstraum muenchen, Munich, 1997

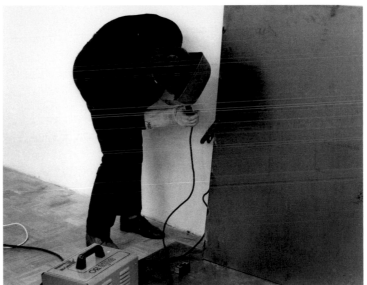

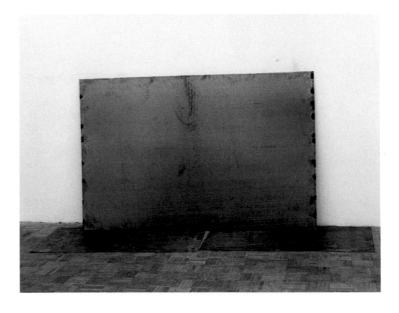

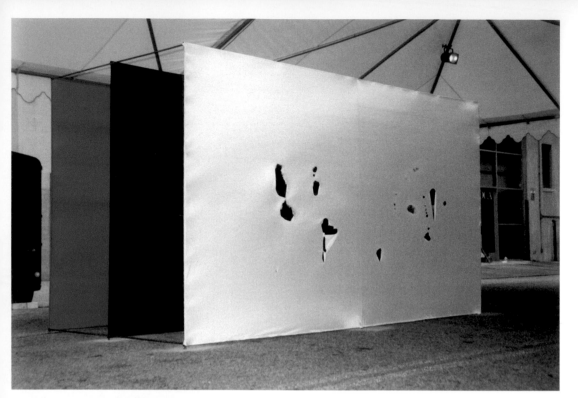

200 *Acid Nylon Painting*, 1998, MOCA, Los Angeles

1998

[February 8 through May 10] Metzger participates in the exhibition *Out of Actions. Between Performance and the Object 1949–1979*, Museum of Contemporary Art (MOCA), Los Angeles, curated by Paul Schimmel. Further venues for the show are the Museum für Angewandte Kunst (MAK), Vienna [June 17 through September 6]; the Museu d'Art Contemporani (MACBA), Barcelona [October 15 through January 6, 1999] and the Museum of Contemporary Art, Tokyo [February 11 through April 11, 1999]. For the opening of the exhibition, Gustav Metzger repeats the *Acid Nylon Painting* he demonstrated at the South Bank in London in summer 1961. Also shown is the South Bank Manifesto, with photos of the first action, as well as a variation of his rejected 1962 project for the *Festival of Misfits*. Two copies of the *Daily Express* are purchased second-hand for each day the *Festival of Misfits* was open. The material for the unrealized project is available. However, a belated reconstruction of the work is rejected. Instead, the pile of newspapers is presented under glass.

[February] Metzger takes part in the conference for the opening of the exhibition *Out of Actions*, University of California, Los Angeles (UCLA).

1998

[July 17 through 19] The event *Gustav Metzger is my dad* takes place in the exhibition space of Camerawork in Bethnal Green, London. During the event, the major portion of the archive of Camerawork is destroyed using a document shredder. Visitors can take part in the shredding. The event marks the end of the Camerawork organization's 21-year existence. Alongside the exhibition space is a laboratory, which will also have to close due to withdrawal of financial support by the London Arts Board.

Gustav Metzger is my dad, 1998, Camerawork, London, invitation card

Drop on Hot Plate, 1998,
Museum of Modern Art, Oxford

1998

[September 11 through November 22] Metzger participates in the exhibition *Speed. Visions of an Accelerated Age*, Whitechapel Art Gallery, London, curated by Jeremy Milar and Suzanne Cotter. There, Metzger shows *Drop on Hot Plate*, a reconstruction of the work from the 1968 exhibition *Extremes Touch: Material/ Transforming Art* in Swansea, Wales.

[October 25 through January 10, 1999] *Gustav Metzger*, solo exhibition, Museum of Modern Art, Oxford, curated by Astrid Bowron and Kerry Brougher. The exhibition gives an overview of Gustav Metzger's work including a variation of the rejected proposal for the *Festival of Misfits* (the front page of the early and late edition of the *Daily Express* from October 24, 1962, are presented, substituting for the unrealized project). Also shown are all (until then) ten of the *Historic Photographs* as well as reconstructions of early works from the 1960s. Under the title *Liquid Crystal Environment*, the first liquid crystal projections are reconstructed now regulated by a newly developed, computer-controlled system. Also shown are the works *Drop on Hot Plate* and *Mica and Air Cube*, both reproductions of the kinetic works in the exhibition *Extremes Touch: Material/Transforming Art* 1968 in Swansea, Wales.
Further venues for the exhibition the following year are the Spacex Gallery, Exeter, Great Britain, and the Kunsthalle Nürnberg, Nuremberg, Germany.

Historic Photographs: The Ramp at Auschwitz, Summer 1944, 1998
Museum of Modern Art, Oxford

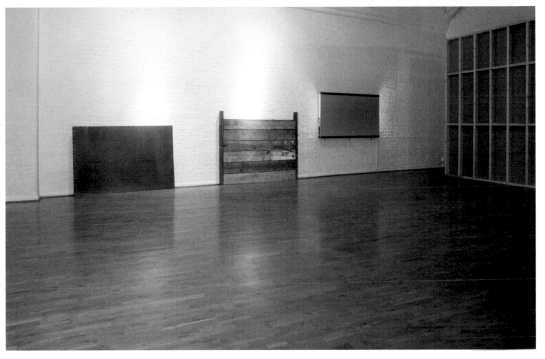

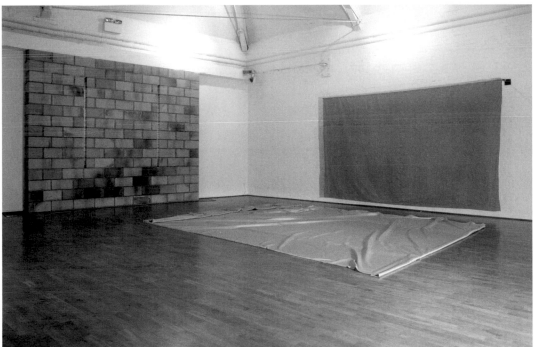

Historic Photographs (left to right):
Hitler-Youth, Eingeschweisst, 1997
Liquidation of the Warsaw Ghetto, April 19 – 28 days, 1943, 1995
Hitler adressing the Reichstag after the fall of France, July 1940, 1995

Fireman With Child, Oklahoma, 1995, 1998
To Crawl Into – Anschluss, Vienna, March 1938, 1996
To Walk Into, Massacre on the Mount, Jerusalem, 8 November, 1990, 1996
Museum of Modern Art, Oxford, 1998, exhibition views

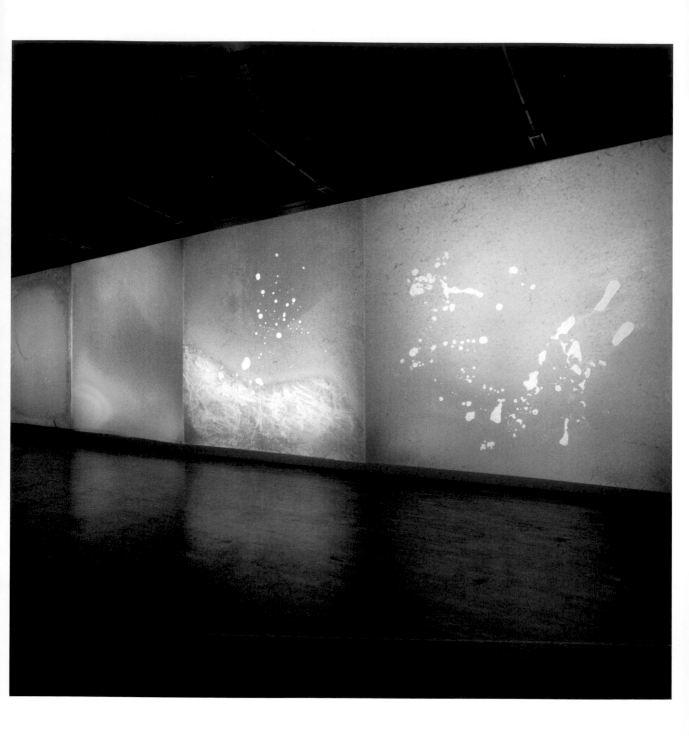

204 *Liquid Crystal Environment*, 1965–66, Museum of Modern Art, Oxford, 1998, installation view

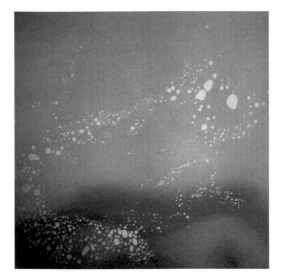

[October] Metzger takes part in the conference for the opening of the exhibition *Out of Actions*, Museu d'Art Contemporani de Barcelona.

[November 3 and November 5] *Time in our time: to the stars* and *Art in time: Happening and Fluxus*, two artists' talks on the occasion of the solo exhibition in the Museum of Modern Art, Oxford, Bernard Sunley Lecture Theatre, St. Catherine's College, Oxford.
The second lecture is accompanied by Fluxus actions as well as John Cage's piece *4'33"*, in which the pianist sits at the piano for four minutes and 33 seconds without playing it. The musician determines the exact time with the help of a stopwatch.

[November] *Earth to Galaxies. On Destruction and Destructivity*, lecture at the conference "Hand in the Fire" for the exhibition *Gustav Metzger* in the Museum of Modern Art, Oxford.

1998

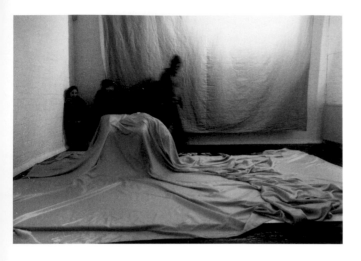

1999
[February 6 through March 20] *Gustav Metzger*, solo exhibition, Spacex Gallery, Exeter, Great Britain.
Gustav Metzger holds a lecture at the exhibition.

[June 24 through September 12] *Gustav Metzger – Ein Schnitt entlang der Zeit*, solo exhibition, Kunsthalle Nürnberg, Nuremberg, curated by Michaela Unterdörfer. (Both are venues for the solo exhibition from the Museum of Modern Art, Oxford). For the exhibition, Gustav Metzger gives a lecture at the Academy of Fine Arts in Nuremberg.

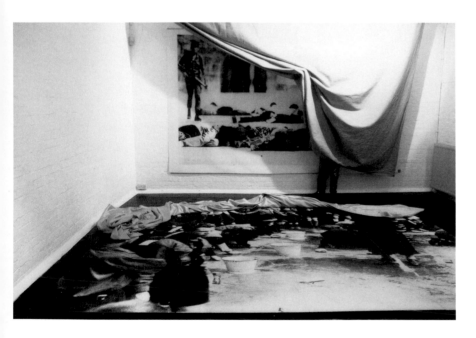

Historic Photographs: To Crawl Into – Anschluss, Vienna, March 1938, 1996;
To Walk Into, Massacre on the Mount, Jerusalem, 8 November, 1990, 1996; 1999
Spacex Gallery, Exeter, exhibition views

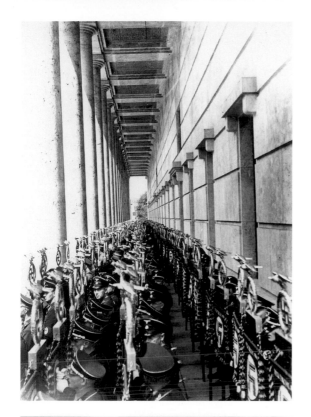

[March 25 through June 20] He participates in the exhibition *Dream City*, a joint project in Munich by kunstraum muenchen, Kunstverein München, Museum Villa Stuck, Siemens Kulturprogramm. Gustav Metzger is represented by a new version of *To Crawl Into– Anschluss, Vienna, March 1938* and the installation *Travertin/Judenpech* in the Haus der Kunst, Munich. *Travertin/Judenpech* is coordinated by the art historian Luise Metzel. The Haus der Kunst was opened by Adolf Hitler in 1937 with the *Große Deutsche Kunstausstellung* (Great German Art Exhibition); in the following days the exhibition *Entartete Kunst* (Degenerate Art) was opened. For the installation *Travertin/Judenpech* Gustav Metzger has parts of the stairway and the columned halls of the Haus der Kunst tarred. The installation remains in situ after the close of the exhibition *Dream City* and is removed later. Gustav Metzger holds a lecture in the Villa Stuck, Munich.

[June 27 through October 3] He participates in the exhibition *Laboratorium*, Antwerp, Belgium, curated by Hans Ulrich Obrist and Barbara Vanderlinden. Metzger is not in the exhibition but is represented in the catalogue with an interview about his exhibition *Extremes Touch: Material/Transforming Art* at the beginning of 1968 in the Filtration Laboratory of the University of Swansea, Wales. Hans Ulrich Obrist conducts the interview.

[July 29 through August 7] He participates in the exhibition *Sublime. The Darkness and the Light. Works from the Arts Council Collection*, John Hansard Gallery, Southhampton, Great Britain. There are further venues in Great Britain. He shows a second version of *Historic Photographs: To Crawl Into – Anschluss, Vienna, March 1938* from the work series *Historic Photographs*. The work has been commissioned by the Arts Council of Great Britain.

1999

Travertin/Judenpech, 1999,
Haus der Kunst, Munich, installation

Projects Realised I (Monument to Bloody Sunday), 1972, reconstruction 1998

Projects Unrealised I, 1971, reconstruction 1998

2000

[February 4 through April 2] Metzger participates in the exhibition *Live in Your Head. Concept and Experiment in Britain 1965–75*, Whitechapel Art Gallery, London, curated by Clive Phillpot and Andrea Tarsia. Two photos, one standing for a realized and one for an unrealized Gustav Metzger project are shown. *Projects Unrealised I 1971/98* shows the east wall of the Royal Festival Hall that Gustav Metzger wanted to use in 1971 in the evenings for liquid crystal projections (a plan that is never realized); *Projects Realised I (Monument to Bloody Sunday) 1972/98* shows the ivy-covered building opposite the Institute of Contemporary Arts in London, which Gustav Metzger dedicated as a monument to Bloody Sunday in 1972. Both photos are reconstructions of works that could be seen in 1972 in the exhibition *3 Life Situations* in Gallery House in London. The original photos were later lost but re-taken for the 1998 exhibition in the Museum of Modern Art in Oxford.

2000

[June] Craig Venter, president of the gentech company Celera Genomics, announces the decoding of 99 percent of human genetic make-up. The British scientist John Sulston plays a decisive role in the project. From 1992 through 2000, as director of the Sanger Centre in Cambridge—one of the four main centers of Human Genome Project—he headed a team of hundreds of scientists working on the decoding and decoded about a third of human genetic make-up.
On both sides of the Atlantic there are around 1,300 biotechnology companies. Almost 400 of them are stock-market oriented.

2001

2001

On the morning of September 11, nineteen Islamic terrorists hijack four passenger aircrafts in the U.S. Two of the aircraft are flown into the twin towers of the World Trade Center in New York resulting in the collapse of the towers, the symbol of the U.S.'s economic might. Surrounding buildings are also damaged. The excavated gap remaining after clean-up work is named Ground Zero.
The third hijacked machine hits the Pentagon, home of the U.S. Department of Defense; another plane, the fourth, probably heading for the White House or Camp David, the president's vacation residence, crashes near Pittsburgh, Pennsylvania. The terrorist attack, for which the terror organization Al Quaeda under the leadership of Osama Bin Laden claims responsibility, takes more than 3,000 lives.

[September 8 through October 29] Metzger participates in the exhibition *Dream Machines*, Camden Arts Centre, London, curated by artist Susan Hiller. He shows liquid crystal projections with two projectors.

[September 15 through November 12] He participates in the exhibition *Protest and Survive*, Whitechapel Art Gallery, London, curated by Matthew Higgs and Paul Noble. Metzger shows the model for *Earth minus Environment,* which was produced in 1995 for the exhibition at workfortheeyetodo and purchased in 1996 by Fonds National d'Art Contemporain (FNAC) in France.

2000

[September 16 through November 11] He participates in the exhibition *Look Out. Art/Society/Politics*, Wolverhampton Art Gallery, Wolverhampton, Great Britain, curated by Cynthia Morrison-Bell and Peter Kennard. He shows *Hitler-Youth, Eingeschweisst*, from the *Historic Photographs* series. Further venues of the exhibition are the Bluecoat Gallery, Liverpool [November 21 through January 11, 2001]; Pitshanger Manor Gallery, London [January 18 through March 3, 2001] and Ipswich/Great Britain [March 17 through May 13].

2001
[January 25 through March 11] He participates in the exhibition *City Racing 1988–1998: A Partial Account*, Institute of Contemporary Arts, London, curated by Matthew Higgs with a new reconstruction of *Cardboards*. This comprises a machine-produced bale of pressed paper packing material reminiscent of César's compressed sculptures in metal. Metzger entitles the work: *been there, done that, K.S.*, referring to Kurt Schwitters.

[November 28] *In diesen heil'gen Hallen ... – Über Ausstellungen im Haus der Kunst von 1937 bis heute*, panel discussion with Gustav Metzger, Christoph Wiedemann, art critic, Klaus Wolbert, director of the Institute Mathildenhöhe in Darmstadt, and Hubertus Gassner, exhibition organizer. The event, of the series "Inszenierte Wirklichkeit, Vier Podiumsgespräche über das Haus der Kunst" is moderated by art historian Jochen Meister.

2002

[June 15 through August 11] He participates in the exhibition *St. Petrischnee*, migros museum, Zurich, with *Liquid Crystal Environment*. The exhibition is curated by Heike Munder.

[August 31 and September 1] He delivers a lecture at the "Crossover-Seminar," Whitechapel Art Gallery, London, organized by the Japanese artist Tomomi Iguchi.

[September 14 through January 19, 2003] Metzger participates in the exhibition *Blast to Freeze – British Art in the Twentieth Century*, Kunstmuseum Wolfsburg, Wolfsburg, Germany. Exhibited is documentary material on Gustav Metzger's South Bank action in summer 1961 and about the *Destruction in Art Symposium*.

[September 14 through November 9] He participates in the exhibition *Strike*, Wolverhampton Art Gallery, Wolverhampton, Great Britain, with the manifesto *Years without Art 1977–1980*, which is painted on the wall of the exhibition as its motto. Curator of the show is Gavin Wade.

[October] *On Extinction*, lecture, Ecology Centre & Art Pavilion, Mile End Park, London, organized by Tomomi Iguchi.

[November 8 and 9] Lecture for the symposium "Nothing ... Nada!," Gulbenkian Foundation, Lisbon, Portugal.

2003

[January 22 through March 23] *100,000 Newspapers. A Public-Active Installation*, solo exhibition, t1+2 artspace, Bedford House, Wheler Street, London.

Metzger opens the exhibition with two performances in which he lets newspaper pages flutter to the floor. The exhibition stretches through two rooms. In the first room, visitors are asked to select articles from newspapers—which are stacked and spread out on the floor—on subjects designated by Metzger, such as biotechnology, information flood, species extinction, etc. These cuttings are ordered according to theme and then presented. The second room contains hundreds of collapsing, rusty, metal-shelved cases loaded with stacks of newspapers. A system of corridors and catwalks allows the visitor to move through the installation as if through a chaotic, sunken library. At the end of the exhibition there is a weekend of discussions, presentations, and performances in the Atlantis Gallery, Truman Brewery, Brick Lane, London. The event takes place under the title "The World's First Conference on Forklift Trucks." The lecturers speak from a forklift truck placed within the huge modernistic space of the gallery.

100,000 Newspapers.
A Public-Active Installation, 2003
t1+2 artspace, London,
exhibition views and performance

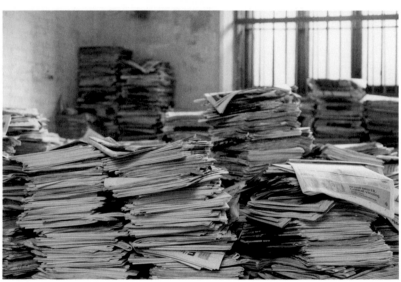

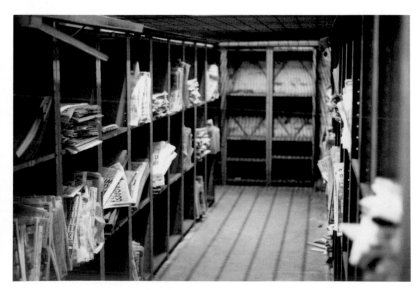

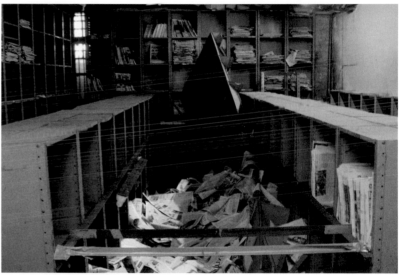

[February] Metzger takes his first trip to New York. He takes part in a two-day conference about Ground Zero, Department of Architecture and Town Planning, Columbia University, New York.

[February] *Hurry up it's time! – The Waste(d) Land*, lecture, Tate Britain, London.

[June 3 through August 3] Metzger participates in the exhibition *Independence*, South London Gallery, London. He shows the video *Power to the People* about pupils protesting against the war in Iraq, shot in London on March 20, 2003, the first day of the war against Iraq.

2003

Power to the People, 2003, video

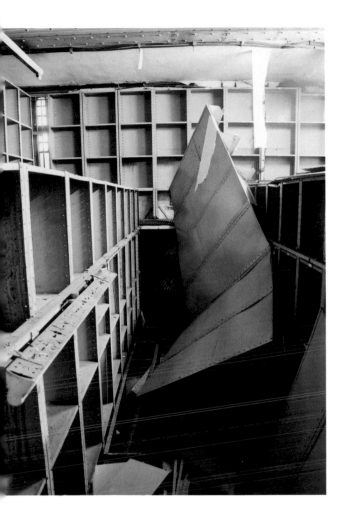

Untitled, 2003, Utopia Station, Biennale di Venezia, Venice, 2003, poster

[June 15 through November 2] He participates in the exhibition *Dreams and Conflicts – The Dictatorship of the Viewer*, 50th Biennale di Venezia, Venedig. Gustav Metzger realizes a poster for *Utopia Station*, a poster project curated by Molly Nesbit, Hans Ulrich Obrist, and Rirkrit Tiravanija. The subject of the poster is a black and white detail photograph of his newspaper installation *100,000 Newspapers* from spring of the same year in London.

[September 18 through January 4, 2004] He participates in the exhibition *C'est arrivé demain*, 7e Biennale de Lyon, Lyon. He shows the *Liquid Crystal Environment* exhibited for the first time in the Museum of Modern Art in Oxford, and an exact copy of the second room of his solo exhibition *100,000 Newspapers* from the beginning of the year in the t1+2 artspace in London. The exhibition is organized by the Dijon-based Le Consortium.

2003

[October 11] In the seminar "On Liquid Modernity," Leeds Metropolitan University, Leeds, Great Britain, Gustav Metzger and Zygmunt Baumann each make a presentation. The event is organized by art historian Griselda Pollock.

[October 29 through January 4, 2004] He participates in the exhibition *Adorno. Die Möglichkeit des Unmöglichen*, Frankfurter Kunstverein, Frankfurt, and shows the recon-structed model for the first *Auto-Destructive Monument*.

He is guest lecturer and has discussions with students at the Royal Academy School, London.

2004

[January 22 through 24] *Ethics, Aesthetics and Biotechnology*, lecture via telephone conferencing at the symposium "Resistencia, Resistance," Teatro de los Insurgentes, Mexico City. Shown simultaneously with the delivery of the lecture by telephone conferencing, are twenty slides. Katia Boot from the British Council, London, is responsible for the successful coordination of the event.

[March 7] *Science and the Arts: The Emergence of a New Consciousness from the 60's to Now*, panel discussion with Gustav Metzger, Roy Ascott, musician Brian Eno, and scientist Margaret Boden; chaired by Philip Dodd, director of the ICA in London at the time. The panel discussion is part of the "Winchester Festival of Art and the Mind" in Winchester. At the Winchester Festival of Art and the Mind, scientists, artists, and academics meet for lectures, demonstrations, and interdisciplinary exchange around a selected topic. The festival takes place for the first time in 2004 and will be repeated annually with a new subject. Accompanying Gustav Metzger's participation in the festival, Ken McMullen's interview film is shown (looped) for three days.

[June 5 through July 23] Participates in the exhibition *Artists' favourites – act I*, ICA, London. The invited artists do not exhibit in the exhibition themselves, they are asked to present a work by an artist of their choice. Gustav Metzger chooses *The Dexion Piece*, 1996–1997, a work by the artist Sarah Jacobs.

[June 29 through September 15] Metzger participates in the exhibition *Signatures of the Invisible*, P.S.1, Contemporary Art Center, Queens, New York. Ken McMullen's interview film is shown (see bibliography).

[June 30 through September 26] He participates in the exhibition *Art and the Sixties – This Was Tomorrow*, Tate Britain, London, curated by Katharine Stout and Chris Stephens. Along with a reconstruction of the first *Auto-destructive acid >action< painting* (the first public presentation of *Auto-Destructive Art* 1960 in the Temple Gallery, London), the film *Auto-Destructive Art – The Activities of G. Metzger* by Harold Liversidge and documents of the *Destruction in Art Symposium* which was certainly the most important artist meeting of the 1960s are shown. Further venues for the exhibition are Birmingham, Great Britain, Canberra, Australia, and Auckland, New Zeeland.

[Summer term] He delivers lectures and also talks with students at Camberwell College of Art, Peckham Library, London, at the invitation of the German artist and writer Claudia Wegner.

[December 21] *1966–1976: from DIAS to Punk*, panel discussion with Gustav Metzger, art critic Andrew Wilson, artist Stewart Home, John Hopkins, photographer and—in the 1970s—a protagonist in the English punk scene, John Dunbar and (Barry) Miles, of Better Books and Indica Bookshop, for "Intelligence Now!" celebrating the 25th anniversary of the October Gallery, London.

2005

[April 25] Lecture, Transmission Gallery, for the Glasgow International. Festival of Contemporary Visual Art, Glasgow, Great Britain.

[May 10 through August 28] *Gustav Metzger. History History*, retrospective, Generali Foundation, Vienna, curated by Sabine Breitwieser.

[May 27 through September 25] He participates in the exhibition *Summer of Love. Art of the Psychedelic Era*, Tate Liverpool with a *Liquid Crystal Projection*.

[July 2 through August 20] Gustav Metzger is selector for the exhibition *East 05*, Norwich Gallery, Norwich School of Art and Design, Norwich. The exhibition *East 05* in the exhibition space of the Norwich Gallery and the Norwich School of Art and Design has taken place annually since 1991.
Gustav Metzger proposes that all works should be able to be communicated via Internet or other electronic media. Object based works will not be accepted. Contributions should be concerned with economic, political, or ethical dimensions.

[September through October] *Eichmann and the Angel*, solo exhibition, Cubitt Gallery, 8 Angel Mews, London, curated by David Bussel. The subject of the exhibition is the trial of Adolf Eichmann, organizer of the "final solution to the Jewish question" and responsible for the deportation of millions of Jews. The Cubitt Gallery in London is an artist-run exhibition space.

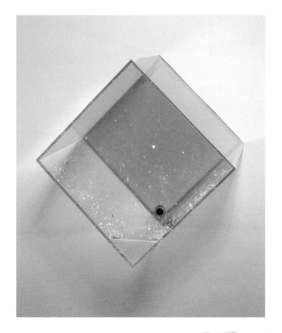

Mica and Air Cube, 1968/2005

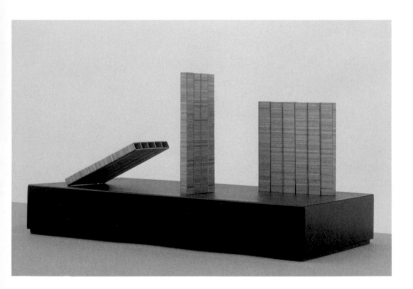

Auto-Destructive Art – The Activities of G. Metzger, film by Harold Liversidge
Acid Nylon Painting, 1960/2004
Model for an Auto-Destructive Monument, 1960/2005
Manifestos and documentation material in showcase

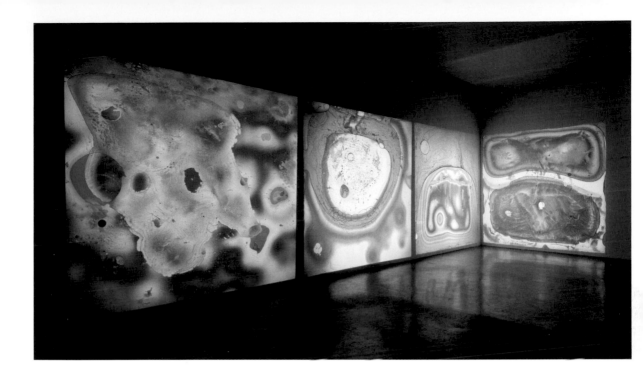

Liquid Crystal Environment, 1965-66/1998

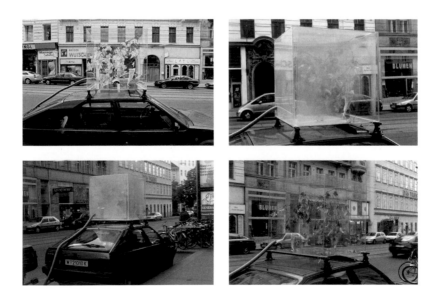

Mobbile, 1970/2005, exhibition opening

Exhibition views, Generali Foundation, Vienna

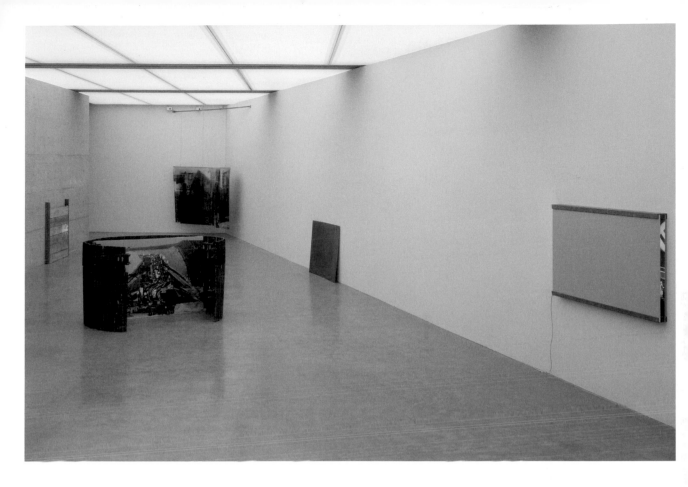

Historic Photographs:

To Crawl Into – Anschluss, Vienna, March 1938, 1996

To Walk Into, Massacre on the Mount, Jerusalem, 8 November, 1990, 1996

No. 1: Liquidation of the Warsaw Ghetto, April 19 – 28 days, 1943, 1995

Till we have built Jerusalem in England's green and pleasant land, 1998

Jerusalem, Jerusalem, 1998

Hitler-Youth, Eingeschweisst, 1997

No. 1: Hitler addressing the Reichstag after the fall of France, July 1940, 1995

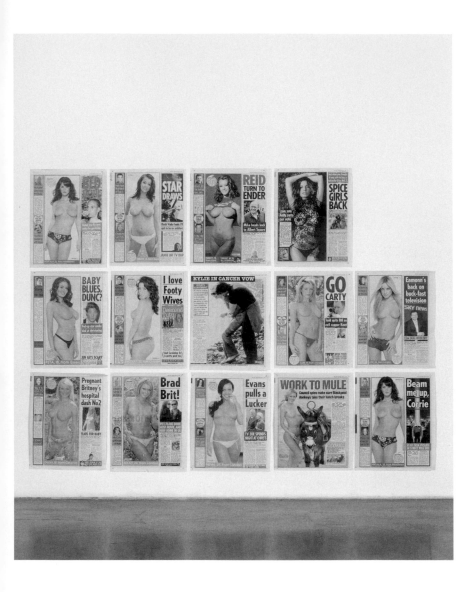

Sun, Page 3 Girls, 1977, current page 3 added on each day of the exhibition,
work in progress photographed 26 May 2005

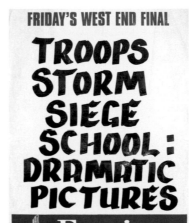

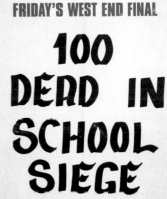

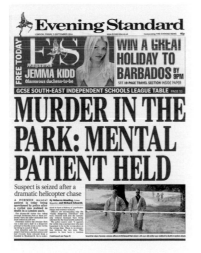

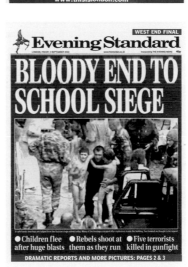

London a.m., London p.m., 2005
Friday, September 3, 2004

Writings by Gustav Metzger

Cardboards
(Cardboards selected and arranged by G. METZGER, London 1959)

Cardboards selected and arranged by G. METZGER at 14 Monmouth Street, W.C.2, near Cambridge Circus.

The discarded cardboard which is on view was probably part of a television package.

These cardboards are nature unadulterated by commercial considerations or the demands of the contemporary drawing room.

They have reference to the greatest qualities in modern painting, sculpture and architecture.

These cardboards were made automatically for a strict purpose and for a temporary usage.

Auto-Destructive Art
(First manifesto, 1959)

Auto-Destructive Art is primarily a form of public art for industrial societies.

Auto-destructive painting, sculpture and construction is a total unity of idea, site, form, colour, method and timing of the disintegrative process.

Auto-Destructive Art can be created with natural forces, traditional art techniques and technological techniques.

The amplified sound of the auto-destructive process can be an integral part of the total conception.

The artist may collaborate with scientists, engineers.

Auto-Destructive Art can be machine produced and factory assembled.

Auto-destructive paintings, sculptures and constructions have a lifetime varying from a few moments to twenty years. When the disintegrative process is complete, the work is to be removed from the site and scrapped.

London, 4 November 1959, G. METZGER

Manifesto Auto-Destructive Art

(Second manifesto, 1960)

Man in Regent Street is auto-destructive.

Rockets, nuclear weapons, are auto-destructive.

Auto-Destructive Art.

The drop drop dropping of HH bombs.

Not interested in ruins, (the picturesque).

Auto-Destructive Art re-enacts the obsession with destruction, the pummelling to which individuals and masses are subjected.

Auto-Destructive Art demonstrates man's power to accelerate disintegrative processes of nature and to order them.

Auto-Destructive Art mirrors the compulsive perfectionism of arms manufacture—polishing to destruction point.

Auto-Destructive Art is the transformation of technology into public art.

The immense productive capacity, the chaos of capitalism and of Soviet communism, the co-existence of surplus and starvation; the increasing stock-piling of nuclear weapons —more than enough to destroy technological societies; the disintegrative effects of machinery and of life in vast built-up areas on the person …

Auto-Destructive Art is art which contains within itself an agent which automatically leads to its destruction within a period of time not to exceed twenty years.

Other forms of *Auto-Destructive Art* involve manual manipulation. There are forms of *Auto-Destructive Art* where the artist has a tight control over the nature and timing of the disintegrative process, and there are other forms where the artist's control is slight.

Materials and techniques used in creating *Auto-Destructive Art* include: Acid, Adhesives, Ballistics, Canvas, Casting, Clay, Combustion, Compression, Concrete, Corrosion, Cybernetics, Drop, Elasticity, Electricity, Electrolysis, Electronics, Explosives, Feed-back, Glass, Heat, Human Energy, Ice, Jet, Light, Load, Mass-production, Metal, Motion, Motion Picture, Natural Forces, Nuclear energy, Paint, Paper, Photography, Plaster, Plastics, Pressure, Radiation, Sand, Solar energy, Sound, Steam, Stress, Terracotta, Vibration, Water, Welding, Wire, Wood.

London, 10 March 1960, G. METZGER

Auto-Destructive Art, Machine Art, Auto-Creative Art
(Third manifesto, 1961)

Each visible fact absolutely expresses its reality.

Certain machine produced forms are the most perfect forms of our period.

In the evenings, some of the finest works of art produced now are dumped on the streets of Soho.

Auto-Creative Art is art of change, growth, movement.

Auto-Destructive Art and *Auto-Creative Art* aim at the integration of art with the advances of science and technology. The immediate objective is the creation, with the aid of computers, of works of art whose movements are programmed and include "self-regulation". The spectator, by means of electronic devices, can have a direct bearing on the action of these works.

Auto-Destructive Art is an attack on capitalist values and the drive to nuclear annihilation.

23 June 1961, G. METZGER

Machine, Auto-Creative, and Auto-Destructive Art

(in: *Ark. Journal of the Royal College of Art*, London, Summer 1962)

Machine Art

The following techniques involving machine-made forms are currently used by artists:

1. Materials (usually so-called waste or junk) are collected and assembled into works. The material can be in any condition; can be manipulated by the artist and can include painted passages etc. The work can be two- or three-dimensional. This technique is generally known as collage or assemblage.
2. So-called waste or rubbish is collected, usually from the street, and exhibited in the same condition as it is found. The artist may use adhesives or other means to hold the work together.
3. Posters are removed from hoardings and exhibited.
4. Machined materials are assembled by the artist. They can be cut, welded, burnt, painted etc.
5. Machine produced materials are assembled by the artist without altering their original shape and finish.
6. Machine products are exhibited by the artist without assembly or alteration of any kind.
7. An object (e.g. a motor-car) is compressed by high-power presses and the resultant block becomes the work.

Techniques 2 and 6 in which the artist's role is confined to selection and presentation are particularly interesting.

The cardboard containers, wooden boxes, transparent bags filled with paper and cloth cuttings, filled rubbish-bins and other unpredictable objects that materialize on pavements of Soho in the afternoon and evenings are among the most significant aesthetic-realistic experiences available to us. They are best seen on the site in the few hours before their removal by the Council wagon. Many of these arrangements cannot be fixed and would lose most of their point if so treated. This is our folk art. It has unaffected decoration, a feeling of relaxation, balance, sometimes tension or horror.

Although at present there is a vast quantity of this material, it is in fact available to us for a limited period. Changes in production and waste-disposal will inevitably occur. It is as worthy of preservation as any material that has come down from the past.

Three main stages are involved in these temporary constructions. Stage 1 includes: pre-production discussions, design discussions, design modifications, production of object. Stage 2 involves transit, purchase, eventual scrapping of object for a variety of reasons. Stage 3: A worker has the task of placing "rubbish" into the street. Some of the factors involved are: functional considerations and decisions, unconscious decisions, aesthetic decisions and performance, physical performance. These constructions, packed with thousands of factors, are dynamite in art.

Machine forms that are strictly functional, that have no decorative or "selling" intentions, sometimes have a gravity and force, a limpidity, an absence of that nervous constrained character that vitiates so much of modern art and design. Some machine forms have a feeling of ruthless power or destructive potential. Many are bland, no-face, or sick.

The decisions that are involved in the production of an object are embodied in its form, material, surface and tone. It is possible, therefore, to understand the nature of the decisions by a study of the object. The study and appreciation of *Machine Art* involves technology, sociology, psychology and other branches of knowledge.

The next step in *Machine Art* is the entry of the artist into factories and the use of every available technique from computers downwards for the creation of works of art.

Bibliography *Machine Art*:

1. Alloway, Lawrence. "Junk Culture", in: *Architectural Design*, March 1961.
2. Bullock, Michael. "Cardboards arranged by G. Metzger", in: *Art News and Review*.

Auto-Creative Art

Auto-Creative Art is an art form of the immediate future. *Auto-Creative Art* aims at the creation of works that grow in volume and works that extend by reproduction. Other aims include the creation of works having limitless change of images without image duplication.

In this art form, as in *Auto-Destructive Art*, time, space, motion, metamorphosis and sound have a different far more important role in the conception, construction and appreciation of the work than in art up to now. Artists working in this field will have close contacts with science and will necessarily work with advanced techniques.

Art in motion, kinetic art, are terms applied to works of art that are in motion. The mobile is an early example.

Transformable art is the term for a work where a changing image is created by the spectator moving elements of the work.

Spectator participation describes the situation where a work is designed to yield multiple images resulting from the movement of the spectator around the work.

Auto-Creative Art can be used instead of, or as well as the above terms. *Auto-Creative Art* is a term that can be applied to any work of art which, through its motion or reflective possibilities,

can produce planned multiple images. Or where planned image multiplication is dependent on optical or manual spectator participation.

One of the most advanced forms of *Auto-Creative Art* in existence is the London Transport Electricity Substation now being completed on an island site at the Elephant and Castle, London.

The walls of this building are composed of over 800 identical pressed stainless-steel panels. The panels were shaped to the architect's specifications and are highly reflective. The building is seen by thousands of people day and night, often from vehicles in motion. It creates an enormous quantity of significant images through spectator participation, sunlight, atmospheric conditions, vehicle lights and street-lighting.

This great work of art is far more than an elaborate light reflector. It proves beyond doubt that only the collaboration of the artist and technology and the use of machine forms can give us certain experiences we need.

Bibliography *Auto-Creative Art*:

1. Agam, Yaacov. *Transformable Painting. Painting in Movement*, Tel-Aviv Museum.

Auto-Destructive Art

Auto-Destructive Art aims at the creation of works of art that diminish in volume until they cease to exist. A work can last a few moments. Its lifetime must not exceed twenty years.

The theory was formulated in two manifestos issued in 1959 and 1960. It has few practitioners and is in an experimental stage.

Auto-Destructive Art is a radical irrevocable change of image.

Ideally, *Auto-Destructive Art* is produced and assembled in factories, the artist's relation to the work being analogous to that of the architect vis-à-vis his building. *Auto-Destructive Art* is public art. It has connections with ritual art of the past. It should be placed where it can be seen by masses of people in the open or inside buildings.

Auto-Destructive Art emerges from the chaotic, obscene present. The world's annual military expenditure is over £ 40,000 millions. For each individual on earth there is a stockpile of 500 tons of T.N.T. In four years' time, this stockpile will increase to 1,000 tons. Eichmannland was a fairy tale playground compared with this. *Auto-Destructive Art* is conceived as a desperate last-minute subversive political weapon used by artists. It is an attack on the capitalist system and the production of war materials. It is committed to nuclear disarmament and people's struggles against war. It is an attack also on art dealers and collectors who manipulate modern art for profit.

Technically elaborate and costly public works of *Auto-Destructive Art* can have a deep insidious and cumulative effect on many people—opening feelings, building up tensions, releasing ideas, arousing controversy. This can lead to a more realistic attitude to the production of (auto-destructive) war materials and to other biologically damaging social activities.

By providing a socially sanctioned outlet for destructive ideas and impulses, *Auto-Destructive Art* can become a valuable instrument of mass psychotherapy in societies where the suppression of aggressive drives is a major factor in the collapse of social balance.

Auto-Destructive Art has many contradictions. It is a paean to destruction. It has extreme aesthetic sensibility. It is an art of protest, revolt and acceptance.

The artist putting up an auto-destructive construction to last ten years knows that his work may still be in existence when the bombs go off.

Bibliography *Auto-Destructive Art*:

1. Arrowsmith, Pat. "Auto-Destructive Art", in: *Peace News*, 22 July 1960.

2. Reichardt, Jasia. "Expendable Art", in: *Architectural Design*, October 1960.

Manifesto World

(Fourth manifesto, 1962)

everything everything everything everything

A world on edge of destruction. Objects become precious, matter becomes subject to feeling of reverence. This is an art form for artists. The mass of people appreciate modern art 50 years after its practice. This art form will not be subject to this time lag since it is unlikely that in 50 years time there will be a world in which to practice it.

An art of extreme sensibility and consciousness.

We take art out of art galleries and museums.

The artist must destroy art galleries. Capitalist institutions. Boxes of deceit.

Events, happenings. Artists cannot compete with reality. The increasing quantity of events, happenings. Artist cannot integrate within himself all the experiences of the present. He cannot render it in painting and sculpture.

New realism. The most vital movement now. However inevitably its course is now one of increasing commercialisation. Nature imitates art.

New realism was a necessary step toward the next development of art. The world in its totality as work of art. Including sound. Newspapers.

New realism shows the importance of one object or relationship between a number of objects. This obviously is the first step to a large ensemble, the total relationship of objects including the human figure.

You stinking fucking cigar smoking bastards and you scented fashionable cows who deal in works of art.

There was a time when there were men and animals.

And men painted men and animals.

Then gods and kings came and men painted gods and kings.

Then men sat in carriages that moved over the earth and men painted carriages.

And now men fly to the stars. And men paint flying to the stars.

At this moment in London; millions of men, millions of objects, millions of machines. Millions of interactions each fraction of a second between men, objects and machines. Day and night inventors create new machines, objects that will be produced day and night.

The artist's entire visual field becomes the work of art.

It is a question of a new artistic sensibility. The artist does not want his work to be in the possession of stinking people. He does not want to be indirectly polluted through his work being stared at by people he detests.

The appropriation by the artist of an object is in many ways a bourgeois activity.

An element of condescension, superiority to workmen.

Profit motive—this is now worth xxxx franc because I have chosen.

The artist acts in a political framework whether he knows it or not. Whether he wants to or not.

The quantity of experience the artist has to pack into a work is so vast now, it is not possible to compress it all into the space of an object.

The acceptance, substitution of World is thus not an escape from production.

The Door by Robin Page is the catalyst of the new aesthetic.

7. 10. 62

On Random Activity in Material/Transforming Works of Art

(Fifth manifesto, in: *Signals*, London, September 1964)

Certain major forms of art can be described as the drawing of belief.

A belief in molecular theory and related definable and undefinable beliefs, intuitions, shared with scientists and others, can best be stated by material/transforming works of art. *Auto-Destructive Art*, *Auto-Creative Art* are forms of material/transforming works of art.

To "draw" in any other manner would be to kill the spirit and capture a mere fragment of the reality.

Random activity, and tangential problems of quality, are now critical and productive problems in art.

Random activity of the work of art escalates an extension of accepted (unproductive) concepts of art, nature and society.

If all factors of a work are understood, each moment is predictable. A great deal of "random" equates with ignorance. The presentation of activity with the minimum of ordering by the artist is belief at its maximum.

The artist desires and achieves a certain form, rhythm, scale: intends, and identifies with, all the transformations, predictable and unpredictable, that the work is capable of.

At a certain point, the work takes over, is in activity beyond the detailed control of the artist, reaches a power, grace, momentum, transcendence … *which the artist could not achieve* except through random activity.

30.7.64

The Chemical Revolution in Art

(Published as "Auto-Destructive Art" in: *Granta*, Cambridge, 6 November 1965)

Statesmen are bellowing that the next war will be the end of humanity. Is it not obvious that the statesman and the people who placed them in power want destruction to a large extent as self-expression, as a release of tensions, as a form of therapy? When people can afford to destroy, they destroy.

Auto-Destructive Art offers to channel some of the aggressive drives in society into directions that promise release of tensions without the utter destructiveness of future wars. This work will cost society in money and materials. But however many millions may be spent on *Auto-Destructive Art* it will only be a minute fraction of the money spent on so called "defence". And while *Auto-Destructive Art* effectively placed in areas where masses of people can benefit from it now, the accumulation of war products, the preparations for war, bottle up energies, hopes—until the time when war starts, when all this force is released ("spasm"—see Herman Kahn[1]), only to be smothered by the shock-waves and heat blast of the nuclear explosions.

People do not only want to destroy. They want also to work, to produce. Scientists and engineers can get satisfaction from devising and making ever more intricate forms of *Auto-Destructive Art*.

Like the arms industry, *Auto-Destructive Art* is in the interest of the economy. This is based on continuous production and consumption. What is produced is irrelevant. From the point of view of the economy, *Auto-Destructive Art* is no good while it remains at the acid + nylon stage. It must jump as fast as possible to the stage where the skills and resources that go into the production of rockets, nuclear weapons, space craft and aircraft-carriers are used in the production of the art product.

Before the uncomprehending stare of the art public, the chemical revolution in art has become an established fact. This revolution is as justifiable as was the artist's expansion into the fields of perspective, mathematics, pathology, anatomy and other sciences in the Renaissance.

There is a limit to the potential of kinetic art while the material employed remains in a "solid" state. Art is enriched by an astronomical number of new forms, colours and textures when the rigidity of material is loosened. The visual arts are also enriched with some of the characteristics of music and dance.

The new art forms are related to current ideas in science and to current technology. This relation is on the level of ideas. It is intuitive and emotional. It is a physical involvement.

In disintegrating and growing art, time ceases to be uni-directional. At "one instant"— *sic*—of time, the work may be going in ten different directions in time. The anisotropy of time.

236

The space that surrounds disintegrating or growing art is as important as the visible material. The peeling or expanding fragments of matter carve, burn or tear their way through the adjacent space. There occur chemical-electrical interactions, fusions, explosions, implosions — between the work and space. The artist seeks the most direct contact with advanced ideas and forms of life. Time reversal, anti-matter, exploding galaxies. Annihilation of men through self-destructive mechanisms. Research into the creation of all forms of life. The art forms are a form of *realism*.

Art is a carrier of information. It is necessary to constantly invent new art forms to carry the available information — expanding at an exponential rate. It is through a maximum use of random forms and motions that art can begin to convey available information. The random in art is also a powerful catalyst in social change.

We need to initiate the most comprehensive analysis ever undertaken of the history and pre-history of man. We must unravel step by step, over a period of over 100,000 years, the manner in which mental and physical activity has related with social activity and scientific and technical invention.

Civilization has built-in destructive factors which are present in science as well as technology. We want to be in a position where we can see how "our" science and technology has become impregnated with the disturbances of man's mind and body.

Nature can be manipulated in a great variety of ways, quite different from the ones we happen to be operating with. We are now faced with the imperative need to take one of the most radical steps in history: The conscious creation of new forms of science and technology that have been cleared, to some extent, of in-built destructive elements.

All available methods of information processing, methods of analysis and control, and other aids will be employed in these tasks. *We shall use science to destroy "science"*.

1 Cp. Kahn, Herman. *On Thermonuclear War*, Princeton 1960.

The Possibility of Auto-Destructive Architecture
(In: *Clip-Kit*, London 1966)

It is widely known that advanced technology has a "spin-off". Techniques used in space research appear eventually on the breakfast table. The "spin-off" for architects may well include auto-destructive architecture. ("Spin-off" is not confined to technology, but includes the possibility, the necessity (?) of seeing established systems of thought and practice from new standpoints.)

Cost is the greatest problem in exploring and exploiting the moon and other planets. It is crucial to keep not only the weight but also the volume of matter sent into space to a minimum.

Considerations of volume determined this US project, announced several years ago. Space platforms to orbit the moon, will be sent packed with equipment and stores to be relayed to the moon and other platforms. When this material has been transferred, the space platform will "grow" its furniture and fittings by means of plastic foam whose shape has been pre-determined. Architects, including Katavolos[1] and Doernach,[2] have worked with ideas of expanding plastic to "grow" buildings.

Since expanding structures are used in space research, let us consider the potential use of *disintegrating* structures in the exploration and exploitation of planets. The following considerations are relevant.

1. The structure is required for a single task only, or for a specific, limited time.
2. The structure is set up at the most convenient point in relation to the landing position, or at the best site available.
3. The structure is likely to increase the hazards of low-flying aircraft, or the tasks of men moving on, or over, the surface of the moon.
4. The permanent existence of the structure may be a threat to the existing balance of life on the planet.
5. The next landing may be by a rival nation, and one is not willing to give the "enemy" the benefit of the structure.

In the first and most crucial phase of moon exploration, structures will constantly be modified and improved. It is necessary to keep the exertions of men on the moon to a minimum, and the cost of m.m.h. (moon man-hour) is enormous. Tasks such as the demolition of redundant structures will be avoided, if possible. There is the problem of disposal of waste materials. If left at the site, it will conflict with points 2, 3 and 4. If the material is removed from the optimum site to a part of the moon not in current use, there will be a conflict with points 3, 4 and 5. There are obvious long term arguments against the dumping of waste building materials. Apart from the question of looks, we cannot foresee how the moon will be developed, and an area now considered useless may in future become "hot property". Abnormal developments may occur around any man-made material left permanently on the moon.

Having sketched in the desirability of erecting structures on the moon having built-in mechanisms to ensure the destruction of the material in a predetermined period of time, we now apply this general approach to earth.

Some situations where auto-destructive architecture is feasible and can be advantageous:
1. War, "defence" etc.
2. Structures used in exploration, mountain climbing.
3. Structures used as temporary laboratories.
4. Structures used as hospitals.
5. Rooms within rooms. Or temporary buildings within a large complex such as a factory or university.
6. Numerous uses in the so-called underdeveloped countries.

1. See point 5 in section on space.
2. This is partly a question of amenity and visual squalor.
3. Particularly useful in extreme climatic conditions, where effort must be kept at a minimum, and time is extremely limited. Or at the edge of an active volcano.
4. Temporary hospitals, for example in epidemic areas, or isolation wards attached to hospitals.

Following my talk and demonstration at the Bartlett in February 1963, some students came up with the proposal of a family house. As the children leave the house, their quarters undergo auto-destruction. This has great advantage to the parents in running their part of the house. *Their declining time and energy can be related to the situation of men on other planets.* There is also the possibility of a *new use* for the released space. We can also foresee developments such as self-disintegrating structures under water, and self-destructive spacecraft satellites.

In an interesting article by Gerald Leach, based on a National Academy of Sciences, Washington, report "Waste Management and Control", occurs the following statement: "Research is needed to give all containers durability while they contain, but built-in self-destruction from the moment they are no longer needed. For example, it should not be too hard to develop paper bottles and cans that are non-absorbent on the inside but degrade quickly into humus when rain soaks their outside; or new kinds of plastic that are easily attacked by bacteria." (*New Statesmen*, 13 May 1966) This approach to the disposal of waste is a lead-in to potential techniques for auto-destructive architecture. It is inevitable that we shall have auto-destructive architecture before long. An obvious reason is that someone will find it profitable to produce it. The discovery and development of materials useful for building but having a limited life-span will be further reasons. It is unlikely that we shall see *Auto-Destructive Art* practised in poor countries, but we can anticipate the spread of auto-destructive architecture in countries with a low standard of life.

Having discussed war and space exploration, I should make it clear that I do not support these activities. With others, *including leading scientists*, I believe that *the way* in which other

planets' exploration is being conducted is one of the greatest tragedies in history. Many scientists have warned of the danger of contaminating, for all time, those planets hit by man.

A danger less often discussed in the press is that men or spacecraft returning from other planets may bring with them organisms that could be modified by earth conditions and spread—with catastrophic effects for the future of earth.

Considerations like these, plus the knowledge that it is governments' concern with war which provides the impetus and resources for the expansion into space, distance me from the *Archigram* ethos: "snop crackle and flop lets all go jolly to the moon"![3]

A thinker, scientist, artist or architect who blithely accepts that which science and technology has to offer *here and now* without the deepest probing and most ruthless criticism of the material and ideas that he is using, is guilty of burying the world.

Gustav Metzger 1966

1 Cp. Fowler, John. "Visionary Architecture at the Museum of Modern Art, New York", in: *Architectural Design*, London, May 1961.

2 Cp. Doernach, Rudolf. "Biotecture", in: *Architectural Design*, London, February 1966.

3 Archigram was a group of London architects. The sentence ironically varies an advertisement slogan for Kellogs Rice Crispies: "Snap, crackle and pop …" (editor's note)

Excerpts from Selected Papers Presented at the 1966 Destruction in Art Symposium

(Lecture (excerpt), in: *Studio International*, London, December 1966)

In the context of the possible wipe-out of civilization, the study of aggression in man, and the psychological, biological, and economic drives to war, is possibly the most urgent work facing man. A central idea of *Destruction in Art Symposium* was to isolate the element of destruction in new art forms, and to discover any links with destruction in society. A glance at the list of headings for Symposium papers makes this clear. ART: Architecture, film, Happenings, language, music, plastic arts, theatre. SOCIETY: Atmospheric pollution, creative vandalism, destruction in protest, planned obsolescence, popular media, urban sprawl/overcrowding, war. SCIENCE: Biology, economics, medicine, physics, psychology, sociology, space research. (*These subjects were to be treated in specific relation to destruction and aggression.*)

It was hoped that artists would discuss their reasons for engaging in art forms that include the actual destruction of materials. Of course it is difficult for artists to probe the motivating power of their art, and any reluctance to reveal their understanding of their activity is usually in the interest of continuing productivity.

An audience responding to destructive art is potentially of great interest to the psychologist. It is not difficult to make snap assessments of the effects of violent art forms on the spectator. It is more desirable to study the reality by means of cameras, tape-recording of audience reactions immediately after the event, followed by long-term research. The value of such studies would not be confined to psychology. Aesthetics, in its slow progress to becoming a science, would benefit by joining in this research.

Notes on the Crisis in Technological Art

(Broadsheet, 1969)

A document presented by Gustav Metzger for the Computer Arts Society's "post-mortem on EVENT ONE" to be held at the British Computer Society, London, 3 April 1969.

Techniques and Aesthetics

The LIMITATIONS of computers are the key to understanding computer art. Just as there are styles and periods in art, so are there styles and periods in computer art. These are determined by human factors (the amount of time, the knowledge and imagination or talent which have gone into creating the art). The end result is also dependent on the computers, their software, and additional techniques employed. It is easier to start measuring the capacity and limitations of the latter than the human factors. Particular attention must be given to the mechanisms employed, which are of course subject to change. This kind of analysis takes up considerable amounts of time, which is probably not available just now. (Far more writing on, say, Renaissance art, was produced in the present century than in that period).

With computer techniques there occur opportunities for a large number of people to rapidly maximise their contribution in a particular field—one which may not even be in existence at present, but which is important to get into. If 500 artists were now to enter computer art they would find it difficult to exhaust the technical and aesthetic possibilities of the existing mechanisms.

The Art World

It is impossible for the museum and commercial gallery structure to accommodate the volume of art that will be produced in technological art in the next few decades. It is therefore vital to begin developing new structures that will enable these works to be produced and exhibited. Work in the present art structure is based on fierce competition to get into the limited space of the galleries, museums, art journals, and other communication media. This forces artists into an isolation where they cannot help other artists in any genuine manner. Dealers and museums see to it that there is a minimum of technical advance, since they cannot afford the expense of advanced technologies; they are faced by new and complex problems of installing advances works, they do not have the space required, their floors may not be strong enough, etc. Dealers have no use for an artist who is so involved with research that his mediums change with a rapidity that give no time to publicise each development, or to reap the economic and publicity rewards that result from the steady exploitation of one type of product. The result is a collusion of the artist with dealers and muse-ums, with the art critic or journalist playing the role of middleman in the operation.

But this collusion is certainly on the point of being exploded by the sheer volume and accessibility of materials and techniques, plus the pressure exerted by rising generations

of artists, who will simply not stand for limitations on their exploitation of the possibilities of technological art. And technology is still in a phase of expansion, where vast numbers of possibilities will be added to those already present. Once these facts are accepted, then the competitive, jealous, and negative spirit that infects the art world can be under-cut.

Art Science Technology Collaboration

It is self-evident that genuine collaboration demands the exactly opposite approach to the mean, conservative one of the art world; it requires willingness to seize on anything that may lead some-where, a preparedness to share, by publication, pooling information on materials and techniques, and by numerous other ways, breaking down the barriers that at present dominate the relations of artists. It is in such an open situation that artists may contribute (however indirectly) towards the development of new techniques in life.

In the meantime, there is the inevitable conflict between those artists integrated within the existing art world (or who hope, eventually, to join it), and those working in the new approach. These conflicts will be present in any organisation that connects artists with science and technology. How is one to prevent the internal collapse of such organisations without the unjustified exclusion of the artist committed to the present art structure? One answer is to see to it that the core of these organisations is composed of people least dependent on the present art world.

Economics and Prestige

Money must be found to enable artists and their dependents to live whilst pursuing work which in many cases will not be at all marketable in old sense. This can be arranged in the form of grants for those working in a university or research situation. Industry can supply free materials and workshop facilities within plants, warehouses, etc. A large pool of money can be arranged where industries, businesses etc., give a portion of tax-deductible money which will be shared out to artists. The government can add to this pool. Some of the economic benefits derived from the research of artists can also be siphoned into this. As for prestige, instead of in the gossip columns, the TV appearances, and articles in the glossy magazines (inevitably limited to a tiny percentage of practicing artists), a far greater number can get the prestige that goes with good work done, or that follows difficult research.

Economics and Politics

For the artists or their organisations to approach science and technology as if they were entirely desirable and constructive forms of activity is extremely unrealistic and dangerous. There is now a clearly established and growing trend among scientists and technicians to create a situation within their disciplines dividing those who are integrated with present structures, and those wanting to

expose and correct the disastrous alliance of science and technology with exploitative and destructive social systems. In the course of the present year there has occurred the formation of the British Society for Social Responsibility in Science. The Union of Concerned Scientists called a one day "research stoppage" in a number of leading American universities including M.I.T. on March 4 (*See New Scientist*, March 20, p. 616). These two are but the latest developments in a campaign that has gained in strength since the end of the last war.

The same U.S. publication *Computers and Automation* which has sponsored computer art, has consistently opened its pages to a serious discussion of the dangers that computers signify for the future of mankind. One of its articles quoted this revealing advert from *Fortune*: "The Computer industry is a union of science and business that makes the auto and appliance industries in their great old days seem like a bunch of kids playing mumbling peg." (*Computers and Automation*, March 1964, Editorial) The computer industry runs at an annual growth rate of 30 percent. Computers are retained in production, or are rendered obsolete, in accord with programmes that are essentially based on profitability factors. If the Computer Art Society (C.A.S.) will not face these facts then it is heading for serious trouble. It would be tragic if the Society did not make some statement about the dangers of computers in war and the control of individual freedom in its policy declarations.

What are the tasks of the artist who is committed to the use of computers and advanced technology? He needs to align himself with those who are working on the sophistication of computers, oppose the stasis in computer development caused by considerations of profit, and align himself with the scientists who are fighting the system from within. A situation where the C.A.S. has access to computers, with no strings attached, and no possibility of commercial success, prestige, or exploitation, is infinitely more desirable than access to the most lavish installation where a company might manipulate the direction of the Society.

Zagreb Manifesto

(In: *Studio International*, London, June 1969)

We salute the initiative of the organizers of the International Symposium on Computers and Visual Research, and its related exhibition, Zagreb, May 1969. A Computer Arts Society has been formed in London this year, whose aims are "to promote the creative use of computers in the arts and to encourage the interchange of information in this area". It is now evident that, where art meets science and technology, the computer and related disciplines provide a nexus.

We concede that the next twenty years could be spent by artists in exploring and assimilating the potential of existing computers and their peripherals. Some artists, however, are alive to the possibilities which are opening up in the application of advanced techniques for organizing and transforming information. These evolving techniques will respond to an infinite variety of events, transform them and offer creative outputs inaccessible to present art. These advances include the use of computers not only for processing inputs into new forms, but also for optimizing the creative potential at the man/machine interface. This interface is perhaps the least satisfactory aspect of present-day computers, because of the rigid mathematical constraints imposed, the design of the internal logic of the machines, and the inadequacy of existing programming languages for handling information in open systems. A great deal of computer art embodies the limitations of existing techniques. The aesthetic demands of artists necessarily lead them to seek an alliance with the most advanced research in natural and artificial intelligence.

Artists are increasingly striving to relate their work and that of the technologist to the current unprecedented crisis in society. Some artists are responding by utilizing their experience of science and technology to try and resolve urgent social problems. Others, researching in cybernetics and the neuro-sciences, are exploring new ideas about the interaction of the human being with the environment. Others again are identifying their work with a concept of ecology, which includes the entire technological environment that man has imposed on nature. There are creative people in science who feel that the resolution of the man/machine problem lies at the heart of making the computer the servant of man and nature. Such people welcome the insight of the artist in this context, lest we lose sight of humanity and beauty.

Gordon Hyde
Jonathan Benthall
Gustav Metzger

London, 4 May 1969

(Text about FACOP Artists Conference in: *Circuit*, No. 10/11, 1969)

The anonymous writing in Circuit 9, "The Need for an Artists' Council", contains a great deal of ambiguity and contradiction. A similar criticism could be levelled against the FACOP conference [Friends of Arts Council Operative][1] at the docks on June 8. But this burst of activity is positive. To get so many people from the art world to spend a day in argument is a considerable achievement, and the organizers of SPACE are to be congratulated for facilitating such a proper use of St. Katharine's.

We are in a society whose basis is the production, the selling and maintaining of systems of mass-murder. It is against this reality that any other forms of social activity must be placed. It is against this that one considers the all too numerous artists and artisans who demand more money so that they can produce more artefacts that can be exhibited so that they become more famous so that they eventually qualify for burial in the Tate Gallery.

It would be strictly suicidal for any radical artists' organization to ignore the divisions that exist among artists. There are those hooked on the dealers/international exhibitions/museums travelogue. There are others refusing to work within the dealers system. Others not wanting to accept subsidies from bodies such as the Arts Council while others are concerned with the threats that capitalist exploitation pose for the future of technological art. An objective understanding of the conflicts engendered between those artists attempting to change society, and others concerned with personal economic survival and tied to the numerous hang-ups of the art world, is basic to the functioning of groupings such as FACOP. Unless such an objectivity is established, the compromise and time wasting will become intolerable—precluding results in terms of useful social change. Yes: the slogan is ARTISTS AGAINST ARTISTS.

1 FACOP (Friends of Arts Council Operative) was a group of activists who critically opposed the policies
 of the Arts Council Great Britain and supported, among other reforms, appointing artists in the committees
 of the Arts Council (editor's note).

New Ideas in Plotter Design Construction and Output
(Unpublished paper for "Computer Graphics '70", London 1970)

This work is based on the realisation that existing plotters are not sufficiently flexible for the demands of art. The paper is in these sections: The adaptation of existing plotters. The invention of new plotters. The development of self-organising drawings. Advanced plotters now and in the future.

The Adaptation of Existing Plotters

Last year I wanted to work with plotters with the aim of producing an entirely different output. In the course of the past ten years I have developed a number of new art techniques. As far back as 1963, I started to adapt slide projectors to show chemical transformation. (Later, this kind of work became popular as chemical light shows, psychedelic environments, etc.)[1]

The intensive work on this paper started with a series of notes and sketches in the last days of January 1970. It may be useful to look at the first notes. "Graphite/heat? Air pressure. Encapsulated techniques. Light through fibre optics. Photo-sensitive paper. Increase light-control line. Laser and fibre optics. Vacuum. Liquid crystal. Diamond. Electrical connections in paper, Sensors. Magnets. Photograph light pen direct in flat-bed. Two or more fibre optics on + off to paper. Sensors in-or-behind paper". It was clear that I was not merely concerned with adapting plotters, but also with the development of new kinds of plotters.

For more than two years I have owned a fibre optics light guide, twelve inches long and one fifth of an inch in diameter. I asked the artist Heather Peri at the beginning of February to make some drawings in a darkroom. A small torch was taped to one end of the guide. Drawing rapidly, she pressed the end of the guide to the photographic paper at some stage, whilst in other parts of the drawing the guide was lifted off the paper at varying heights and angles. (Figure 1) In the middle of March, the first drawings on a plotter were made by D. E. Evans, of the Computer Unit, Imperial College, London. Based on my design, these three exercises were produced on a Calcomp 563 under magnetic control tape. The tape was information generated by a computer programme. The end of the guide was about a quarter inch away from the paper when producing the curved line, and was pressed as close as possible to the thin sheet of plastic covering the paper whilst making the angular line. (Figure 2)

There are a number of problems in using light. The plotter needs to be in a dark room; the prints have to be processed. At Imperial College, the room was not completely in the dark, resulting in imperfect prints. Manufactured light guides can be bought from 1/32 inch diameter upwards. It is also possible to buy a quantity of fibres and make up any desired shape, each resulting in different effects.

Let us now consider other aspects of the use of fibre optics in plotters. As seen in the illustrations, by varying the distance of the light guide to the paper, there follows a change from a clearly bounded line where the light is closer to the paper, to a wider, more "painterly" line which can be more than four times the width of the bounded line, depending on the distance at which the guide is held. The use of filters will modulate the light, resulting in different tones; alternatively, the light source can be modulated. A number of different sized light guides can be placed into the plotter; drawings of considerable complexity can be achieved, particularly if the tone of each guide is varied, and light is switched on and off in accordance with a plan.

Different light guides can receive light from a single source. By placing filters in front of each guide, we can stop transmission of light, or change the tone of the output. Each guide needs to have the ability to retract and advance. Instead of having a number of different shaped guides, we can make a disc on which there are various shapes made up of fibre optics. By switching the required shape under the light source, we keep changing the design. Or there could be globes or wheels serving a similar function. Colour can be incorporated. As seen in Figure 1, changing the angle of the guide in relation to the paper changes the image. It is possible to line up fibre optics into a kind of ribbon. This could be modulated into different shapes under numerical control, producing a wide range of results when light is passed through. The addition of mirrors to the guides opens up other possibilities. Laser light could be used to light up individual sets of fibres, thus printing and drawing with greater precision and speed. This is only a sketch of possibilities. It is clear that we are not only faced by a great extension of the range of computer art, but also the programming of computer art can achieve new levels of sophistication. Time and process are more critical than previously. Of course, apart from fibre optics, many other techniques and materials can be adapted to the plotter.[2] The artist needs to have access to a machine that can be adapted and strengthened to carry new fittings.

The Invention of New Plotters

Many of the techniques discussed above could be interfaced with a computer. But a point may be reached where the demands made will be beyond the capacity of the plotter. The plotters in use now are of the family of the drawing automata of the eighteenth century.[3] We must abandon a mechanistic approach to drawing machines, and immerse ourselves in space age techniques. The hand is a delicate thing; paper is delicate; ink, pencil, chalk, are delicate—why imprison all this in a steamroller? The stylus must have the capacity to act very much like the hand. It must be able to press hard, or gently touch a surface. It must bend at any required angle. Drawing is texture, tone and a range of difficult to describe actions and qualities; it is not merely that bland line of uniform density and texture that emerges from today's plotter. Above all, a plotter that is used for art must have the capacity to move beyond the X Y confines.

Is it not time that some of the principles inherent in well-established techniques are adapted to the plotter? Take "Sketchpad" of 1963, and the "Rand Tablet" of 1964. Since then there have been many developments.[4] We establish a series of new connections from plotter to computer. Using manual controls, we make a drawing. The "Rand Tablet" principle operating beneath the paper feeds information into the computer; at the same time it can display the drawing on a CRT. A press of a button gets the computer to repeat the drawing on paper, modify it, enlarge or reduce it, change the perspective—in short, get on the plotter the kind of results we take for granted on CRT. There is a trackerball, and it is used to get subtle effects, to tilt the angle of the stylus, for instance. The information is stored, and can be repeated by the machine later.

Now people who are frustrated by delays when using interactive CRT techniques may well shudder at the thought of watching the laborious tracking of a large flat-bed plotter trying to run in step with a computer (not to speak of computer time and a host of other expenses). No, to implement this approach requires plotters so different from existing models that the term revolution in computer graphics would be appropriate.

We start with a vision, a system where the stylus can move freely to any point of the board, without going through the contortions imposed by the fixed arm working on the X, Y alignment. The stylus does not only travels along the ground—it also goes into space. There are computer-controlled satellites—surely there is the capacity to transport a tiny stick over a small part of the earth?

There are many ways of envisaging the new plotters. The stylus might be attached to the end of a flexible tube, whose other end is connected to the side of the board, or suspended above the board. The tube contains the entire mechanism for controlling itself and the stylus. The board uses the "Rand Tablet" principle to interact with the computer, and a CRT is used as a check by the operator. Alternatively, control is divided between the perambulating tube and the board; signals sent into the board, and from the board into the tube, affect the activity. The materials used could be electro-magnetic, air, water, and a range of materials. Advantage is taken of recent work such as the "sound pen" invented by Charles Zajde.[5]

Self-Organising Drawings
Having removed the fixed arm, we have room for more than one drawing implement on the board. This can have practical advantages if a very large drawing has to be produced. When each imple-ment has the task of completing one section of the drawing, a great saving of time will result. Several drawing implements operating on one drawing could interact and produce original results. One implement can influence the activity of the other; they can collaborate, fight, go separate ways.

Once we have drawing machines whose complexity approaches the capacity of the hand, we can think of abandoning programming as it is known, and turn towards self-organizing

drawing techniques. The stylus is placed on the board and begins to move, producing a drawing as it proceeds. It could interact with sensors and signals in the board. The paper or film used can have sensors built-in affecting the motion and output from the drawing implement. Some instructions may be built into the situation. Several drawing implements could produce very subtle interactions, as their motion and energy is linked via the computer.

One of the aims of this approach is to produce genuine *Machine Art*, where the drawing emerges as an inevitable activity from within the mechanism that is engaged in doing the drawing. We are after a drawing that is more subtle than the human could devise. If this technique can work, then we shall be faced with drawings that contain a mass of incomprehensible information. That indeed is one of the objectives of the theory of self-organising drawings. We need machines to tell us things we do not know, and cannot understand. This must be one of the goals of computer art.[6]

Advanced Plotters Now and in the Future

The Gerber Scientific Instrument Company produces some of the most advanced plotters available. They incorporate variable aperture photo exposure heads, which permit the drawing of extremely accurate and variable lines, symbols, and other images. Their techniques are used for making printed circuit masters, for example. Artists using Gerber machines could produce outstanding results. There are only five of these machines in Britain, all with large industrial firms.[7] A tailoring firm in this country is experimenting with using tape controlled laser light to cut many suits simultaneously; plotters using laser light focused on mirrors are being investigated. There is no doubt that the laser and holographic techniques will be adapted to the plotter, greatly enlarging the range of computer art.

Of instruments that I have seen, the one that is closest to an arm able to move in any desirable direction is the prototype laser beam manipulator developed at AWRE Aldermaston, and used by the Department of Surgical Science at the Royal College of Surgeons of England. The laser light is channelled along mirrors, whilst a stream of cool air is forced against the area adjacent to the emerging light, which can cut into bone. A smaller version is now under development.[8] In thinking about the laser, we need to remind ourselves, that graphics include etching, engraving, and other abrasive/incisive techniques.

One of the most critical areas in life is a fundamental change in our understanding and use of matter. We have witnessed one aspect of this change in a catastrophic and traumatic form; nuclear energy. But this search to transform matter into energy in the most direct and fluid manner will not be halted, and could, if handled with ability, be beneficial in the long run. Thinking in this general direction, we can envisage drawing machines that are a bed of compressed air, with the stylus another jet of air that is carrying the ink. A floating bed of air can be the carrier of chemicals which produce a sculptural or graphic output.

I would like to thank Neil Teller for trying to persuade me that electro-magnets will not do what I want; and express my gratitude to Gordon Hyde for the many stimulating discussions on computers and related areas.[9]

1 The first of these "slides" consisted of stretched nylon, which was painted with acid. The resulting changing image was projected on a screen. This technique was featured in the film *Auto-Destructive Art – The Activities of G. Metzger* by Harold Liversidge at the Polytechnic Film School, London 1963. Bann, Stephen. *Experimental Painting*. London 1970.

2 Letter from a student who is adapting plotters to produce new outputs. In: *Computers and Automation*, December 1969.

3 Metzger, Gustav. "Automata in History", in: *Studio International*, October 1969.

4 Article, "Graphic Data Systems and Devices", in: *Computer Industry Annual*, 1969–70.

5 *New Scientist*, 19 February, 1970: 356.

6 Mallary, Robert. "Computer Sculpture: Six Levels of Cybernetics", in: *Artforum*, May 1969.

7 Sanderson, Kenneth R. "Solving Artwork Generation Problems by Computer", in: *Electro-Technology*, November 1969.

8 "Laser Surgery Apparatus", in: *The Physics Exhibition Handbook*, London, 1970: 8.

9 Benthall, Jonathan; Hyde, Gordon; Metzger, Gustav. "Zagreb Manifesto", in: *Studio International*, June 1969.

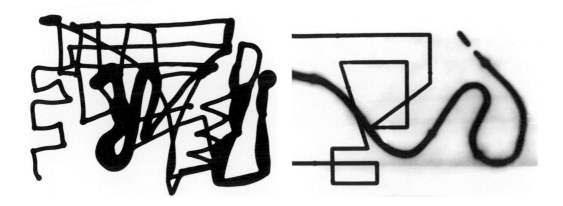

Five Screens with Computer. Computer Graphic Aspects of a Sculpture Project
(Project description, 1971)

The Project Outlined

This sculpture consists of five walls or screens, each about 30 feet in height and 40 feet long and 2 feet deep. They are arranged about 25 feet apart and staggered in plan. I envisage these in a central area between a group of three very large densely populated blocks of flats in a country setting.

Each wall is composed of 10,000 uniform elements. These could be made of stainless steel, glass or plastics. The elements in one of the walls could be square or rectangular and in another wall they could all be hexagonal.

The principle of the action of this work is that each element is ejected until finally after a period of ten years, the walls cease to exist. I propose the use of a digital computer that will control the movement of this work. This would be housed underground in the centre of the sculpture complex.

Numerous techniques could be developed for holding and ejecting the elements. One technique could be the use of attractive and repulsive energy of magnets. Another could be compressed air. The difficulty is in holding a small number of elements in complex, isolated relations.

A programme will be prepared by the artist. This determines the order and timing in which each element is ejected. In preparing the programme, the artist can bear in mind such factors as shadows created by the work in all its phases. Complex interactions between light and shade of all screens could be created. The artist will take into consideration the revolution of the earth and will relate the changing forms to the various seasons. Extremely complex counterpoints between the five screens can be prepared, interesting not merely from the ground but when seen from the windows of the three blocks. The programme can allow for variations due to spectator participation via the photo-electric effect. There can also be sections of the programme where there are a series of random ejections determined by atmospheric conditions—this idea was suggested by Beverly Rowe.

The computer is used for a variety of reasons. One is the complexity of ordering the movements of 50,000 elements over a period of ten years. In fact, it may be *necessary* to use a computer in the *design* of the sculpture and in the writing of the programme. It can be used in order to link art, technology and society, and because only through its use can the artist achieve forms and rhythms that correspond to his aims.

Extract from lecture at the Architectural Association, London, February, 1965.[1]

Background of the project

This is the most elaborate project that has emerged from the theory of *Auto-Destructive Art*. This theory was formulated in the autumn of 1959, and published in a number of manifestos.[2] Here we are concerned to isolate some strands of the theory that link with the project. A major objective of the theory is the establishment of the closest possible relations between art, science and technology. The first manifesto (November, 1959) states: "Self-destructive art can be machine produced and factory assembled." The second manifesto (March, 1960) includes the statement "*Auto-Destructive Art* is the transformation of technology into public art". The same manifesto gives a list of 50 materials and techniques that can be used in *Auto-Destructive Art*; included cybernetics — used in the broadest sense to include theories and hardware. It is the next manifesto titled *Auto-Destructive Art, Machine Art, Auto-Creative Art* (June, 1961), which has some of the basic ideas of the project: "*Auto-Destructive Art* and *Auto-Creative Art* aim at the integration of art with the advances of science and technology. The immediate objective is the creation, with the aid of computers, of works of art whose movements are programmed and include 'self-regulation'. The spectator, by means of electronic devices, can have a direct bearing on the action of these works."

The project was outlined in the lecture at the Architectural Association. (See above) In 1968, a drawing for the project was published.[3] In the beginning of 1969, I started to collaborate with computer experts on the production of the first computer graphics connected with the project. These were exhibited, with models of the sculpture, at EVENT ONE, Royal College of Art, London, organised by the Computer Arts Society in March 1969, and at the Gallery of Contemporary Art, Zagreb, in the exhibition *Computers and Visual Research* May–August, 1969.[4] Recent models and computer graphics will be shown in the Computer Arts Society exhibition within "Computer Graphics '70". It is hoped to show a film based on CRT display during the presentation of this paper.

Modifications of project since 1965

There have been several changes in the concept since the talk at the Architectural Association. The project has been discussed with a number of professionals. The number of elements per screen has been dropped to 1,200. The idea of extrusion of elements was present in the early formulations. The plan now is to have no ejections in the first year of the life of the project. In this period, elements can move forwards and back (left and right) within a frame. An element can jut out almost its entire length (2–3 feet). Each element can move independently of others. Any element can be moved at speeds so slow as to be imperceptible to the eye, or as fast as the technology will permit. The control mechanism should be so refined that all elements can be in motion in varying speeds in the same period. It will be possible to have an enormous range of form and rhythm relations, extrusions and recessions with shadow effects. The screens can be manipulated to achieve effects that are analogous to music and dance. These "performances" can be programmed, and

performed automatically. It is also envisaged that a number of concerts will be arranged in the first year of the project where artists and other specialists will be invited to "play" the screens. Such a performance could be combined with programmed activity of the screens: other interaction between player, computer, and other technical equipment, as well as light and sound activity can occur.

There are many reasons why it is desirable to have no ejections in the first year. It will provide an opportunity to run in the various systems, check faults, simulate the ten-year activity, and finalize the ejection programme.

The role of computer graphics in the project
Computer graphics have the capacity for creative interaction with the artist, the design and production team, *and the concept*. We rely on computer graphics for accuracy, variability, definition, and many other qualities and capabilities.

In this project, the production of computer graphics which are exhibited as computer art is a low priority. Computer graphics are used in a bigger fabric—not as ends in themselves. The ultimate aim is the work of art—the five screens with computer in operation. To this end, computer graphics are used in the *design* of the work, as aids in the *functioning* of the sculpture; to *record* the development of the screens.

Let us consider some of the functions of computer graphics in this project.
1. They are *form-making* on a high level.
2. With their aid, decisions are reached that are superior to decisions the artist could make if working on his own.
3. They achieve formulations that are more numerous, involuted, and comprehensive, than the artist could make if working on his own.
4. The aesthetic qualities of line, tone, texture or design, can be superior to the work the artist might achieve.

We now join the "artificial intelligence" controversy in the area of aesthetics with the view that computer graphics can already operate on a very high creative plane.

Computer graphics in the design of the project
Before the screens are produced it will be necessary to work out in great detail how the sculpture will develop over the ten-year period. Graphs will be produced showing the position of many elements in that period. These graphs will not only give the day, but also the precise time, at which a particular element will be ejected. The graph will also give details such as the velocity of a given ejection. In

preparing the programme governing the ejections, recourse will be had to CRT simulation of elements in flight, impacting on the ground, and so on.

One of the five screens will be eliminated in a more or less random manner. But within each screen there will be sections of the screens that will be eliminated in a manner that is not pre-determined in the original programme. There will be a large range of these "random" ejections, and they will tend to occur within limits of space and time laid down in the original programme. A major feature of the project is the planned use of shadows; created by the sun on the ground; on a screen caused by extrusion of elements; in the vacant spaces of a screen caused by the ejection of elements — such shadows and their *development in time* will have to be simulated at the design stage, and the decisions resulting from this study fed into the original programme.

In order to build this project, it is necessary to fully understand the ten-year activity of the screens while we are at the design stage; without the insight that simulation provides it would not be possible to master the vast quantity of technical problems presented by the project. There is a tight interface between technical and aesthetic factors — simulation of the activity of the screens and computer graphics will bring the technical and artistic sides of the design team onto a common ground.

Aspects of functioning and maintenance

The technical complexity of this project is comparable to space flight, indeed some of the technology of space flight will be incorporated in the sculpture; one example is automatic checkout and diagnostic equipment. The correct functioning of the screens depends on millions of parts in a state of readiness interacting on a nanosecond time scale.

A large metal construction packed with electronic and other delicate equipment exposed to the weather, and subject to vandalism, needs a staff that will be responsible for maintenance. One of the functions of the computer graphics used in the design and production of the screens is to aid the maintenance staff in their work. The objective is to make a construction that is as fully automatic as possible, but the need for repairs has to be anticipated.

Recording the activity of the screens

As the sculpture disintegrates, as each element is ejected, there will be a printout of the date and time of each radical change; periodically there will also be drawings showing the changing appearance of each screen shown singly, as well as perspective drawings of screens in relation to each other. A comparison between this output and the design prints and drawings will establish if the programme is running accurately, and will greatly help the tasks of maintenance.

It is proposed to preserve in a suitable archive the bulk of the computer graphics connected with the project, as well as photos and films.

Informing the spectator

A project as elaborate and expensive as this will attract visitors from close by, and from afar. Critics and art historians can be expected to turn up. Some of these people will not be content to view the screens, but will want to have some acquaintance with the "works", and may want other information on the sculpture.

It is proposed to establish a viewing area adjacent to the chamber housing the computer and other control devices. From this viewing area, separated by large glass divisions from the control area, visitors will be able to see the technicians at work; they will also see the current print-out showing the transformation of the screens and CRT displays and television monitoring the sculpture. In the viewing area there will also be the information centre on the sculpture complex. People will be able to obtain literature on the subject, photographs and other related material. By phoning the adjacent computer, they will obtain answers to their questions on the project. On the walls of this room there will be descriptive diagrams, photos of the project from its inception to its current state. Here visitors will see samples of computer graphics used in designing the work, as well as the more recent output.

Aesthetics

The material used in the sculpture will be reflective, but not polished. Each screen will be composed of elements having a uniform shape, but the shape in each screen may differ. Essentially, the shape will be square, one foot or less, and two to three feet in length.

Each ejection is regarded as a potential aesthetic experience. The factors include: distance of element from the ground, direction of element in flight, velocity, the relation of one element to others in flight, and reflections during flight. Each element can be ejected either to the right or left of a screen. On holidays, or special occasions, the screens will be programmed to have a particularly interesting sequence of ejections. Hundreds of carefully designed ejections could occur in the space of a few minutes. Comparable visual experiences are fireworks, a number of divers leaving boards set at different heights at staggered intervals, or masses of birds in motion.

The work will incorporate a great range of speeds. The extrusions may occur very slowly, elements moving forward at the rate of a fraction of an inch per month. Ejections can be very slow or fast. The computer may order the ejection of eight adjacent elements, each one leaving the screen *at different times* within a one-second period. The different speeds and directions of a number of elements in flight from different screens in one period of time, will provide one of the most significant experiences this project can offer.

One of the most important aspects of the project is the planned development of shadows in time. A careful study of the weather will precede the finalizing of the programme.

It will be evident that in a project of this complexity, hundreds of thousands of factors have to be considered; it is equally clear that only a small fraction can be considered in a paper of this form.

Bibliography

1 Metzger, Gustav. *Auto-Destructive Art: Metzger at AA*, in: ACC, London, June 1965.

2 Cp. in this volume: *Auto-Destructive Art* (1959), *Manifesto Auto-Destructive Art* (1960), *Auto-Destructive Art, Machine Art, Auto-Creative Art* (1961), *Manifesto World* (1962), *Machine Art, Auto-Creative Art and Auto-Destructive Art* (1964) as well as *The Chemical Revolution in Art* (1965).

3 Reichhardt, Jasia (ed.). *Cybernetic Serendipity: The Computer and the Arts*. Special issue of *Studio International*, London 1968.

4 Cp. *Event One* Document, Computer Arts Society, London 1969; and *Tendencije 4: Zagreb, 1968–1969*. (Computers and Visual Research), (cat.), Zagreb 1969.

Second Floor

(Exhibition text for *3 Life Situations*, Gallery House, London 1972)

Strictly NO SMOKING ON THE SECOND FLOOR: please stub out your cigarette before ascending.

ROOM 1. *Stockholm June*: a project for Stockholm 1–15 June 1972.
Phase 1. 120 cars surround a rectangular structure two and a half to four meters in height, enclosed in transparent plastic, perforated at intervals to permit some escape for exhaust. The exhaust of all the cars is fed into the structure. The car engines will run from morning till late at night.
Phase 2. On the night of the 14th, the cars are taken inside the structure, lined up at the edge, the engines filled with petrol and started. The structure is now covered with un-perforated plastic sheeting and sealed up. If by noon on the 15th, the cars have not gone up in flames, small bombs are to be hurled into the sculpture.
The Bathroom. The facilities, including bath and shower are available to the visitor. Towels may be collected from the office in the basement; the lift adjoins ROOM 4. Visitors can also make an appointment for massage by a professional in The Bathroom. Arrange through the office: phone 01-589 7207/3648.
The Kitchen. Food such as rice and lentils are provided, and the visitor may rinse and cook this.

ROOM 2. Projects for sculpture and architecture

ROOM 3. *Controlling Information from Below*. It is vital to contain the volume of information that is hurled at us. By analysis and critique of this information, one moves towards some form of control. A large number of newspapers from different countries, magazines and learned journals will form the basic material of this section. The visitor is encouraged to manipulate this material by cutting up, re-arranging, writing comments … There will also be TV, radio, and a tape recorder. In the evenings and weekends, there will be meetings where various groups will present their approach to the problems posed by the mass media.
There is a great need for several archives in this country and elsewhere, where people collaborate in these tasks. Newspapers and other communication bodies could not survive without up-dated reference libraries. If we want to undermine the power of the existing media (and this implies undermining the power of the existing social order), we must counter their power with access to our own efficient archives. Instead of so much chatting, people should spend 15 minutes per day bringing cuttings to their local archive.

ROOM 4. This room will normally be closed to the visitor. It will be used in the tasks of organising ROOM 3, and for discussions with a few people. These rooms provide a good opportunity for making controlled experiments with the mass media. The success of the operation depends largely on the level of contributions by participants.

From the City Pages

(in: *Studio International*, London. December 1972)

It is embarrassing these days to be an artist. Artists move around *sans* pencil; *sans* paper; *sans* bags, which might conceivably conceal the dreaded weapons of their craft. This embarrassment stems partly from the unsatisfactory position of the artist as handmaiden to the social system: in particular it relates to the financing of art. The Arts Council and other art-subsidizing bodies derive theirs funds from the Government. Now many artists oppose the Government and the kind of society it seeks to foster, and there is therefore inevitably a sense of compromise when accepting money or invitations to exhibit from organizations whose source of finance is ultimately Government money.

To some extent I have managed to resolve these conflicts by showing work which represents my political views, which is aimed at changing society, and which at the same time seeks to alter the habitual usage of the gallery or museum, and the expectations that visitors bring to these institutions.

The *Executive Profile* exhibition taking place in the Concourse of the Institute of Contemporary Arts, November/December 1972, follows two other shows where newspapers were used.

Like many people, I am fascinated by newspapers. Newspapers are informative; they distort reality and foster illusions; they serve the interests of governments and big business; they record history; their design is fascinating; the comparison of newspapers and journals is an absorbing activity. In my contribution to the large *Art Spectrum* exhibition at Alexandra Palace, August 1971, I managed to work with these interests. Each day, generally in the morning before the show opened, I went through the British national press, selecting pages and cuttings, which were pinned onto the four walls. Usually I typed a crisp critical comment on the electric typewriter; and sometimes entire pages were displayed without comment. For instance, each page of *The Sun*, *Daily Mirror* and *Daily Mail*, which are almost identical in size, were placed below each other. The rather horrifying similarity of content, nudes and advertisements made further comment superfluous.

Halfway through the exhibition George Jackson was killed at San Quentin prison.[1] An entire wall—the best place—was cleared of all other material and by the end of the show that wall was filled with cuttings relating to that murder. Red roses from the Rose Garden at Alexandra Palace were placed against the centre of the wall to reinforce this act of homage and protest.

The work was presented as a prototype for centres where people can fight back against the powers of the press to distort and suppress reality. There is a crucial difference between the internal or private comment that is made in a newspaper, and a public statement shared with others. The kind of public activity shown at *Art Spectrum* where people make on-going comments—in a sense re-write the daily press—can be a valuable contribution to a community.

In the inaugural exhibition at Gallery House London, which I shared with Stuart Brisley and Marc Chaimowicz in the spring of this year, two of the six rooms available to me on the second floor were turned over to the mass-media. These two rooms were titled *Controlling Information from Below*. The objective was to encourage the visitor to take part in making cuttings from newspapers and filing them, with the aim of building up a library of news-cuttings, which is such an indispensable aid to newspapers and other organisations. In order to change a society as complex as ours, people will need a large store of readily available information, and whilst criticising newspapers, we should acknowledge that they are doubtless a source of important and easily obtainable information.

The visitor entering the larger of the two rooms was faced by a tall wooden structure in the far corner piled with newspapers and magazines including a number of foreign ones, and black painted boards resting on the floor serving as seats and tables. The walls were bare except for one which had the slogan SMASH IT painted in bold black letters, plus a picture of Lenin from the *Observer* colour supplement. Scissors, paper and glue were provided. The smaller room contained a filing cabinet and a tape recorder. Visitors did indeed cut up newspapers and stuck these and the collages they produced on the walls, to my dismay, wrecked the pile of newspapers and wanted to set fire to it in the middle of the room, but failed to do any coherent work on the filing system.

The present show is closer to the *Art Spectrum* presentation than to the work at Gallery House. It consists basically of newspaper cuttings and typed comments. But whereas the entire paper was used in 1971, now the material is limited to the business pages. The exhibition is part of the ICA's programme *The Body as a Medium of Expression*, and special emphasis will be placed on bodily and facial expression. The material comes from *The Times*, *Observer*, *Sunday Times*, *Financial Times* and other newspapers, including some produced outside London. Journals like *Campaign* and *The Director* will be used, and a variety of specialized magazines not on general sale will be featured.

In planning the exhibition I have deliberately steered clear of special investigations. I have not spoken to photographers who work for the City pages, nor to City Editors, because I want to base my comments on the same visual information that confronts other readers.

At the *Art Spectrum* show, sheets of paper were placed between the exhibits on some days with the request that visitors might add their comments; many people did so. This aspect has been extended, again making a closer link with the Body programme. Profile sheets will be available at the ICA reception desk in the form of a questionnaire. Before collecting a profile sheet, the visitor needs to go to the automatic photographic studio, which forms part of the exhibition (similar to the ones installed at tube stations), and have his/her photo taken. These prints are then attached to the profile sheet, and will give us a more rounded idea of the person making the comments.

The subject matter is presented in sections. For instance, grasping—where the executive is posed with hands and limbs outstretched; accumulating—where executives are seen in proximity

to the source of their wealth; these images range from men posing with model girls, to piles of live ammunition. (Such photographs are a feature of the "quality" Sunday papers, where we are meant to skim through the Business part along with the art and interior design pages.) There will be sections covering physical and psychological states: withdrawal, advancing, aggression, power, sickness. The executive as presented in advertisements will form a section.

Guiding the choice of materials and comments is a structure that is concerned with such factors as the self-image of the executive (a term given me by Jonathan Benthall); the photographer's treatment of the subject; the use of the photograph by the editor and designer; the correlation of image to text; the objective of the newspaper in presenting the image; the usefulness or damage to the subject of the published image and text, and a variety of other thoughts. A newspaper is a complex multi-level reality, and in probing it we must respond on a variety of levels.

A certain objectivity is aimed at in presenting this work: I am certainly working in conformity with certain principles and rules. But there is an irreconcilable clash between my views of society and those upheld in the City pages.

A marked split exists between sections of some newspapers and their business pages over pollution and environment. The general editorial writing may seek to accommodate or absorb the powerful international protest movements that have formed on these issues. But the City section features ecology only when a firm is cashing in on the interest, or when some big financial power is directly threatened. In the City pages, capitalism is laid bare. The City Editor reigns firmly over the jungle. He will prod his beasts—goad them towards success, "the kill". And those not savage enough to make it will not escape disciplining: we see them occasionally, their heads bowed, with drawn faces, set up as a warning to the pack. But the standard City face stares with confidence straight at the camera, or faces us in an advantageous three-quarter profile. The face may smile, or it rests stern and authoritative. The face whose company launched a thousand ships is conscious of its role in projecting confidence in its company and its 100,000 employees.

It is not true to say that we are living under Fascism. We are living in a state that is a hundred times worse than Fascism. They were prepared to wage all-out war, and kill millions of Jews. We are actively preparing to kill all life on earth. Newspapers are aligned with this society: they help to maintain it and must share the blame for the increasing ugliness of people and cities. The advertisements of the polluters and destroyers keep the presses rolling. Picasso said that art is a weapon to fight the enemy. I have something to say; and I am saying it—and that is politics.

1 George Jackson, an Afro-American and prominent member of the militant Black Panther Party, which progagated armed defence against racism, died of gun shots fired by prison officials on 21 August 1971 in the state prison San Quentin (editor's note).

Years without Art 1977–1980

(Catalogue contribution for the exhibition *Art into Society – Society into Art*,
Institute of Contemporary Arts, London 1974)

Artists engaged in political struggle act in two key areas: the use of their art for direct social change, and actions to change the structures of the art world. It needs to be understood that this activity is necessarily of a reformist, rather than revolutionary, character. Indeed, this political activity often serves to consolidate the existing order, in the West, as well as in the East.

The use of art for social change is bedevilled by the close integration of art and society. The state supports art, it needs art as a cosmetic cloak to its horrifying reality, and uses art to confuse, divert and entertain large numbers of people. Even when deployed against the interests of the state, art cannot cut loose from the umbilical cord of the state. Art in the service of revolution is unsatisfactory and mistrusted because of the numerous links of art with the state and capitalism. Despite these problems, artists will go on using art to change society.

Throughout the century, artists have attacked the prevailing methods of production, distribution and consumption of art. These attacks on the organisation of the art world have gained momentum in recent years. This struggle, aimed at the destruction of existing commercial and public marketing and patronage systems, can be brought to a successful conclusion in the course of the present decade.

The refusal to labour is the chief weapon of workers fighting the system; artists can use the same weapon. To bring down the art system it is necessary to call for years without art, a period of three years—1977 to 1980—when artists will not produce work, sell work, permit work to go on exhibitions, and refuse collaboration with any part of the publicity machinery of the art world. This total withdrawal of labour is the most extreme collective challenge that artists can make to the state.

The years without art will see the collapse of many private galleries. Museums and cultural institutions handling contemporary art will be severely hit, suffer loss of funds, and will have to reduce their staff. National and local government institutions for the financing and administration of contemporary art will be in serious trouble. Art magazines will fold. The international ramifications of the dealer/museum/publicity complex make for vulnerability; it is a system that is keyed to a continuous juggling of artists, finance, works and information—damage one part, and the effect is felt world-wide.

Three years is the minimum period required to cripple the system, whilst a longer period of time would create difficulties for artists. The very small number of artists who live from the practice of art are sufficiently wealthy to live on their capital for three years. The vast majority of people who produce art have to subsidise this work by other means: they will, in fact, be saving money and time. Most people who practice art never sell their work at a profit, do not get the chance to

exhibit their work under proper conditions, and are unmentioned by the publicity organs. Some artists may find it difficult to restrain themselves from producing art. These artists will be invited to enter camps, where the making of art works is forbidden, and where any work produced is destroyed at regular intervals.

In place of the practice of art, people can spend time on the numerous historical, aesthetic and social issues facing art. It will be necessary to construct more equitable forms for marketing, exhibiting and publicising art in the future. As the twentieth century has progressed, capitalism has smothered art—the deep surgery of the years without art will give art a new chance.

Art in Germany under National Socialism

(in: *Studio International*, London. March/April 1976)

In October 1974, there opened at the Frankfurter Kunstverein the most sensational political art exhibition seen in Germany since 1937, when the Nazi hierarchy placed on view two concurrent exhibitions in Munich—designated City of Art by the Führer. The *Great German Art Exhibition 1937*, held in Troost' s new Haus der Deutschen Kunst, displayed the art favoured by the National Socialists. The other, the notorious *Entartete Kunst*, collected together the modern art the Nazi leaders were determined to eliminate.

The Frankfurt exhibition, *Art in the Third Reich. Documents of Submission*, was conceived as a solemn historical act of retribution. Using photographs, original works and statements, it grasps the State and Party architecture, along with the art shown annually from 1937-1944 in the Haus der Deutschen Kunst and featured in the official art journal *Kunst im Dritten Reich*, and submits it—and the society and ideology at its base—to the kind of savage treatment which the Nazis splattered on Degenerate Art. But unlike the Nazi's blooded, apoplectic presentation of *Entartete Kunst*, the Frankfurt installation was based on extensive historical research and notable for its aseptic character.

The exhibition was commissioned by the City of Frankfurt and organised by the Frankfurter Kunstverein, with the working group of the Art Historical Institute, Frankfurt University, and Iring Fetscher as adviser. This team also produced the catalogue, edited by Dr. Georg Bussmann, Director of the Kunstverein. With fourteen articles, 247 illustrations, a political, economic, social and cultural chronology, and a wealth of bibliographical information, it represents an advanced direction in art-historical work. The exhibition was also seen in Hamburg, Stuttgart, Ludwigshafen and Wuppertal, and aroused considerable controversy.

The groundwork for the study of German fascist art has been laid in the past thirty years; we are now in the phase of arduous detailed research. To further this, the first international symposium on the subject has been arranged. AGUN *Art in Germany under National Socialism* will take place in London, 17–19 September 1976. It will be conducted in English and German, with translation arrangements. It will enable scholars in this field to meet and present a platform for their latest work. Since most of the literature is in German, English-speaking artists, art historians and writers on art may find the AGUN Symposium useful.

The German Left has made extensive studies of Fascism. Since the fall of the Hitler regime, the German Left has been very active in art theory and art history: most of this work is not known in the English-speaking world. The German Democratic Republic has an extensive translation programme from Russian to German, facilitating access to Russian art theory. The AGUN Symposium plans to display some of this work and pave the way for translation projects into English.

The Munich *tendenzen*, unknown in Britain, is one of the liveliest art journals in Europe: its pro-gramme is "criticism of late-capitalist society, and development of the tradition and presence of revolutionary art". This, and publications like *The Fox*, New York, will be available.

Art is a product. When the recluse of Mougins[1] departed, £ 350 million of products were inveigled into Paris bank vaults. And what will be the value of the sculptures now garnered in the fields and barns of Much Hadham[2] when the final explosive figures are released? The advent of nuclear weapons exposed the continuance of big-time war as total lunacy: Picasso's legacy is art's Hiroshima. Like the most alert and responsible scientists in the post-1945 period, who sought to find out what went wrong with science and society, some of the most acute minds in art today, having abandoned the production of products, are trying to assess the nature of the catastrophe in which art is placed.

The Frankfurt exhibition and catalogue is aligned with a world-wide direction which must achieve dominance; one could label it *art history with a gun*. Art history has been an instrument which upheld the sacredness of art and social institutions. It bolstered the cash and prestige value of collections. It distorted reality and history in every conceivable way in order to uphold the status quo. Art history is produced by the politically neutered for the eternally unsatisfiable. The field of art history is directly affected by the increased power and violence in the world. Primed with the blocked energy of artists (and those close to artists) unable—or unwilling—to produce art products, we are experiencing one of the greatest upheavals ever known in the field. Starting with attacks on the existing social order, we must expose the social and economic power structures governing the production and consumption of art in history. We are then faced with the necessity of creating a completely new history of art. To succeed we need to use the knowledge gained in the twentieth century, and the numerous information handling devices that have become available. A most aggressive struggle against the established strongholds—art-historical institutions, art schools, art magazines, art dealers, museums, art councils, etc.—is essential.[3]

In this crisis, the art of the Third Reich provides a unique test-bed for working out some of the principles of art history with a gun:

1. It is as closed a period as Ancient Mexico, but it lasted less than twenty years and took place in our lifetime.

2. The Third Reich aimed to survive more than a thousand years. Nazi ideology tried to penetrate all aspects of life, private and public, and the National Socialists were exceptionally open about their programme. Being an exceedingly bureaucratic system, a vast amount of paperwork was produced dealing with all aspects of life. With the collapse in 1945, the state archives became available for in-depth study.

3. Several magazines placed the approved art and architecture before the public. With high quality illustrations, and authoritative texts, these, and numerous books on life and art, give one a very deep insight into the period; particularly when reinforced by film, photography and recordings. A number of original art works are preserved in official collections, and architecture and sculpture have survived.

1 A play on Pablo Picasso, who died in Mougins on 8 April 1973 (editor's note).

2 Much Hadham was the residence of Henry Moore (editor's note).

3 For other aspects see *Art into Society – Society into Art*, catalogue ICA, London 1974.

Passive – Explosive. Proposal for an Exhibition

(Passiv – Explosiv. Entwurf einer Ausstellung, Press release for the *Passiv – Explosiv* Exhibition, Hahnentorburg, Cologne, 1981)

Collective: Cordula Frowein, Gustav Metzger, Klaus Staeck
Architect: Hanns Fritz Hoffmanns

The world is becoming increasingly explosive; people—under constant threat of extermination—are becoming passive.

The reason for the exhibition *Passiv – Explosiv* is a critique of *Westkunst*. "*Westkunst* shows how avant-garde art has developed in Europe and North America." In its realization, the *Westkunst* program—to show contemporary art since 1939—reveals major informational gaps. On top of that are historical distortions, particularly since 1959. Aspects of today's art are missing entirely, for example, political art. While the *Westkunst* handbook is concerned with political events at the time of World War II, the political reality of the last two decades has been almost completely suppressed.

The plan for the exhibition *Passiv – Explosiv* came into being following a public discussion with Klaus Staeck on May 29, 1981 in Hahnentorburg, one day after the *Westkunst* opening. On June 12 the exhibition concept was submitted to the BBK. The decision to go through with it came on July 3.

Passiv – Explosiv, a model for a larger exhibition, shows mainly photocopies of texts and pictures. In addition, there are books, documents, and posters. No art works or photographs will be shown.

There has been no period in art history in which so many technical and conceptual developments have taken place as the last 25 years. How can one present these complex art trends in context with society, science, and culture in exhibitions and museums? The exhibition poses this ignored, crucial complex of questions for discussion. How can one show Actions, transient art, *Concept Art*, *Mail Art*, art denial, not-for-sale art, *Land Art* and other developments? Apart from the usual photographs or relicts of Actions, what information does the visitor need in order to find their way into art? *Westkunst* shows the trends in art in a way that is "consciously conventional", pushing the problem aside.

Anti-war, anti-armaments, and anti-atomic energy movements, resistance to technological progress, and the confrontation with new social problems characterize the art—as do withdrawal, passivity, and conformity.

The diverse room organizations are an attempt to reflect the various trends in art. All six rooms of the Hahnentorburg are included.

1. Structural room. Artists' protests of *Westkunst* will be documented: Pentagram, Wulle Konsumkunst, Klaus Staeck and others. The film "1939: Kunst im Schatten der Weltgeschichte" [1939: Art in the Shadow of World History] will be analyzed—the first of a nine-part film series, a cooperation between *Westkunst* and Westdeutschen Rundfunk. The film contains untenable theses and errors. Documents relating to artist emigration to England, to official English war art, as well as American art of the 1930s and 1940s will be shown. A glass tower contains books on topical subjects: war and peace, unemployment, youth revolt, drugs, environmental protection. ... Books and documents will be lying on the black stone floor, including pamphlets by John Heartfield, which he wrote from England during his emigration. They will be protected by low glass cases. One wall shows the cover of catalogues—an overview of the art of the last decades.

2. Fabric room. Semi-circular room. Documents about: Happening, Fluxus, Environment, psychedelic art, feminist art/women's movement, video. The photocopies will be attached to hanging fabrics.

3. Interaction room. Visitors' room. Laid out are a book for comments and suggestions, addition of artists' names and art trends. A collection of articles about the *Westkunst* exhibition.

4. Museum room. The concept of a museum is introduced. *Passiv – Explosiv* asks the question: How is it possible to adequately represent "transient" art? Four examples of rooms with flexible exhibition possibilities. They are only one part of the museum space available for mediating art that is no longer in existence. The four rooms offer opportunities for: Room 1: Actions; Room 2: work with water—the material can fill the room up to the ceiling; Room 3: destruction room, where material can be destroyed and where walls, ceiling, and floor may be destroyed and repaired; Room 4: technological possibilities such as compressed air, laser, electronic. The laboratory will be integrated into the museum. All four rooms are accessible from a central core. The rooms are available to artists. Past works will be reconstructed. *Passiv – Explosiv* wishes to influence the planning of museums.

5. Kinetic room. Hanging panels will document, amongst other things, kinetic art, idea art/*Concept Art*, technological art, earth art, forensics, field research, *Autodestruktive Art*, and the international Situationists.

6. Political art. The semi-circular wall will be covered with newspaper and magazine clippings—a wealth of political and social events. A large wall with documents about international political art—as well as the sometimes vehement reactions to it—stands in front of it.

Concept: Gustav Metzger

Wiener Aktionismus 1960–1974

(Leaflet for the exhibition *Wiener Aktionismus 1960–1974*, Studio Oggetto, Milan 1990)

Francesco Conz's collection of Wiener Aktionismus is very large and comprehensive. This is the first public presentation of a part of the collection, and the exhibition focuses on the photographic documentation of actions by Günter Brus, Otto Mühl, Hermann Nitsch and Rudolf Schwarzkogler.

The collection consists of thousands of photographic documents in various sizes, and also includes works of art, letters and notes, books, posters, and ephemera. One can follow Otto Mühl's development from an early travel sketchbook to his break with art in 1973, and the founding of the AA commune. This material, which Conz managed to save from its intended destruction by the artist in 1973, is invaluable for our perception of a man, who has made a considerable contribution to our understanding of life and art.

Schwarzkogler's lifework, actions, other works, and documentation, were reproduced by Conz in photographic prints from the negatives of Ludwig Hoffenreich, now in the Museum Ludwig, Cologne. This unique series of prints was authorized by the executors of Schwarzkogler's estate: Hermann Nitsch, Edith Adams and Günter Brus, who signed the material in Asolo in 1973. Brus and Nitsch are represented by numerous photographs, other works, and documents. Two works commissioned by Conz were documented in book-form: the environmental work by Brus, *La Croce del Veneto*, Asolo, 1973–74, and the *Asolo Raum* by Hermann Nitsch, also 1973, the latter still in Conz's possession. Edizioni Conz has published portfolios of works by the artists, and editions in various materials. Francesco Conz has known Nitsch and Brus since the end of 1972, this was the period in Berlin, when he came into contact with Fluxus through Joe Jones. This led Conz to change his way of life and he moved to Asolo. In Asolo, until the move to Verona in 1981, Conz kept a kind of open house for artists: artists would stay in the town on extended visits, and produce work, with him acting as publisher. Asolo was the meeting point between Wiener Aktionismus and Fluxus.

Now that the artists have gone their separate ways, we can reflect on the years of close—at times—ecstatic, collaboration, as can be seen in that inspiring sequence of images from Nitsch's *9th Action*, 1965. Here, all four artists were united, with some of their wives also taking part. Their closeness raises questions, since distancing and isolation are key concepts in approaching their life and art.

Mühl's isolation of a bared breast from the rest of the body; Brus's presentation, in front of the clothed body, of a fractured penis, and the innumerable instances in the art of Nitsch of isolating and framing with blood and animal matter. Schwarzkogler, who jumped to his death from his fourth floor balcony in June 1969, took framing, distancing, and isolating, to unsurpassed heights.

Look at the distanced, superior manner, with which Brus in his white Dandy attire, walks the streets of Vienna, the disdain with which he looks at the policeman, or consider Mühl's presentation of women, equating their isolated, framed, heads, to packets of "OMO" detergent, and bags of flour.

And then the climax of the collaboration of Mühl and Brus, with Weibel, Wiener, and others: *kunst und revolution am 7. Juni 1968 im Hörsaal 1 der Wiener Universität*: there followed arrest, prison, poverty, and exile. Nitsch did not take part, but left Austria the same year.

It's not been said, but theirs was an aristocratic art. Aristocrats also pissed, shat *and* fucked—not only in front of the servants, but their guests as well. The Viennese were Moral Philosophers showing the world as it is: and as it should not be. And the world has not begun to harvest the wisdom and humility that they have sown. Theirs was an art of mourning. It was also an art of submission and sacrifice. The sacrified body is simulated indeed, but we take it for real. And their life was sacrificed, indeed, prison, isolation, exile and death.

They were poets, they had to sing. But in face of *that* reality, they sang with blood and excrement. The artist as scapegoat, the artist as fool, as criminal, as maniac—all states prefigured in the self-portraits of Vincent, were blown-up, lived through, in Vienna, London, Munich, New York, and elsewhere … The artist's task is to reveal beauty, and they showered us with it: the bared vagina, the painted figure—and the scents and sounds in the work of Nitsch.

That's how I met them in 1966. DIAS. London, September. They came; Brus, Kren, Mühl, Nitsch, Weibel—they were jubilant, like a release from prison. They had an overwhelming impact on the *Destruction in Art Symposium*. They were truly accepted for the first time; it was the international breakthrough. *Time* and *Life* reported, with illustrations. And when they returned, it was just as before.

There is a lyrical and humorous aspect to Wiener Aktionismus. *There is put-on and come-on*; and not just blood, sweat and tears. This we experienced at DIAS when Brus and Mühl, with the assistance of Peter Weibel, presented *Ten Rounds for Cassius Clay*. There were feelings of ineffable grace as the model was showered with flour and flowers: Mozart.

The Viennese artists used photography head-on: the camera was accepted. Their work, their looks, their manners. All has been fixed: it fascinates, as it repels. The questioning, and the critique, of the medium of photography are among the important activities of our century. The issue is a particularly sensitive one in our area of ephemeral art. Joseph Beuys and the Viennese group are leading examples, who just wade in and use it without scruples, take up positions of dominance. Yet its unrestrained, unmediated use has catastrophic implications. An entire culture can be swamped by the image. And where fractions of reality are recorded and fixed, immeasurable segments are distorted and eliminated. Photography as used here, *as it confronts us in this exhibition*, is a frightful jump in a darkness, heightening the torture entrapped in the actions of the artists.

Milan, November 1990

Earth minus Environment

(A sculptural project for the UN earth summit Rio de Janeiro, 1–12 June 1992, project description, Amsterdam 1992)

The Conference

In June 1992, the United Nations will host the most ambitious meeting ever planned on development and environment. Government representatives, heads of state, international agencies, and observers are due to take part in the proceedings. Non-governmental organizations and citizens groups will have their own summit in Rio de Janeiro. The conference will address a vast array of interrelated issues, overshadowed by conflicts between North and South. Protection of the atmosphere; protection of land and freshwater resources; protection of oceans, seas and costal areas; conservation of biological diversity; improvement in living and working conditions of the poor, are among the tasks to be faced. The conference will be asked to adopt an Earth Charter that will embody principles which must govern the economic and environmental behaviour of peoples and nations, and a more extensive document titled Agenda 21, "a blueprint for planetary survival in the 21st century". In the words of Maurice Strong, secretary-general of the conference: "No conference in history has ever faced the need to take such an important range of decisions—decisions that will literally determine, the fate of the earth."[1]

The Project

A conference with such truly global perspectives cannot live by words alone. We seek to establish, alongside the profusion of ideas, words and texts, a dramatic image; a sign, a symbol, that can convey, some of the central issues—a work so large that it cannot be ignored. Vast numbers of people throughout the world cannot read at all, or understand the languages most in use.

The sculptural project will consist of 120 cars, arranged outdoors around a large construction in the shape of the letter E. The cars, whose engines will be running day and night, will lead their exhaust into the plastic-enclosed structure. The structure will be made up of metal rods, making a framework, whose plan —a truncated F—relates to the shape of the E on the left of the logo above. The framework will be about two and a half meters high, and one meter wide, and will be completely sealed in with transparent plastic sheeting. The cars will stand side by side around the inside as well as the outside of the E, with the rears of the cars facing it, and the exhaust brought into the structure by means of tubes. Day by day, the gas, water and dirt from the exhaust will transform the appearance of the work, as it settles on the interior of the plastic. The logo above indicates the progression from the start on the left, to the final stage on the right; Earth minus Environment.

271

Background

Gustav Metzger first had planned to use the exhaust of vehicles around 1964. The exhaust would be brought into a plastic-covered construction on top of an open lorry; the lorry would then be driven around. In the autumn of 1970, a car with a plastic construction on top linked to the exhaust was driven through central London on the occasion of the opening of the Arts Council *Kinetics* exhibition at the Hayward Gallery.[2]

The project for *Documenta 5*, 1972, with four stationary cars leading their exhaust into a three meter cube of transparent plastic, was printed in the catalogue, but was not built and exhibited. The catalogue also has text and illustrations for the project called *Stockholm June*. This design was sparked off by the United Nations Conference on the Human Environment which took place in Stockholm in June 1972. The design was made in March 1972; a scale model with 120 toy cars was shown in an exhibition at Gallery House, London, in March/April, 1972. No attempt was made to carry out the project. The present project follows from *Stockholm June*. It differs in shape and programme, and is less difficult to realize. It may be asked why a twenty-year old project should still be pursued. There is wide agreement that motor vehicles are among the most dangerous products of our time. In the course of these twenty years, the numbers of vehicles has expanded enormously, and further increase is pre-programmed. Cars and lorries have done enormous damage to towns and countryside, and have turned life in towns into a very harsh experience for most people. Terrible harm has been done to forests and lakes, in particular. There are the deaths and injuries on the roads. And by now, far more is known of other dangers connected with motor vehicles; climatic change being just one aspect.

Environmental aspects

We must face a contradiction. Wherever the work is to be placed—in a town or outside—it will lead to a considerable increase in pollution. Understandably, this will lead to controversies, and we must anticipate some angry reactions to the plan. We shall point to the hundreds of thousands of vehicles which people have come to accept as part of daily life in cities. Apart from controversy on the environmental aspects, we can expect reactions to the "waste" involved; the cars merely standing there, the amount of fuel used up. Again we can respond by questioning the value of the "normal" use of the car.

Earth minus Environment; a sculptural project

It would be all too easy and quite tempting to see the project entirely in terms of protest and agitation. But that would be missing a great deal. The work will have considerable visual complexity, with reflections playing a large part. The work
will be in a continuous state of a flux as the gas and vapour flows through its vast expanse.

The exhaust particles progressively settling on the interior of the plastic shell will lead to further degrees of complexity—marking its development.

Technical Aspects

There will be consultations with people who have experience with cars and aerodynamics. Full-scale tests will be made with up to twenty cars. The work must function safely for the duration planned. Holes will be made to allow gas to escape. Second-hand cars will be used; these may have external and internal defects, but must not look as if they are only fit for scrapping. They could be bought or hired, and supporters of the project may give or lend cars. The construction will have to be guarded day and night against theft and vandalism. The people on guard will also do the maintenance work required, and fill the cars with petrol and water.

The Project in Europe

It seems desirable to make the project in Europe as well as in Brazil. It would then be seen by far more people, and it would be interesting to compare reactions. The functioning of the work is affected by weather conditions and temperature, which are reflected in its appearance, ensuring that the work would look different in Brazil and Europe. Constructing the two works will also be in line with the central issue of the Earth Summit; the indivisibility of North and South in solving global problems.

Amsterdam, 6 January 1992

1 Quotations are from the article by Fred Pearce, "North-South rift bars path to Summit", in: *New Scientist*, London, 23 November, 1991: 20–21.

2 The car is illustrated in *Art Spectrum*, Alexandra Palace, London, 1971, exhibition catalogue.

(Text for the reconstruction of the *Cardboards* for the exhibition *Made New*, City Racing, London 1996)

The *Cardboards* exhibition in 1959 took place as my "white heat of technology" phase was revving up: it lasted a long time.

Remaking that exhibition would be extremely difficult. The *Cardboards* shown now fall within the aesthetic parameters as defined in the early sixties, in particular the "as found" character of the exhibits.

The distinction between the highly finished forms then and now reflects a deep change in my response to science, technology, and the technological environment. I see the need to wind this down, and pare it, to a level that would be unacceptable to many people.

Cardboards, cardboard boxes, are for us now inextricably linked to fraught figures seeking shelter in cities; the present showing re-emphasizes the social content of — cardboards.

20 October 1996

(Catalogue contribution for the exhibition *Life/Live*, Musée d'Art Moderne de la Ville de Paris, 1996)

The work: The productions are a response to catastrophes. The present: Once upon a time two enemies faced each other locked in a life and death struggle. With the demise of the Soviet Union only one enemy remains—Capitalism. The future: We are entering the period of the technoid double. Never before has the body been so threatened as now. The body is taken on by an emergent ever-expanding assembly of instrumentation, surrounded by surrogates who replicate and replace—the body. The human being is locked into a technoid double and becomes a mere template of that machine self.

The past: The past cannot be recaptured, and there is no question of returning to it. Civilisation demands a breathing space where people can look back on the cataclysmic changes of the past 200 years. Far too much has happened. Humanity is shell-shocked, literally out of mind. A winding down of the technological environment, a voluntary abandonment, is the key to survival.

Earth to Galaxies. On Destruction and Destructivity
(Lecture, Glasgow 1996)

We are poised on a trajectory that takes us from the bowels of the earth to the infinity or near infinity of space.

Can it be said that the sun is destructive? So much has been said about the generative nature of the sun. Ancient Egypt is a hymn to the sun. Thousands of years later, the same sun is seen as a threat—no—*the* threat to humanity. We believe that the sun, that self same sun, will burn and devour the earth. There are quite a large number of cultures which have also seen the sun as a predator and destroyer.

It is evident that the sun burns crops, parches the land and destroys people and animals who are without water and shelter.

And yet without it there would not be life as we know it on this earth. It is this bifocal balancing of opposites, the dance on the edge of an abyss, which runs through human life and suffuses so much of art —all the arts.

Art arises from the feeling and the knowledge that the line between a generative and a destructive reality is paper-thin. I find that in the music for piano by Chopin it is this line which maintains and sustains. Opening to the expansion and even within that expansion runs a line of declension. "Himmelhoch jauchzend zu Tode betrübt" (Goethe, *Egmont*). This line quoted again and again says the same in a manner that is more easily apprehended.

We live in a scientific age. When it comes to the question of the slaughter of thousands of living cattle it is *science* that is called upon by the British government to decide on life or death.

If the science is right, they will go under.

When we look at everything that we know and everything that we do not know about BSE, we are entitled to ask whether we are so different from witch doctors or Aztec priests in making decisions on life or death.

The question that I am facing in recent years is this: to what extent are human beings part of this ceaseless chain of destruction? Do we absorb it; does it impinge on us; is the chemical, biological entity that is the human being penetrated by that which is so overwhelmingly the stuff of life?

Is the destructivity, so deeply embedded in us, inescapably there because it is in the entire cosmos? We absorb in the course of the development of life, of which we are a part, the bombardment that is present on the earth and in the galaxies. Cataclysmic forces, which is what galaxies are, are present as life evolves and evolving life inevitably absorbs such elements like milk from the mother's breast.

Why should it not be so? Confirmation of a sort comes from that vast accumulation of folklore and myth on creation and destruction that has been handed down.

If destruction and creation is so profoundly embedded in the human being, in the atoms and cells—and the origins go back to the first beginnings of biological life—if there is a total mix between that which is on earth and in the galaxies, how should we respond?

Destruction is *not nice*. Religion after religion has tried to turn away from it, but always only with partial success.

Everything that is on the surface of the earth will go. Mountains will melt in the heat. Vast periods of time before this, even the best preserved works of art will have gone, and human beings also. Nothing is forever.

When I wrote in the first *Auto-Destructive Art* manifesto that a work of *Auto-Destructive Art* can last a few seconds and no more than twenty years, I had a certain doubt. Really, only a few seconds? I was right to query but erred in the direction. Today, in the work with electronics, a second is a vast expanse of time. Time is considered in terms of a millionth part of a second.

As the years have passed, I observed the changes taking place and have found confirmation of so much I had believed in. Scientists who predict future developments in their field qualify for the Nobel Prize. If this principle applied in the field of the visual arts, my work would have received wide recognition.

Right across the spectrum of developments in society, in science and technology and in thought and invention, there are links with ideas that I have worked with. There are big ideas, such as the Big Bang or Black Holes; there is the recently discussed theory that cells in the human body are in a constant process of self-destruction.

Responding to the crisis of pollution and waste disposal, leading car manufacturers have started to build cars on the principle of disassembly. This means that the end disposal of the components is considered from the earliest design stage, with the intention to reduce to a minimum any materials which cannot be reused and recycled in some form or another. What a step forward from the times when old cars were simply smashed up!

In thought there is deconstruction, which started in the second half of the sixties. One would need days to list the links of auto-destruction and auto-creation in the context of change since 1959.

And beyond this, there are attitudes towards environment, the critique of capitalist consumer society, the critique of science and technology, and the emphasis on individual responsibility.

There is a deep-seated fear of destruction in many people. What is the origin of this fear? In part, it is a fear of destructivity lodged in ourselves. Our urge to be aggressive and act with violence gives rise to a reaction that seeks to ban and inhibit aggression and violence in general.

Black Holes. In 1959, before coming onto the theory of *Auto-Destructive Art*, I was fascinated by the possibility of using very powerful steel presses to make sculpture. I had seen a report of a press that had the power to crush large pieces of metal but could be attuned to the point of delicacy where it would crack the shell of an egg. I wanted to use such a machine to form relatively small pieces of sculpture. What interested me was the thought of the trace of the impact of the press on the surface of the sculpture.

One of the profound concepts of Judaism is that of *Ruach*, referring to the "Breath" of God. Here, there would be an exploration of the "breath" of the all-powerful press, with its capacity to manipulate vast power on a quite modest piece of matter.

As you know, at about the same time, César was crushing pieces of metal using presses in Paris, making sculptures in the form of small blocks.

The point in relation to Black Holes is this: I was concerned with the enormous pressure contained in the implement and the pressure built up in the emergent sculpture. And the pressure of forces within a Black Hole is a key feature of the phenomena. In a way, I was setting up the equivalent of Black Holes within a sculptural form. This feeling for enormous pressures stayed with me when later in that year, 1959, I developed the theory of *Auto-Destructive Art*.

In the acid-nylon painting of 1961, connections could also be made to Black Holes. Holes are burned in the nylon and the material inevitably collapses in upon itself as the process is being observed. There are three screens and one could envisage channels of communication from one screen to another. The open air activity then, and even more markedly at the same time of the filming on the South Bank in 1963, can be seen as statements on earth and heaven: the earth and the beyond.

We are part of nature. We *are* nature. But is nature red in tooth and claw?

Certain micro-organisms can live within nuclear reactors. It has been said that should there be a nuclear destruction of the world microbes will manage to survive better than any other species. So what life can survive amongst the galaxies? Are the Galaxies nature? Is what is going on there *natural*? Well, not by our standards. But presumably being a galaxy is as natural as apple pie for the galaxy. For a galaxy, life on earth is meaningless soft and soppy. Who wants all that soggy stuff, trees swaying in the wind? How can a Niagara Falls or an atom bomb compare with the immense expanse, the power billion times greater than the sun, the sheer empowerment of it all? What a life!

The fact that we could not live there and that we would find those conditions unnatural must not blind us to the realisation that galaxies *are* nature.

From the burning core of our earth to those expanses where we could never go, and if we did, never survive. Do we share the burning to the point where everything disintegrates? What

is the fever pitch of a person in love; or the maniacal excess of a creative act; or the blind onslaught of a killer? What has it to do with the torrents within a galaxy?

It is the extreme and the excess. It is the burning to the point threatened by dissolution. Dissolution does not take place—any more than the galaxy dissolves—despite its white heat.

That is what unites us with the beyond: the capacity to reach a core, burning, endangered, exposed. And to go on. To go through the furnace, remember the Bible story, go through the galaxy and emerge intact.

Destruction and destructivity are inextricably entwined in the nature that we know; fire does not make moral judgements. In so far that we are nature, that nature suffuses us, we are inescapably entrapped within it. The murderer hits out like the branch falls off the tree.

We do not need visual reminders to conjure up the destructivity ongoing in humanity. We need merely to repeat a mantra of atrocities. The Hordes of Ghengis Khan, the Thirty Years War, in the manner perhaps of Alastair MacLennan's recent installation at The Arches, Glasgow, speaking of the Troubles in Northern Ireland. The Sacking of Rome. The Gates of Jericho. Sabra and Shatilla. Hiroshima and Nagasaki. The Massacre on the Temple Mount. The First World War. The Second World War. The Third World War. Zaire. Rwanda. Yugoslavia. My Lai.

Nature and natural—Natural Born Killers.

Killing Fields. Sketch for an Exhibition[1]

(in: *Camera Austria*, Graz, Herbst 1999)

One is steering on a hairpin bend degree of risk. One can tip over and it becomes something that all can recognize and say, "aha—that is that". When it becomes too obvious, there is a loss of complexity. The fine balance lies in a form that has distinct, undeniable correlations to the depicted subject. The material itself must speak. If that is the starting point, then one is on the right way. The material needs to exude the presence of the subject. We need matter that is at a tangent to the subject. The subject needs, as it were, to pour through the cover; the cover in this sense is *porous*, permitting the depicted image a transmission towards the public.

When this is accepted, there is no need for specific reminders—the boots on the moon landing, for example.[2] If there were only the pair of boots, it would be too much like literature. One needs a presence that will convey the meaning in the absence of the boots. The boots are, as it were, the icing on the cake, they could be dispensed with. Their addition is in a way redundant, because the work already embodies the meaning.

The boots are successful when they are a reminder of the meaning, but not the meaning itself. They must not stand in for the meaning. Meaning is contained in the totality of the image— its size, volume. The sculptural presence. The distinction of the works to others in the series.

But how to represent the moon, is it snow-white, pitted?

Variety expressed in dimensions will be a basis. Each image demands its own size. But in planning an exhibition for a particular gallery, one will approach the question of size bearing in mind that space. But it would be a mistake to tailor each work exclusively for that exhibition/installation. One needs to bear in mind the dispersal of the exhibits, or their reassembly in a quite different place, at a future date.

And so it will be right to begin planning each work for the particular space, and decide on the number of works, the subject matter of each work, their individual size in relation to the others, in accordance with the given circumstances—but whilst doing so, bear in mind what may happen in the future.

And so, decisions will be taken that each piece will be freestanding, can be used independently of the ensemble. Each piece will need to stand on its own, hold its own, in any future combination, when others are absent.

Clearly, it is easier to decide on one exhibition for one particular space, than to follow the course outlined above. But that does not make it an impossibility. Indeed, in pursuit of the overall objective, we may improve the quality of the project. Taking a broad, long-term view, is likely to lead to a questioning frame of mind, where values come to the fore that can strengthen the entire project; it can add further layers of complexity.

We communicate meaning by size. The volume penetrating from the wall is another leading factor. A sculptural form is created whose meaning is inextricably interwoven with the presented image. The sculpted form itself is the equivalent of the image. But here we must insert a note of caution. If that is indeed the case, there is no need for the hidden photograph.

And so we must face another level of complication. If the sculptural form stands fully for the photograph, then it is not a successful resolution, since it cuts out the presence of the photograph: the starting point of the entire exercise. The sculptural framework must not overwhelm and subdue the original concept, which is to present a photograph. It must be held back from blotting out, as it were, the photographic image. In other words, it must not be too loud, too blatant and obvious.

Elements of ambiguity need to remain: uncertainty is a factor in a successful resolution. After all, the photograph is hidden. If it merely surfaces in another guise in front, what was the point of hiding it?

Each photograph chosen demands its own size, sculptural treatment, and so on. In planning an exhibition, each work will be decided on in relation to all others. When these decisions are made, one looks at the total ensemble, and makes correlations and adjustments. The next stage will be to reflect on the eventual splitting off of works, and their reassembly elsewhere at a future date. One can then proceed with the construction of individual works.

An exhibition can be on one theme, one period of history. It can also be a mixture of themes and periods. One needs to guard against having too big a mix. Also, it is better to have fewer works rather than two or three too many. Each piece demands considerably more attention than an actual photograph. The summation of, say, fifteen works means a considerable effort on the part of the spectator.

Seeing a line of photographs, it is possible to switch from one to the other in rapidity. In the case of these works, this is not possible, if only because the reflective effort involved is more considerable. Time is involved. And in leaving one piece to direct attention to another, an interval of time is needed in making adjustments. Then again, in exploring one work after another, a deeper insight into the whole is acquired, and this may lead the visitor to go back to earlier seen objects. The entire project is concerned with layers of meaning, and the experience is highly subjective. There is an open-ended opportunity to respond.

The viewer is used to walking among installed works, and so is faced by a series of forms not entirely unfamiliar. A difference is that in exhibitions one is faced by defined, articulated statements, each viewer confronted by the same objects. Here, the viewer has another range of possibility and freedom. No one is forced to engage with the hidden photographs, reflect on the hidden photographs, but they exert a challenge to do just that.

There is a short time span in viewing photographs. More time can be given to viewing these works, than to viewing photographs.

There is a contradiction involved. One aim of the series *Historic Photographs* is to put photography down: to indicate that we do not need its all-pervasive presence. The series gives photography a new significance, another lease of life. It is just another indication that within an advanced technical society one ceaselessly comes up against no-win situations. With everything so enmeshed, there is no way of reaching the clear resolutions possible in earlier times.

We are now trapped in conditions that remove elements of choice. Whichever way we turn, we are up against given conditions that allow no leeway.

An exhibition is an organization of sculptural forms. Since the individual works are so abstract, another range of freedom in arranging and presenting them is possible.

Their meaning is hidden; their significance has to be teased forth. This has implications for the arranger as well as the viewer. An exhibition is arranged on the basis of relationships and/or contrast. This way of organization can apply here. But since the reality of each object is obscured, how is one to convey this to the viewer? In other words, the "normal" patterns of presentation won't fit.

A viewer moving through an exhibition will constantly come across "blank" spaces where uncertainty prevails—these gaps in consciousness are inescapable.

From the point of the view of the organizer, these "gaps" are key points in the assembly. They will be used in structuring the display. They are like echo sounders: invisible and not palpable, but serving a crucial purpose. The "gaps" will occur regardless of intention. The point is to be aware of them and incorporate these into a programme, so that punctuation takes place.

People go into exhibitions with certainty and looking for certainty, and reassurance. Here much of this is abandoned. In moving from one work to another, the relationship between works is a crucial feature of the progress. Here, elements of uncertainty are structured into the experience. One goes from one to another with a haze of uncertainty a feature of the progression. Both the work just passed, and the next to be confronted, are part of that haze. These are the "gaps". Being inevitable, they need to be considered in planning, in the design of the exhibits, and the overall layout of the show. It calls for a new look at exhibition design, and clearly demands a certain amount of space to play with.
Uncertainty. The inevitability of its arising in this context, is seen as a positive element.

Everyone knows photography, has seen exhibitions where small or large prints are shown. Here a new start is available. We cannot be sure what we are looking at. Memory and recall are in action, but what certainties are there?

Here we come to a central aspect of the experience. The experience throws open these questions. The "gaps" punctuating the construction of the exhibition are intentional, since they assist in the creation of a psychic space, where uncertainty and the unknown are given free range.

The bafflement in confronting the works has its correspondence in so many experiences faced in daily life: bafflement, uncertainty, a sense of loss. The exhibits, their alignment in an exhibition space, stand in for a multitude of experiences perceived elsewhere.

The art of the organizer will be to orchestrate the works and space into a whole that will maximize the potential experience. The images have to do with horror, drama and tension; elements of catharsis. The art will lie in bringing it to the fore.

There is the sloughing of illusions. The plateau is a stand where illusions can be shed. The perceived images reinforce each other, building up to climaxes of destruction and chaos. In addition, there is no escape possible. The viewer is trapped as image reinforces image. As the viewer moves through the display, the sequence of hiders and hidden is constantly jumbled; the hidden and the hiders changing in a convoluted and constantly changing manner. This builds up the complexity of the experience.

Often, a viewer moves from one exhibit to the other; this is especially so with works in large dimensions. Here, the sequential form of viewing is less likely, it will be more a form of skimming from object to object. Inevitably, there will be moments where the surface and other moments where the photograph will take over consciousness. The photograph of one work will be perceived against the surface of another object. An intermingling will take place between different works. Interpenetration will be a major feature.

Penetrating the surface is the first priority. Once this has been achieved, the way is open for other potentials.

How does it end? After the considerable effort demanded by these works, what will be the state of mind of the viewer? It could well be a state of increased confidence. The struggle involved in "reading" the works, and taking in the exhibition as a whole, can lead to a feeling of elation. There is a limit to impenetrability. People can go so far, and when stretched to an extreme, when limits are finally—eventually—reached, there is a rebound. One returns to zero. After a pause, one is ready to begin a new cycle. But that will not simply be a rerun of the previous experience. Something is gained from that experience. A point of conclusion is reached, experience is ordered, and in that sense resolved. Facing profound issues within an aesthetic context can give insights which affirm "life-enhancing" capacities.

Art that is demanding, art which focuses on issues of importance can advance the viewer towards a resolution of difficult problems. Catharsis. The *Killing Field* is an arena where the

extreme is placed on view, but the activity takes place in the mind of the viewer. The suffocating horror is felt, not seen. It is strictly internalized: there is no blood on the floor. But here is a psychic arena set up when people move through an exhibition. Signals are sent and received, often against the will of the participants. The destructive imagery, withheld, can only emerge in the minds of the viewers. Efforts to restrain its materialization can be anticipated.

The surface is the stage where impenetrability is made manifest. The surface is a block that is faced to begin with. It holds up the viewer: the viewer is confronted by impenetrability. The cumulative effect is to place the viewer in the present ongoing perception of reality. The viewer faces the impossibility of escaping from the perception of incapacity. The works confirm entrapment. This is the state that we are in. Looking, but closed in on all sides from any chance of resolution.

When we breach this first covering layer, we confront horror, human evil, errors, tragedy. This compounds the first layers of perception. The photographs are slices of history: slices through history. The photographs speak of man's inhumanity to man. The photographs are confrontational, in many ways they are unbearable.

We are now dealing with two layers. The surface—the hider—and the hidden. The viewer invariably moves from one to the other: between one and the other. An interweaving process is taking place. The hider is inescapable; the hidden needs to be teased out. When the hidden is perceived, there is a reinforcement of negativity. We are working with a double shock. A reinforcement.

The first confrontation with the surface can conclude with a neutral stance, not so with the hidden. The hidden, when perceived, may then add to the gravity of the surface. There is a dialectical interweaving between the one and the other.

The viewer is bounced back from one work to the other. There is an entrapment. The inescapable sense of being caught, which is our underlying reality, is represented in the space. The space becomes a killing field in a variety of forms.

Killing Fields. The need to go onto a plateau, but no one is forced to do so. For blind people, gloves for touching. Ultra sound instruments to perceive volumes and shapes.

ADA[3] ends with nothing. Here we begin with nothing. Extend range of freedom. Confrontation. The exhibits confront the viewers—they are confrontational. They encapsulate the horror of reality: horror and danger. The works act as a catalyst that enables the viewer to confront. The viewers confront their own presence. What is at stake is perception. What do we perceive and how does it happen? What happens when we look at works, at works of art, for instance? There is a constant enlargement of perception: one leads to another, coming up against blank walls is a part of the project. From a blank wall one can bounce off realizations.

If one is blocked by one work, one can turn to another. The inability to penetrate is an integral phase. Our reality now is the impossibility to see through reality. We are blocked in by

impenetrable layers of reality. We stand unable to go through. There are no answers, no flashes of insight that might bring a resolution. There are no social mechanisms that could be put in place to resolve the crisis. This incapacity to go towards resolutions is the element binding us together. This up-against-a-wall-presence is found in these works. The works themselves are walls of impenetrability. The viewers are blocked from entering, and they are literally an embodiment of the state people are in.

In this context, the works are realistic; they are a form of realism. They mirror a state of mind. We are up against a wall. We look, but cannot go through. After a while, people give up, knowing there will be no resolution.

The works do not hide: they reveal. The surface, the palpable surface has the edge of perception. The surface originally meant to hide the photographic image takes over the meaning of the work: At first, it was a means to an end; it can become the end itself.

1 In this text from 1995, based on a handwritten manuscript (Tate Gallery Archive, London) and published by *Camera Austria* for the first time, Gustav Metzger sketches his concept for the *Historic Photographs*, which he originally intended to put on show bearing the title *Killing Fields*. The first two *Historic Photographs* (*Historic Photographs No. 1 Liquidation of the Warsaw Ghetto ...* and *Historic Photographs No. 1 Hitler Addressing the Reichstag ...*) were exhibited in September 1995, at the bookspace workfortheeyetodo, Hanbury Street, London E1, which was run by Simon Cuts and Erica Van Horn.

2 In the following passage, Gustav Metzger outlines his concept for a *Historic Photograph* using the famous picture of the astronaut Neil Armstrong taking the first steps on the moon. Metzger's comments refer to the possible sculptural form of an (as yet) unrealised work, such as the question of what role might be played by the astronaut's boots so prominent in the original photograph.

3 In 1959, Gustav Metzger developed his concept of *Auto-Destructive Art* (ADA), "primarily a form of public art for industrial societies ... which is a total unity of idea, sight, form, colour, method and timing of the disintegrative process.... Auto-destructive paintings, sculptures and constructions have a life-time varying from a few moments to twenty years. When the disintegrative process is complete, the work is to be removed from the site and scrapped."

Bibliography

Manifestos

1959
*Cardboards selected and arranged by
G. Metzger ... Auto-Destructive Art*. First
Manifesto, London, November 4, 1959.

1960
Manifesto Auto-Destructive Art. Second
Manifesto, London, March 10, 1960.

1961
*Auto-Destructive Art, Machine Art,
Auto-Creative Art*. Third Manifesto
(*South-Bank-Manifesto*), London, June 23, 1961.

1962
Manifesto World. Fourth Manifesto, London,
October 7, 1962.

1964
*On Random Activity in Material/Transforming Works of
Art*. Fifth Manifesto, London, July 30, 1964, in: *Signals.
Newsbulletin of the Centre for Advanced Creative Study*,
London. Vol. 1, No. 2, September 1964: 14.

1969
Zagreb Manifesto. With Jonathan Benthall and Gordon
Hyde, in: *Studio International*, London. June 1969.

Books by the Artist

1996
Metzger, Gustav. *damaged nature, auto-destructive art*.
coracle @ workfortheeyetodo, London 1996.

1997
Hoffmann, Justin (ed). Gustav Metzger.
Manifeste, Schriften, Konzepte. Verlag
Silke Schreiber, München 1997.

Writings by the Artist

1951-53
Letters to David Bomberg. David Bomberg Archive,
Tate Gallery Archive.

1953
Letter to *Jewish Quarterly*. Unpublished draft.
David Bomberg Archive.

1956
"These Artists are possessed. They gamble with life,"
in: *Lynn News and Advertiser*, King's Lynn. July 27, 1956.
(Article on the Hatwell/Paolozzi/Turnbull exhibition)

1957
Leaflets concerning the North End protest.
King's Lynn 1957.

"North End protest – answer to Mayor," in: *Lynn News
and Advertiser*, King's Lynn. December 20, 1957.
(Letter to the editor)

Old Church Art. King's Lynn Festival, King's Lynn 1957. (Cat.)

1960
"The Temple Gallery...June 1960...
A New Movement in Art...," London 1960.
(Invitation to the first *Lecture/Demonstration*
June 22, 1960, Temple Gallery)

1962
"Machine, Auto-Creative and Auto-Destructive Art," in:
Ark. Journal of the Royal College of Art, London. No. 32,
Summer 1962.

1963
Centre for Advanced Creative Studies, London 1963.
(Joint declaration with Marcello Salvadori about the aims
of the centre. Single sheet)

1964
"With the five bubble machines ... ," in: *Signals. News-
bulletin of the Centre for Advanced Creative Study*,
London. Vol. 1, No. 2, September 1964: 8. (Statement
on David Medalla)

1965

"Auto-Destructive Art: Metzger at AA," *ACC*, London. June 1965. (Extended version of lecture given at the Architectural Association on February 24, 1965)

Auto-Destructive Art. A Talk at the Architectural Association London by Gustav Metzger. Destruction/Creation (self-published by Gustav Metzger), London 1965. (Lecture given at the Architectural Association on February 24, 1965. Reprint of version published by *ACC* and reprints of Gustav Metzger's five manifestos)

"Auto-Destructive Art," in: *Granta*, Cambridge. Vol. 71, No. 12457, November 6, 1965.

1966

"An Overwhelming Concern with Shelter!," in: *Peace News*, London. No. 2, September 1966.

Art of Liquid Crystals. Better Books, London, January 1966. (Single sheet)

"Auto-Destructive Art," in: *Anarchy Magazine*, London. No. 64, June 1966. (Letter to the editor in answer to an article on *Lecture/Demonstration* at the Architectural Association 1965, in: *Anarchy Magazine*, London. No. 61, March 1966.)

"DIAS," in: *Resurgence*, London. Vol. 1, No. 4, November/December 1966.

"Excerpts from Selected Papers Presented at the 1966 Destruction in Art Symposium," in: *Studio International*, London. December 1966: 282–283.

"Gustav Metzger," in: Mario Amaya (ed). *Art and Artists. Auto-Destructive*, London. Vol. 1, No. 5, August 1966.

"The possibility of Auto-Destructive Architecture," in: *Clip-Kit. Studies in Environmental Design*, London. No. 2, 1966. (Independent publication of students at the Architectural Association)

1967

DIAS Preliminary Report. London, February 1967.

DIAS-Information. London. Five single sheets. No. 1, March 1967. No. 2, June 1967. No. 3, August 1967. No. 4, September 1967. No. 5, March 1968.

"Manifest 1961," "Briefe von Gustav Metzger an Wolf Vostell," "DIAS Preliminary Report," in: *dé-coll/age*, Köln. No. 6, July 1967.

1968

Arts Festival '68, University College of Swansea, Extremes Touch. Swansea 1968. (Single sheet on the exhibition)

"Five Screens with Computer," in: Jasia Reichardt (ed). *Studio International. Cybernetic Serendipity. The Computer and the Arts*. London 1968.

"Theory of Auto-Destructive Art," in: Calendar of the (only briefly existing) Anti-University. London 1968.

1969

"Automata in History," in: *Studio International*, London. Part 1, March 1969: 107–109. Part 2, October 1969: 109–117.

"Five Screens with Computer (1963–69)," in: *Event One*. Computer Arts Society, London 1969. (Cat.)

Notes on the Crisis in Technological Art. London 1969. (Single sheet. Handed out at *Post Mortem on Event One*, British Computer Society, April 3, 1969.)

PAGE. Bulletin of the Computer Arts Society, London. (Gustav Metzger was editor from 1969 to 1973.)

"Statements," in: *Circuit*, Cambridge. No. 10/11, 1969.

1970

Do You Eat?. University College, London; Slade School of Fine Art, London, February 1970. (Single sheet)

"Five Screens with Computer," "Design Studies…," in: *Tendencije 4. Zagreb, 1968–1969. Computers and Visual Research*. Galerija Suvremene Umjetnosti, Zagreb 1970. (Cat.)

"Gordon Hyde," in: *PAGE. Bulletin of the Computer Arts Society*, London. No. 11, October 1970.

International Coalition for the Liquidation of Art. London, 15 October 1970. (Single sheet)

"Kinetics," in: *Art and Artists*, London. September 1970.

New Ideas in Plotter Design Construction and Output, London 1970. (Unpublished lecture at "Computer Graphics '70")

"Notes on the Crisis in Technological Art," "4 Manifestos by Gustav Metzger," in: *Klepht*, Swansea. No. 1, January 1970.

"Social Responsibility and the Computer Professional: The Rise of an Idea in America. Part 1," in: *PAGE. Bulletin of the Computer Arts Society*, London. No. 11, October 1970.

1971
"Five Screens with Computer. Computer Graphic Aspects of a Sculpture Project," in: *Computer Graphics '70*. Plenum Press, London 1971.

"Sculpture with Power," in: A. Alonso Concheiro (ed). *Memoria de la Conferencia Internacional sobre Sistemas, Redes y Computadoras*. Mexico 1971.

"Untitled Paper on Theme Number Three for 'Computer and Visual Research Symposium', Zagreb 1969," in: *Bit International*, Zagreb. No. 7, 1971.

1972
"A Critical Look at Artist Placement Group," in: *Studio International*, London. January 1972: 4–5.

Beuys, Joseph. *Information Action*. Video transcription of Joseph Beuys' action in the Tate Gallery on February 25, 1972. Includes a discusssion between Gustav Metzger and Joseph Beuys. Tate Gallery Archive TAV 616AB.

Executive Profile. Institute of Contemporary Arts, London 1972. (Single sheet)

"From the City Pages," in: *Studio International*, London. December 1972: 210–211.

"Notes on Recent Work," "Projects for 'British Thing' Show," in: *Prismavis*, Hovikødden/Norway. No. 4, September 1972.

"Second Floor … ," in: *Newssheet. Gallery House*, London. No. 1, 1972.

"Stockholm June: ein Projekt für Stockholm 1. bis 15. Juni 1972," in: *Documenta 5*, Kassel. Verlag Documenta/ Bertelsmann Verlag, Gütersloh 1972. Section 16: 55–56.

1974
"Years without Art 1977-1980," "The Art Dealer: A Bibliography," in: Christos Joachimides, Norman Rosenthal (eds). *Art into Society – Society into Art. Seven German Artists*. Institute of Contemporary Arts, London 1974: 79–86.

1976
"Art in Germany under National Socialism," in: *Studio International*, London. March–April 1976: 110–111.

1981
"Faschismus Deutschland: Darstellung, Analyse, Bekämpfen". Two loose pages in: Anne Abegglen (ed). *Vor dem Abbruch. Künstlerische Aktionen in den dem Abbruch geweihten Räumen des Museums*. Kunstmuseum, Bern 1981.

Kollektiv Cordula Frowein, Gustav Metzger, Klaus Staeck [Passiv – Explosiv]. Pressegespräch. Köln 1981. (Single sheet)

Passiv – Explosiv. Entwurf einer Ausstellung. Köln 1981. (Two sheets)

1984
Press Release. Artists Support Peace, January 6th 1983. (Wrong year stated: should read 1984. Single sheet)

1990
Wiener Aktionismus 1960–1974. Studio Oggetto, Milano 1990. (Folder)

1992

Earth minus Environment. A Sculptural Project for the UN Earth Summit, Rio de Janeiro, 1–12 June 1992. Galerie A, Amsterdam, 6 January 1992. (Two sheets)

1994

Elements Centre. Amsterdam 1994. (Single sheet)

1995

Text in: Martin Craiger-Smith (ed). *Yves Klein Now. Sixteen Views.* Southbank Centre, London 1995.

1996

"Earth to Galaxies. On Destruction and Destructivity," in: Pavel Büchler; Charles Esche (eds). *Earth to Galaxies. On Destruction and Destructivity.* Tramline No. 5, Glasgow School of Art, Glasgow 1996: 7–12.

Mad Cows Talk. Lecture manuscript (1996). First published in German in: Justin Hoffmann (ed). Gustav Metzger. *Manifeste, Schriften, Konzepte.* Verlag Silke Schreiber, München 1997: 51–65.

Text (English/French) in: Laurence Bossé, Hans Ulrich Obrist (ed). *Life/Live*, 2 Vol. Musée d'Art Moderne de la Ville de Paris, Paris 1996.

Text on the reconstruction of *Cardboards* for the exhibition *Made New. Barry Flanagan, Tim Mapston, Gustav Metzger, Alfred Jarry*, 20 October 1996, City Racing, London 1996. (Single sheet)

1997

Metzger, Gustav; Davis, Ivor; Gibbs, Michael. "Is that an apple?," in: *Art Monthly*, London. December 1997–January 1998: 2–3.

1998

"The artist in the face of social collapse," in: Melanie Keen (ed). *Frequencies. Investigations into culture, history and technology.* inIVA, London 1998.

1999

"Killing Fields. Sketch for an Exhibition," in: *Camera Austria*, Graz. Nr. 67, Herbst 1999: 30–37.

Interviews with the Artist

1996

Birrell, Ross. *The Distance to Utopia. Gustav Metzger interviewed by Ross Birrell*. Unpublished interview, London, August 3, 1996.

Cutts, Simon; van Horn, Erica. In: *JAB–The Journal of Artists' Books*, USA. No. 5, Spring 1996.

1997

Hoffmann, Justin. "Die Erfindung des Art Strike," in: *Vierte Hilfe*, München. Winter 1997/98: 54–57.

1998

Jones, Alison. "Gustav Metzger Interview with Alison Jones," in: *Forum for Holocaust Studies*. http://www.ucl.ac.uk/forum-for-holocaust-studies/metzger_interview.html (August 14, 1998)

Wilson, Andrew. "A terrible beauty," in: *Art Monthly*, London. December 1998–January 1999: 7–11.

1999

Müller, Dorothee. "Leben im Widerstand," in: *Süddeutsche Zeitung*, München. Donnerstag, 25. März 1999: 22.

Obrist, Hans Ulrich. "Metzger's Quest for Social Change – From the Auto-Destructive Art Manifesto and onwards," in: *Artnode*. http://www.artnode.se/artorbit/issue4/i_metzger/i_metzger.html (March 30, 1999)

Unterdörfer, Michaela. "'Form ist das Wichtigste' oder 'Ich würde niemals meine Arbeiten nur als Kunst betrachten'," in: *Gustav Metzger. Ein Schnitt entlang der Zeit.* Kunsthalle Nürnberg. Verlag für moderne Kunst Nürnberg, Nürnberg 1999: 29–46.

2001

Obrist, Hans Ulrich; Vanderlinden, Barbara. "Extremes Touch," in: *Laboratorium is the answer, what is the question?.* DuMont Buchverlag, Köln 2001: 27–31.

Monographs, Catalogues Solo Exhibitions

1992
Ruhé, Harry. *Galerie A. Gustav Metzger Documents 1959-1992*. Amsterdam 1992. (Portfolio)

van Diest, Antje. *Gustav Metzger. London Art in the Sixties*. Leiden University 1992. Master thesis.

1998
Bowron, Astrid; Brougher, Kerry (ed). *Gustav Metzger*. Museum of Modern Art, Oxford. Oxford 1998.

1999
Cole, Ian (ed). *Gustav Metzger. Retrospectives*. Museum of Modern Art Papers Vol. 3. Book of a conference. MOMA Oxford, 1999.

Gustav Metzger. Ein Schnitt entlang der Zeit. Kunsthalle Nürnberg. Verlag für moderne Kunst Nürnberg, Nürnberg 1999.

2005
Breitwieser, Sabine (ed). *Gustav Metzger. History History*. Generali Foundation Wien. Hatje Cantz Verlag, Ostfildern-Ruit 2005.

Catalogues Group Exhibitions

1953
Borough Bottega. Berkeley Galleries, London 1953.

1960
Hultén, Pontus. *Bewogen Beweging*. Stedelijk Museum, Amsterdam; Museum Louisiana, Humlebæk. Amsterdam, Humlebæk 1960. Swedish edition: *Roerelse i Konsten*. Moderna Museet, Stockholm 1960.

1970
Kinetics. Hayward Gallery, London; Arts Council of Great Britain. London 1970.

Sohm, Hanns (ed). *Happening und Fluxus: Materialien*. Kölnischer Kunstverein, Köln 1970.

1971
Campbell, Robin; Lynton, Norbert (eds). *Art Spectrum: London*. Alexandra Palace, London. London 1971: 18–19.

Kelemen, Boris; Putar, Radoslav (ed). *Dialogue with the Machine*. Bit International and Galerija Grada, Zagreb 1971. (Reprint of *Bit International*, Zagreb. No. 7, 1971.)

1972
documenta 5. Befragung der Realität, Bildwelten heute. Documenta 5, Kassel. Verlag Documenta/Bertelsmann Verlag, Gütersloh 1972. Section 16: 55–56.

1974
Joachimides, Christos; Rosenthal, Norman. *Art into Society – Society into Art. Seven German Artists*. Institute of Contemporary Arts, London. London 1974: 5, 9–10, 14, 37, 79–86.

1977
Brighton, Andrew; Morris, Lynda (eds). *Towards Another Picture. An Anthology of Writings by Artists Working in Britain 1945–1977*. Midland Group, Nottingham 1977.

Joachimides, Christos (ed). *Joseph Beuys Richtkräfte*. Nationalgalerie Berlin. Berlin 1977: 5–6, 23, 32.

1981
Abegglen, Anne (ed). *Vor dem Abbruch. Künstlerische Aktionen in den dem Abbruch geweihten Räumen des Museums*. Kunstmuseum Bern, Bern 1981.

1986
Krug, Hartmut (ed). *Kunst im Exil in Großbritannien 1933–1945*. Neue Gesellschaft für Bildende Kunst, Berlin. Verlag Frölich und Kaufmann, Berlin 1986.

1990
Syring, Marie-Louise (ed). *Um 1968: konkrete Utopien in Kunst und Gesellschaft*. Städtische Kunsthalle Düsseldorf; Museum für Gestaltung, Zürich. DuMont Verlag, Köln 1990.

1992
Mellor, David. *The Sixties Art Scene in London*. Barbican Art Centre, London. Phaidon, London 1993: 31–34, 40–41, 232.

1994
Glew, Adrian; Hendricks, Jon. *Fluxbritannica: Aspects of the Fluxus Movement 1962–73*. Tate Gallery, London. London 1994. (Exhibition brochure)

1996
Bossé, Laurence; Obrist, Hans Ulrich. *Life/Live*. 2 Vol. Musée d'Art Moderne de la Ville de Paris, Paris 1996.

1998
Millar, Jeremy; Schwarz, Michiel (eds). *Speed. Visions of an Accelerated Age*. Whitechapel Art Gallery; Photographers' Gallery, London. London 1998.

Schimmel, Paul (ed). *Out of Actions–Between Performance and the Object 1949–1978*. Los Angeles 1998: 88, 272–273.

1999
Danzker, Jo-Anne Birnie; Horn, Luise et al. (eds). *Dream City. Ein Münchner Gemeinschaftsprojekt*. Kunstraum München; Kunstverein München; Museum Villa Stuck; Siemens Kulturprogramm. München 1999: 81–83.

Sublime: the darkness and the light–Works from the Arts Council collection. Hayward Gallery, London 1999.

2000
Higgs, Matthew; Noble, Paul (eds). *Protest and Survive*. Whitechapel Art Gallery, London 2000.

Morrison-Bell, Cynthia; Slyce, John. *Look Out. Art/Society/Politics*. DPICT (UK), London, Aug–Sept 2000.

Phillpot, Clive; Tarsia, Andrea (eds). *Live in Your Head. Concept and Experiment in Britain 1965–75*. Whitechapel Art Gallery, London 2000: 9–15, 130–131.

2002
Latour, Bruno; Weibel, Peter (eds). *Iconoclash*. ZKM, Karlsruhe 2002.

van Tujl, Gijs; Meyric-Hughes, Henry. *Blast to Freeze. British Art in the 20th Century*. Kunstmuseum Wolfsburg. Verlag Hatje Cantz, Ostfildern-Ruit 2002: 214–220.

Wade, Gavin. *Strike*. Wolverhampton Art Gallery. Wolverhampton, London 2002.

Wilson, Andrew et al. (ed). *City Racing: The Life and Times of an Artist-Run Gallery, 1988–1998*. Black Dog Publishing, London 2002.

2003
C'est arrivé demain. 7e Biennale d'art contemporain. Biennale de Lyon, Lyon 2003: 211–213, 272–292.

Dreams and Conflicts. The dictatorship of the viewer. Venice Biennale. Marsilio Editori, Venezia 2003: 306.

Munder, Heike; Gygax, Raphael (eds). *St. Petrischnee*. Migros Museum für Gegenwartskunst, Zürich 2003.

Schafhausen, Nicolaus; Müller, Vanessa Joan; Hirsch, Michael (eds). *Adorno. Die Möglichkeit des Unmöglichen*. Vlg. Lukas & Sternberg, Berlin 2003.

2004
Stephens, Chris; Stout, Katharine. *Art and the Sixties–This Was Tomorrow*. Tate Britain, London 2004: 93–111.

Essays

1965
Sharp, Willoughby. "Chronology of Kineticism," in: *Tsai*. Amel Gallery, New York 1965.

1966
Popper, Frank. *The Relationships of Auto-Destructive and Auto-Creative Art and Kinetic Art*. Unpublished, January 1966.

1970
Bann, Stephen. *Experimental Painting. Construction, abstraction, destruction, reduction*. Studio Vista, London 1970: 59–62.

1983
Popper, Frank. "Introduction," in: *Electra*. Musée d'Art
Moderne de la Ville de Paris, Paris 1983.

1988
Hartley, Keith. "Wien und Großbritannien," in: *Von
der Aktionsmalerei zum Aktionismus, Wien 1960-1965*.
Museum Fridericianum, Kassel; Kunstmuseum
Winterthur; Scottish National Gallery of Modern Art,
Edinburgh. Ritter Verlag, Klagenfurt 1988: 81–88.

1991
Stiles, Kristine. "Thresholds of Control. Destruction in Art
and Terminal Culture," in: *Out of Control*. Ars Electronica,
Linz. Veritas Verlag, Linz 1991: 29–50.

1992
Stiles, Kristine. "Selected Comments on Destruction in
Art," in: Alex Adriaansen; Joke Brouwer et al. (eds). *Boek
voor de Instabiele Media (Book for the unstable Media)*.
V2 publishing, Rotterdam, 's-Hertogenbosch 1992.

Stiles, Kristine. "Survival Ethos and Destruction Art,"
in: *Discourse. Berkeley Journal for Theoretical Studies
in Media and Culture*, Berkeley. No. 14, Spring 1992:
74–102.

1996
Stiles, Kristine. "Art and Technology," in: Kristine Stiles,
Peter Selz. *Theories and Documents of Contemporary
Art. A Sourcebook of Artists' Writings*. University of
California Press, Berkely, Los Angeles, London 1996:
384–396.

1997
Stiles, Kristine. "Thoughts on Destruction Art,"
in: *Impakt 1997*. Impakt Festival, Utrecht: 2–5.

1999
Luckow, Dirk. "Joseph Beuys, Gustav Metzger und
marginales Denken der 90er Jahre zwischen Kritik
und Corporate Design," in: *Dream City. Ein Münchner
Gemeinschaftsprojekt*. Kunstraum München;
Kunstverein München; Museum Villa Stuck;
Siemens Kulturprogramm. München 1999: 37–42.

2000
Kemp, Martin. *Visualizations, the "Nature" Book of Art
and Science*. Oxford, New York 2000: 144–145.

Articles and Reviews

1954
Bullock, Michael. "The Borough Bottega," in: *Plan*,
January 1954.

1957
Betjeman, John. "City and Suburban," in: *The Spectator*,
London. 13 December 1957.

North End protest. Five articles in: *Lynn News and
Advertiser*, King's Lynn. All N.N.:
- "Champion of Lynn North End Speaks Out,"
November 19, 1957: 3.
- "For and against road through North End,"
November 26, 1957: front page with photograph.
- "Mr. Metzger takes North End cause to London,"
December 10, 1957: front page with photograph.
- "Mayor answers the critics," December 13, 1957:
front page.
- "Civic Society Chairman meets 'Champion' on VHF,"
December 17, 1957: front page.

1958
N.N. "Kennedy-US will bar all ships carrying Castro
arms," in: *Daily Express*, London, December 23, 1958.
(On Metzger's project for the *Festival of Misfits*)

Two articles on the Rocket Base marches in: *Lynn News
and Advertiser*, King's Lynn. Both N.N.:
- "Violent Scenes at Missile Base," December 9, 1958:
front page with photographs.
- "Protest Marchers arrested at the Thor Site,"
December 23, 1958: front page with photograph.

1959
Bullock, Michael. "Cardboards arranged by
Gustav Metzger," in: *Art News and Review*, London.
November 21, 1959.

Rydon, John. "It's Pictures from Packing Cases,"
in: *Daily Express*, London. November 12, 1959.

1960
Arrowsmith, Pat. "Auto-Destructive Art,"
in: *Peace News*, London. July 1960.

Bullock, Michael. "Cardboards,"
in: *Art News and Review*, London. 1960.

N.N. "Gustav Metzger," in: *Varsity*, Cambridge.
October 1960.

Reichardt, Jasia. "Expendable Art," in: *Architectural
Design*, London. October 1960: 421–422.

Reichardt, Jasia. "The Art of Suicide," in: *Time and Tide*,
London. 25 June 1960.

Rydon, John. "Modern art will fall to bits," in: *Daily
Express*, London. 15 March 1960. (Publication of the
first model for the *Auto-Destructive Monument*)

1965
Crallan, John. "Letters to the Editor," in: *AA Journal*,
London. June 1965.

Oliver, Paul. "Auto-Destructive Art," in: *AA Journal*,
London. April 1965.

Plagemann, Stephen. "Auto-Destructive Art,"
in: *Sinistra*, Cambridge 1965.

Smith, John. "Correction," in: *AA Journal*, London.
May 1965.

Smith, John. "Editor's Viewpoint," in: *AA Journal*,
London. March 1965.

1966
Amaya, Mario. "Destruction in Art … What are
They Trying to Prove?," in: *London Life*, London.
8 October 1966.

Amaya, Mario (ed). *Art and Artists. Auto-Destructive*,
London. Vol. 1, No. 5, August 1966.

Blackburn, Susan. "If You Had 200 Pound To Spend on
Art," in: *Weekend Telegraph*, London. 10 June 1966.

Clay, Jean. "Art Should Change Man: Commentary
from Stockholm," in: *Studio International*, London.
March 1966: 116–120.

Ellerby, John. "Notes on Vandalism," in: *Anarchy*,
London. March 1966.

Hansen, Al. "London: Destruction in Art Symposium,"
in: *Arts Magazine*, New York. November 1966.

Houédard, Dom Sylvester. "The Aesthetics of the
Death Wish," in: *Art and Artists*, London. August 1966.

Prosser, John. "Photoreport on DIAS," in: *Art and Artists*,
London. October 1966.

1967
Livesey, Anthony. "Art Politic: Crime and Punishment,"
in: *Art and Artists*, London. September 1967.

"Miles interviews Pete Townshend," in: *International
Times* (IT), London. 13 February 1967.

Reichardt, Jasia. "Some Notes on the Brighton
Conference," in: *Studio International*, London.
June 1967: 278–279.

1968
Lippard, Lucy; Chandler, John. "The Dematerialization
of Art," in: *Art International*, Lugano. Vol. XII/2,
February 1968: 31–36.

Williams, Sheldon. "Scapegoats and Outsiders
and Artists in Danger," in: *Help*, London. 1968.

1969
Benthall, Jonathan. "Art and Technology," in: *Studio
International*, London. May 1969: 212 and November
1969: 152.

Reichardt, Jasia (ed). "Cybernetic Serendipity.
The Computer and the Arts," *Studio International*,
special issue, London 1969.

1970
Brett, Guy. "On the Move," in: *The Times*, London.
29 September 1970.

Feaver, William. "Arte Povera," in: *London Magazine*,
London. Vol. 9, No. 12, March 1970: 97–101.

Fuller, Peter. "The LSD of Art," in: *New Society*, London.
9 July 1970.

1971
Benthall, Jonathan. Text in: *Colóquio Artes*,
Lissabon. No. 4, October 1971.

Sheperd, Michael. "In the Picture," in: *Daily Telegraph*,
London. December 1971.

1972
Bowen, Denis. "Inaugural Exhibition, Gallery House,
London," in: *Arts Review*, London. Vol. XXIV, No. 8,
22 April 1972.

Brett, Guy. "David Medalla/Gustav Metzger,"
in: *The Times*, London. 5 December 1972.

Musgrave, Victor. "The Unknown Art Movement,"
in: *Art and Artists*, special issue *Free Fluxus Now*,
London. October 1972: 12–14.

1974
Gilmour, Pat. "Art into Society, Society into Art,"
in: *Arts Review*, London. 1974.

1975
Dallett, Anne. "The ARLIS International Conference
on Art Periodicals," in: *Art Libraries Journal*, Preston.
Summer 1975.

Joachimides, Christos. "Art into Society," in:
Kunstforum, Mainz. Bd. 13, Februar-April 1975.

1977
Schönberger, Angela. "Art in Germany under National
Socialism," in: *Kritische Berichte*, Gießen. Heft 1, 1977:
70–72.

1978
Walker, John A. "Art and Anarchism," in: *Art and Artists*,
London. May 1978.

1981
"Faschismus: Darstellung, Analyse, Bekämpfen,"
in: *Woka* (Wochenkalender der Studentenschaft
Universität Bern), Bern. No. 5, 14.05.1981.

"Passiv – Explosiv," in: *Monochrom*, Köln 1981.

1987
Stiles, Kristine. "Synopsis of the Destruction in Art
Symposium (DIAS) and its Theoretical Significance,"
in: *The Act*, New York. Spring 1987.

Stiles, Kristine. "Introduction to the Destruction in
Art Symposium: DIAS," "Discussion with Ivor Davies,"
in: *Link 52*. September 1987: 4–10.

1988
"Deconstruction and the Arts," in: *Art and Design*,
London. No. 3 and 4, 1988.

1989
Stiles, Kristine. "Sticks and Stones: The Destruction
in Art Symposium," in: *Arts Magazine*, New York.
January 1989.

1991
Hoffmann, Justin. "Gustav Metzger und die Autodestruk-
tive Kunst," in: *Artis. Zeitschrift für neue Kunst*, Bern.
Heft 5, Mai 1991: 40–45.

1993
Wilson, Andrew. "Telling it Like it Really Wasn't,"
in: *Art Monthly*, London. May 1993.

1994
Galeyev, Bulat M. "Schoenberg/Kandinsky Symposium
and the Academy of Light," in: *Leonardo*, Oxford. Vol.
27, No. 1, 1994: 3–5.

1995
Glew, Adrian. "The Mad Messiah ... ," in: *Don't Tell It*,
London. October 1995.

Walker, John A. "Message from the Margin,"
in: *Art Monthly*, London. October 1995: 14–17.

1996
Cruz, Juan. "Made New, City Racing," in: *Art Monthly*,
London. December 1996.

Rosenthal, Norman. "Gustav Metzger," in: *Turner*,
London. 1996.

Stiles, Kristine. "Auto-Destructive Art," in: *Turner*,
London. 1996.

Wilson, Andrew. "Life versus Art," in: *Art Monthly*,
London. November 1996.

1997
Fricke, Harald. "Vom Säureattentat zum Rinder-
wahnsinn," in: *Tageszeitung*, Berlin. 5.11. 1997: 17.

Maier, Anne. "Gustav Metzger im Kunstraum," in: *Das
Kunst-Bulletin*, Zürich. Nr. 9, September 1997: 48–49.

O. W. "Disappearing act," in: *The Art Newspaper*,
London. No. 85, October 1998.

Palmer, Judith. "Talks Judith Palmer",
in: *The Independent*, London. June 22, 1998: 12.

1998
"Blow up," in: *Scene*, London. November 1998: 15.

Collings, Matthew. "Dropping acid. Gustav Metzger, Art
and Language and Bank," in: *The Observer*, London.
8 November 1998: 10.

Cork, Richard. "Finger on the Self-destruct Button,"
in: *The Times*, London. 15 December 1998: 33.

Draxler, Helmut. "Gustav Metzger. Kunstraum München,"
in: *Springer*, Wien. Bd. III, Heft 4,
Dezember 1997–Februar 1998: 76–77.

Flint, Rob. "Art Attack," in: *Red Pepper*, London.
December 1998: 25–26.

Hauffen, Michael. "Gustav Metzger: Manifeste, Schriften,
Konzepte," in: *Kunstforum International*, Köln. Bd. 141,
Juli–September 1998: 487.

Hervé, Louise. "Gustav Metzger," in: *Les cahiers de la
sculpture*, London, Paris. No. 10/98, October 1998.

Jones, Alison. "The assault course," in: *Socialist Review*,
London. Issue 225, December 1998.

Jones, Jonathan. "Guru in a gasmask," in: *The Guardian*,
London. 31 October 1998.

Kuhn, Nicola. "Unerhörter Warner in der Wüste –
abgetaucht, wieder entdeckt, mißverstanden:
Die 'Young British Artists' lieben Gustav Metzger," in:
Der Tagesspiegel, Berlin. Sonntag, 20. Dezember 1998: 27.

O'Rorke, Imogen. "Back on the road to ruin,"
in: *The Independent*, London. 26 October 1998.

Puvogel, Renate. " 'Out of Actions?. Between Performance
and the Object 1949-1979," in: *Eikon. Internationale
Zeitschrift für Photographie und Medienkunst*, Wien.
Heft 24, 1998: 56–57.

Weiner, Julia. "Chasids and acids," in: *Jewish Chronicle*,
London. 4 December 1998.

1999
Archer, Michael. "Gustav Metzger, Museum of Modern
Art, Oxford," in: *Artforum International*, New York.
February 1999: 107.

Blättner, Martin. "Gustav Metzger. Ein Schnitt entlang
der Zeit," in: *Kunstforum International*, Köln. Bd. 147,
September–November 1999: 435.

Christofori, Ralf. "Die Kunst des Autokreativen Han-
delns," in: *Frankfurter Allgemeine Zeitung*, Frankfurt.
Freitag, 13. August 1999: 44.

Dattenberger, Simone. "Ich bleibe auf der Schwelle,"
in: *Münchner Merkur*, München. 20./21. März 1999.

Hauschild, Joachim. "Finster entschlossen zur Kritik. München Dream City," in: *Art, das Kunstmagazin*, Hamburg. Nr. 6, Juni 1999: 96.

Hoffmann, Justin. "Gustav Metzger. Kunsthalle Nürnberg," in: *Springerin*, Wien. Bd. V, Heft 3, September–November 1999: 71–72.

Jeffreys, David. "Yoko Ono, Gustav Metzger, Ilya Kabakov," in: *The Burlington Magazine*, London. April 1999: 242–243.

Labelle Roujoux, Arnaud. "Gustav Metzger, Museum of Modern Art, Oxford," in: *Art Press*, Paris. No. 244, March 1999: 70–71.

Schütz, Heinz. "Dream City," in: *Kunstforum International*, Köln. Bd. 145, Mai–Juni 1999: 312.

Searle, Adrian. "Tale of the Mermaid," in: *The Guardian*, London. Tuesday, July 6 1999: 10–11.

Wallace, Christopher Martin. "Intimate Auto-Destruction, Gustav Metzger at Spacex Gallery, Exeter. February/March 1999," in: *Tangents*. http://www.tangents.co.uk/tangents/main/pre-2001/metzger.html

Wege, Astrid. "In der Glaskugel," in: *Texte zur Kunst*, Köln. Nr. 34, Juni 1999: 157–162.

2000
Cumming, Laura. "Revisit 1967, you bourgeois sucker," in: *The Observer*, London. 13 February 2000.

Jones, Jonathan. "The Mentors: School of Thought," in: *The Observer*, London. 19 March 2000.

Kraushaar, Wolfgang. "Gitarrenzertrümmerung. Gustav Metzger, die Idee des autodestruktiven Kunstwerks und deren Folgen in der Rockmusik," in: *Mittelweg 36*. Zeitschrift des Hamburger Instituts für Sozialforschung, Hamburg. 10. Jahrgang, Heft 1, Februar–März 2001.

2001
Haines, Luke. "Down mikes–we're going on strike," in: *The Guardian*, London. Wednesday, 31 May 2001: 13.

2002
Jones, Jonathan. "The Bomb in Art; Magic Mushrooms," in: *The Guardian*, London. August 6, 2002: 18–19.

2003
Ardenne, Pierre et al. "C'est arrivé demain. 7e Biennale d'art contemporain, Lyon," *Art Press*, Paris. No. 293, September 2003.

Ford, Simon. "Technological Kindergarten. Gustav Metzger and Early Computer Art," in: *Mute*, London. No. 26, 2003.

Garlake, Margaret. "Blast to Freeze, Kunstmuseum Wolfsburg," in: *Art Monthly*, London, April 2003.

Hackworth, Nick. "Signs of Subversion in a derelict gin factory," in: *Evening Standard*, London. January 30, 2003.

Jäger, Lorenz. "Blumfeld, ach so...," in: *Frankfurter Allgemeine Zeitung*, Frankfurt. Donnerstag, 30. Oktober 2003: 35.

Schürenberg, Barbara. "Dialog mit Gabelstapler," in: *Die Welt*, Berlin. 11. April 2003.

Suchin, Peter. "Gustav Metzger. t1+2 Artspace, London," in: *Frieze*, London. No. 75, May 2003.

2004
Burrell, Ian. "Modern Art is rubbish – and confusing for Tate cleaner," in: *The Independent*, London. August 27, 2004: 21.

Jones, Alison. "Introduction to the Historic Photographs of Gustav Metzger," in: *Forum for Holocaust Studies*. http://www.ucl.ac.uk/forum-for-holocaust-studies/metzger.html (July 2004)

Renton, Andrew. "The daddy of destruction," in: *The Evening Standard*, London. 27 July 2004.

General References and Further Reading

1961
Seitz, William. *The Art of Assemblage*. Museum of Modern Art, New York 1961: 87–92.

1964
Driver, Christopher P. *The Disarmers. A study in protest*. Hodder and Stoughton, London 1964.

Greer, Herb. *Mud Pie. The CND Story*. M. Parrish, London 1964.

Page, Robin. "Manifesto for The Door/a universal exhibition," in: *Signals*, London. Vol. I, No. 2, September 1964: 6.

1965
Hansen, Al. *A Primer of Happenings and Time/Space Art*. Something Else Press, New York 1965.

Schwenck, Theodor. *Sensitive Chaos. The Creation of Flowing Forms in Water and Air*. Rudolf Steiner Press, London 1965.

Sharp, Willoughby. *Art and Movement*. 1965.

1966
Bann, Stephen; Gadney, Reg; Popper, Frank; Steadman, Phil. *4 essays on kinetic art*. Motion Books, London 1966.

Freeman, Alan. "The truth about our generation," in: *Rave*, London. February 1966.

1967
"1966 in Art," Special issue of *Art and Artists*, London 1967.

Kultermann, Udo. *Neue Formen des Bildes*. Tübingen 1967.

Lipke, William. *David Bomberg. A Critical Study of His Life and Work*. Evelyn, Adams and Mackay, London 1967.

Popper, Frank. *Naissance de l'Art Cinétique*. Editions Gauthier-Villars, Paris 1967.

1968
Gimpel, Jean. *Contre l'art et les artistes ou la naissance d'une religion*. Ed. du Seuil, Paris 1968.

Nuttall, Jeff. *Bomb Culture*. MacGibbon and Kee, London 1968.

1969
Kultermann, Udo. *The New Painting*. Pall Mall Press, London 1969.

Rosenberg, Harold. *Artworks and Packages*. Thames and Hudson and New Horizon Press, London, New York 1969.

1970
Coutts-Smith, Kenneth. *Dada*. Studio Vista, London 1970.

Coutts-Smith, Kenneth. *The Dream of Icarus*, Hutchinson, London 1970.

Huyghe, René; Rudel, Jean. *L'Art et le Monde Moderne*. Vol. 2, Larousse, Paris 1970.

Hyde, Gordon. "A New Sort of Computer?," in: PAGE. *Bulletin of the Computer Arts Society*, London. No. 11, 1970.

Rookmaker, H.R. *Modern Art and the Death of a Culture*. Inter Varsity Press, London 1970.

Tatham, Laura. *Computers in Everyday Life*. Pelham, London 1970.

1971
Kultermann, Udo. *Art-Events and Happenings*. Mathews Miller Dunbar, London 1971.

Pluchart, Francois. *Pop Art et Cie 1960–1970*. Editions Martin Malburet, Paris 1971.

Reichardt, Jasia. *The Computer in Art*. Studio Vista, London 1971.

1972

Benthall, Jonathan. *Science and Technology in Art Today*. Thames and Hudson, London 1972.

Filliou, Robert. *Defrosting the Frozen Exhibition*. Galerie Philomène Magers, Bonn 1972. (Edition: 170)

Icasm. Institute of Contemporary Arts, London, November 1972. (Journal)

1973

Davis, Douglas. *Art and the Future. A history/prophecy of the collaboration between science, technology and art*. Thames and Hudson, London 1973.

1974

Henri, Adrian. *Total Art: Environments, Happenings, and Performance*. Oxford University Press, New York, Toronto 1974.

1975

Hultén, K. G. Pontus. *Jean Tinguely. Meta*. Propylaen Verlag, Berlin 1975: 111.

Popper, Frank. *Art-Action and Participation*. Studio Vista, London 1975.

Popper, Frank. *Die Kinetische Kunst. Licht und Bewegung, Umweltkunst und Aktion*. Verlag M. DuMont Schauberg, Köln 1975: 61, 147, 151.

Wolfram, Eddie. *History of Collage. An anthology of collage, assemblage and event structures*. Studio Vista, London 1975: 174–187.

1976

Oxlade, Roy. *David Bomberg and the Borough. An Approach to Drawing*. Royal College of Art, London 1976. Masters thesis, 2 Vol.

Williams, Christopher. *A survey of the relationship between Pop art, Pop music and Pop films*. Royal College of Art, London 1976. Masters thesis.

1978

Adams, Hugh. *Art of the Sixties*. Phaidon Press Lt., Oxford 1978: 60–61, 64–65.

Locher, J. L. *Mark Boyle's Journey to the Surface of the Earth*. Edition Hansjörg Mayer, Stuttgart, London 1978.

1979

Hinz, Berthold; Mittig, Hans E. et al. (eds). *Die Dekoration der Gewalt–Kunst und Medien im Faschismus*. Anabas Verlag, Gießen 1979: 5.

Thompson, Michael. *Rubbish Theory. The Creation and Destruction of Value*. Oxford University Press, Oxford (et al.) 1979.

1982

Barnes, Richard. *The Who. Maximum R and B*. Eel Pie, London 1982.

1983

Marsh, Dave. *Before I Get Old: the Story of the Who*. Plexus, London 1983.

1985

Jaeger, Stan. *Stromingen en begrijpen in de Kunst van 1880 tot heden*. Cantecleer 1985.

1986

Kellein, Thomas. *"Fröhliche Wissenschaft": Das Archiv Sohm*. Staatsgalerie Stuttgart, Stuttgart 1986.

1987

Cork, Richard. *David Bomberg*. Yale University Press, New Haven 1987.

Frith, Simon; Horne, Howard. *Art into Pop*. Methuen, London 1987.

Frowein, Cordula. "Nachtrag: Faschistische Kunst," in: *Kritische Berichte*, Gießen. Heft 2, 1987: 70–71.

Hewison, Robert. *Too Much. Art and Society in the Sixties*. Oxford University Press, Oxford, New York 1987.

Stiles, Kristine. *The Destruction in Art Symposium (DIAS). The Radical Cultural Project of Event-Structured Live-Art*. University of California, Berkeley 1987. Doctoral dissertation.

Walker, John A. *Cross-Overs. Art into Pop, Pop into Art*. Methuen, London 1987.

1988
Home, Stewart. *The Assault on Culture. Utopian Currents from Lettrisme to Class War*. Aporia with Unpopular Books, London 1988.

1989
Home, Stewart. *Art Strike Handbook*. London 1989.

Klocker, Hubert (ed). *Der zertrümmerte Spiegel/ The Shattered Mirror. Wiener Aktionismus/Viennese Actionism 1960-1971*. Ritter Verlag, Klagenfurt 1989.

Yawn: Sporadic Critique of Culture. Oakdale L.A. 1989-1993. (Journal of "Art Strike 1990-1993"). See also http://www.thing.de/projekte/7:9%23/ y__yawn.html

1990
Hughes, Robert. *Frank Auerbach*. Thames and Hudson, London 1990.

Oliva, Achille Bonito (ed). *Ubi Fluxus ibi Motus 1990-1962*. Mazzotta, Milano 1990.

1991
Home, Stewart. *Neoist Manifestos/The Art Strike Papers*. AK-Press, Stirling 1991.

Williams, Emmett. *My Life in Flux–and Vice Versa*. Ed. Mayer Verlag, Stuttgart (et al.) 1991: 61–64.

1992
Conzen-Meairs, Ina. *Jonathan Latham. Art After Physics*. Museum of Modern Art, Oxford. Oxford 1992.

Larkin, Colin (ed). *The Guiness Who's Who of Sixties Music*. Guiness, London 1992.

Seitz, William C. *Art in the Age of Aquarius 1955–1970*. Smithsonian Institution Press, Washington 1992: 167–184.

1992
Armstrong, Elizabeth; Rothfuss, Joan (eds). *In the Spirit of Fluxus*, Walker Art Center, Minneapolis 1993.

Gray, John. *Action Art. A Bibliography of Artists' Performance from Futurism to Fluxus and Beyond*. CT Greenwood Press, Westport 1993.

1994
Blotkamp, Carel. *Mondrian. The Art of Destruction*. Reaktion Books, London 1994.

Bois, Yve-Alain. *Mondrian*. Haags Gemeentemuseum, Den Haag, Leonardo Arte Verlag, Milano 1994.

1995
Brett, Guy. *Exploding Galaxies. The Art of David Medalla*. Kala, London 1995.

Grasskamp, Walter. "Das einsame Massenidol (John Lennon)," in: *Der Spiegel*, Hamburg. Nr. 21/22, Mai 1995: 198–201.

Hoffmann, Justin. *Destruktionskunst. Der Mythos der Zerstörung in der Kunst der frühen sechziger Jahre*. Verlag Silke Schreiber, München 1995: 43–54.

Home, Stewart. *Neoism, Plagiarism and Praxis*. AK Press, Edinburgh 1995: 12, 25, 79–81, 99, 191, 193–194, 201.

Kureishi, Hanif; Savage, Jon (ed). *The Faber Book of Pop*. Faber and Faber, London 1995: 168–171.

Walker, John A. *John Latham. The Incidental Person. His Art and Ideas*. Middlesex University Press, London 1995.

Welch, Chris. *Teenage Wasteland. The Early Who*. Castle, Chessington 1995.

1996
West, Shearer. *Guide to Art*. London 1996.

1997

Gamboni, Dario. *The Destruction of Art. Iconoclasm and Vandalism Since The French Revolution*. Reaktion Books, London 1997.

Obrist, Hans Ulrich; Tortosa, Guy (eds). *Unbuilt Roads. 107 Unrealized Projects*. Verlag Hatje, Ostfildern 1997: 71–72.

1998

Garlake, Margaret. *New Art, new world. British Art in post-war society*. Yale, New Haven, London 1998: 144–149.

Wood, John (ed). *The Virtual Embodied: Presence/ Practice/Technology*. Routledge, London 1998: 105–108.

1999

Walker, John A. "1966: Art and Destruction," in: John A. Walker. *Art and Outrage. Provocation, Controversity and The Visual Arts*. Pluto Press, London 1999: 42–47.

2000

Carotti, Elena (ed). *Vanished Paths. Crisis of Representation and Description in the Arts form the 1950s to the End of the Century*. Edizioni Charta, Milano 2000: 65, 167.

Hopkins, David. *After Modern Art 1945-2000*. Oxford, New York 2000.

Julius, Anthony. *Idolizing pictures. Idolatry, Iconoclasm and Jewish Art*. Thames and Hudson, London 2000.

2001

Blistène, Bernard. *A History of 20th Century Art*. Paris 2001.

Brener, Alexander; Schurz, Barbara. "Streiken ist nicht obsolet!," in: *context XXI*, Wien. März–April 2001.

2002

Archer, Michael. *Art since 1960*. New Edition, London 2002: 111–117.

Julius, Anthony. *Transgressions. The Offences of Art*. London 2002: 125–128.

Morris, Simon; Brennan, Tim; Smith, Cindy. *Interpretation*. New York 2002.

Walker, John A. *Left Shift. Radical Art in 1970s Britain*. London, New York 2002.

2005

Bois, Yve-Alain; Buchloh, Benjamin; Foster, Hal; Kraus, Rosalind. *Art Since 1900: Modernism, Antimodernism, Postmodernism*. Thames and Hudson, London 2005.

Films, Radio and TV Broadcastings on the Artist

1963

Auto-Destructive Art, The Activities of G. Metzger. Film, 15 minutes, directed by Harold Liversidge. London 1963.

1969

Art in Europe Since 1945. Directed by Nancy Thomas, Paul Overy, BBC-TV, February 1969.

1997

Obrist, Hans Ulrich. Video interview with Gustav Metzger. London, November 1997.

Phillpot, Clive. Interview series. National Sound Archive, London 1997.

2003

You Are Hear. A broadcast with Gustav Metzger and Stewart Home. Resonance 104.4fm, 24.02.2003.

2004

Pioneers in Art and Science: Metzger. DVD, directed by Ken McMullen, produced by Arts Council England, June 2004.

"Politics and Performance," part 3 of *Art and The Sixties*. BBC-TV. Directed by Vanessa Engle. July 2004.

English Dictionary Entries on Gustav Metzger and/or on the Term Auto-Destructive Art

1977
Bullock, Alan; Stallybrass; Oliver. *Fontana Dictionary of Modern Thought*. London 1977.

Naylor, Colin; Genesis, Orridge P. *Contemporary Artists*. London, New York, Chicago 1977: 641–642.

1982
Oxford English Dictionary Supplements. Vol. 1, Oxford 1982.

1983
Strauss, Herbert; Räder, Werner (eds). *International Biographical Dictionary of Central European Emigres 1933-1945*. Vol. 2, München, Wien, New York, London, Paris 1983.

1984
Lucie-Smith, Edward. *Thames and Hudson Dictionary of Art*. London 1984.

Osbome, Harold (ed). *The Oxford Companion to Twentieth Century Art*. Oxford, New York 1984.

Piper, David. *A-Z of Art and Artists*. London 1984.

1988
Piper, David. *Dictionary of Art and Artists*. London 1988.

Piper, David (ed). *Random House Dictionary of Art and Artists*. New York 1988.

1990
Chilvers, Ian (ed). *The Concise Oxford Dictionary of Art and Artists*. Oxford, New York 1990.

Davies, Diana (ed). *Harrap's Illustrated Dictionary of Art and Artists*. London 1990.

1992
Walker, John A (ed). *Glossary of Art and Design since 1945*. London 1992.

1993
Simpson, John; Weiner, Edmund. *Oxford English Dicitonary Additions Series*. Vol. 1, Oxford University Press, New York 1993.

1995
Hutchinson's Dictionary of the Arts, London 1995.

1996
Turner, Jane (ed). *The Dictionary of Art*. Vol. 2 and 21. London, New York 1996.

West, Shearer (ed). *Guide to Art*. London 1996.

1997
Chilvers, Ian (ed). *Oxford Dictionary of Art and Artists*. Oxford, New York 1997.

1998
Buckman, David. *Dictionary of Artists in Britain since 1945*. Bristol 1998.

Chilvers, Ian (ed). *Oxford Dictionary of 20th Century Art*. Oxford 1998.

Kelly, Michael (ed). *Encyclopaedia of Aesthetics*. Oxford, New York 1998.

2000
Frazier, Nancy. *The Penguin Concise Dictionary of Art History*. London 2000.

Langmuir, Erika; Lynton, Norbert (ed). *The Yale Dictionary of Art and Artists*, London 2000.

The Prestel Dictionary of Art and Artists in the 20th Century. London 2000.

Turner, Jane (ed). *From Expressionism to Post-Modernism. Styles and Movements in 20th Century Western Art*. Oxford, New York 2000.

2001
Birgstocke, Hugh (ed). *The Oxford Companion to Western Art*. Oxford, New York 2001.

Clarke, Michael. *The Concise Oxford Dictionary of Art Terms*. Oxford, New York 2001.

2002
Crystal, David. *The New Penguin Encyclopaedia*. London 2002.

Dempsey, Amy. *An Encyclopaedic Guide to Modern Art*. London 2002.

2003
Chilvers, Ian. *The Concise Oxford Dictionary of Art and Artists*. Oxford, New York 2003.

Crystal, David. *The Penguin Concise Encyclopaedia*. London 2003.

Exhibition Check List

If not stated otherwise, collection of the artist.
Dimensions: height by width, followed by depth
Activities, projects and works, that are only indicated
with title, dating and category, are presented through
documentation material and ephemera in the exhibition.

Manifestos

Auto-Destructive Art, 1959
First manifesto, includes also a statement
on *Cardboards*
Typescript text, print run approx. 150
33 x 20.5 cm
Archiv Sohm, Staatsgalerie Stuttgart

Manifesto Auto-Destructive Art, 1960
Second manifesto, includes also the first manifesto
Typescript text, reproduction with stencil,
print run approx. 150,
33 x 20.5 cm
Archiv Sohm, Staatsgalerie Stuttgart

Auto-Destructive Art, Machine Art, Auto-Creative Art,
1961
Third manifesto (South Bank manifesto),
includes also a reprint of the first two manifestos
Offset print
28.2 x 21.7 cm
Archiv Sohm, Staatsgalerie Stuttgart

Manifesto World, 1962
Fourth manifesto, neither original nor facsimile
preserved, reprint self-published *Destruction/Creation*,
1965, print run approx. 150
27 x 20.3 cm
Archiv Sohm, Staatsgalerie Stuttgart

*On Random Activity in Material/Transforming
Works of Art*, 1964
Fifth manifesto, published in: *Signals. Newsbulletin of
the Centre for Advanced Creative Study*, London. Vol. 1,
No. 2, September 1964
50.1 x 34.2 cm
Generali Foundation Collection

Political activism since 1957
Newspaper articles, leaflets
"King's Lynn Committee for Nuclear Disarmament"
"Campaign for Nuclear Disarmament"
"North End Society"
"Direct Action Committee Against Nuclear War"
"Committee of 100"

Cardboards, 1959
Found cardboards

Bag, 1959
Found object

Untitled, 1959-60
Sculpture
Aluminum wire
approx. 30 x 90 x 45 cm
Reconstruction 2005 Generali Foundation

Act or Perish, 1960
Leaflet (facsimile)
Graphic design Gustav Metzger
The Library of the London School of Economics
and Political Science

Auto-Destructive Art, 1960
First *Lecture/Demonstration*, Temple Gallery, London

Auto-Destructive Monument, 1960
Model
Staples, steel, varnished
approx. 20 x 40 x 23 cm
Reconstruction 2005 Generali Foundation

Acid Nylon Painting, 1960
Demonstration, non-public, acid nylon painting
Nylon, glass
150 x 270 x 5 cm
Production 2004 Tate Britain, London

Auto-Destructive Art, 1961
Demonstration, South Bank, London

Acid Nylon Painting, 1962
Demonstration, *Festival of Misfits*, ICA, London

Daily Express, 1962
2 issues of *Daily Express*, London, October 24, 1962
framed in perspex box 70.8 x 93.5 x 12.5 cm
Production 1998 Museum of Modern Art, Oxford

The Chemical Revolution in Art, 1965
Lecture/Demonstration, Cambridge

Liquid Crystal Environment, 1965–66
Installation
Modified slide projectors, liquid crystals,
35mm slides with glass, polaroid filter,
computer control
Dimensions variable
Production 1998 Museum of Modern Art, Oxford

Art of Liquid Crystals, 1966
Solo exhibition, Better Books, London

Destruction in Art Symposium (DIAS), 1966
Symposium, Africa Centre, September 9 to 11, 1966
Events at different venues,
August 31 to September 30, 1966, London

Liquid Crystal Projections, 1966/67
Light show for Cream, Roundhouse, London

Extremes Touch: Material/Transforming Art, 1968
Exhibition text, Swansea Arts Festival

Drop on Hot Plate, 1968
Installation
Hot plate, silicon tube, steel pipe, water
approx. 200 x 30 x 30 cm
Reconstruction 2005 Generali Foundation

Mica and Air Cube, 1968
Object
Perspex cube, mica flakes, compressed air
43.5 x 43.5 x 53 cm
Reconstruction 2005 Generali Foundation

Five Screens with Computer, 1969
Model
Computer-controlled *Auto-Destructive Monument*
7.2 x 44.4 x 30.9 cm

PAGE, 1969–1973
Bulletin of the Computer Arts Society,
Gustav Metzger (ed)
Generali Foundation Collection

Mobbile, 1970
Car, on the roof a transparent perspex box, plants,
entrails, exhaust gases
Reconstruction 2005 Generali Foundation

Project *Stockholm June*, 1972
Model
Polystyrene, red toy car, perspex box
13.8 x 18.8 x 35.7 cm
Production 1997 kunstraum muenchen

Projects Unrealised I, 1971
b&w photograph, cibachrome, dry-mounted on aluminum
framed in perspex box, 71 x 101.5 x 12.5 cm
Reconstruction 1998 Museum of Modern Art, Oxford

Projects Realised I (Monument to Bloody Sunday), 1972
b&w photograph, cibachrome, dry-mounted on aluminum
framed in perspex box, 101.7 x 71.3 x 12.2 cm
Reconstruction 1998 Museum of Modern Art, Oxford

KARBA, 1972
Concept for *Documenta 5*, Kassel

Second Floor, 1972
Installation, instructions,
3 Life Situations, Gallery House, London

Years without Art 1977–1980, 1974
Text for *Art into Society – Society into Art*, ICA, London

AGUN – *Art in Germany under National Socialism*, 1976
Symposium, School of Oriental and African Studies,
University of London und Drill Hall,
September 17 to 19, 1976, London

Sun, Page 3 Girls, 1977
Installation, page 3 of *The Sun*, current page 3 added
on each day of the exhibition
36.5 x 30.1 cm each
Production 2005 Generali Foundation

Faschismus Deutschland, 1981
Installation, for the exhibition *Vor dem Abbruch*,
Kunstmuseum Bern

Passiv – Explosiv, 1981
Exhibition concept and installation with
Cordula Frowein and Klaus Staeck,
Hahnentorburg, Cologne

Artists Support Peace, 1983
Initiative founded by Gustav Metzger

Earth minus Environment, 1992
Model
Wood board, perspex, 120 toy cars
11.5 x 120 x 120 cm
Harry Ruhé/Galerie A., Amsterdam

Mad Cows Talk, 1996
12 newspaper clippings
Archive Luise Metzel

Group of Works *Historic Photographs*, 1995–1998
Installations

*No. 1: Hitler addressing the Reichstag after the fall
of France, July 1940*, 1995
b&w photograph, mounted on MDF board,
grey formica board, fluorescent lighting
108 x 183.5 x 8 cm

*No. 1: Liquidation of the Warsaw Ghetto,
April 19 – 28 days, 1943*, 1995
b&w photograph, mounted on MDF board,
vertical metal rails, board partition
184 x 123 cm

To Crawl Into – Anschluss, Vienna, March 1938, 1996
b&w photograph on pvc, cotton (cover)
315 x 425 cm

*To Walk Into, Massacre on the Mount, Jerusalem,
8 November, 1990*, 1996
b&w photograph on pvc, linen (cover)
238 x 395 x 30 cm

Hitler-Youth, Eingeschweisst, 1997
b&w photograph, mounted between two welded
steel sheets
121 x 177.5 x 0.4 cm
Production 1998 Museum of Modern Art, Oxford

Jerusalem, Jerusalem, 1998
2 b&w photographs on transparent pvc foils
193 x 303.5 cm and 200 x 347.5 cm

*Till we have built Jerusalem in England's green
and pleasant land*, 1998
Color photograph, mounted on aluminum,
caterpillar treads
128 x 192.3 x 190 cm

Après Paolozzi PN 004886402, 1997
Found object, polystyrene
43 x 20 x 18 cm

breath in$_g$ culture, 1997
Slide lecture, Lise Autogena, London

Travertin/Judenpech, 1999
Video, color, sound
Documentation, installation at Haus der Kunst,
Munich 1999
Camera Juli Lambert, courtesy kunstraum muenchen
and Kunstverein München
Editing Generali Foundation, 2005
Generali Foundation Collection

Power to the People, 2003
Video, color, sound, 20 min
Technical production Chris Hammonds

Group of works *London a.m., London p.m.*, 2005
Evening Standard 2 issues of the same day with
announcement poster each
Newspapers 39,3 x 30 cm each
Posters 63,5 x 45 cm each
Monday, July 19, 2004
Friday, October 8, 2004
Tuesday, October 19, 2004
Friday, November 19, 2004
Monday, November 29, 2004
Wednesday, December 8, 2004
Tuesday, March 22, 2005

Friday, September 3, 2004
Evening Standard 3 issues of the same day
with announcement posters

Film- and Video Documentaries

Auto-Destructive Art – The Activities of G. Metzger, 1963
Video, transferred from film, 16mm, b&w, silent, 8 min
Director Harold Liversidge
Contemporary Films Ltd., London

Interview by Hans-Ulrich Obrist, London, 1997
Video, color, sound, 63 min

Interview by Andrew Wilson at the ICA, London 1998
Video, color, sound, 60 min

Art & the 60s, *Episode 3 Politics and Performance*, 2004
Video, color, sound, approx. 60 min
BBC Television, London

Pioneers in Art and Science: Metzger, 2004
Video, color, sound, 139 min
Director Ken McMullen
Production Arts Council England, London

From DIAS to Punk, 2004
Video, color, sound, 63 min
Panel discussion with Gustav Metzger, John Dunbar,
John Hopkins, Barry Miles, Andrew Wilson
October Gallery, London

Biographies Authors

Justin Hoffmann, born 1955 in Cham, Germany, lives in Munich and Wolfsburg. He is an art critic, musician (FSK), and curator. He contributes regularly to the *Süddeutsche Zeitung, Frieze, Kunstforum International,* and *Springerin,* amongst other publications. He has been the director of Kunstverein Wolfsburg since 2004. For his doctoral dissertation on 1960s Destruction Art, he conducted a number of interviews with Gustav Metzger and curated his first solo exhibition in Germany at the kunstraum muenchen in 1997. He also published a collection of Gustav Metzger's manifestos, writings, and concepts translated into German.

Kristine Stiles, born 1947 in Denver, Colorado, lives in Durham, North Carolina. She is an artist and associate professor of Art and Art History at Duke University, USA, where she has taught since 1988. She is the author of *Theories and Documents of Contemporary Art*, 1996, and several monographs on artists. She is a specialist on performance and experimental art, as well as destruction, violence, and trauma in art and culture. Her unpublished doctoral dissertation at the University of California, Berkeley, 1987, was the first scholarly examination of the *Destruction in Art Symposium* (DIAS) and the first biography of Gustav Metzger. She is currently working on three publications on performance art, trauma, and Joseph Beuys.

Andrew Wilson, born in 1962, lives in London. He is a curator, art historian, and art critic. He has been deputy editor of *Art Monthly* since 1997. He has continuously collaborated with Gustav Metzger and published extensively on 1960s art and culture since the 1980s. Recent publications include studies of Hamish Fulton, Art & Language, the Boyle Family, and Tony Hancock. He was a juror for the 2003 Tate Turner Prize. His recent exhibition *No Future: Sex, Seditionaries and the Sex Pistols* was at The Hospital in London and is at Urbis in Manchester (May to August 2005). He is currently working on a major study of the counterculture in London in the 1960s and 1970s.

Colophon

Gustav Metzger
History History

Exhibition

May 11 to August 28, 2005
Generali Foundation, Vienna

Curated by Sabine Breitwieser
Curatorial Assistant, Exhibition Production: Cosima Rainer
Research: Anna Artaker, Adeline Blanchard
Interns: Carmen Carmona, Katrin Hornek, Luise Reitstätter
Press, Marketing: Carmen Buchacher
Exhibition Installation: Thomas Ehringer (Head), Didi Ebenhofer (Audiovisual Engineering) with Thomas Cerny,
Isolde Christandl, Michal Estrada, Dietmar Hochhauser, Thomas Latzl-Ochoa, Hans Neumayer, Bernie Schwabl,
Marcus Stöger, Christoph Thausing
Frontoffice: Astrid Steinbacher with Linda Erker, Stephanie Lang, Sophie Reichetzeder, David Wiltschek
Art Education Program: Claudia Slanar, Nikolaus Zeiner
Graphic Design of PR-Media: Dorit Margreiter
Transport: Oxford Exhibition Services

Publication

Edited by Sabine Breitwieser
for

Generali Foundation
Wiedner Hauptstrasse 15
1040 Vienna, Austria

Telephone +43 1 504 98 80
Telefax +43 1 504 98 83
foundation@generali.at
http://foundation.generall.at

Generali Foundation, Vienna
ISBN 3-901107-47-9 (English)
ISBN 3-901107-46-0 (German)

Hardcover published by
Hatje Cantz Verlag
Senefelderstrasse 12
73760 Ostfildern-Ruit, Germany
Telephone +49 711 4405 0
Telefax +49 711 4405 220
www.hatjecantz.com
ISBN 3-7757-1650-5 (English)
ISBN 3-7757-1649-1 (German)

Concept, Project Director: Sabine Breitwieser
Bibliography, Chronology, Text Editing: Anna Artaker
Production Manager: Julia Heine
List of Works: Cosima Rainer
Photo Editors: Iris Ranzinger, Luise Reitstätter
Translations: Timothy Jones (The Invention of Auto-Destructive Art; Foreword; Acknowledgments; Introduction),
Tim Sharp (Chronology; Passive – Explosive)
Copy Editor: Lisa Rosenblatt
Lithography: Markus Wörgötter
Graphic Design Publication: Dorit Margreiter

Printed by Holzhausen, Vienna, Austria
Paper: Euro Art matt, 150 g
Total Production: Generali Foundation